AHMANSON · MURPHY
FINE ARTS IMPRINT

Published with the assistance of the Getty Grant Program.

*The publisher also gratefully acknowledges the generous
contribution to this book provided by the Art Endowment
of the University of California Press Associates, which is
supported by a major gift from the Ahmanson Foundation.*

JOHN VACHON'S AMERICA

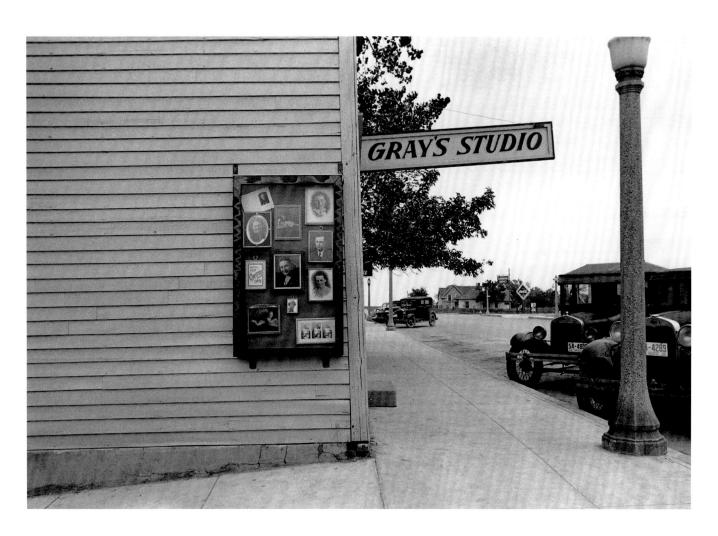

UNIVERSITY OF CALIFORNIA PRESS

Berkeley Los Angeles London

JOHN VACHON'S AMERICA

PHOTOGRAPHS AND LETTERS FROM THE DEPRESSION TO WORLD WAR II

JOHN VACHON

Edited, with Introductory Texts, by

MILES ORVELL

University of California Press

Berkeley and Los Angeles, California

University of California Press, Ltd.

London, England

Library of Congress Cataloging-in-Publication Data

Vachon, John, 1914–1975.

 John Vachon's America : photographs and letters from the Depression to World War II / John Vachon ; edited, with introductory texts, by Miles Orvell.

 p. cm.

 "The Ahmanson-Murphy fine arts imprint."

 Includes bibliographical references and index.

 ISBN 0-520-22378-0 (cloth : alk. paper)

 1. Vachon, John, 1914–1975—Correspondence. 2. Photographers—United States—Correspondence. 3. Documentary photography—United States—History—20th century. 4. United States—Rural conditions—Pictorial works. 5. United States—Social conditions—1933–1945—Pictorial works. 6. United States. Farm Security Administration. I. Orvell, Miles. II. Title.

TR140.V33 A4 2003

770'.92—dc21 2003011770

Manufactured in Canada

12 11 10 09 08 07 06 05 04 03
10 9 8 7 6 5 4 3 2 1

The paper used in this publication meets the minimum requirements of ANSI/NISO Z39.48-1992 (R 1997) (*Permanence of Paper*).♾

TO JOHN VACHON'S CHILDREN:

ANN, BRIAN, GAIL, CHRISTINE, MICHAEL

CONTENTS

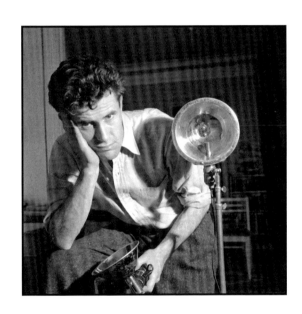

PREFACE

This book had its start in some conversations I had nearly twenty years ago with Ann Vachon, John's daughter, a dancer and choreographer who happens to be a colleague of mine. Given my interest in Farm Security Administration (FSA) photographic campaigns generally, I had known John Vachon's work, but only slightly, for at that time little of it had been reproduced. I had seen Ann's dance company give a performance of a piece that used her father's photographs as a kind of backdrop, and I was intrigued by this connection to the FSA so close to home. When we met to talk about John Vachon, Ann revealed a trunk full of letters in her possession; and as we looked at a few of them, I became drawn into his story—you might say, by his voice. We agreed, in a general way, that we would work together at some point to produce a volume of his work.

But there were other projects engaging my immediate attention, and it was only many years later that I found some time at last to turn back again to this endeavor. By then Ann had published her father's photographs of Poland, made in the aftermath of World War II (*Poland, 1946: The Photographs and Letters of John Vachon* [Washington, D.C.: Smithsonian Institution Press, 1995]), and she herself was engaged in making a film about José Limon. As my own interest in the project grew, Ann turned over to me a carton of about three hundred letters John had written to his wife Penny; soon after, another carton turned up with three hundred letters he'd written to his mother. That was followed by a carton of manuscripts, notebooks, and related materials, and thus over time I came into possession of an archive whose extent and richness gradually dawned on me. Knowing so little of Vachon's photographic work, I was equally unprepared to discover that he was perhaps the most prolific of the FSA photographers and that to review the body of his work—thousands and thousands of images—would be a labor of months, stretching to years.

It must be clear by now that this volume would not have come about without the generous and continual assistance and advice of Ann Vachon. Neither of us quite knew what producing a work of this sort would involve (I certainly did not), but her aid was indispensable. Brian Vachon, John's second child, also generously helped me, from beginning to end, and encouraged me along the way. (Brian

has himself written about his father's work and at one point contemplated publishing some of those reflections.) Brian and Ann had gone so far as to transcribe most of John's letters to Penny, along with his journals, and their giving me access to that material was absolutely essential. Other members of John Vachon's family—his younger brother, Robert, and John's son Michael (from his second marriage)—spoke generously and honestly with me about John. This volume is as much a tribute to them as it is to John Vachon.

The staff of the Library of Congress Prints and Photographs Division, especially Beverly Brannan, offered crucial and astute advice at several key points, and the Photoduplication Office of the Library of Congress efficiently handled an order of no small complexity. Some parts of this project have appeared along the way—in *DoubleTake* magazine and in a volume called *A Modern Mosaic: Art and Modernism in the United States*. The editors of those works were hospitable to the Vachon materials and enthusiastically interested in them: Alex Harris, of the Duke Center for Documentary Studies, and Robert Coles, editors of *DoubleTake;* Townsend Ludington, professor of American studies at the University of North Carolina, editor of *A Modern Mosaic*. Stephanie Fay, of the University of California Press, supported this book with steady encouragement, wise advice, and continuing patience. And Lynn Meinhardt has expertly overseen preparations for editing and production.

Among the colleagues and friends who have heard me talk about Vachon (for ages, it seems), Alan Trachtenberg shrewdly criticized the project and advised me at a crucial stage, and Maren Stange supported my work with her generous advice and enthusiasm. I am glad to have this book now to show as a reward for their patience and that of other friends along the way who have watched it grow, offering counsel and comfort.

Temple University granted me both research funds and a study leave, during which I was able to accomplish a good deal. Dean Morris Vogel and my colleagues in American studies at Temple, especially Philip Yannella, Regina Bannan, and Carolyn Karcher, foster an environment in which work can be done. Nadia Kravchenko, also of Temple, provided assistance and good cheer when I needed them most, and Greg Jacoski helped me prepare the manuscript. Closer to home, I thank my wife, Gabriella, who sustained me with her own interest in Vachon's work and her confidence in this project, even when its completion was delayed. And to my children, Ariana and Dylan, my thanks as always for sharing the joy of their daily lives with me and for letting me get to work at times when I should have been playing.

INTRODUCTION

LOOKING BACK FROM a distant perspective on his first days with the Farm Security Administration (FSA) photography unit, John Vachon wrote:

> Once upon a time when I was 21 years old it was a soft Spring day in Washington, D.C. and I needed a job. As a matter of fact it was the 27th of April, 1936 and I had been cleared for patronage through the Demo Natl Comm. That was the way you got jobs that year. I don't know how many applicants there were, but I got the job. Mr Stryker, Roy Stryker it was told me kindly that it was rather dull work, but he hired me. Perhaps I looked dull to him. So two days later I started in, and very gradually realized that I was working for the Historical Division of the Division of Information of the Resettlement Administration. This was the RA headed by Rex Tugwell in the year when they had AAA, NRA, WPA, PWA. The RA was turned into the FSA for Farm Security Administration about a year later. I don't think any of them are operating any more.
>
> My job was to write captions in pencil onto the back of 8 × 10 glossy prints of photographs. I would copy out such identifications as: Dust Storm, Cimmaron Co. Okla, Migrant mother and child working peaches in Calif, Main street, Selma Alabama, new house of tenant farm family, etc. And then I would take the proper rubber stamp and stamp on the back RA/ FSA photo by: Arthur Rothstein. Or it might say Ben Shahn, Dorothea Lange, Walker Evans, Carl Mydans. I had never heard of any of these names.
>
> —undated, untitled MS in Vachon Collection[1]

All of that would soon change, and the country at large, in the midst of the Great Depression, would shortly begin seeing pictures by this new group of photographers that would make the meaning of that economic situation concretely visual. Out of the FSA file have come the indelible pictures— Dorothea Lange's *Migrant Madonna,* Walker Evans's Alabama portraits, Arthur Rothstein's dust bowl landscapes—that have shaped our collective memory of the 1930s. Yet the richness of the collection is mostly unknown to us, for the vast pictorial archive defies any single effort to comprehend it in all its ramifications.[2] Some books of FSA images published in recent years have been organized around particular regions; others have taken a thematic or topical approach.[3] Still others have focused on individual FSA photographers. In the past few decades, in addition to Evans and Lange, several others have been recognized—Ben Shahn (better known as a painter), Russell Lee, Marion Post Wolcott, Gordon Parks, Jack Delano, and Rothstein. Yet one of the major figures of this documentary effort—John

Vachon—has by and large escaped our notice; Vachon's images have been selectively represented in several collections of FSA work and in journalistic retrospectives, but there has been, until now, no serious study of his career, or any adequate representation of his FSA work.[4] As we expand our view of the FSA effort, Vachon makes a number of striking claims on our attention, not only because of the huge volume of his output but also because of its social and aesthetic significance.

First, as a documentary photographer, Vachon created images that have a distinctive formal elegance and a captivating observational quality that demands recognition; in many ways, he is a missing link between the social documentary movement of the thirties and the postwar sensibility of Robert Frank and his followers. Second, his self-consciousness about the documentary movement (see his "Standards of the Documentary File" in the "Additional Writings" at the end of this book) gives his work a special dimension among the FSA photographers. Third, his account, provided in the letters he wrote home to his wife, of what it was like to work within the FSA under Stryker offers us our most extensive and detailed view of the documentary photographer's daily strategies during this period. Fourth, the extension of Vachon's work into the later years of the FSA, when it became the Office of War Information (OWI)—revealing the domestic front as America prepared for war—offers a counternarrative to the more commonly seen FSA work of the thirties. Because Vachon worked for the FSA-OWI as long as he did, his work forms a narrative from the despair and desolation of the Depression to the energy and mobilization of World War II. (The spectacle of a country united against a common enemy was, we realize in retrospect, not to occur again during the twentieth century; we would see it again only after the events of September 11, 2001.) And finally, Vachon traveled the Midwest with his eyes wide open, taking in a wide range of American social life and mores, indulging his taste for movies and music at every opportunity; his observations on America during this time are expressed vividly in the letters he wrote back home to his wife, a selection of which are printed in this volume.

VACHON WAS HIRED by Roy Stryker in 1936 just as the picture agency was beginning to take shape and define its purpose: it would indirectly promote the efforts of the Resettlement Administration (later the Farm Security Administration) by providing pictorial evidence of the nation's condition. It is certainly no accident that the photographic image is so central to 1930s culture: building on the precedent of European picture magazines, editors in the United States were putting photographs in newspapers, magazines, and books; *Life* magazine commenced in 1936 and *Look* in 1937. *Time* magazine, first published in 1923, by the thirties increasingly featured photographs.[5] A new book genre, photojournalism, appeared with Erskine Caldwell and Margaret Bourke-White's infamous *You Have Seen Their Faces* (1937) and continued with Dorothea Lange's *American Exodus* (1939), Richard Wright's *Twelve Million Black Voices* (1941), and, most notably, James Agee and Walker Evans's *Let Us Now Praise Famous Men* (1941).

Above all, from 1935 to 1943 the government, through the Farm Security Administration, conducted the greatest documentary effort in history, sending more than forty photographers into the field and across the United States to collect images of American life that would result in an archive of 165,000 classified FSA prints, with an additional 100,000 negatives gathered from other sources and put into the general archive. Most of the FSA images were taken under the direction of Stryker, the chief of the Historical Unit, who managed and directed from two to a dozen photographers at any given time (depending on available funding), spread out across the nation.

Vachon toiled under Roy Stryker longer than virtually any other FSA photographer (six years), and he went on, before being drafted into the army, to work briefly for the Standard Oil Company, which was gathering a photographic archive ostensibly relating to oil production, again under Stryker's direction. In 1946 Vachon undertook, with great excitement, an assignment for the United Nations Relief and Rehabilitation Administration, photographing postwar Poland.[6] Following his return to the United States (after another brief stint with Standard Oil) he served, from 1947 to 1971, as one of the few regular staff photographers at *Look* magazine, where he was celebrated by his editors as their "poet photographer."[7]

Why, then, has Vachon been relatively neglected in accounts of the FSA movement? A primary reason was that, unlike better-known photographers of the era, he produced no single picture or set of pictures that achieved iconic status.[8] Fame is partly a function of accident and timing, as well as the photographer's ability to advance him- or herself in the competitive world of photojournalism. And here Vachon may have had himself to blame, and his own habits of self-deprecation: immensely gifted yet deeply suspicious of his gifts, Vachon was anything but self-promoting. Another possible reason for his general neglect is that he began photographing for the agency in 1937, after Evans, Lange, Shahn, Rothstein, and others had already established their reputations by photographing largely rural and farming subjects, often in the South or in dust bowl regions. Moreover, his assignments were rarely in these rural areas, where the FSA photographers early registered their strongest impact. After working in the field part-time for four years (with the file in Washington his other responsibility), Vachon finally became an "official" photographer only in 1941, by which time the FSA was shifting its function to war propaganda and changing its name to the Office of War Information. And that too may explain why he has often been overlooked, for historians have generally slighted the work of the FSA-OWI—favoring that of the earlier agency.

Whatever the reasons, Vachon's relative neglect is all the more regrettable because of the extraordinary aesthetic quality of his photographic work and the rich complexity of his sensibility. Vachon offers a detailed case study of government work in the FSA program, one that is at once representative and exceptional: a mirror of his times, he simultaneously possessed a complex inner life and a lifetime's ambition to be a writer. Though he published little during his life—some brief writings on photography, a memoir of Stryker, a memoir of his father—Vachon was an indefatigable letter writer,

and the letters he wrote to his wife Penny back home constitute a valuable literary and human document of the period. Introspective, sharply observant, by turns passionately idealistic and cynical about his FSA mission, Vachon's letters richly convey the texture of the times and an understanding of the complex mentality—and often vexed circumstances—underlying the production of documentary photography during the late years of the Depression and the early years of the war. Vachon's sizable legacy of manuscripts (in addition to the letters, notebooks, and drafts of stories and novels he tried to publish in the 1950s and 1960s, Vachon kept a remarkable journal for many years, excerpts from which are included in this volume) makes it possible to construct an inner portrait of a photographer who was, almost against his will, working at the center of the twentieth century's emerging visual culture.

I

One of the anomalies of Vachon's career, in many ways a determining one, is how he came to photography in the first place.[9] Born in 1914, Vachon grew up in an Irish Catholic middle-class family in St. Paul. His father traveled throughout Minnesota as a salesman specializing in stationery; Harry Vachon's occasional alcoholic binges vexed John without preventing him from taking his father, in this regard, as something of a model. John liked his father and wrote an affectionate memoir of him late in his life, but when he needed help, he turned to his mother—for advice, supplies, and, not infrequently, cash. She was the anchor of the home, and his relations with her were intensely demanding, to judge from the voluminous correspondence he carried on with her for many years, from the time he first left home. John went to St. Thomas College in St. Paul, where he conceived his ambition to be a great writer, perhaps an essayist, and also imagined (for a while at least) entering the priesthood. Decidedly something of a Romantic during his college years, Vachon enjoyed long walks, communing with himself and his bosom friends, and engaging in the usual fantasies—and relationships—of a passionate, sexually awakening young man. Gradually the idea of the priestly calling disappeared in the face of competing interests, and on graduating from St. Thomas in 1935, Vachon applied for a fellowship to pursue graduate studies in English at Catholic University. Initially denied the fellowship, Vachon was despondent; but days before the beginning of the fall semester, space opened up at Catholic and, ecstatic at this new turn of events, he galloped off to Washington, D.C. There he immersed himself in his new existence—excited and challenged by the demands of the program—even as he began to wonder whether the scholar's life was really what he wanted. His thoughts turned to more creative writing, but evidently he was also drinking extravagantly, and he was forced to leave school. Keeping the specifics of his expulsion from his mother, to whom he was otherwise meticulously accountable, Vachon decided to stay in Washington and managed to find work as a messenger—thanks to some Minnesota political influence—at the Resettlement Administration. By just such an accident was his life determined, for he would have preferred an opening at the Library of Congress.

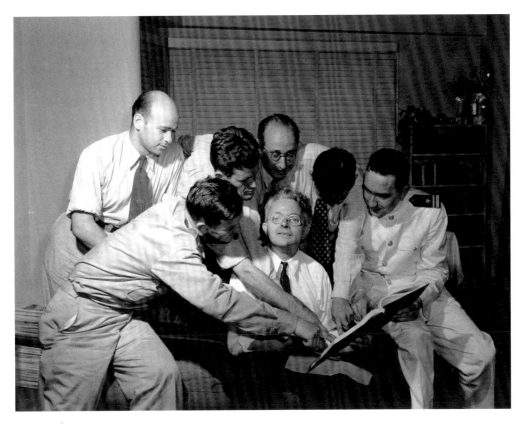

FIGURE 1 | *Roy Stryker and FSA Photographers* (John Vachon, second from left, back row)

His responsibility at the RA (which was transferred to the Farm Security Administration in early 1937) was simply to write the captions on the back of each photograph added to the file. Through this process Vachon came to know the file as well as anyone and to absorb the style and themes of the FSA enterprise; seeing gaps in the file, he offered to take pictures in his spare time of the Washington, D.C., area, undertaking the work on weekends. With Stryker's encouragement (and borrowed cameras), and under the occasional tutelage of Arthur Rothstein and Walker Evans (who insisted he train with a large-format view camera), Vachon began taking longer photographic excursions, ultimately contributing pictures to the file on a regular basis until he was officially classified as a photographer in 1941 (figure 1).

Vachon liked to say that he became a photographer by accident, that he had no interest in photography before coming to work at the FSA as a messenger—that this may even explain why Stryker hired him. The story, although literally true, belies the extent to which Vachon, without realizing it,

was prepared by personal disposition and intellectual habits for the career he was about to fall into. (Indeed, the alternatives available to the lonely, unemployed graduate school dropout seemed few: "I can always become a damn no account begging, bumming, traveling hobo, if ever I get the moral courage to become such. Or I can always go directly to my mother's house, and go on as before, if ever I so lose all feeling and hope for greatness" [Journals, April 23, 1936].)

WHAT WAS STRYKER looking for in his photographers? As he said many years later in an interview with Richard Doud, it was "curiosity, it was a desire to know, it was the eye to see the significance around them. Very much what a journalist or a good artist is, is what I looked for. Could the man read? What interested him? What did he see about him? How sharp was his vision? How sharp was his mental vision as well as what he saw with his eyes? Those are the things you look for."[10] Evidently, Vachon impressed Stryker in just these ways. Though wholly accidental, Vachon's becoming a photographer seems—especially as viewed through the lens of his journals—virtually an act of predestination. Consider, to begin with, his strong visual sensibility, evident in the earliest entries in the journal he started when he was nineteen, which reveal an interest in painting and an acerbic critical eye. ("So little of value," he observes after attending an annual exhibit of American painters at the Minneapolis Institute [February 8, 1933].) He is thrilled at the Century of Progress Art Exhibit in Chicago (May 15, 1933) and reads Roger Fry on Cézanne. Vachon continues to frequent art museums whenever he visits cities and at one point even conceives of becoming an artist, attending art classes at the Corcoran Art School in Washington after dropping out of Catholic University. ("I go so far as to think it very possible that I shall become an artist to reckon with" [September 27, 1936].) Vachon abandoned that idea as he moved into photography, but his cartoons and drawings would adorn his office, and friends valued them enough to keep them.

What is even more predictive of his photographic career is the strongly visual character of Vachon's journal observations and his conscious wish to express, to memorialize those observations. "What saved today from being an empty void?" the twenty-year-old Vachon asks his journal. "Very little—only hearing Cyril Schomer play his violin and seeing when I awoke at four o'clock this afternoon a single bird flying wildly through a storm-stricken sky" (April 18, 1934). A week later he rationalizes his neglect of his reading assignment: "a young man who would rather walk river paths, and follow (by eye) the white swooping gulls, and rejoice in fresh strong winds all of a blue and golden afternoon, does not wrong himself to neglect Swift" (April 27, 1934). During the summer of that year, he offers in his journal an extended description of clouds:

> Gradually the blue disappeared entirely and the merged sky was a grandeur of grey, darkling
> grey, heavy white, and splintering streaks of bright metallic yellow. . . . The forms were real—

pictures, or perhaps visions of men—faces I'd never seen . . . I saw generals, strange African savages, old women, queerly garbed children, and delicately beautiful faces of ladies. All these I swear were distinctly limned as though by a master with a pencil, yet not still like drawings, but real and changing. (July 9, 1934)

Not even dreaming of photography, he cannot imagine the best way of preserving these visions and images, as when he attempts to describe how his own awkward exit from the company of an elderly neighbor affects the expression on the man's face: "I fear I can't—a smile—'Alright, John' in his regular old quavering tone—his weak eyes had in them something which saddened his smile. I cannot express this, only feel it. Shakespeare could express it, or perhaps El Greco. Music would be the best medium. I shall remember it" (August 3, 1933).

Though photography is unknown to him at this point, he seems able to imagine at least some need to correct his overly impressionistic habits, as when he chastises himself for writing too subjectively, too intellectually: "I pray that God will make me more objective" (March 29, 1934). And even his vocabulary, as he wrestles with his frustrated creativity after joining the FSA agency in a clerical position, reflects a subliminal movement toward the "framing" technique of photography: how can the artist, he wonders, put a painting into the world, or a piece of music, or a "joyful, pagan, clean" lyric poem? "All three of you, Van Gogh, Debussy and Herrick, produced definite little things out of you, and what was given you. How could you do that? How could you take a little piece out of all this and frame it?" (September 28, 1936).

Meanwhile, Vachon was also refining his sensibility and expanding his ambitions, through his readings in contemporary literature. In March 1934 (still in college, assigned to read the classics of English literature) Vachon on his own encounters James Joyce. "I read first 'Dubliners' and was greatly pleased with my fresh discovery of 'realism.' Next 'Portrait of the Artist as a Young Man,' and I knew not whither to turn. I yet admired Joyce; I had not ever approached grasping him." Reading this fiction without benefit of priestly or academic intervention, Vachon uses Joyce to propel himself more quickly in the direction he was anyway going, and his journal entries increasingly acquire an air of ironic detachment, in prose of increasing complexity: "The labyrinthic confusion that hemmed me in could be drawn out to but one path in my mind at that time: (truly I admit this to myself shamefully) I resolved to grow naturalistic; I resolved to find sensual pleasures foremost. . . . [I]n short, I resolved immediately to sin. That is what Joyce did for me" (March 29, 1934). Joyce would continue, for the rest of his life, to be one of Vachon's ruling passions, a liberating force for his own creativity and an intellectual model for the perennially lapsing Irish Catholic.[11] From that point on, Vachon expanded his reading beyond the established English curriculum of the day to encompass contemporary literature: Thomas Wolfe is one of his great favorites, along with James T. Farrell and Sinclair Lewis. In the early 1940s he begins reading, with even greater delight, Proust and Faulkner, and on the road in his hotel room he often reads Whitman and Sandberg (figure 2).

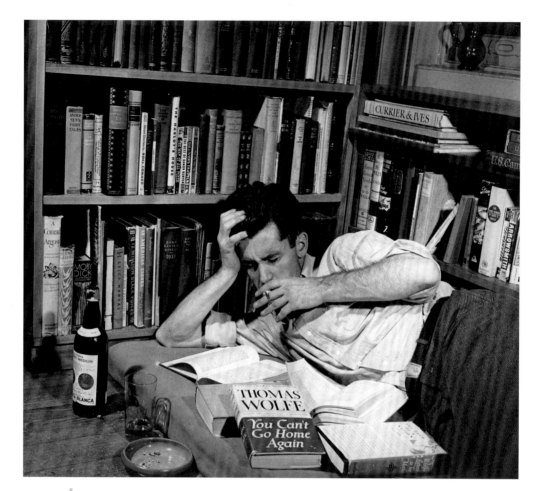

FIGURE 2 | *John Vachon, 1943*

What also emerges from his journals, as Vachon moves from college to graduate school to the FSA, is an extraordinary receptiveness to the new modernist currents in the arts and a serious interest in their nineteenth-century roots. Jazz he is always interested in, noting with a nice mixture of pedantry and sensuality that "I anticipate no future time when I shall lose my liking for today's many well done jazz bits. Decried though it be, today's jazz displays something of a sensual universality. The spark of genius is entirely within the arranger—masters like Ted Lewis, Whiteman, sometimes, Art Kassel, sometimes, Waring, often, Duke Ellington, and Cab Calloway" (July 20, 1933). Following a concert on March 24, 1934, he writes, with an epicurean sensitivity: "There is a maddened fealty to modernity— Rhapsody in Blue—its maniacal restraint, snarling jazzed rhythm, diabolical phases, all bespeaking

something. It is music that must not, cannot, be ignored. The Mpls [Minneapolis] Symphony was unable to give it its fullest meaning. Somehow they couldn't render the sin and metropolitanism. Gershwin's conception, nevertheless, shone through with clarity."[12] He reads Dostoyevsky, Dos Passos, Saroyan, and, as he comes into the progressive sphere of the FSA, Bellamy's utopian *Looking Backward* and *Equality;* he listens to Wagner, to Stravinsky, to Debussy; he celebrates Van Gogh.

Also uncannily predictive of Vachon's later career, when he did so much of his work away from home, is this musing from 1933, while he was still in college in St. Paul: "I must make it my lot to live, travel and enjoy life. Then, if I don't rise in the creative field, I can at least have seen, have read, have been, have lived! All of which is a wonderful lot." (And he adds, already a jazz aficionado, "But God, please take me away from Guy Lombardo who is just commencing his evening whining over the radio" [February 13, 1933].) It is hard to know Vachon's deepest motivations, but we do know that he kept, later in his life, an astonishingly regular record of his travels by air, filling a notebook with the dates of travel, destinations, airlines, and number of hours aloft, as if those records alone might provide evidence that he had "lived." That record keeping is not the only sign of Vachon's compulsivity, but it is one he himself sometimes pondered, thinking he might one day write about it. His postwar years at *Look* magazine, in any case, produced precisely the ample travel log that proved he had "lived" as he had once determined to do.

II

Vachon's photographic work—to which I shall return—ultimately usurped his other duties at the agency, but his responsibilities before 1941 included designing and constructing the archive itself and formulating its purpose. Stryker's project gradually took on a life of its own as a quasi-independent documentary program, bringing together the photographer, the social scientist, and the historian.[13] The aim, as it evolved, was to create a huge bank of available imagery—a visual and national equivalent, one might say, of Robert and Helen Lynd's exhaustive sociological investigation of a single town, "Middletown"; Lynd in fact advised Stryker on what images to get. But how to put this massive file into some usable form? That was a question answered twice.

The FSA-OWI file that we know today was organized by Paul Vanderbilt in 1942 and is arranged according to what Vanderbilt felt was the main subject of the image (e.g., farming, housing, health). But the initial organization of the file—before Vanderbilt was hired—was Vachon's work, which he did by grouping assignments within each state and then by the set of pictures (the assignment) made in a given locale, followed by miscellaneous groupings, such as "Small Town Scenes" or "General Rural Areas."[14] Early on, possibly in 1937, Vachon wrote a memo, now in the Stryker Papers at the University of Louisville, called "Standards of the Documentary File," which outlines his own sense of the purpose of the FSA files. (The memo is reprinted in "Additional Writings.") That Stryker presum-

ably solicited the document says much for the creative atmosphere of the agency at that time, and for the impression the twenty-three-year-old Vachon must have made on Stryker. In fact, Stryker was generally open to the suggestions of his photographers—Walker Evans and Ben Shahn especially—in the early stages of the project, as its purpose was taking shape and evolving beyond the original narrowly defined effort to provide publicity for agricultural policies.

Vachon's "Standards" represents a milestone in his intellectual development. Although he rapidly moved beyond his early Romanticism and his scholarly ambitions, he still had a sense of grand destiny (not to mention grand rhetoric), elevating the notion of "documentary" to a central position within twentieth-century culture: he begins, "The documentary urge is the most civilized manifestation of the instinct for self preservation." In celebrating the still camera, Vachon articulates a major shift from the verbal to the visual that had accelerated since the 1920s, with the advent of the small camera and the phenomenal growth of pictorial magazines and motion pictures.[15] Vachon recognizes the historical record that can be found in the arts—from Renaissance painting to Hollywood movies—but unlike those incidental pictures of a given culture, "we are today making a *conscious* effort to preserve in permanent media the fact and appearance of the 20th century." Vachon goes on to inveigh against the sentimental or falsely Romantic, excessively dramatized "glorification of things typical of our times" (he is thinking of such films as the British *Night Mail* [1936]), arguing instead for a more truthfully "unimpassioned" form, whose primary instrument is the camera: "Still photography, not cinematic, is the most impersonal and truthful device yet perfected for factual recording. It is able to include the widest range of subject matter and employ the least plastic materials of all the arts." Leaving a picture for the future of "what people of today look like, of what they do and build," the camera is creating "a monumental document comparable to the tombs of Egyptian pharaohs, or to the Greek temples, but far more accurate." Vachon's emphasis on accuracy confirms the implicit FSA aesthetic of straight photography, initiated by Walker Evans: it focused largely on the thing itself with relatively little of the theatrics of modernism that had dominated the twenties. In this context, photography was a medium of fact, of honesty, of authenticity.

But the value of the FSA archive did not lie in individual pictures; rather, the photographic file itself is the monument—"perhaps the only important file of this sort." To Vachon's thinking, the file is not an art collection or a picture library; nor is it an antiquarian's file or a technical collection (portraying, say, the detailed story of an experimental farm). Nor, for that matter, should it serve some future photographic editor, looking for "slightly different pictures of the same subject" that might fit into an ideal layout. Its sole purpose, he argues, should be "the honest presentation and preservation of the American scene. If that is done it can be drawn upon like dependable statistics to support or refute. If formed only to present, it can be used to propagandize." Taking a lofty view, Vachon insists that the file should encompass rural and urban, lower and upper classes. "Like the philosopher," it should include and understand all; yet significantly, it is striving to represent not

"the unique" but "the typical." (His examples suggest what he meant here—Rothstein's image of the boy standing by his cabin, the ruined land in the background; Lee's abandoned Texaco station; Evans's indignant American Legionnaire, his "hill-climbing industrial towns"; Lange's intensely suffering faces.) This notion of "typicality" is central to the iconic status of certain of these images: for all their individuality in subject and treatment, they have a quality that nonetheless enables us to read the individual for the group he or she represents. Not all documentary photography aims for this typicality, and post–World War II documentary took a turn toward the grotesque, making a particular individual the documentary subject—by virtue, say, of some exceptional quality. In the thirties it was otherwise: the individual represented a larger volume of experience and conditions, and typicality was thus essential.

Vachon was seeking to combine, in his ideal of documentary photography, both an informed intelligence (the result of prior research) and "*feeling*": "the humorousness, the pity, the beauty of the situation" being photographed. The photographer, in other words, must have a point of view on his subject, and he must want to "freeze instantaneously the reality before him that it may be seen and felt by others." Nevertheless, maintaining the chastity of his vision, Vachon insists that it is not the use of the pictures that is important "but the actual existence of the pictures in an organized file."[16]

Arguing for a "monumental" archive, Vachon's manifesto—which gives primacy to the photographer over the social scientist, and to the file over its use—has an undeniable aesthetic and democratic grandeur, as if the photographer was helping to create the visual equivalent of the great naturalist novel, encompassing the whole of society. But it also indicates Vachon's own intellectual temperament—an encyclopedic urge to encompass the multiplicity of experience, the variety of facts: in a 1973 memoir of his father, Harry Vachon, John recalls that "a school superintendent lent my father a book called *Sidney Morse's Outline of Universal Knowledge*. I read it, and it inspired me to believe that *everything* could be known, if not by me, by someone. And if I could not *know* everything, at least I would know what *could* be known, what there *was* to be known."[17] In reality, the uses of the images came to preoccupy Stryker and the agency almost from the beginning, as indeed they would preoccupy Vachon himself once he began photographing on a regular basis. (In a conversation at Vachon's apartment in New York some years later, Stryker and Rothstein agreed that it was during the 1936 presidential campaign that "pictures became important." Rothstein asked rhetorically, "Wouldn't you say that that particular period indicated to everyone the terrific impact of photographs, in particular the photographs that were being taken for that project, because they were used so much by the press?")[18] More than once Vachon would remark proudly in his letters on seeing his own photographs (or indeed those of other FSA photographers) in the news media. And the creation of the file that Vachon theorized so easily from Washington was itself a process, one he would come to see firsthand in the field as a labor of great complexity, fraught with frustrations he could not have dreamed of.

We are only just beginning to come to terms with the sheer size and volume of the FSA collection, and our knowledge of the archive is weakest where we might now be most curious—at the level of production.[19] We know generally how things worked: the photographer would send film back to Washington for development and printing, then it would go back to the field for captioning, then back to Washington for archiving, then out to the pictorial magazines and newspapers for free use. Though Stryker initially found it difficult to place agency images, by 1940 the Historical Section was disseminating an average of 1,400 images a month to the press; by 1942 a dozen books had been illustrated with FSA images.[20] By the time an image reached the consumer, it might have been cropped and re-captioned to suit the needs of news and picture editors. The FSA project did not, however, compete with the photojournalists of the day, whose purpose was to record daily events, or "news." FSA photographers were instead after the larger picture of what was happening in America, the underlying issues and causes of the Depression, in an effort to provide information that would relate to government agricultural programs.

Yet many questions remain about the FSA operation: How did the photographers conceptualize their work? With what combination of freedom and constraints did they operate? To what extent was the individual photographer subsumed under the program of the FSA? How, in other words, was his or her vision mediated or compromised by the agency's supervision? The FSA project was crucial to a pivotal cultural turn in twentieth-century America—toward accepting a central government's vision of reshaping habits of individualism through agricultural engineering and technocratic control, through social intervention and the rational employment of philanthropic surveillance. What was it like to be a part of this massive effort, which was itself part of the visual culture arising in, and being shaped by, pictorial mass circulation magazines and exhibitions? Vachon, because he densely documented his life during these years, offers intriguingly complex material from which to construct an answer.

Many of the FSA photographers, Vachon included, were consciously expressing an individual vision, a point we shall return to later. But their official purpose was to get the images that would be used to legitimate the agency's existence and promote the New Deal. Covering the entire country (with an emphasis on the stricken areas of the South and the Midwest), the photographers documented government housing assistance, loans for equipment and supplies, and agricultural advice. "We'd make pictures designed to appear in the local newspaper or hopefully to get into some Department of Agriculture publication, and those were fairly dull pictures," Vachon later recalled, "but that was the chief reason for my traveling" through the farmlands.[21] In addition to the common themes that surface in the work of all the FSA photographers, there was one subject that recurred regardless of region—the small town, whose character and culture were at the ideological center of the FSA.

The small town, according to a publicity release, was "the cross-roads where the land meets the city, where the farm meets commerce and industry. It is the contact point where men of the land keep in touch with a civilization based on mass-produced, city-mad gadgets, machines, canned movies and canned beef."[22] Photographers were to carry the "Small Town" script with them, in their heads, in fact, as a perennial assignment. They were to look at the stores along Main Street, cars and trucks, menus in windows, ice-cream parlors, the church, people on the street, and—a reflection of prewar gendering—"Men loafing and talking. Women waiting for the men, coming out of stores, window shopping, tending children." Photographers were to be alert to similarities among the towns, indicative of a "national" character, but also to the obvious "regional differences" visible in living standards, crops, clothing, folkways, and so forth. Conceived thus, the small town was clearly important to the FSA as a microcosm of the national portrait the photographers were creating.[23] But in describing the small town as the meeting place for an agricultural economy and an industrial, mass-produced economy, Stryker also captured the historical moment of the 1930s, when the United States was undergoing both an intractable depression and a movement toward modernity. For Stryker personally, the small town was a nostalgic symbol of a simpler America—the *"not modern,"* as Terry Smith calls it[24]—an anchor of social and moral tradition amid the churning bureaucracies of Washington. Walker Evans's 1935–36 images of southern small towns first brought out this response in Stryker, and it's something Vachon responded to as well in Evans's work. For Vachon such images may also have connected with his father's life on the road, traveling from town to town, and with adventures that excited the young Vachon, creating a pattern for him to follow. Out with his father on one such trip, Vachon recalled years later, he experienced the joy of exploring each town "in constant astonishment. I would walk up and down the main street and through the residential streets, investing each store and house with a personality."[25]

Beyond their focus on the core of the small town, Vachon's photos followed the broad themes of historical change that the FSA-OWI emphasized during the years from 1937 to 1943: from the economic dislocation and high unemployment of the earlier period, when the Resettlement Administration was actively helping its clients in a range of services—food, housing, agricultural practices—through the years of prewar mobilization and wartime itself, when with a single mind and energy the country was geared toward the war effort (see plates 80–82). Portraits of the unemployed give way to portraits of workers. Images of slums and poverty are succeeded by images of industrial production on a colossal scale. Vachon's pictures, along with those of the other FSA photographers, record the shift in subject from a nation suffering through the Depression to one that is mobilizing successfully for war. The broad theme of these years was apparently change, and Vachon expresses it through pictorial contrast—older urban buildings being torn down to make way for newer ones (see plate 69), for example, or the contrast between a Victorian church and a modern telegraph pole, with its multidirectional wires.

How can we distinguish Vachon's work for the FSA from that of the other photographers in the group? We can, after all, talk about an "FSA style"—a descriptive approach that was governed by the need for certain illustrative pictures; a tendency to frame figures in space so as to provide contextual information about housing, land conditions, work, family; the practice of directing subjects so as to achieve a sense of the "typical" or representative person, place, or condition; general use of available light, favoring outdoor pictures over indoor studies; an attention to oddities in landscape or road that convey the unique character of a place. Yet granting these general characteristics across the spectrum of FSA work, the photographers had individual expressive vocabularies and differing senses of their work for the FSA agency.

Evans, for example, studiously avoided producing photographs that could function as propaganda for the government, and thus enjoyed famously uneasy relations with Stryker. Although he often gave Stryker the kind of photographs requested, more often he surprised the FSA chief by submitting images that far surpassed what Stryker might have imagined, images of an elegance and wit that confirmed Evans's premier status among the group, however short his tenure there. Dorothea Lange, who likewise sought the maximum control over the physical production of her images and their publication, characteristically took a more narrative approach than Evans, producing images that told the stories of the midwestern exodus and migration to California by paying attention to the graphic details of what she saw and to the telling gestures of her subjects. Others, like Arthur Rothstein, produced images that deliberately (sometimes too deliberately) illustrated government intentions, summing up in a single image the conditions of hardship that stalked the midwestern drought states.

Entering the FSA initially through the file as a whole and coming to know each photographer's style and methods as well as he did, Vachon began his own work as a photographer with his vision well educated in the conventions of the FSA. He worked best, he felt, within the general framework of Stryker's supervision, needing to know how his images turned out once they were sent to Washington and how Stryker—something of a father figure to the young photographer—viewed them. Yet his best shots, he came to realize, derived from subjects and approaches he developed himself, outside the given assignment. Vachon often paid tribute to his masters in the FSA—Evans, Lange, Shahn, Delano, Rothstein—but his modesty and generosity may obscure for us his own persistent effort to create an individual style against the very models that had so strongly influenced him.

In fact, Vachon's whole experience of the American landscape, once he moved out of the office and into the field, was shaped by the pressure to see things fresh: "I was awake as we went thru Omaha. I was kind of disappointed, because it looks *so damned* unspectacular, ordinary. It looks like it will be tough to photograph. . . . I took several stray shots around Lincoln—oil tanks, coal yards, gravel pit—The oil tanks, by the way, were the same ones of which Rothstein has a rather good picture in the

files" (Vachon to Penny, October 12, 1938).[26] Rothstein is again on his mind a few years later, in 1942, when he drives through North Dakota; he calls Grassy Butte "a wonderful town that I associate with my earliest feeling for pictures—Rothstein photod its main street, people going to church to pray for rain, etc. in 1936" (Vachon to Penny, March 2, 1942). And later that year, he thinks of Russell Lee—and of John Steinbeck—when he drives from Fort Smith to Tulsa and sees "real grapes of wrath stuff, shacks and tin houses, all those starved faces out of Russell Lee pictures" (Vachon to Penny, October 5, 1942).[27]

The single strongest influence on Vachon was Walker Evans, who had given him instruction in his earliest efforts and whose images struck deepest and stayed longest in the young photographer's memory. It was the "thingness" of Evans's images that Vachon especially admired, and one can see that quality in the Nebraska church Vachon photographed in 1938 (figure 3), in which he approaches the subject head-on, in full appreciation of the structure, letting the sun's shadows accentuate the form.

At times emulation became idolatry, as when Vachon arrived in Atlanta and hired a cab to drive around the city in search of the twin houses (with their framed porches looking like two eyes and the Carole Lombard billboard in front of them) Evans had photographed; finding them at last, he photographed them himself. "I found the very place, and it was like finding a first folio Shakespeare."[28] Vachon may have thus inadvertently and precociously initiated the rephotographing projects of the 1970s—those of Bill Ganzel, Mark Klett, and others.[29] Another time, in Oklahoma City, Vachon wrote to Penny that he'd been driving around the city, visiting former shack towns photographed by Russell Lee and noting immense stockpiles of used tires and vulgar commercial signs—"the kind of stuff Walker Evans and I used to dream about" (October 24, 1942). When he hears in 1942 that photographer John Collier's pictures are being admired "in our little salon group, etc. . . . it fills me up with wanting to go out and photograph with an intensity" (Vachon to Penny, March 18, 1942).

But it wasn't only the FSA photographers he felt he was competing with: writing from Oklahoma he noted that a recent *Life* magazine spread featured images of the oil pipeline construction that are similar (some better, some worse) than those he himself had recently shot (Vachon to Penny, October 24, 1942).[30] Seeking to build his reputation, his place in the photographic community, Vachon feared being typed—as, for example, when *U.S. Camera* seemed to be interested only in his pictures of farmers and grain elevators. And if he was down on himself from time to time, he clearly felt under it all an inner confidence that his work was going in the right direction during these years, as when he berated Penny for failing to console him after his own self-criticism: "You could have told me that I *do* have something to contribute to photography. You could have mentioned what a lasting contribution I have *already* made" (June 30, 1941).

Looking more deeply at Vachon's work and at his work habits, we can see his photographs as the product of a creative tension between the directions he was receiving from Washington and his own artistic drive. The directions from Washington took the form, most explicitly, of Roy Stryker's "shoot-

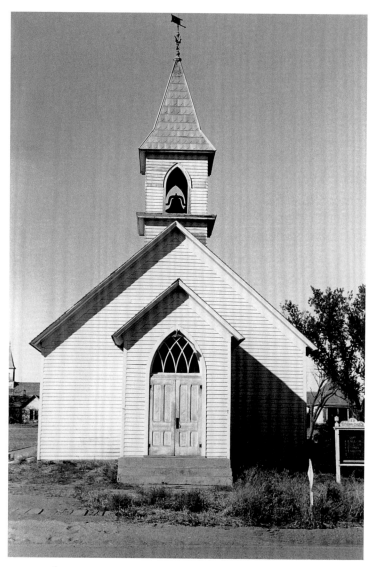

FIGURE 3 | *Church,* Gilead, Nebraska, October 1938

ing scripts." To the extent that the FSA had a unified vision, it derived from the photographers' familiarity with one another's work, but it also resulted from their all working under Stryker's direction. It was Stryker who prepared the photographers for the various regions they were entering, keying them into the planting and harvesting seasons; it was he who supplied the intellectual framework for the photographers in the field—advising them to read J. Russell Smith's *North America,* for example, to get a sense of the cultural and economic geography of a given region. More important, he

supplied them with detailed instructions on the pictures needed, in the form of his often elaborate shooting scripts.

These were of two kinds: those intended for everyone, regardless of their regional assignment, and those designed specifically for a given locale and photographer (examples are reprinted in "Additional Writings"). Among the general scripts, Stryker sent out instructions, at various times over the course of the FSA-OWI years, for photographs of "Rural" subjects, "Industry," "The Highway," "Spring," "Garden Pictures," "migrants," the "Large Urban Railroad Station," "American Gestures," and "Life on the Homesteads." At times the specificity of Stryker's suggestions is surprising, almost as if he had previsualized, literally scripted, the photographs he solicited: at the railroad station, he wants people waiting for trains, buying tickets, just waiting, waiting to meet friends or relatives, paying redcaps, sending telegrams, using slot machines, and so forth. Stryker was looking for candid shots but also suggesting that his photographers "direct" the picture story, as in his instructions for "community photographs" featuring life in the homesteads, designed to stress the normality of the residents' lives: "Try to arrange that the members of the family are doing something, i.e. the woman canning, shelling peas or hanging out the wash—the man working in the garden, etc." On another occasion he wrote that the file needed something as specific as "Two women talking *over back-yard fence*" (emphasis in original). On a page titled "Ideas for Pictures" Stryker asks for photographs of the smoking habits of men as well as their "Telephone habits— . . . at club-house with highball in hand." He wants pictures of women "pulling down girdle; fixing stockings; holding hat on windy day; pulling up shoulder straps; powdering; lip painting; . . . combing hair."[31] Stryker seems, at such times, carried away by his own voyeuristic excess.

Vachon's own special scripts in Iowa called for such specific scenes as "Town water tanks; . . . Courthouse squares" and, in Minnesota and Wisconsin, for pictures of "housing, home life, community buildings, stores, school, school children," and so forth. Again, Stryker imagines exactly the kind of photograph he wants—the patterned shot that Bourke-White had made popular as early as the late twenties, which carried into the thirties and forties as a sign of modernism: "a shot in early morning or late afternoon to accent the pattern of the turned soil"; "watch for chance to get pictures with early or late light showing *land texture*" (emphasis in original). At other times (drawing on his own background in farming and ranching) Stryker seems to be directing *The Plow That Broke the Plains*: "1. low (almost on the ground with camera) and up at plow from 'land side.' 2. dirt rolling from mold-board. Do *not* shoot too fast. This picture should give some sense of the motion of the dirt coming off the mold board" (emphasis in original). Other cinematic effects are also called for: "Threshing operations—Closeup of grain pouring from chute. . . . Rain (hard to get pix which really 'show rain'). . . . 1. Window pane in hard rain. Water running down glass in side of car. . . . Wind (really depends on movie technique)."[32]

At a certain point, Stryker evidently "trusted" Vachon sufficiently not to give him a script. But Stryker's failure to supply specific directions would sometimes leave the photographer in the field

floundering and unsure what Washington wanted; and occasionally in the letters Vachon seems to feel dry, without ideas, pressuring himself to come up with fresh subjects, fresh angles, begging his wife to feed him possibilities, at times excoriating himself. Looking at a batch of pictures he'd taken of a farm in North Dakota, Vachon wrote to Penny (March 3, 1942): "I guess the main trouble is that they are all just formula pictures, they look like Farm Security stuff. . . . And I am so damned anxious to put new blood in them, new ideas, approaches, and to say something different with them." Being in the field required moment-to-moment decisions as well as a sense of what to look for, and the materials presenting themselves in reality might well differ from what armchair director Stryker imagined in Washington. The Vachon archive of more than ten thousand images includes many of the sort Stryker solicited—uninspired images, dutifully collected, that record the workings of the FSA. Yet there are others, responding to more open-ended categories, in which the photographer seems inspired, expressing his own vision and his own sense of the political reality of the times.

Though the cautious Stryker, ever mindful of legislative interference in his program, usually blunted the political edge, we see a distinctive militancy in Vachon that was at odds with the generally softer, more "poignant" approach of the other FSA photographers and at odds too with the adamantly apolitical stance of Evans.[33] A 1940 visit to Dubuque, Iowa, for example, revealed the trauma and suffering of the Depression in a way that seems to have strongly shocked Vachon, and he writes Stryker of the shantytowns and of the men foraging for food in the dump.[34] The satire implicit in Vachon's photograph of the "New American Home" (figure 4) is in the subject itself; the photographer had only to note it. But the man in the dump (figure 5), photographed about the same time, shows us, with unflinching curiosity and empathy, the shocking reality of Depression life at the margins.

Labor strife was yet another subject not in any of Stryker's scripts. "There are pictures that say labor and pictures that say capital and pictures that say Depression," Stryker wrote, looking back on the project. "But there are no pictures of sit-down strikes, no apple salesmen on street corners, not a single shot of Wall Street, and absolutely no celebrities."[35] Whether Stryker was forgetting or trying to shape an image of the project as politically neutral, he clearly was mistaken, for Vachon's attraction to issues of class and labor conflict resulted in several photographs that stand out in the FSA collection as revealing the passion and determination of the worker (figures 6 and 7).

Vachon's sense of social justice is evident in other ways as well, not least in his treatment of African Americans. The portrait of Mrs. Sam Schonebrooks gives her a dignity and calm sharply contrasting with the indignities of her home, its walls covered with newspapers (figure 8). The dog's presence suggests that despite deprivations, "normal" life is possible there. Vachon's angle of vision in the photograph of the Virginia courtroom takes in the power and stolidity of the judge, who sits seemingly unmoved by the case before the "law" (figure 9). The same judge is featured in another photograph, where he stands against a shop window, flanked by an African American (figure 10). The two men, who might both be employed by the court, seem at first like black and white mirror images: the only differences are in hat color and tie style. But a closer inspection reveals the subtle difference in the condition of

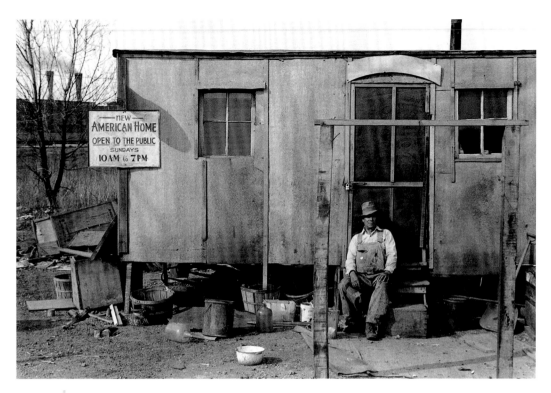

FIGURE 4 *Shack on the Edge of the City,* Dubuque, Iowa, April 1940

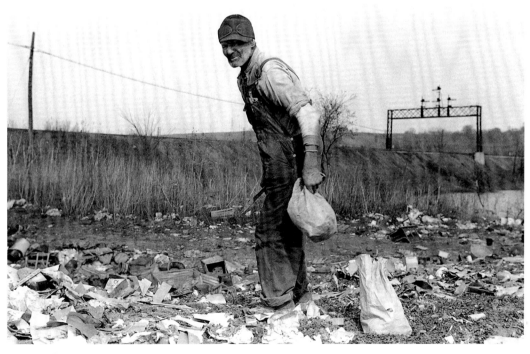

FIGURE 5 *Foraging for Food, City Dump, Dubuque, Iowa. Produce Houses Dump Apples,*
Grapefruit, etc., Which Are Not Quite Bad. Dubuque, Iowa, April 1940

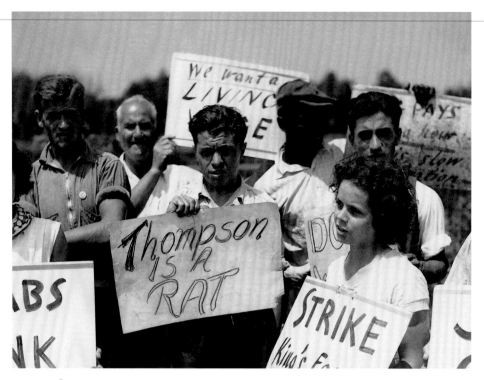

FIGURE 6 | *Picket Line at the King Farm Strike,* Morrisville, Pennsylvania, August 1939

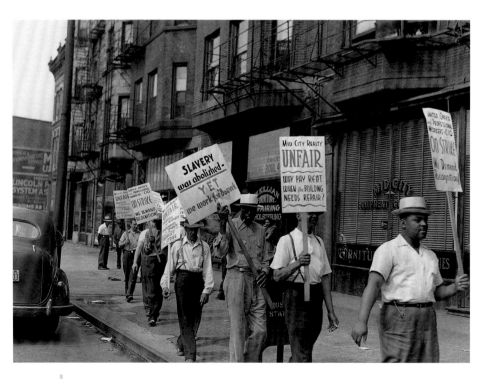

FIGURE 7 | *Picket Line in Front of the Mid-City Realty Company,* South Chicago, Illinois, July 1941

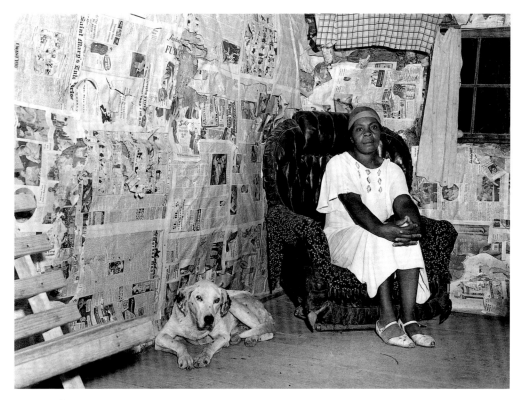

FIGURE 8 | *Mrs. Sam Schonebrooks in Her Home,* St. Mary's County, Maryland, September 1940

their clothes: the judge wears a newish suit and coat, the black man, a worn three-piece suit. The Phi Beta Kappa key hanging from the judge's vest pocket declares yet another element of privilege. Stryker claimed that the FSA was always interested in the "Negro problem," but in reality whites were heavily emphasized in the photographs, perhaps because, as Stryker put it, "we know that these will receive much wider use."[36] Vachon, with his persistent interest in African Americans, was an exception to the general FSA rule.

Perhaps the most striking of Vachon's political subjects was Emile Riche, or rather his house, adorned with the sign that tells his life story (figure 11). While a sense of injustice might lurk in Vachon's other pictures of the legal process, this one declares unequivocally the subject's obsessive outrage at the injustice done to him. The house and its message are the outer sign of the man's inner life.

Power and powerlessness are frequent themes in Vachon's social imagery. A good many of the scripted photographs involve, naturally, the activities of the Farm Security Administration itself. Vachon's perception of the relationship of the farmer to the government was a mordant one: in *Farmer*

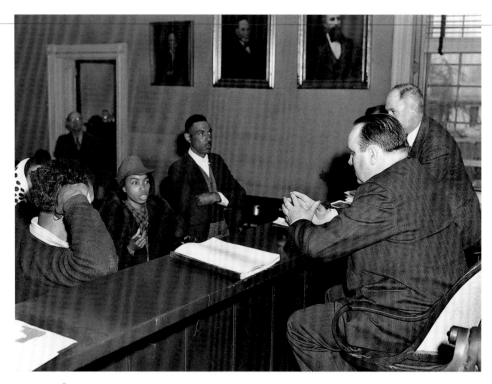

FIGURE 9 | *A Court Room with the Judge Presiding. The Eye of God Surrounded by a Glory on the Wall behind the Judge's Seat.* Rustburg, Virginia, March 1941

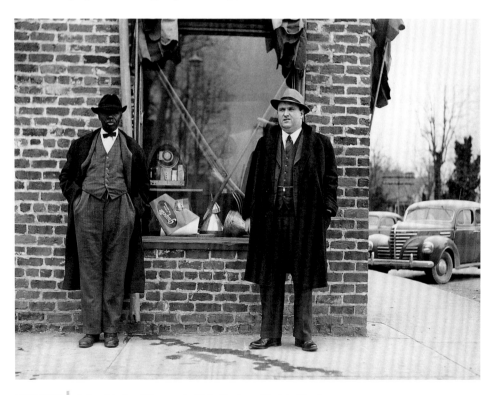

FIGURE 10 | *Judge of the Local Court on the Right,* Rustburg, Virginia, March 1941

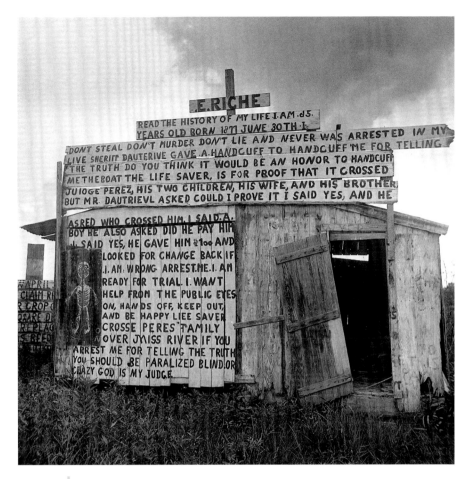

FIGURE 11 | *Signs along the Highway,* Plaquemines Parish, Louisiana, June 1943

Applying to County Supervisor for an FSA Loan the calm superiority of the government employee contrasts markedly with the dispirited posture of the farmer and the anxious contortions of his wife (figure 12). A similar power differential is visible in *Mr. Younkers Talking with His Boss,* in which from his perspective below eye level, Vachon captures both the relaxed and smiling boss and the frightened, hands-in-pockets, pinned-against-the-wall look of the employee (figure 13). On such occasions, Vachon was going beyond the script to fashion a documentary style that could comment powerfully on social relations in America.

When Vachon looked back on the FSA years in 1960, he went so far as to deny, in a general way, Stryker's scripts, remembering instead how much on his own he had felt. Having been "steered" by

FIGURE 12 | *Farmer Applying to County Supervisor for an FSA Loan,* Oskaloosa, Kansas, October 1938

FIGURE 13 | *Mr. Younkers Talking with His Boss, Fred Bowers, a Poultry Farmer. Mr. Younkers, His Wife and Three Sons Have Come Up from Kentucky.* Pickaway County, Ohio, February 1943

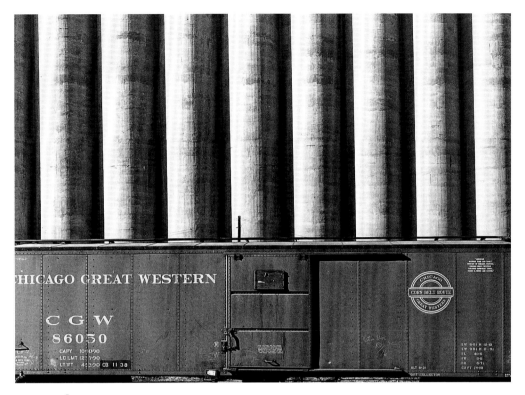

FIGURE 14 | *Freight Car and Grain Elevators*, Omaha, Nebraska, November 1938

Stryker in one direction, Vachon at a certain point would feel, as he faced the vast reality before him, a kind of existential moment: "One becomes keenly alive to the seeking of picture material. It becomes part of your existence to make a visual report on a particular place or environment."[37] The turning point, in his own memory, was Omaha (most likely during a trip in 1938): "One morning I photographed a grain elevator: pure sun-brushed silo columns of cement rising from behind a CB&Q freight car [figure 14]. The genius of Walker Evans and Charles Sheeler welded into one supreme photographic statement, I told myself. Then it occurred to me that it was I who was looking at that grain elevator. For the past year I had been sedulously aping the masters. And in Omaha I realized that I had developed my own style of seeing with a camera [figures 15 and 16]. I knew that I would photograph only what pleased or astonished my eye, and only in the way I saw it."[38]

It is significant that Vachon places his realization of what he could do with a camera in a city, for he enjoyed immensely his opportunities to photograph in places such as Pittsburgh, Chicago, St. Louis, Minneapolis and St. Paul, and Detroit. Vachon's enthusiasm for the city sprang from his own

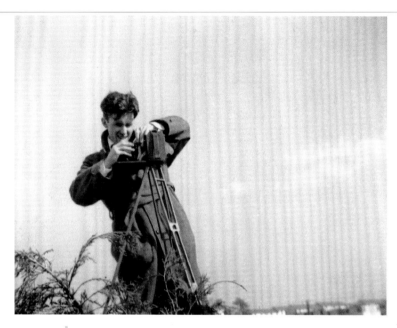

FIGURE 15 Untitled (Vachon with tripod, outdoors), 1940

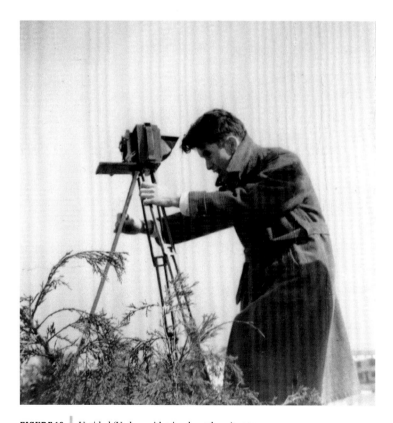

FIGURE 16 Untitled (Vachon with tripod, outdoors), 1940

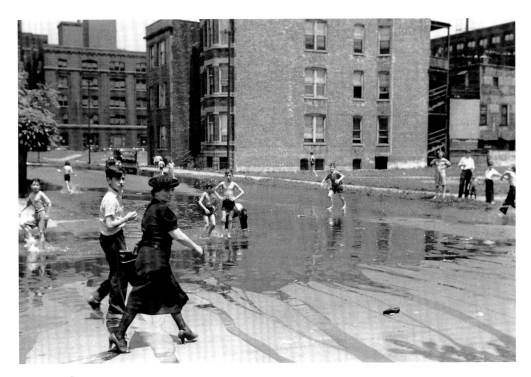

FIGURE 17 *Cooling Off at a Hydrant*, Chicago, Illinois, July 1941

sensibility, but he was also doubtless influenced by Berenice Abbott's successful *Changing New York* exhibition (1937) and book (1939). The essence of that influence is struck by Abbott's formulation of her goals in a 1937 statement: "It is the contrasts, the paradoxes, the anomalies, the illogicalities of life today which contain the most vital and interesting material for future historians to examine."[39] Like Abbott, Vachon responded most strongly to the movement and dynamism of urban life, where the speed of the shutter can record the fleeting glimpse: the woman caught in midstride as she crosses the street, glancing back at the cameraman; the children playing in the hydrant (figure 17).

Many of Vachon's best images—those that particularly look forward to the postwar snapshot aesthetic—are of urban subjects: the pedestrian caught in the midst of a traffic jam; the woman waiting for a bus; the man ascending steps to the El; two women caught through a coffee shop window, deep in conversation; the loneliness of deserted train stations; the anonymity of crowded bus depots. A favorite shot was the intersection, seen at street level—a pedestrian waiting for a light to change or casting a long look across at a gossamer figure on the opposing street corner—or viewed from overhead, looking down on the abstract patterns of streets and buildings. Again and again—it is a favorite

strategy of Vachon's—he pictures an intersection or an otherwise deserted space (the stairway of an art museum) with a single figure crossing it, thus giving us a human presence in the scene: a center of consciousness, as it were, whom we can imagine experiencing it all. That figure also functions, like Wallace Stevens's jar in Tennessee, as an organizing point for the shot, all the while surrounded in a structure of lines and angles. The tension between the moving figure and the firm structure of the composition as framed in the lens is a hallmark of Vachon's style.

Vachon discovered the joy of this kind of photography, as he wrote to his wife from Cincinnati, after shooting a parade and deliberately focusing his Leica on the spectators (see figure 23): "Really got some good material. I don't know what it is worth to John Citizen who is paying for it, but it pleases me, and was a great deal of fun." And he adds, guiltily, "Our organization really should be part of the WPA art project. That is my only trouble these days, getting an untroubled and respectable conscience about what I'm doing. The parade was the nuts" (October 11, 1938). Vachon may have been influenced by Evans's street photographs—especially the New York shots he took in the late twenties that were printed in *American Photographs*—but because Evans's book came out in the fall of 1938, it is doubtful that Vachon had yet seen it. Moreover, Vachon's work has a greater spontaneity and fluidity of composition, looking forward to Robert Frank's social observations of the fifties, to the choreography of the street captured by Garry Winogrand in the sixties, and to the contemporaneous abstract intersections of Lee Friedlander.

Picking up on Henri Cartier-Bresson's snapshot aesthetic, Vachon celebrates the camera's ability to "seize the brief evanescent moment" that seemed to him—in a 1949 review of *U.S. Camera Annual*—"to fulfill photography's best function." The work he admires apprehends "the reality of an instant and there it is—in early morning fog, or late afternoon sun, deep shade, light coming in through a window. I find these pictures immediately arresting. They don't make me think of flashbulbs, or focal lengths of lenses, or any other photographic apparatus. They give an actual sense of being in a place, a mood, a moment which lasted long enough to be recorded."[40] Many of the images in the photographic section of this book fulfill that criterion, presenting a frozen landscape, a railroad station or industrial building, or even a group of children who have been asked to hold still in the middle of a field. (Vachon's portraits of children, individually and collectively, demonstrate the subjects' trust in the photographer, who captures their open faces.) And there are many small-town and urban images in which Vachon has captured the mood of a place, whether a surreal shop window, the bored manager standing at the entrance to a girlie-movie theater, a deserted gas station, or a casual picnic.

But as Vachon wrote in that same review, he was open to more formalist abstractions by Harry Callahan; to portraits by Paul Strand, Richard Avedon, and Gene Smith; and to Evans's "terrifying" street corner snapshots of city people walking past the camera's observant eye. The range and variety of Vachon's work represented in photographs in this volume reflect his openness to a broad range of photographic possibilities and his lack of dogmatism (except for a stated antipathy to formula pictures

and the merely technical tour de force). Whether or not Vachon belongs in the select company of Evans, Cartier-Bresson, and Strand (very few do), the images published here, most of them for the first time, argue for his importance in the FSA group, an importance not previously recognized. They establish too, I believe, his significance as a transitional figure in twentieth-century photography—between the social documentary mode of the thirties and the more spontaneous postwar street-shooting style that captured the feel of the moment.

Teaching a class in photography toward the end of his life (he died in 1975), Vachon kept a note-book in which he jotted down the main points of the day. For December 9, 1974, he reflects that an earlier assignment he had given his students—to emulate the work of the FSA photographers—was misleading and anachronistic, as he had forgotten "that in the meantime there have been people like Lee Friedlander, Robert Frank, Garry Winogrand, and Elliot Erwitt and Burk Uzzle, all of whom would undoubtedly have a strong influence on what other photographers were doing."[41] It is telling that Vachon should start with the FSA documentary tradition and then, in effect, articulate a later, post–World War II tradition, starting with Frank. The connection between Frank and Evans has long been noted.[42] What we have not been able to see until now is that Vachon—his eye educated by Evans, his ear by the spontaneities of jazz—anticipated in his FSA work the improvisatory freedom Frank claimed for postwar photography. It is a commonplace in the criticism of thirties' social documentary photography that, with the possible exception of Walker Evans, it turned its back on the modernist formalism of the twenties. As Abigail Solomon-Godeau puts it, the FSA "took for granted that a photography of advocacy or reform should effectively concentrate on subject matter."[43] Vachon's work, however, violates those generalizations, and Vachon may have been neglected in the ensuing years in part because the narrow expectation of what constituted "FSA photography" precluded our even noticing a photographer who—within the confines of the government program—was consciously trying to fashion a style of his own, an amalgam of the formalist and the documentary modes.[44] Washington gave him a frame of vision with which to encounter the world, allowing him to observe patterns as well as "facts"; freeing him to engage with aesthetic angles and textures, to play with point of view; letting him gaze at the everyday, the gesture, the details of daily life that might otherwise have escaped observation; enabling him to gaze at relationships, behavior in public places, that would normally compel viewers to avert their gaze. That school of photography, with Evans and Ben Shahn, Rothstein, Russell Lee, and Jack Delano as instructors, was, in a way, ideal for Vachon. And added to these documentary influences, one can see as well a sensibility that has been formed, at least in part, by the surrealists, who draw his attention to peanut shells tossed to the sidewalk; to the mannequins in shop windows; to the humor of billboards and street signs; to the backyard long underwear couple, set out on a clothesline. Above all, Vachon's work shows a formal elegance that borrows from the geometries of modernism, visible in his attention to the industrial forms of the vernacular landscape (gas tanks, oil wells, automobiles) as well as in the characteristically strong diagonal frequently used to organize and frame his subject.

V

Vachon, like all the photographers in the FSA group, was an employee of the United States government, but what exactly did that mean? At the most mundane level, it meant, during the late thirties and early forties, a meager expense account and inadequate equipment. Worrying about the day-to-day expenses of his field trips was a constant in Vachon's life on the road: Was the hotel too costly? What could he afford in meals? Could he afford to take in a movie or have a drink in a public place? After traveling several times by train and bus or hitching rides (with needed equipment) into the midwestern countryside for his various appointments, Vachon was forced to buy a car, which gave him a new worry—the constant expenses (his expenses) for repairs, batteries, tires. Tires, especially, became an obsession for the traveling photographer during the war years, when rubber was strictly rationed. Telegrams went back and forth, documents were solicited, political influence exerted, but to little avail: at best, Vachon rated retreads. Equally annoying was the constant need for fresh supplies—film, flashbulbs—to be sent from Washington to meet him along the way. More than once Vachon squeaked by on a loan from his mother.[45]

If working for the government meant anything, surely it must have meant having the authority to photograph subjects relating to government programs; but the process was more complex than one might suppose. Meetings had to be arranged with local officials who might prove helpful, unhelpful, or too helpful in arranging subjects for the Washington photographer. "Too helpful" was a particular problem if what the local official had in mind would yield images that were just too boring by Vachon's standards. More than once Vachon complained to his wife that he could not concentrate on his work—which required spontaneity and a creative response to the situation—because of the need to follow his host's implicit agenda.[46]

A different problem arose during the war years, when Vachon was seeking to document the industrial machine. Armed with the appropriate letters from Washington government agencies and boards, Vachon still found it difficult, sometimes impossible, to break through the shield of protection and secrecy surrounding the war industries. The mere presence of a camera was enough to get Vachon arrested on several occasions. Even when he would seek advance permission from the local chief of police—to photograph railroad sites, for example—he might have to check with local FBI officials as well. But the particular company itself might resist, often not wanting its manufacturing or handling processes photographed, lest the information fall into the hands of the competition. What, after all, was the public interest, in the face of private interests?

The FSA-OWI did not function as an indirect arm of corporate America; nor was it operating hand in glove with the larger functions of government.[47] It was an independent agency, negotiating its position and its strategies amid a welter of government agencies, both friendly and hostile. (The file itself might well have been destroyed when the FSA-OWI was shut down in 1943 had various con-

gressional forces had their way; Stryker managed to pull strings of his own to get the archive deposited safely at the Library of Congress.)[48] Yet the paradoxes implicit within the FSA and in its position within the government as an agency often fighting for its survival may have given the photographers in the field a useful sense of alienation, an edginess that translates, at best, into resolutely individualistic visions and acute perceptions.

That alienation surfaces most notably in 1942, on assignment in Lincoln, Nebraska, when Vachon steps back and begins to sense a profound change in American society. He had always reacted negatively to what he called "the fat boys"—the local officials, elected or appointed, who pulled the strings in a given locale. Now he has been asked to photograph a graduation class, and he can see in these seedlings of the future America some of what he most dislikes, where he least expected to see it. Vachon must first scurry about on this assignment—it is the end of the semester and commencement is only days away—to find his subjects. Assisted by college administrators, he winds up with a diverse sample, including several different types, some of whom he can appreciate and others he cannot, try as he might. Those in the second group are the most interesting in some ways, for Vachon seems uncannily able to read postwar America in his subjects, a smug America aloof from "the honest to god world" that Vachon—by now well traveled—has seen about him. He reads his bleakest prognosis in one of his college subjects, a young man described as

> essentially, the industrialist. He comes I gather from a banker family, in Sioux Falls. That is his fence side. He will, eventually, aside from the war, end up as chief of personnel for the Nebraska Power Co. or something like that. What I most feel is that he is the kind of guy I would like to like, a lot, but can't. Must actually stay away from. And that makes me sad. Really sad. Because he is so many of the finest young men in the country, the smart boys, the college boys, the boys who will have the chance to run things. And it looks no good for the future when you see their complacency, their willingness for instance, to leave the Negro situation as it is. Nothing about that moves them at all. They are part of the backward pullers, they want to be status queers. They want to be associated with the "men who made AMERICA." (Vachon to Penny, May 22, 1942)

VI

Vachon's employment with the FSA came to an end in 1943, when Stryker left to work for Standard Oil on a photographic project documenting the oil industry and its ramifications. Shortly thereafter the FSA Historical Unit itself was shut down, but Vachon had already been moving restlessly away from its purpose for a while. Writing from North Dakota in 1942, he complains about the sense of confusion, the loss of purpose, he was feeling: "I'm amazed at the masses of exposed film I keep piling up, always knowing that I haven't been getting anything good. I'm completely losing sight of objectives—

don't know why in hell I'm out here. I always get good ideas at night, new ways to go about executing them, and during the day everything flops and fizzles" (Vachon to Penny, February 24, 1942). The ongoing war only exacerbates the photographer's feelings of frustration, as he finds himself questioned more than once by the local population: why is a seemingly healthy young man loitering about with a camera while the country is fighting a war?[49] Privileged by his family exemption and his OWI status, Vachon feels guilty and fatally outside the stream of history. In an undated letter to his mother from this last period, he tries to explain about "my troubles with me and my job." It is an exceptionally illuminating statement about what Vachon valued in the FSA project and why it had already passed its zenith.

> Maybe I did say this set up was made for me. It's a swell job, interesting, travel, I like my salary. Up until the war began, and we became the Office of War Information, there was nothing I would rather be doing than working for Stryker. Now there is sincerely nothing I would rather do than work for an office of war information that was actively engaged in the particular business I happen to think an OWI should be engaged in—real concentrated selling of the war (from the angle I want it sold), making concentrated attacks on bad things in America—prejudices, etc., convincing the country along the old Henry Wallace lines, building up pictures of what kind of future we should make. That is just my idea of what kind of work I would like to be doing, but there isn't in existence such an OWI, and I'm stuck making pictures of lady bus drivers, nursery schools, the same old shipyard pictures, I don't see much real value in what I'm doing, so I want to get out of it [figure 18]. It was different when we were engaged solely in the task of building up the greatest collection of pictures in the world, which we really did do, and putting out effective propaganda on farm problems, migrant workers, Negroes, etc. . . . There is also the factor that it is very hard for me to work as much as I have to do around military people, and war industries without becoming very conscious of my civilian necktie. People make you feel that way whether you like it or not. Also, having no conviction about what I am doing, I usually can't convince people that it is important that they let me make the pictures I want. So I got to get out.

Not surprisingly, his letters from the summer of 1943 are filled with the sense that he will not be working for Stryker much longer and wants to set his own agenda. But a last trip up the Mississippi Delta brings out his strong desire to make a final good effort: "I want to do my last fling, really work good and hard, thoughtful, get pictures of towns, riverboats, industries, do my very damn best at making a fine set of pictures" (Vachon to Penny, June 5, 1943). By October, with Stryker gone, conditions have changed, and Vachon's sense of professional freedom is even more in jeopardy: "I can't feel that old freedom at all this trip. More than once today I had the camera poised to photograph a cemetery or an autumn treed street, and I put it away self consciously. Maybe you don't understand that, but it's funny that way—there can't be any going around and photographing what I see under this set up. I

FIGURE 18 | *Mamie Fairchild and Dorothy Mason Working on a Bus at the City Transit Company*, Beaumont, Texas, May 1943

keep thinking: they will want to know WHY I took this" (Vachon to Penny, October 9, 1943). In retrospect, the FSA-OWI period would begin to take on a special quality—despite the constraints, the confusions, the hardships in the field—as a time of creative freedom; and Vachon, from the perspective of a few years later, would come to idolize Stryker.[50] Stryker, beneficent as always, hired Vachon for the Standard Oil project, but the photographer soon fell into an opportunity that was perfect for him at the time—the chance to photograph postwar Poland for the United Nations. And after that came two decades of employment, and countless stories, as one of *Look*'s chief photographers.

Though Vachon's career is, in a sense, a continuous one, from his early days as an FSA photographer to his long employment as an international photojournalist, he maintained a certain distance from it, regarding the turn of his life to photography as something of an accident, if not an act of vexatious calculation. Stryker "made a photographer out of me," he said in a late interview with Richard Doud. Not merely anyone could be shaped in that way, he admitted, but still, he added with self-mocking candor, "I've always resented it."[51] Bound up with his sense that he had failed to achieve his true

ambition—to become a writer—Vachon's misgivings are also the product of his insight into the whole machinery of modern civilization, and his own part in it. The last entry in his journals—which he started in 1933, when he was nineteen, and continued on and off until 1954—puts the matter with startling self-consciousness and ambivalence:

> Full breasted, average age girls walk enticingly on Madison Avenue, their lips sullen with lipstick. I, too, walk through the crowd with other men in grey suits, seeing the girls and considering my fortune. At the corner of Fifth Avenue and 51st Street I stand among the rich, towering monuments—the symbolic and the real centers and representations of the wealth and power of civilization. The money, the clothing, the religion, the ideas, and all forms of the desires and lusts as well as the comforts of the whole world are here, arranged for on this very spot. I am in the middle of it all, and I am moreover part of it. I contribute, through my work with the magazine, to the thinking and forming of values which spreads out from these stone buildings to the pliant acceptors of this false, refined civilization in all parts of the world. I am indeed in an envied position. And though I say, truthfully, that I reject this civilization, and had rather been no part of it, and surely am so by chance and no wish of mine—I nevertheless rejoice in it, and pander to it, as I fly out in early morning airplanes to photograph a famous ballplayer in Evansville, Indiana, or to see a senator in Washington or Maine. (May 4, 1954)

Vachon's extraordinarily clear-sighted introspection here captures his sense of destiny, his good fortune, but also his sense of futility: having achieved the envied status of his professional entitlement, he is simultaneously riven by existential angst. If Vachon's life imitates anyone's fiction, it is less his beloved Joyce than Dos Passos that we might hear in this passage—the sense that his own existence is wrapped in the totality of modern civilization, its rhythms, its pleasures, its sights and sounds, its comforts. Yet deep within, not easily erased by the rewards of "the big money," is an abiding sense of detachment and alienation. During the FSA-OWI years, Vachon undoubtedly took the measure of a changing country, but he also took his own measure and experienced deeply the sense of complicity that seems, in his case at least, part of the achievement, and the predicament, of twentieth-century America.

PHOTOGRAPHIC PLATES

FIGURE 19 | *John Vachon*, self-portrait, 1945

DURING HIS LONG TENURE as a photographer in the FSA group, Vachon took many thousands of images, only a tiny fraction of which could be reproduced here. Selecting a representative sample was not an easy task. Although Vachon's photographs have been published previously in several gatherings of FSA images relating to a specific region or theme, the selection here presents the first overview of his work from the FSA years.[1] Accordingly, I offer here a broad range of themes—from the rural farm scene to the urban street, from the industrial subject to the portrait, from everyday observations of the social scene to more formal landscapes—and I include as well a range of Vachon's styles—from candid images to posed, from the subject-centered straightforward composition to the more complex abstract ones. What comes through again and again are the empathy and compassion of Vachon's way of looking at the world and, along with that, an elegance of design and a sharp visual wit, visible in the juxtapositions of elements within the picture.

The selected photographs are organized here roughly according to subject, progressing from rural America during the Depression to urban and industrial America during wartime. They are linked not by rigid categories but by motifs or subjects that carry over in some way from one image to another. And they cover the years from 1938 to 1943. Vachon went on, after his FSA experience, to settle into a career at *Look* magazine, and from that vantage point he was able to reflect on his FSA work and see what was distinctive about his method of working under Roy Stryker. Whereas the magazine photographer has to develop a particular story, known in advance, and works as a member of a photographer-writer team, the FSA photographer could take a more open attitude, reacting to what was out there, looking for the one picture that would say it all.

But though the one good picture may have been the goal, the process of achieving it was a trial of many labors, much film, and several cameras. Of the latter, Vachon's favorite format was the miniature or 35 mm, which allowed for maximum flexibility and speed, and he frequently refers in his letters to his Leica (though he began by 1940 to feel it was "too easy"); but he also mentions his Speed Graphic (4×5 inch negative), his Graflex ($3^{1}/_{4} \times 4^{1}/_{4}$), and his Rollicord ($2^{1}/_{4} \times 2^{1}/_{4}$). He took a few other images in a larger format (8×10).[2] When he was shooting landscapes or structures and could take the time to set up the shot, he usually took only two or three images of a given subject, from slightly different angles; when he was shooting a scene in motion, especially the street scenes that he favored, he would typically shoot several images in succession (capturing changing figures at an intersection, for example), relying more on his spontaneous intuition. Occasionally, he would pause and study a subject in a given locale, making a dozen photographs (one example from such a study—of the front of a burlesque house—is reproduced here as plate 54). Other images, more formally constructed as ab-

stractions, seem like inspirations of the moment and stand as unique images. Presented in this sequence, out of their original context, the selection that follows is, to state the obvious, my own personal choice. And choosing these images was, at a certain point—when I had narrowed down my choice to about a thousand photographs—extraordinarily painful, so reluctant was I to consign to oblivion any shot that I thought "great" (and there were many).

Vachon's work appeared in a variety of venues during his FSA years: in newspapers and national magazines, as part of the broad distribution of agency images undertaken by Stryker; in *U.S. Camera Annual* publications, a roundup of the year's best photojournalism, where Vachon was of course delighted to appear but mildly chagrined to be represented repeatedly by midwestern grain elevator shots; in state guidebooks put together by the Federal Writers' Project; in books that exploited the FSA collection, which was made readily available to authors; in books for which photographs were taken specially on assignment as illustrations;[3] and in exhibitions of FSA work. Years later, Vachon was the subject of at least four one-man shows, beginning in the sixties.[4]

I started this project in the microfilm era of the twentieth century, and microfilm was my primary medium of research; but with much of Vachon's work now on the Internet (at the Library of Congress's American Memory website) it is possible to study the sequence of Vachon's work in detail, looking at the images grouped in their "lots," as they were originally made. This broader exposure of his work— through print and through the Web—will open up a significant body of material to further research, understanding, and appreciation.

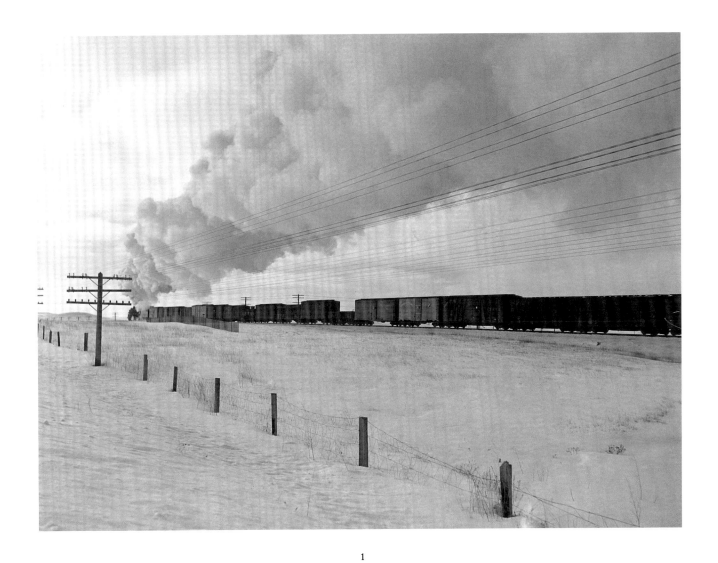

1

Morton County, North Dakota, February 1942

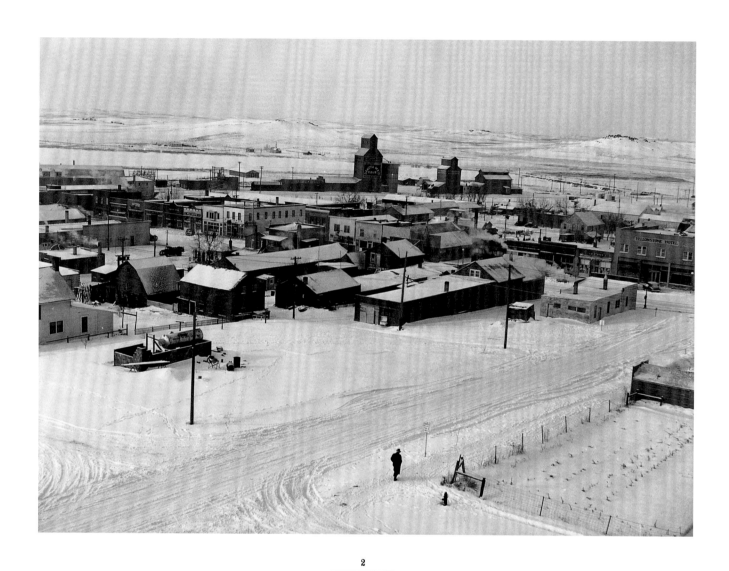

2

Hettinger, North Dakota, February 1942

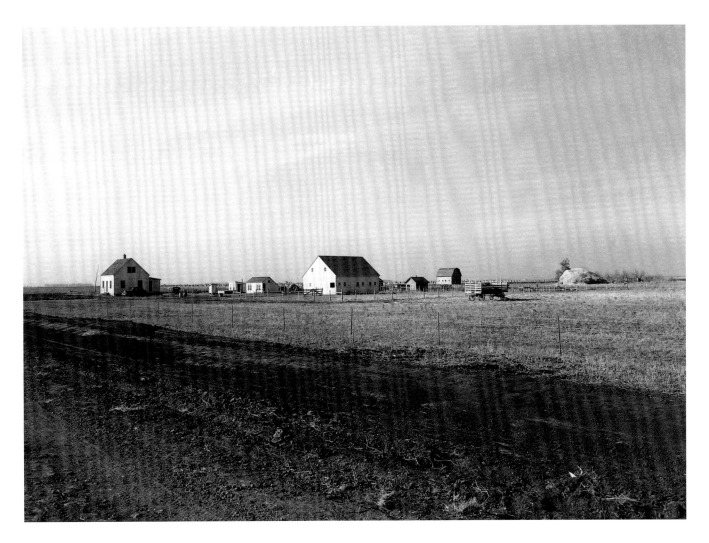

3

Amundson Farm Unit, Red River Valley Farms,
North Dakota, October 1940

4

Packaged Butter at the Land-o-Lakes Plant
Chicago, Illinois, June 1941

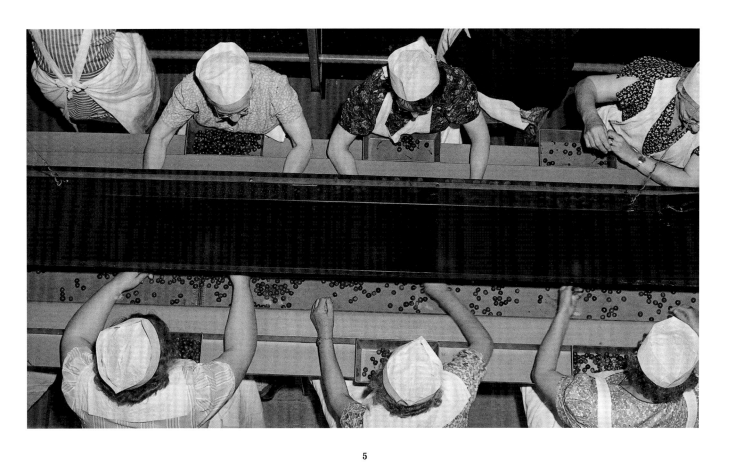

5

*Women Removing Stems and Defective Cherries
in a Canning Plant,* Door County, Wisconsin, July 1940

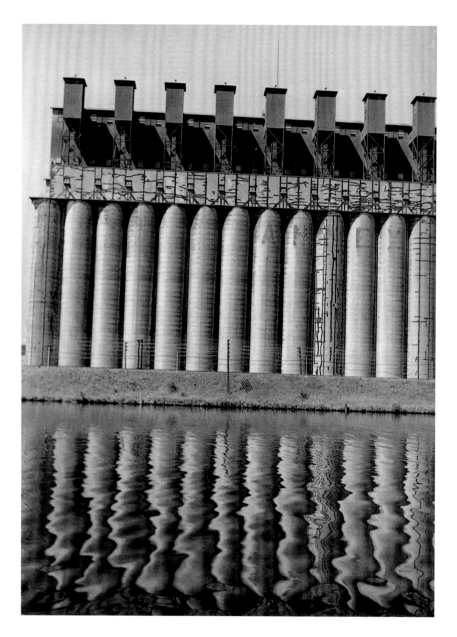

6

Grain Elevator, Superior, Wisconsin, August 1941

7

Stockyards, Omaha, Nebraska, November 1938

8

Wires, Poles, and Fences along U.S. Highway #10
Dickinson, North Dakota, February 1942

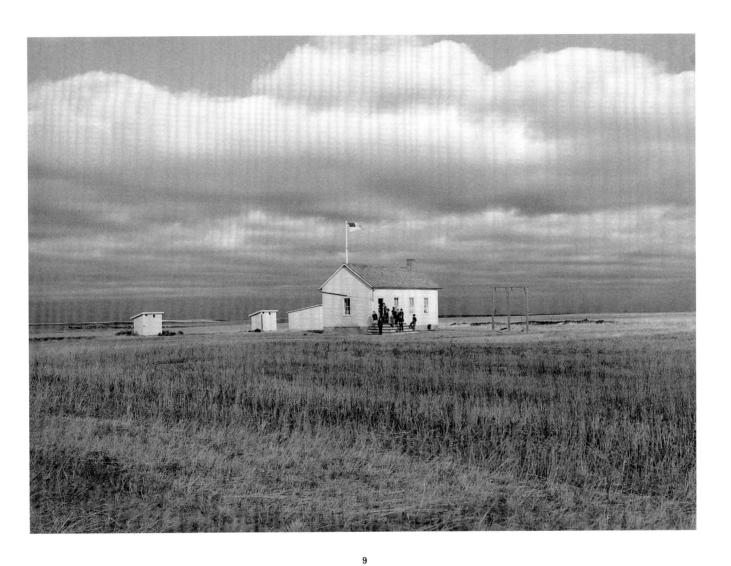

9

School House, Ward County, North Dakota, November 1940

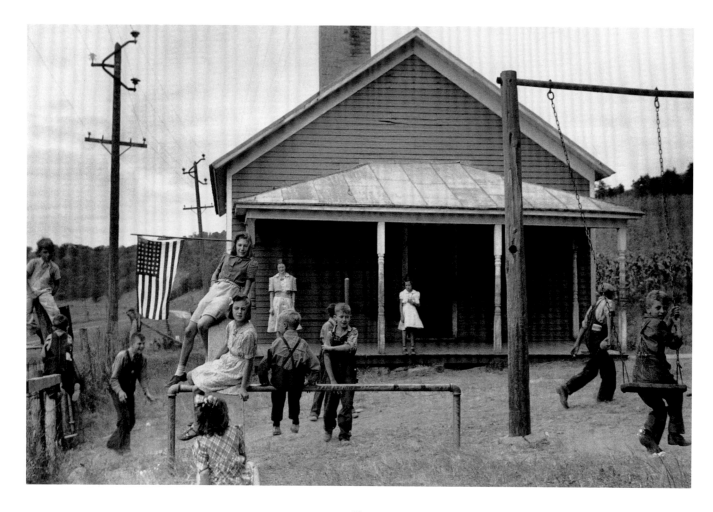

10

Rural School, Wisconsin, September 1939

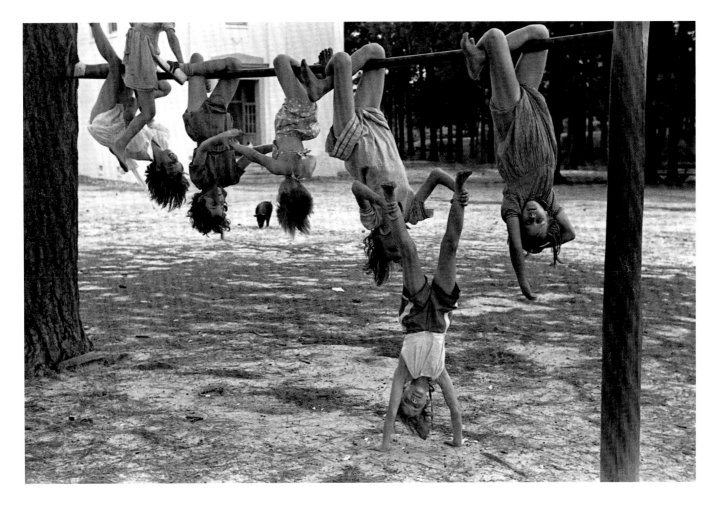

11

Children Doing Calisthenics at the School Playground
Irwinville, Georgia, May 1938

12

Playing "Out to Pie" or "Fox and Geese"
at Noon Recess at Rural School
Morton County, North Dakota, February 1942

13

School Girl, Morton County, North Dakota, February 1942

14

Negro Dock Worker and Son
New Orleans, Louisiana, March 1943

15

School Children at the Post Office to Buy Defense Stamps
New Boston, Ohio, January 1942

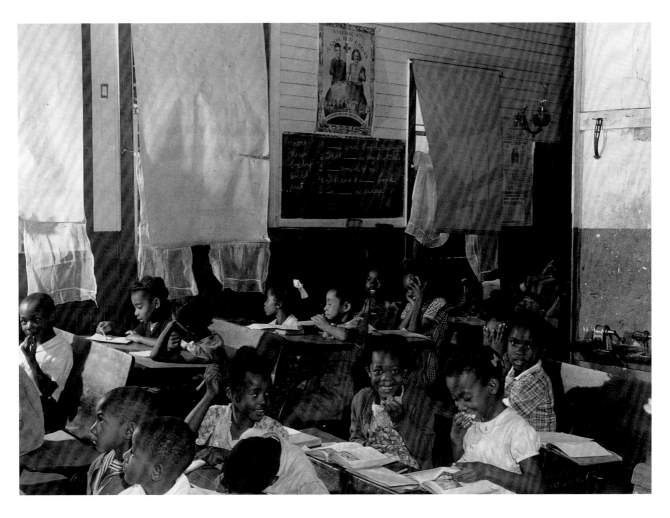

16

A One Room Schoolhouse, St. Mary's County,
Maryland, September 1940

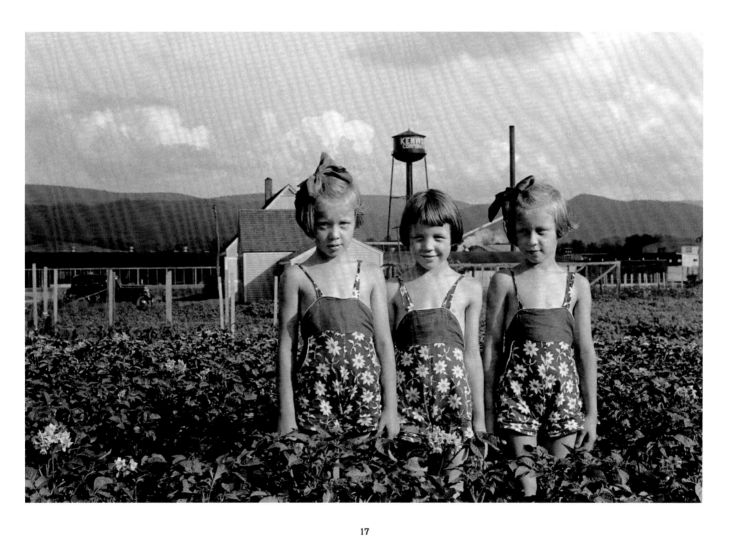

17

The Tygart Valley Subsistence Homesteads, a Project of the
U.S. Resettlement Administration. Daughters of a Homesteader
with a House and a Factory in the Background.
Elkins, West Virginia, June 1939

18

Girls Who Work at Aberdeen Proving Grounds,
and Share a Room in the Farm Security Administration's
Dormitory for Defense Workers
Aberdeen, Maryland, December 1941

19

Ladies Who Live in the Rooming House
St. Paul, Minnesota, September 1939

*The Tygart Valley Subsistence Homesteads, a Project of the
U.S. Resettlement Administration. Meeting of the Women's Club.*
Elkins, West Virginia, June 1939

21

The Tygart Valley Subsistence Homesteads,
a Project of the U.S. Resettlement Administration
Elkins, West Virginia, June 1939

22

Oil Wells, Kilgore, Texas, April 1943

23

Soda Fountain in Rushing's Drug Store on Saturday Afternoon
San Augustine, Texas, April 1943

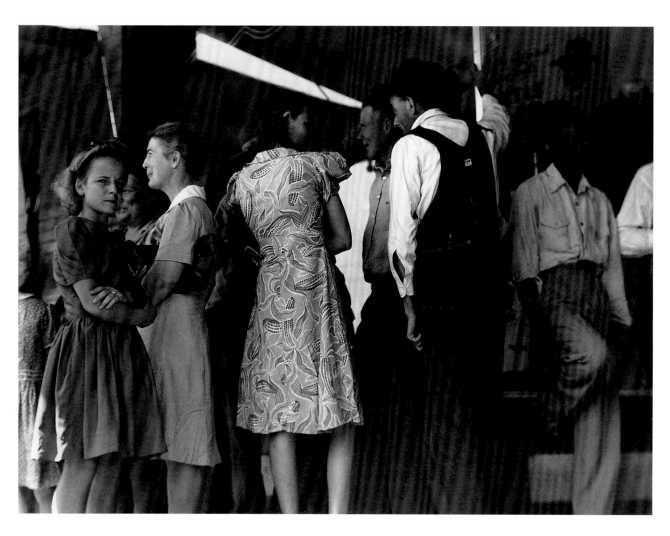

24

People on the Main Street on Saturday Afternoon
San Augustine, Texas, April 1943

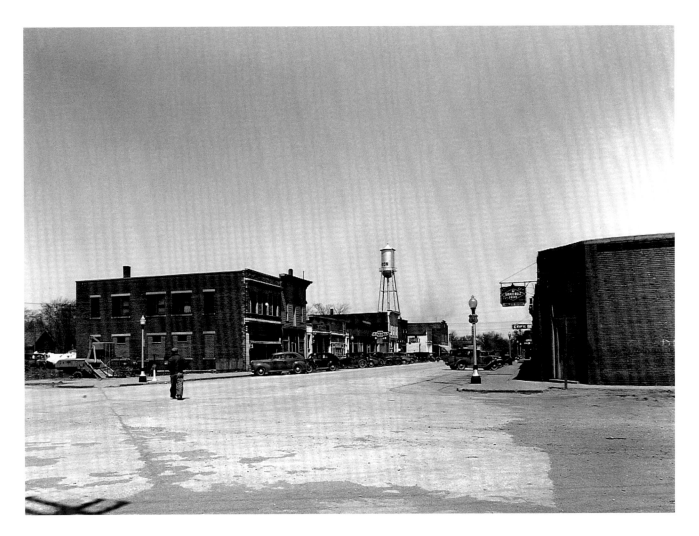

25

The Main Street, Scranton, Iowa, May 1940

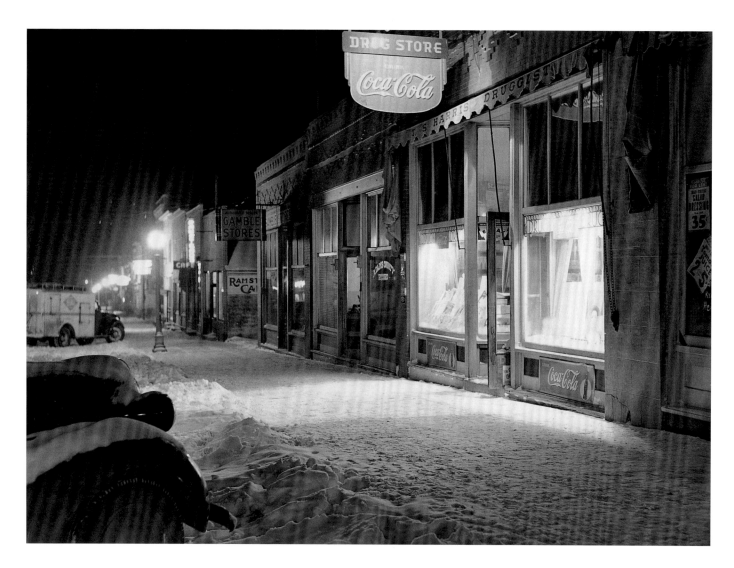

26

Untitled, February 1942 [?]

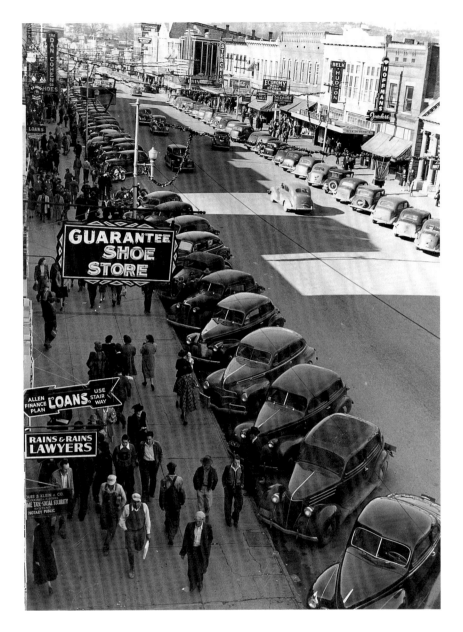

Christmas Shopping Crowds
Gadsden, Alabama, December 1940

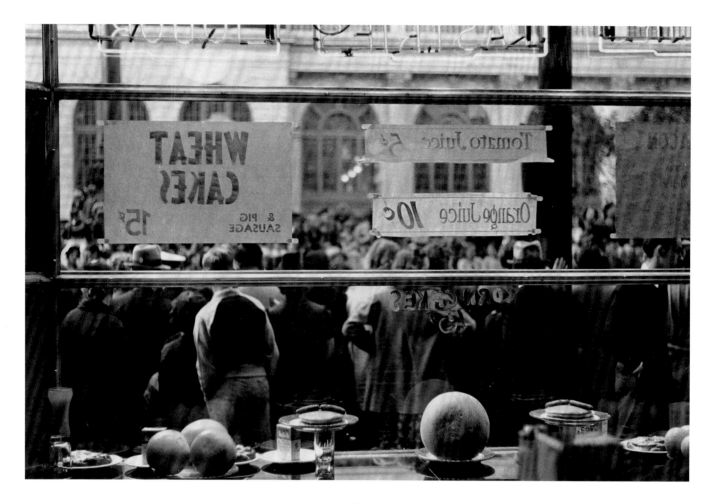

28

Untitled, Cincinnati, Ohio, October 1938

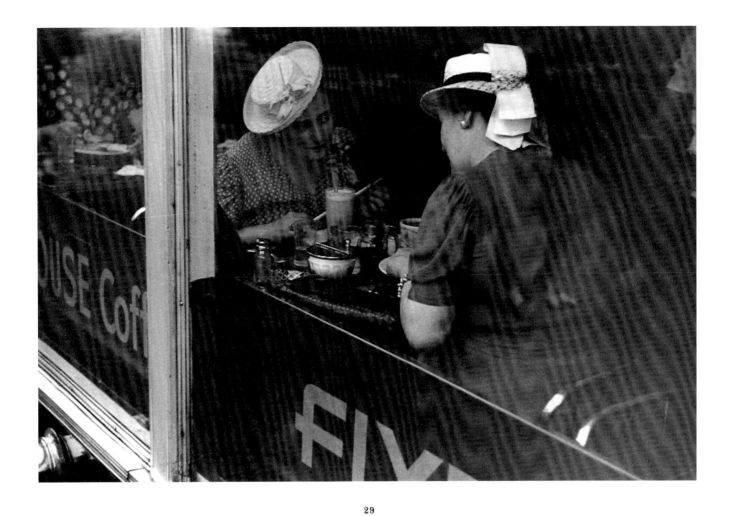

29

Coffee Shop, Chicago, Illinois, July 1941

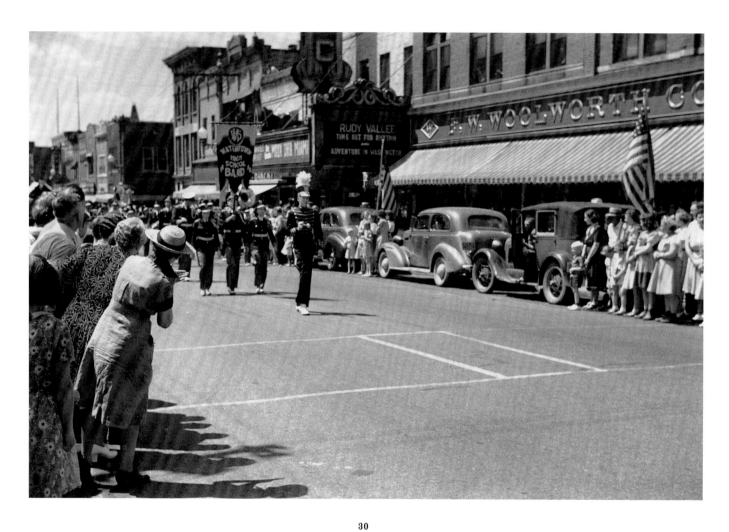

30

The 4th of July Parade, Watertown, Wisconsin, July 1941

31

Watching Ballgame, Vincennes, Indiana, July 1941

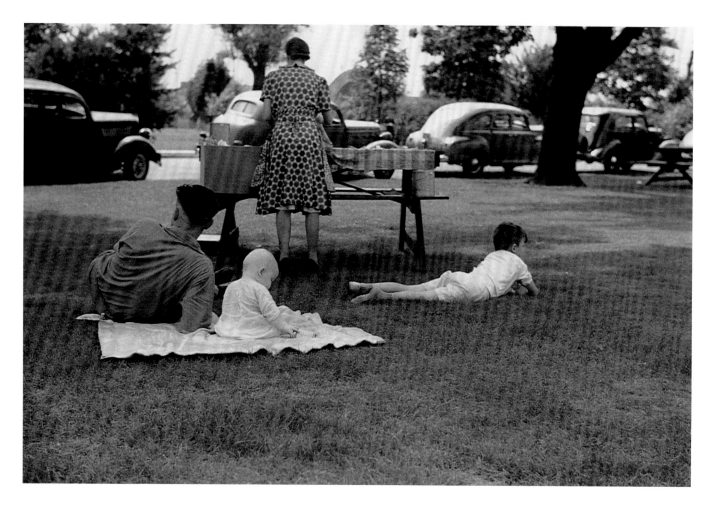

32

Picnickers, Vincennes, Indiana, July 1941

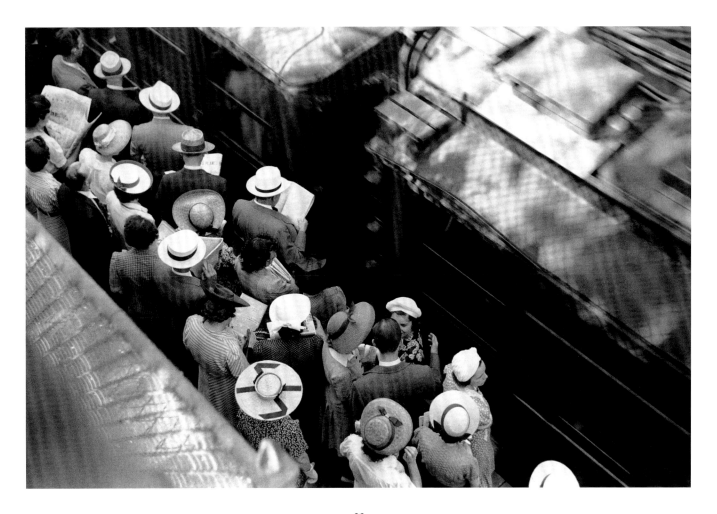

33

Commuters Waiting for South-bound Trains
Chicago, Illinois, July 1941

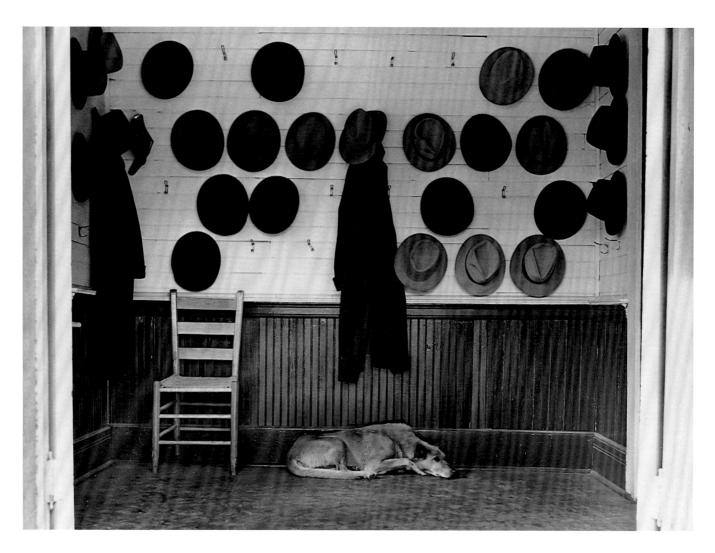

34

The Vestibule of the Baptist Church during Sunday Services
with Hats Hanging on the Wall. They Belong to Parishioners
Who Are Mostly Steel and Cotton Workers.
Gadsden, Alabama, December 1940

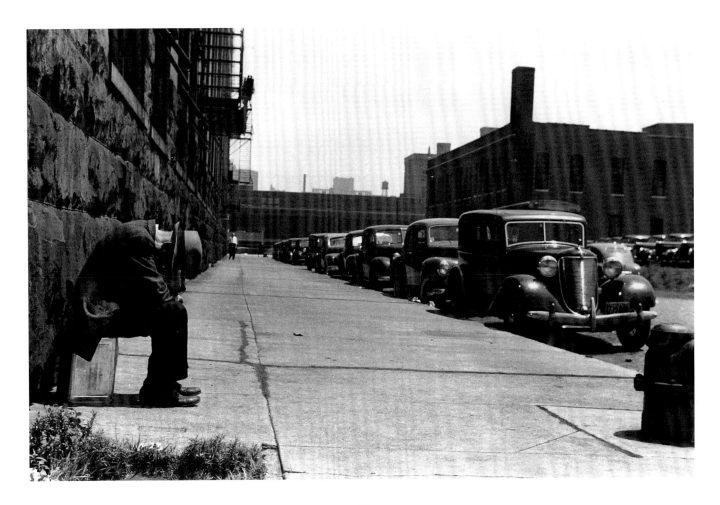

35

Untitled, Chicago, Illinois, July 1941

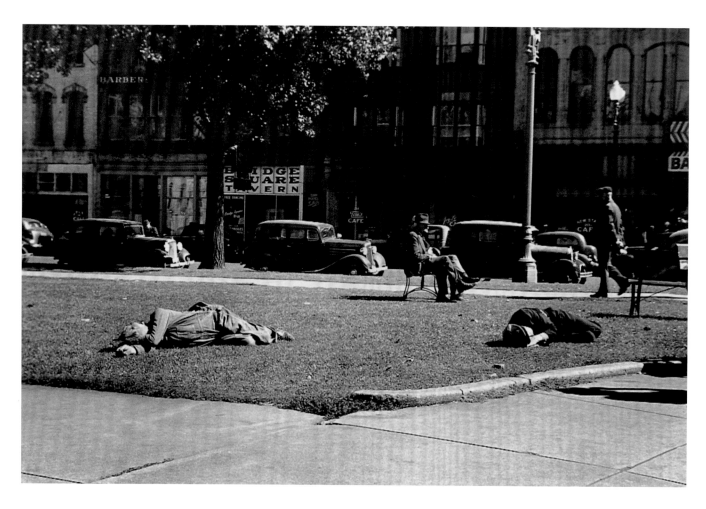

36

Unemployed Men in the Gateway District
Minneapolis, Minnesota, September 1939

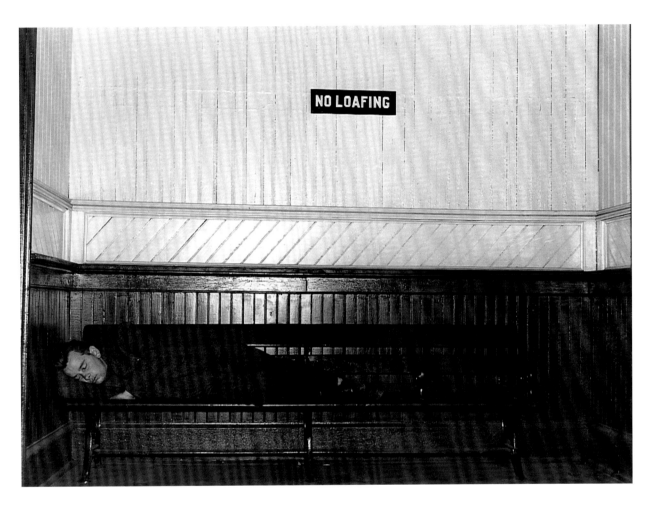

37

Boy from out of Town Sleeping in the Railroad Station
Radford, Virginia, December 1940

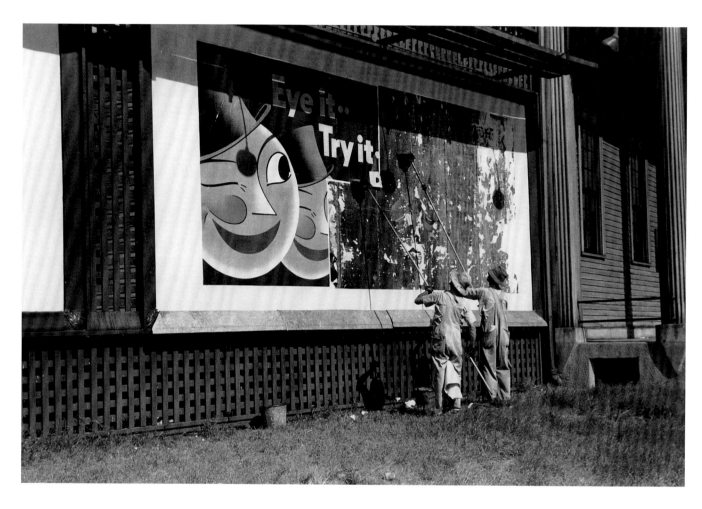

38

Billboard in Transition
Minneapolis, Minnesota, September 1939

39

Advertising near Mansfield, Ohio, July 1941

40

Garage with a False Front
Sisseton, South Dakota, September 1939

41

Trucks on U.S. Highway Route No. 1
between Baltimore and Washington, March 1943

42

Parking Lot, Chicago, Illinois, July 1940

43

Man and Boy Crossing the Street, Dubuque, Iowa, April 1940

44

Under the Elevated Railway, Chicago, Illinois, July 1940

45

Jay Walkers, Chicago, Illinois, July 1940

46

Spectators at the Sesquicentennial Parade
Cincinnati, Ohio, October 1938

The following text appears within the image/poster:

SEE CHICAGO'S WONDERS

The BROOKFIELD ZOO

J·A·KOENIG

GO by "L"

Hear the lions roar; flip peanuts to the bears;

47

Ascending Steps of El, Chicago, Illinois, July 1941

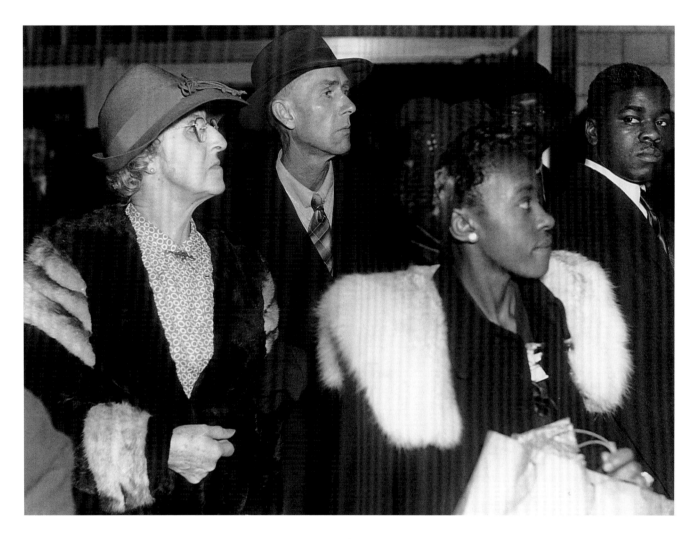

48

Greyhound Bus Terminal on the Day before Christmas.
Waiting to Board the Bus to Richmond.
Washington, D.C., December 1941

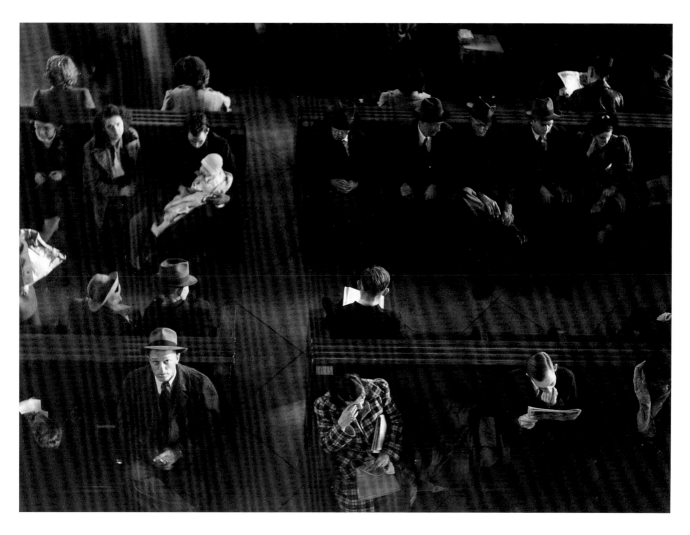

49

Greyhound Bus Terminal on the Day
before Christmas. Waiting Room.
Washington, D.C., December 1941

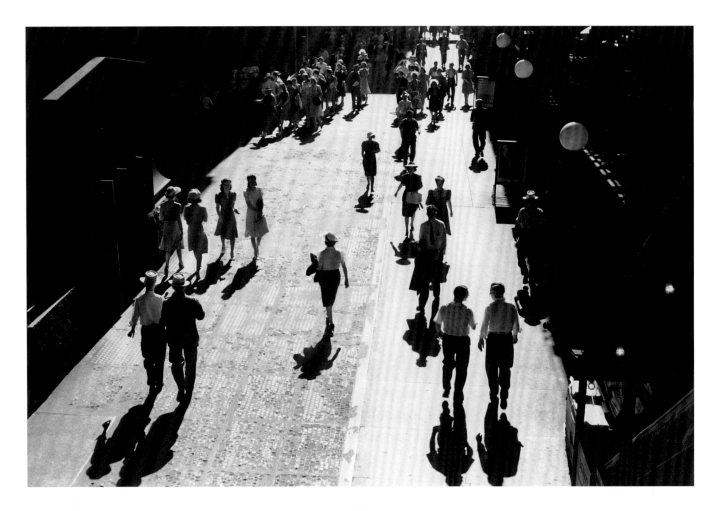

50

5 O'clock Crowds, Chicago, Illinois, July 1940

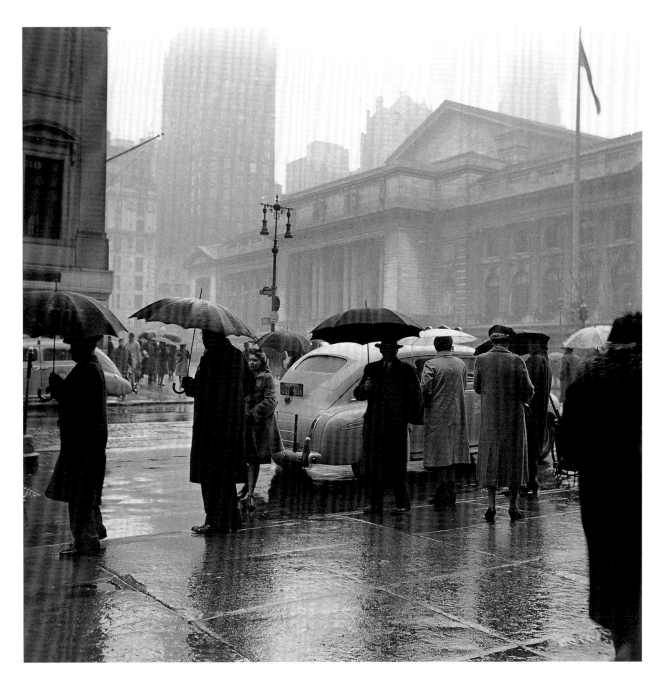

51

Forty-second Street and 8th Avenue on a Rainy Day
New York, New York, March 1943

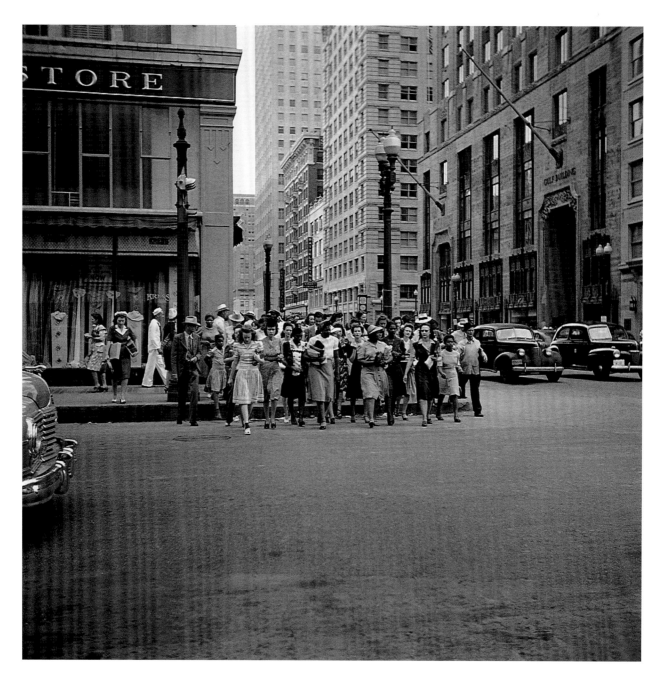

52

People Crossing a Downtown Street with the Green Light
Houston, Texas, May 1943

News Stand, Omaha, Nebraska, November 1938

54

Burlesque House on South State Street
Chicago, Illinois, July 1941

55

Waiting for a Street Car, Chicago, Illinois, July 1941

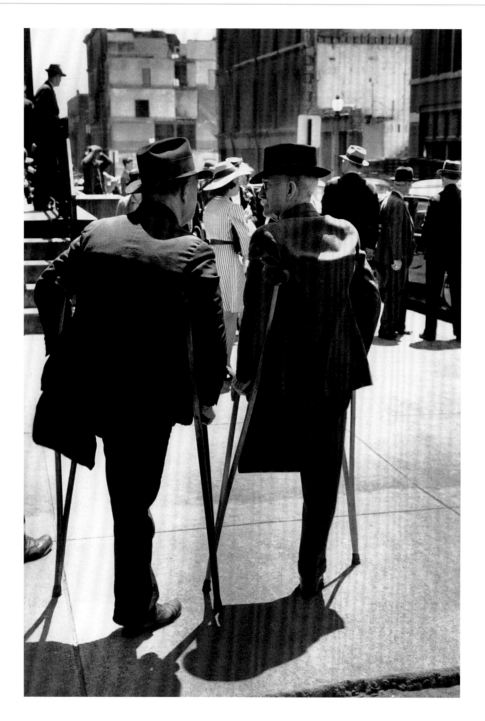

Two One-Legged Men outside a Church on Sunday Morning
St. Louis, Missouri, May 1940

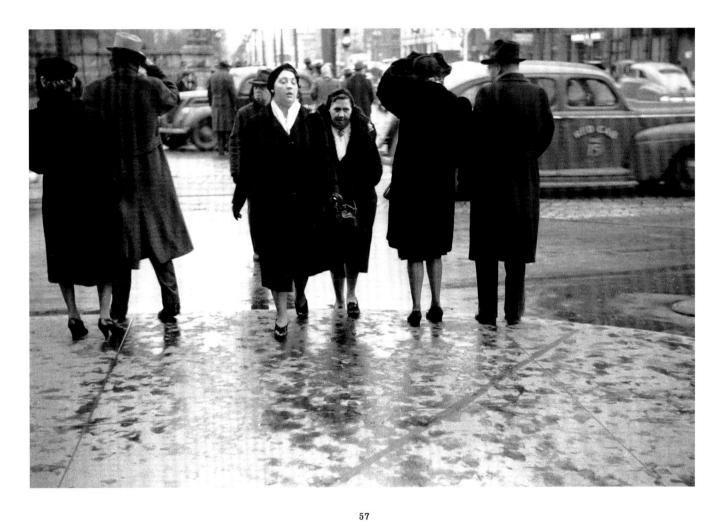

57

Rainy Day, Indianapolis, Indiana, January 1942

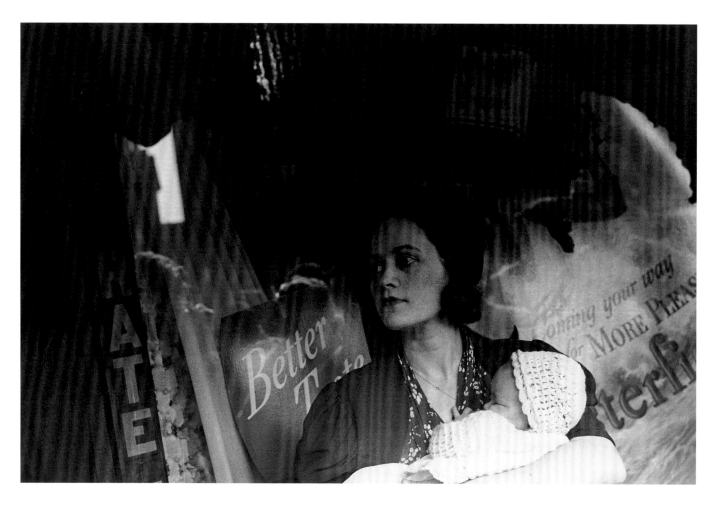

58

Watching the Parade, Cincinnati, Ohio, October 1938

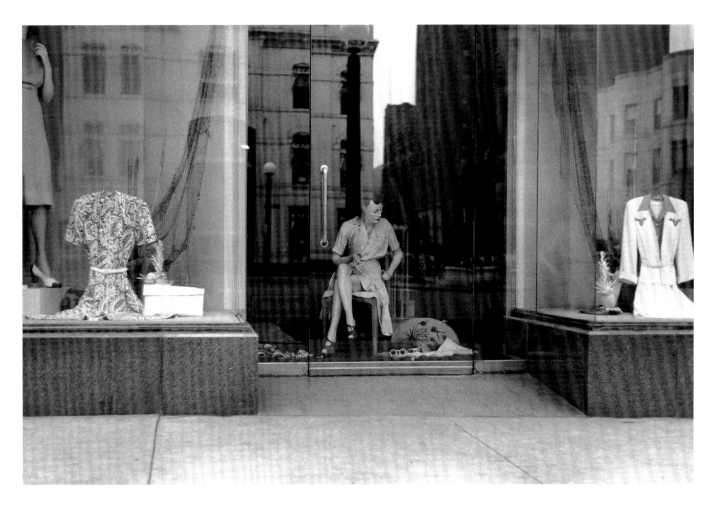

59

Window Display, Chicago, Illinois, July 1941

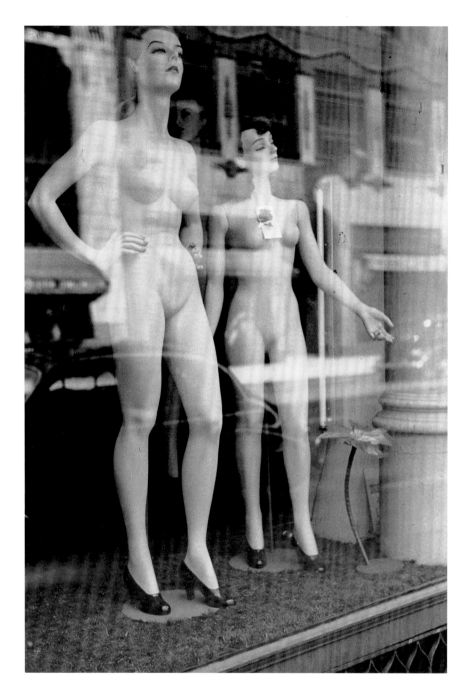

60

Department Store Models, Chicago, Illinois, July 1940

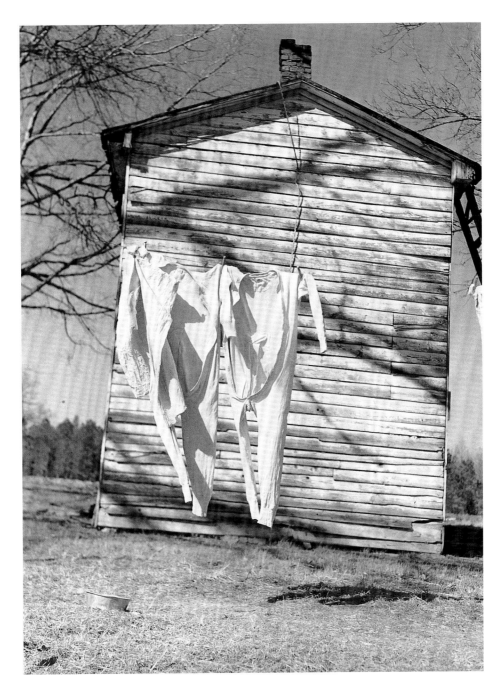

61

A Farm House with Clothes on Line
Essex County, Virginia, March 1941

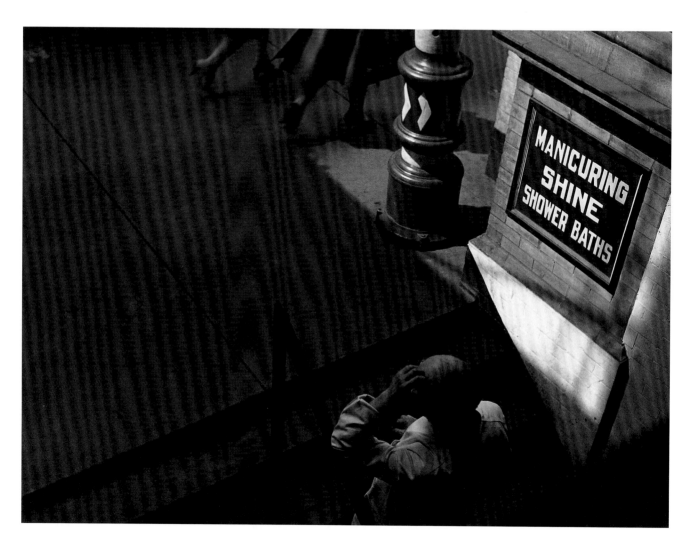

62

A Barber in Front of His Shop
Lynchburg, Virginia, March 1943

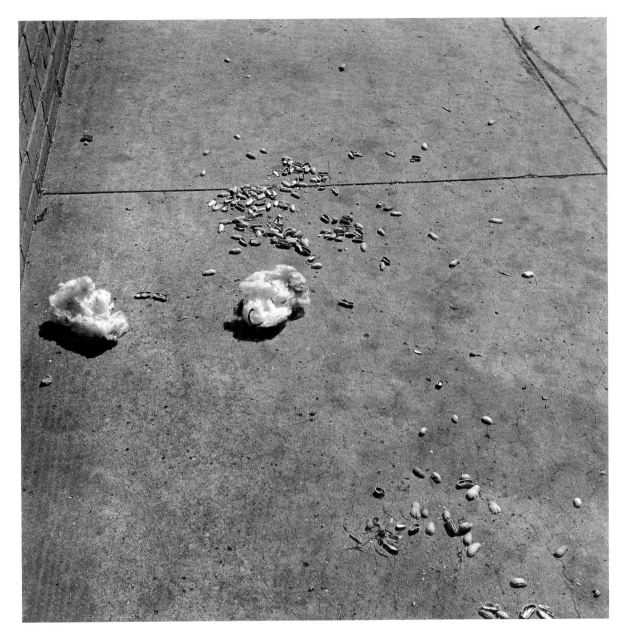

63

Cotton and Peanut Shells on the Sidewalk
Montgomery, Alabama, March 1943

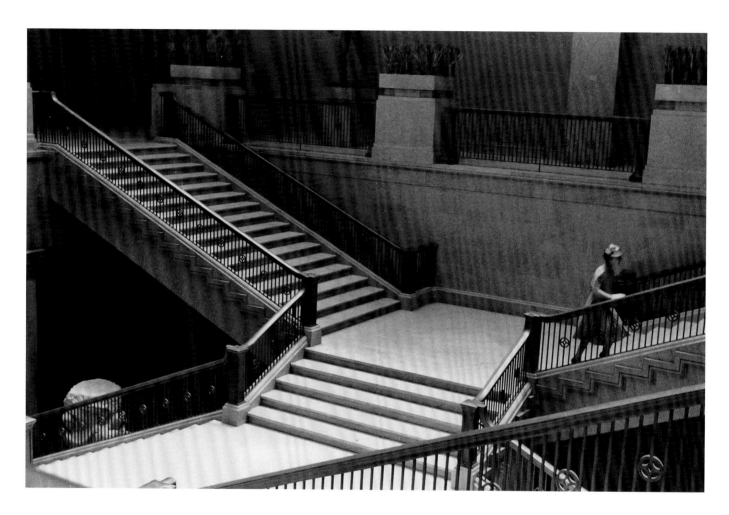

64

Chicago Art Institute, Chicago, Illinois, July 1941

65

Window Display, Chicago, Illinois, July 1941

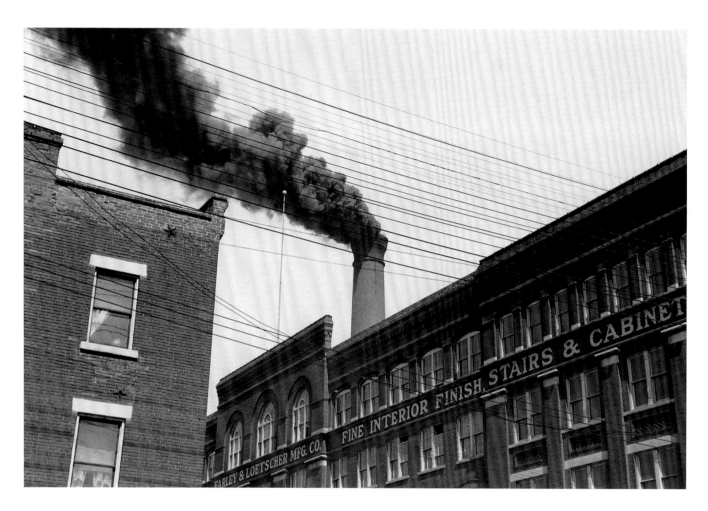

66

Sash and Door Mill, Which Is the City's Largest Industry
Dubuque, Iowa, April 1940

67

Untitled, Vincennes, Indiana, July 1941

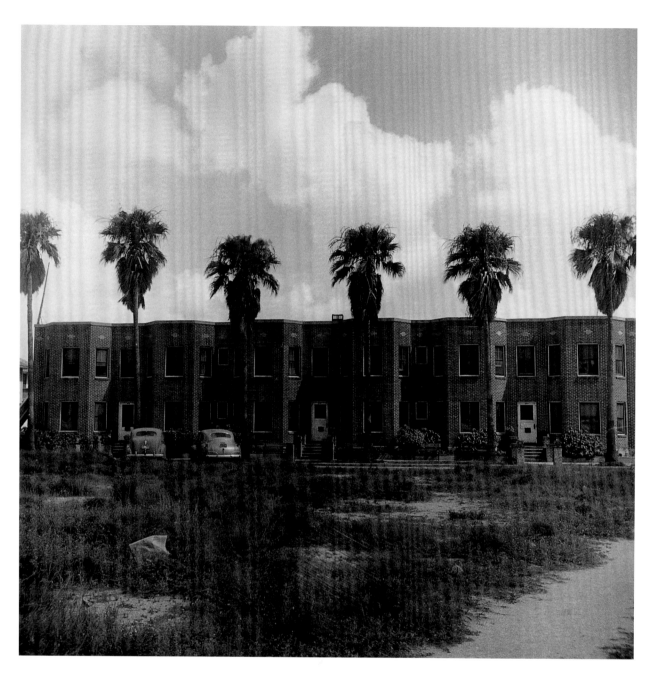

68

Apartment Houses, Corpus Christi, Texas, June 1943

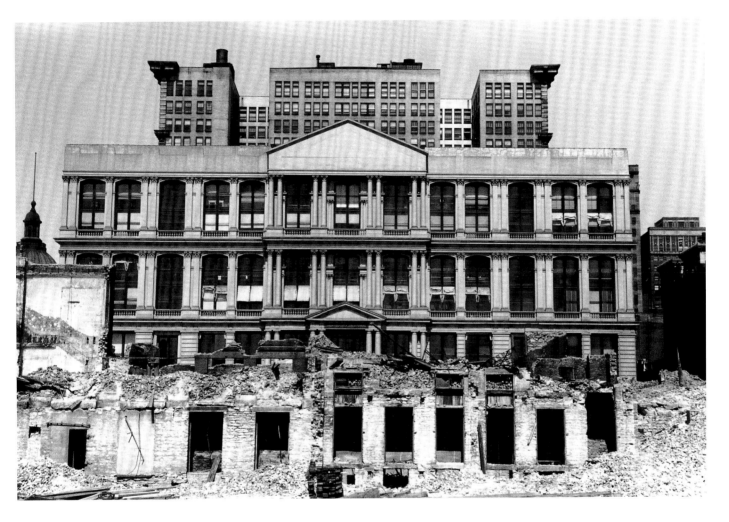

69

Tearing Down Buildings, St. Louis, Missouri, May 1940

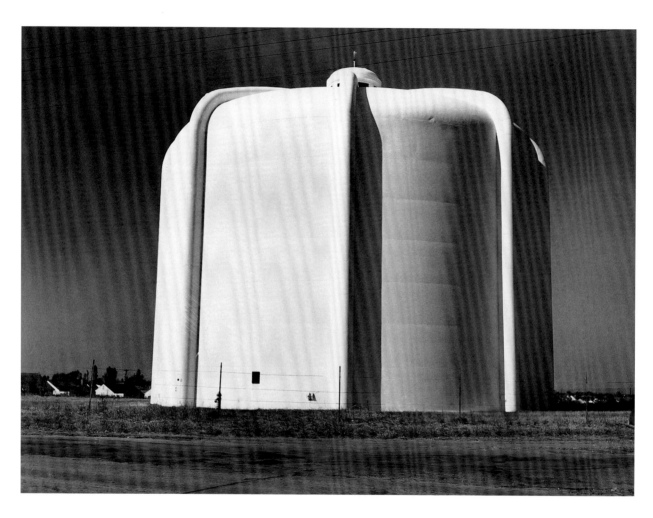

70

Oil Tank on the Grounds
of the International Petroleum Exposition
Tulsa, Oklahoma, October 1942

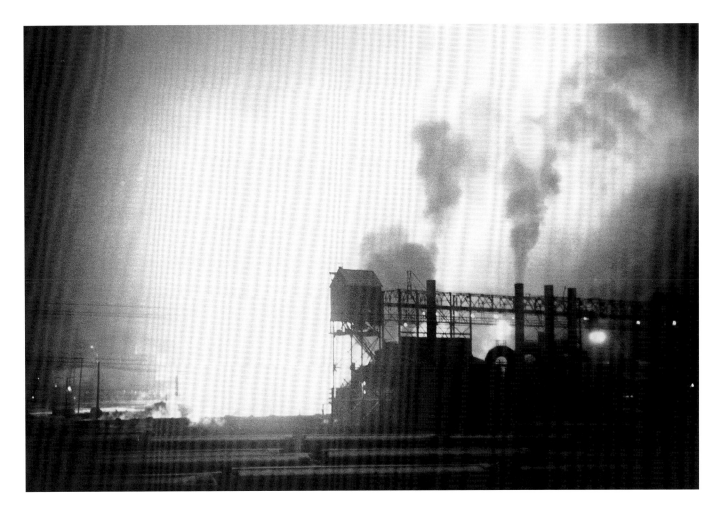

71

*The Bessemers "Blooming" at the Jones
and Laughlin Steel Company*
Aliquippa, Pennsylvania, January 1941

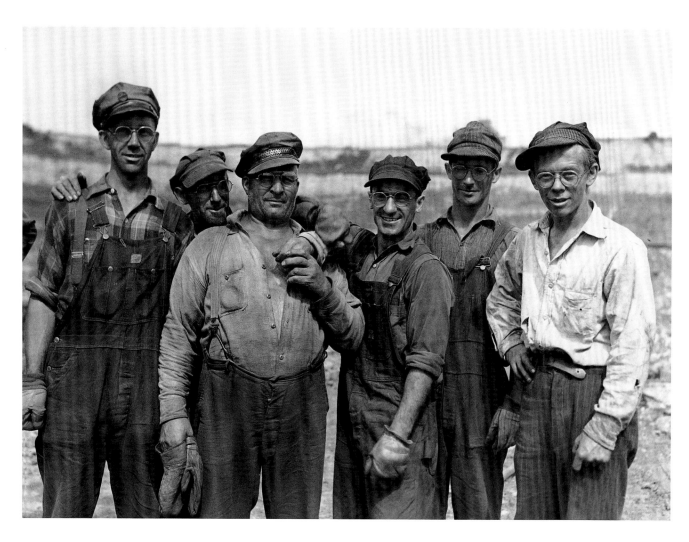

72

Blasting Crew in the Danube Iron Mine
Bovey, Minnesota, August 1941

73

Concentration Plant of the Danube Iron Mine
Bovey, Minnesota, August 1941

74

Hydrogen Tanks at the Champion Paper Mill
Houston, Texas, May 1943

75

Loading Grain Boat at the Occident Elevator
Duluth, Minnesota, August 1939

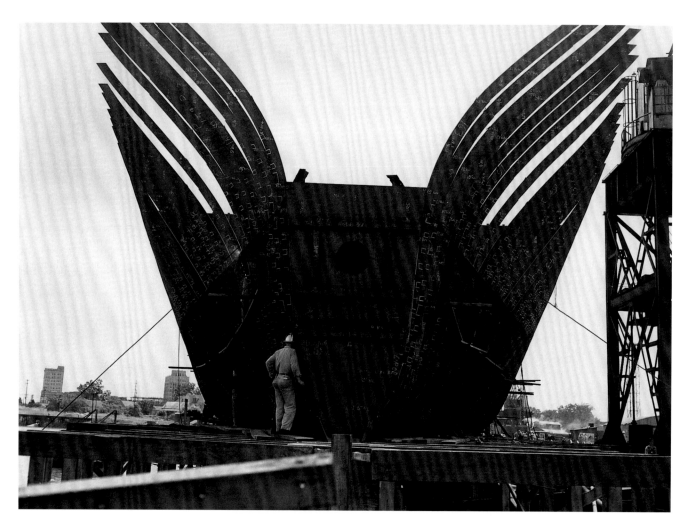

76

Hull of Vessel under Construction at the
Pennsylvania Shipyards
Beaumont, Texas, May 1943

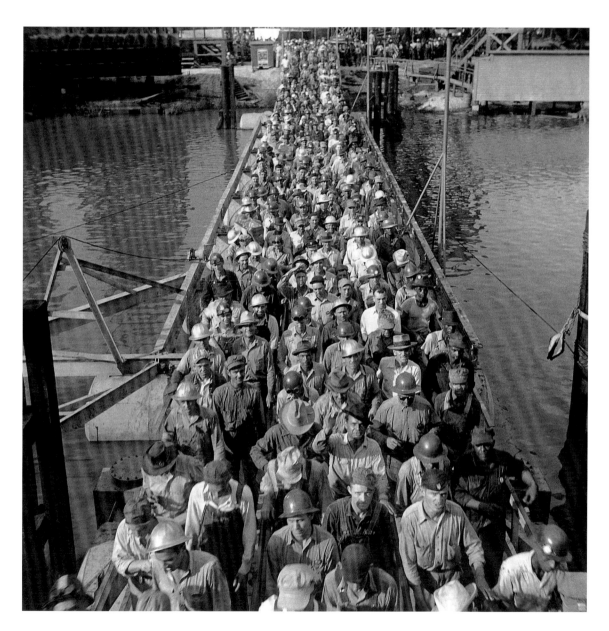

77

Workers Leaving the Pennsylvania Shipyards
Beaumont, Texas, May 1943

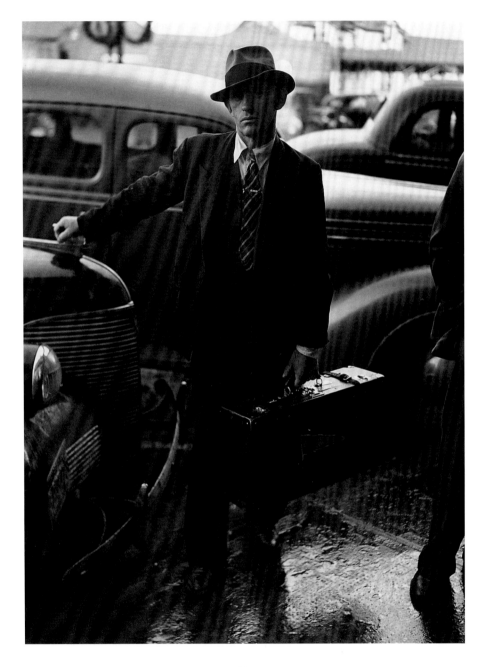

78

A Man Who Has Just Arrived to Report for Work
Radford, Virginia, December 1940

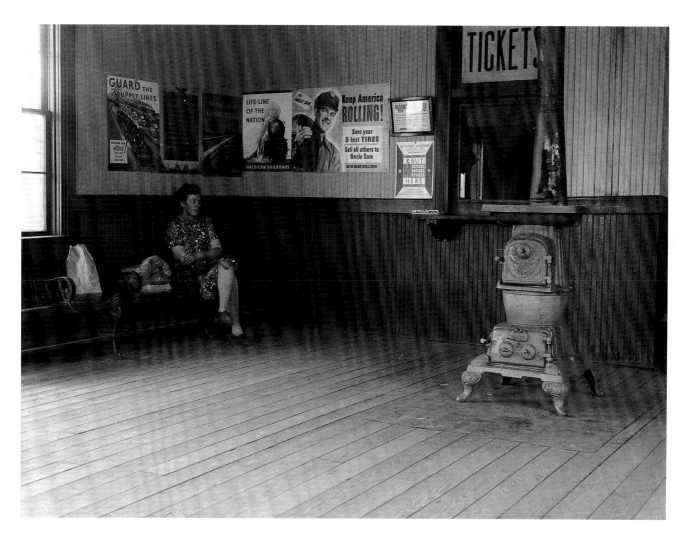

79

The Waiting Room in the Railroad Station
San Augustine, Texas, April 1943

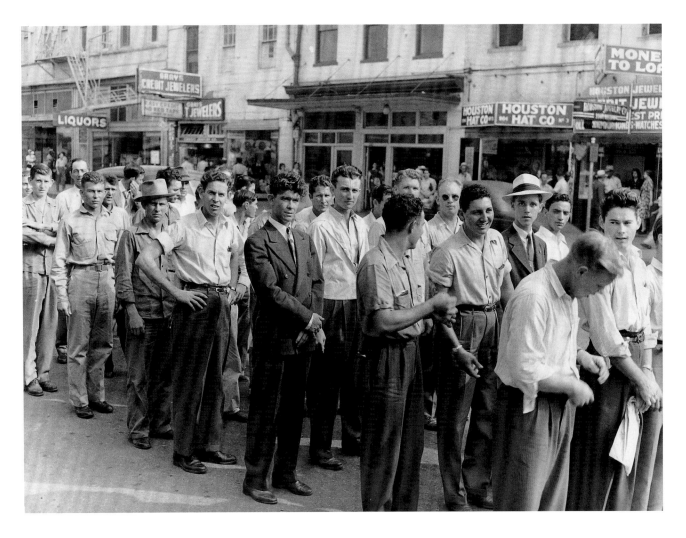

80

Inducted Men Marching to a Reception Center
Houston, Texas, May 1943

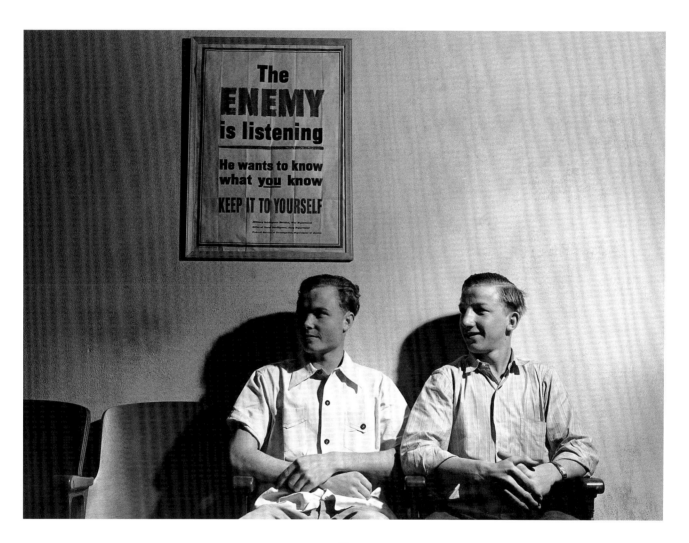

81

Two 18 Year Old Boys Waiting for Their Physical
Examinations prior to Induction into the Army
San Augustine, Texas, April 1943

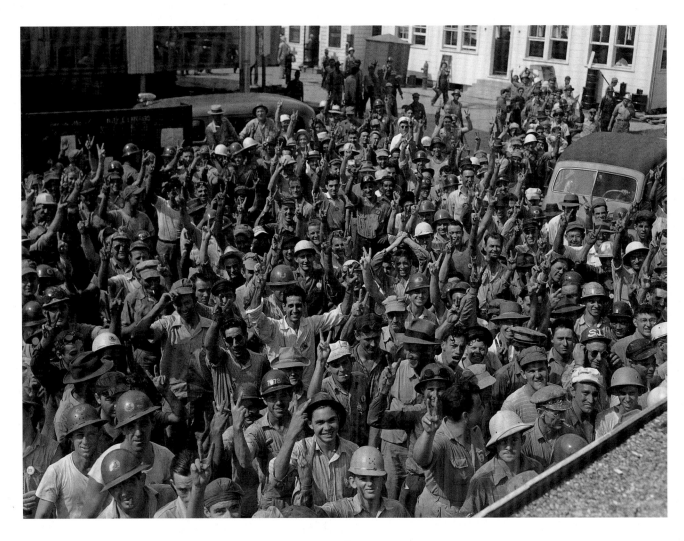

82

Higgins Shipyard Workers Leaving at 4 PM
New Orleans, Louisiana, June 1943

LETTERS TO PENNY

FIGURE 20 | *Penny,* photographer unknown (probably John Vachon), 1940

WRITTEN ALMOST DAILY from hundreds of hotel rooms around the country, John Vachon's letters to his wife Millicent (or Penny, figure 20) form a unique record of the FSA period and of one photographer's observations about the changing social fabric of American society.

Since their relationship at times comes to the foreground in these letters, some background on it is useful. Coming to Washington in 1935, John meets Penny in August 1936, and by January 1938 they are married. (Vachon's own summary chronology of these early years can be found in his journal entries for March 14, 1938; April 26, 1938; and June 4, 1938—printed in the "Additional Writings" section of the present volume.) A couple of years older than John, Penny has been previously engaged, but John brushes aside somewhat nervously her previous experience and curses his suspected rivals of the moment: "Damn, I burn to have her" (September 20, 1936). In his journal John writes, "I have met, and been with three times, and been drunk with, and read my poetry to, and made ardentest love to [he means necking]—Millicent, or Penny, as she is called." Likening her to Joan Crawford—and later to Norma Shearer—in appearance and manner, John affirms incredulously, "She loves me." A month later, John is quite sure the feelings are mutual: "Whether I am defamed or not, I love this woman now as I have never known I could love." And he adds, strangely, "I will not commit suicide at any stage of the game" (October 10, 1936). Twenty-three years later, Penny would herself commit suicide.

To his mother, John writes of his new love with exaltation, excitement, and some trepidation, for she is not Catholic. John's mother, as he expects, raises objections; meanwhile, Penny's Protestant family has corresponding qualms, but both sets of parents get over their terror of the religious unknown once they meet the prospective son- and daughter-in-law. John, who in his teenage years contemplated the priesthood, sees no problem in this "mixed" marriage; he himself holds fast throughout his life to some sort of Catholic identity—going to mass on occasion, keeping up with Catholic intellectual thought, above all entertaining from time to time notions of spiritual calling and destiny. Vachon abhorred narrow-mindedness and prejudice of any kind—religious, ethnic, racial—so he is gratified when his parents relent and bless their union. (In any case, with Penny pregnant, they would be going through with the marriage with or without parental blessings, and speedily.) It will be obvious to any reader of the letters to Penny that John was intensely in love with her, at the same time that he brought to the marriage a passionate Romanticism and striving for the perfect (and therefore ever elusive) relationship—sexually, spiritually, conversationally. Whether they achieved that perfection, or for how long, is hard to say, but the letters convey a great romance in the early years. By 1942, however, with John on the road for a period stretching to six months, with careful budgeting required both on the road and at

home, with unexpected expenses and tedious wartime inconveniences—with all of this, the marriage was strained. John's usually sunny disposition turns sour and bitter; he sends Penny long tirades from the field, criticizing her for everything conceivable; on November 13, 1942, he sends her what was apparently an especially nasty letter, which, on second thought, he tears into little pieces before stuffing into an envelope. Penny somehow manages to piece it together (but with the pieces glued together now, it is unreadable).

Around this time—1943—Penny begins to develop certain dissatisfactions revolving around her own life choices. A graduate of Oberlin, she was an accomplished pianist, though she never pursued a professional career. Six years into her marriage, the mother of a five-year-old girl and a two-year-old boy, her husband on the road a good part of the year while she was living at home in the new Washington suburb of Greenbelt, Maryland—a government-sponsored housing development that looked like utopia when they moved in—Penny is growing restless, uncertain, somewhat depressed. Though with some difficulty, she and John manage to weather this period.

John clearly had great respect for Penny, begging her for ideas to help with his photography, urging her to research and write various magazine articles. After they moved to New York City (later in 1943), Penny did indeed return to work, writing captions for Roy Stryker's operation at Standard Oil, and—after attending a course at Columbia—taking on various other editorial jobs. At times during the years of transition before John became employed regularly at *Look*, she was producing the main household income.

Yet Penny's psychological problems continued, on and off, for years, even when she had found considerable satisfaction working outside the home. Finally in early 1960, having been in and out of private sanitariums and after several half-serious attempts in the previous year or so, Penny succeeded in taking her own life by jumping off the roof of their apartment house.

Apart from the necessity and desire to stay in touch with his wife while on the road, Vachon, it is clear, had an interest in the letter as a literary form—even before he met Penny. After a visit from a cousin for whom he had great affection, he wrote in his journal, with typically Romantic ambition, "I should like to write letters to her which would be read forever" (January 29, 1935). There is no evidence that he ever made such an attempt, but writing to Penny easily became an even better literary structure for the young photographer, allowing him to exhibit a wide range of his feelings and observations as well as a sense of play that extended to the form of the letter itself—the greeting, the farewell, his use of illustrations, and so forth. (In one of his letters he lists compulsively the postmarks, signatures, and envelopes Penny has employed in all her letters to him.)

These extraordinary letters are the product of a moment in our history when it was possible to stay in almost daily touch through an inexpensive, reliable overnight postal service—before the telephone would be an affordable convenience and e-mail an evanescent one. In any case, John hated his occasionally necessary telephone conversations with Penny, feeling that the tense and rushed exchanges

HOTEL CORNHUSKER
Lincoln, Nebraska

EMILIE MILLICENT LEEPER VACHON
BOX 448
GREENBELT
MARYLAND

FIGURE 21 Envelope sent by Vachon from Lincoln, Nebraska, May 19, 1942

were utterly false representations of their feelings for one another. The letters were his conversational medium, and often he somewhat pedantically, or mock-pedantically, instructed his wife, as he sometimes instructed his mother, on the etiquette of letter writing: the obligation of the correspondent to write in a timely fashion; to provide lively news and interesting observation; and, above all, to respond to the points and queries of his or her partner.

PENNY PRESERVED THE letters, and after her death John took them over. Placed in packets according to their dates, they were then passed on to his daughter Ann.

I have selected a fraction of the complete set of letters, perhaps 10 percent—those that relate most directly to Vachon's experience as a member of the FSA team. Each letter is printed in its entirety, and they provide as much information in their incidental observations about life on the road, which document the changing culture, as in their direct comments on his work. None of the letters were dated, but almost all of them were preserved in their original envelopes (figure 21), which allows for fairly reliable dating. For each letter, I have used the date stamped on the envelope by the post office.

All but a few were handwritten, the others typed. Of the handwritten ones, virtually all were composed on hotel stationery, picked up along the way (and sometimes carried a considerable distance before being used). To make them more readable, I have silently corrected the occasional spelling and punctuation errors, as well as the quirks of Vachon's hasty composition—for example, the omitted apos-

to arrange lights around, or to take time
enough to get at best possible angle, or
even to think it out right. Just blind
shootin'. My score so far is zero, and I've
got my first man half used up. I've got to
put more mastery into this stuff.

Tomorrow I'll go see Mr. DeBrown again. He'll
probably have another guy ready for me.
Just think. A week from today I'll still
be here.

What does old Phil say these days?

Does ann draw any more?

a b c d e f g h i j k l m n o p q r s t u V W X Y

I must go to bed now.
Good night dearest old FART. Keep my love
always before you. ─────────────

FIGURE 22 | Letter from Vachon to Penny, May 19, 1942

trophe in the word *don't*. Where words are deliberately misspelled for effect, I have left them alone. Many of the letters contain scripted flourishes, especially in the valediction, that do not reproduce in type. Vachon had taken art lessons and remained a habitual cartoonist throughout his life. Throughout the letters are scattered drawings, cartoons, and other marks and signs of Vachon's wit and imagination as he tries to amplify a verbal description by an illustration of landscape or housing, or simply bursts into drawings out of sheer playfulness. In one instance, he writes the entire alphabet and draws arrows to *p* and *q*. "Watch these," he adds (figure 22).

Except where noted, letters from 1936 to November 1938 are addressed to 3809 Alton Place, N.W., Washington, D.C.; in March 1939 the Vachons moved to Greenbelt, Maryland, and letters were then sent to Box 448, Greenbelt, Maryland; from October 1942 to September 1943, they are addressed to 3G Eastway, Greenbelt, Maryland.

DECEMBER 22, 1936
Saint Paul, Minn.

The Archbishop's Tomb
Midnight

Very dearest & best beloved of all things in the world:

Sine qua non of life:

Dear Penny:

That I love you, that I shall never cease to love you, that I think of nothing but you, and that your hand was in the pocket of each of the 64 overcoats my mother made me try on today, indicate, I think, that I love you.

I am being un-Greek. Am I spilling over? It is late, you know, it is really 2:15 C.S.T., Tuesday morning. I have had two more letters from you. Some things have begun to happen since I wrote earlier today. I see now that I can have no thought of finishing, or even saying anything definite in this. I am up out of bed to do it, not as an afterthought, but as a planned procedure after an alien crowded evening. I lay abed abit athinking of all I wanted to say, and it raveled on into such complexities, and into such bulk, that tonight I shall say nothing but that there is a hell of a lot to say.

The Court at Versailles in the time of Louis XVI
Several days later

Well, my dear, it is noon again. I haven't yet had the opportunity to write you in solitude. My brother is omnipresent and shattering. Being home is by no means the simple clear and crystalline thing I had wanted it to be. So many people I must see, and all that stuff. In fact I'm booked solid from 3 PM today until Christmas Even. I have stood again upon my native soil, I have embraced my mother, I have clasped my father by the hand, layed my hand upon the head of my brother, and seen again my aging grandmother. Now restlessness sets in, and one would be back in the same city with one's Millicent.

But let me tell you passing things: My Mother Aided and hampered me in the selection of an overcoat until now it has simmered down to two to be sent out on approval today. Why do I use space telling you that? That is unimportant.

I got home last night about 8:00, to find two letters from you! Holding them violent hearted and unopened, I was called to the telephone. Kennedy! I'll be damned,— And there with your two unopened letters I stood talking to Bill for half an hour. Sadism of the exquisitest, that. Tolstoi, to pleasantly torture and discipline himself, used to carry letters unopened for several days. He, Kennedy, got in yesterday. He has the book with him, and mighty fine words to say—our reader has gone thru it again; it is attaining. I shall discuss it over the cups with him this afternoon. Watch for it at your local bookdealers, or if he can not furnish you with a copy write us directly! (no stamps)

Then Jim called. I have told you of him? He is the boy who has left Remington Rand, who is coming perhaps to Washington with me, who will share a perhaps apartment with me, whom I shall also see this afternoon and tonight. It will take you a few days to appreciate this boy—he's a great chested, warm hearted, sensual lipped, akin-witted companionable mind to mine, but not one you would necessarily admire. He is the very emblem of humanity, reeking with fine weaknesses and strengths. I shall teach you to appreciate him. But think—an apartment perhaps! (I also owe this guy money.)

Then I called Dan, to terminate my triumvirate. He is the wealthy-soap-manufacturers-self-made-man's son, you know. The boy with whom as a youth I got my training among Swedish girls. He I shall see Thursday at 5:00 PM. Wednesday is booked with relatives.

You know I thought I had a lot to tell you in telling you that, but I've really told you nothing at all, have I?

I shall now take inventory of your letters, answering such questions as you may have asked, discussing such points as you may have brought up for discussion, and commenting upon some of your more spirited observations:

You will note that I ignore the matter of our alleged personal resemblance. I must have more time to think it over. Anyhoo—you know you say you easily forget what I look like. Is it too much to expect to find you, when I come back, with a Narcissus complex?

Your swollen eyelid. I am at a loss. I can't imagine it. But I am so terribly sorry. Please treat it as an interesting function of nature which you don't get a chance to observe every day. They don't hurt, do they?

O. Your tasty collection, or six penny book of miscellany. with moral observations. and illustrations for the younger reader. It is so neat, so span, so spic, it indicates such care in preparation, so nicely neatly pasted down, that I just can't bring myself to read it.

Acknowledgments:
Joke about Lois Adams.
Letter from Roscoe.
Othello.
Ted Lewis among the peanuts.

Also the musical snatches. They have afforded me great pleasure. I will bring back to you a lot of old unused music which has found its way to this house because we have a piano though no virtuoso. I haven't yet been to my river. I will send my next letter to you to old 96? Yes I guess so. You'll be home Thursday night won't you?

See first paragraph,
JFV

DECEMBER 27, 1936
Saint Paul, Minnesota

Saturday night—

You to whom I turn:

What would I rather do tonight or write you a letter? Obviously, nothing. In the face of the fact, my fickle jade, that today's males brought me nothing from you. After six successive days of you in the post box, there comes this gloomy Saturday, this soggy skied end of a week in December. Why have you grown cold and indifferent? Is there someone else? How long have you known this Osbert? O don't think I haven't noticed.

You have been home and back, haven't you? You are working again, aren't you, poor kid? You are perhaps even in your new building. How did You find your familiars? How did your familiars find You? Tell me: about that apartment: You know: girl go New York: leave apartment: You take: tell me.

In letter writing, my dear, the great fault of us—but most especially of you—is excessive individualism. We (You) climb out on separate limbs from that taken by your correspondent. The true letter should take something of its key and spirit from the letter last received from one's opponent. All questions, as any schoolboy could tell you, should be answered. Also all requests. One should not chatter along merrily by one's self with no thought to what has been asked or told one. One should at least say "o, is that so?," as one would in polite conversation. One's letter should, of course, present new ideas and original material, but that not unblended with something of the tone and quality of the last letter received from whomsoeverto one is writing. Now let us take, e.g., the letter in which I asked you to send me a transcription of your curious interpretation of Sweet Sue. Did you send it? Did you explain your failure to send it? Did you so much as mention my request? Let me answer for you. You did not, You did not, and You did not. Perhaps you think to hurl a similar charge at me. First then, remember that I am now writing you a "successive," or "uninterrupted-by-one-from-you" letter. All the spirit of your last letter has already been spent in the one I wrote you last night. "C'est une autre chose," as Virgil (B.C. 70–19) puts it in his fourth eclogue.*

But come, I know you are anxious to hear what I had for breakfast this morning. I had crimson tomato juice from a fresh opened can, brave brown coffee from a fragrant pot, and sparkling marmalade on faintly bronzed toast.

Dear: I miss you. I miss you all the time. I miss so very damned much the seeing of you. So please go to Kresge's or whatever store you said offers that feature, and have your self duplicated for a dime. Then send it to me. I am at present confined to seeing only one side of your face, and that very scantily. Now don't think me a sentimentalist. I only want it as materials for the study I am making of Ten Cent Photography in America.

Since I have been home I have not: seen a show, read a book, visited a hall of paintings, paced my

river paths, gone to the library, played our phonograph, or written President Roosevelt. By the way,—speaking of deep sea fishing reminded me of it—did you know that Gladys Hasty Carol lives a mere stone's throw from us? About a quarter mile up the river in a big red brick house? Yup.

I spent this afternoon very smugly in reading over all the letters I have written to my mother since September 1935. It was most entertaining; just like a journal, only less cheek-burning. I was amazed at a number of things—Great perspective, realization of motives, and analyses of cause and effect one had with reading of one's forgotten writings—as you so accurately put it on one occasion while we were walking through the fish market district. You are mentioned far more often in this last season's letter than I had thought. It is startling. That is why I found my mother so far more aware of you than I thought I had led her to be.

Affection of the mind caused by that which delights; Fondness; strong attachment; Preeminent kindness; Reverential regard; Devoted attachment to one of the opposite sex—

<div align="right">Theogones—</div>

* CF.—A. J. Lovejoy, "An extensive Inquiry Into the Status of the Common House Fly, or Hibiscus Sabdiriffus from Beowolf to Thomas Hardy" [Harvard University Press, 1672] [*JV's note and square brackets*]

JULY 26, 1938
Trenton, New Jersey

11:55 D.S.T.

Drst wf:

Radio in room is playing Summertime. How are you? M. Ballou is a good guy. Hope you are resting a plenty, and getting the sun when it breaks. I certainly am fond of you as you are now.

We took the Newcastle ferry, and that was my 1st crack at a ferry. It was fun. We ate at Elkton, Md. The lousiest meal I have ever ate irregardless. And that 85¢. Whew I was boiled up. Those are about all the events. Except o yes. In Morristown, or maybe Morrisville, Pa. the berry pickers, migrant workers, have gone on a strike because their wages were cut from 20¢ to 15¢ an hour. They are camped out, starving to death, and have appealed to FSA for funds. Ballou just found out about that today, and intends to go there Wednesday. So maybe that means I will have an opportunity to get some grade A photographics. I mean high quality stuff. But more of that later. Tomorrow's story is going to be very dull—even Ballou says so. I'll tell you why when I see you.

In the meantime keep your shirt on, in sound knowledge that I, yr hsbnd Jn, and fthr of yr chld, am up here in Trenton totally in love with you, and being entirely faithful.

<div align="right">Embargoes of true love</div>

OCTOBER 10, 1938
Cincinnati, Ohio

ONE PM

SUNDAY

Dearest wife Millicent—

I awoke at 7 and considered the fact that you were now feeding Sorto, then I went back to sleep till 9.

This writing will be interrupted very soon, I think. I am going to be called for and taken to Greenhills, which is about 15 miles hence.

I will start from the beginning on the assumption that you want to know everything that has happened to me.

When I took a seat in the observation car last night I was right next to the radio, a symphony orchestra was on. But then I went to get my cigarettes and when I got back my seat, and all the other seats were taken. So I went into the men's room and sat, smoked, read the Daily News. A guy came in and said "What's Hugh Johnson got to say?" This guy looked just like Johnson, so I spent 2 or 3 minutes convinced that it was He. Then I sees that this guy is kind of tight. He turns out to be an engineer for US Housing Authority, bound for Houston, Texas, & slum clearing. After a bit he said, thickly "well now that I got your tongue loosened, I'm going to get you a drink." And he came back in a few minutes with a bottle of very good Scotch. I had one medium one out of a paper cup, followed by a paper cup full of water. Then I talked to this guy for a half hour or so, he agreed that he did look like Hugh Johnson. And about 10:30 I upped and went to bed. I guess I slept averagely well, but with alternating heat and cold, waking up, etc. However, I didn't have you and your unborn Sorto to worry about this time. Out the window looked swell all night—a full moon, and very mountainous looking towns. At my 7 o'clock waking things looked wonderful, I began to take imaginary pictures. Lots of corn stalks [*in the MS drawing of corn*] you know?

6:30 PM

Interrupted as I suggested we would be, dear. I spent the afternoon at Greenhills and took about a dozen still shots, houses, community bldg. firehouse & engine, project mgr. etc. Failed to pull slide once during flash picture. But did well enough. Hope to finish all tomorrow.

There is a lot of school spirit here in the form of anti-Greenbelt sentiment. They all speak belittlingly of Greenbelt and all its publicity—Green H beats Green B a mile, they say. Ugh, those awful raspberry and yellow colors on the houses, they say. Our houses are well constructed. This is by far the finest planned community in the U.S. they say.

It isn't as good looking as Greenbelt, this boy says. More variety in types of houses, and fairly rolling country. But no old trees, hundreds of little new ones.

Remind me to tell you about Mr. Fenton, the guy who drove me out. He talked just like Bob Burns. He said very nasty things about niggers, the only thing he has against this city. "Why do you know they can walk right into the same barber shop you and me can?" Then a young Mr. Tucker, sort of nice guy, voiced anti-Negro sentiment. So, you may put down in your book of conclusions: Cincinnatians think they're Southerners.

Cincinnati is hillier than Pittsburgh, guys tell me. It's hillier than hell.

I've got to mail this and go dear gal. I've gotta eat; I've gotta wire Lincoln, after I find out about trains, I've gotta locate the Leica Co. to visit before I leave here, I gotta buy Aqua Velva.

This morning after my bath I went up the Carew Tower, 48th floor for 2 bits. I mastered the city while there. Covington, Ky. & Newport, Ky. are smack across the river. I will try to visit them Tuesday before I leave.

Jim wasn't at the station; I waited for him until the last minute.

I've taken no pictures yet which make my pulse beat fast. Mr. Sharpe, the project mgr. is kind of a drawback, though I think he has the right idea. He doesn't want to give his people a guinea pig complex by photographing families in homes, etc. Prefers that I specialize on community activities, adult education, etc.—things which will start in about 2 weeks. He wants me to stop in on my way back. I'll have to get up at 7 o'clock tomorrow & get a bus to Greenhills—I'll have to stay out there quite late tomorrow night in order to photograph the boy scouts. I might miss mailing a letter tomorrow but I'll try not to.—All my love dear M'cent, to you & yours.

I rode on an inclined railway street car today.

OCTOBER 11, 1938
Cincinnati, Ohio

Noon, Tuesday

my sainted wife:

I got ya lettah this morning. You old dear girl. And now I'm gonna take it on the lamb. I don't know whether I'll have time to get a hair carve or not. I'd like to do the 1:30 train.

I got up about 9 o'clock went down for breakfast and then out to find a haircut, when whoops! Millions of people milling and muttering, mewling and puling, lining the streets for blocks & blocks to watch the parade go by. Cincinnati's Sesquicentennial parade. And me without a camera. So up I scoots to the 10th floor, loads me Leica, and down I am again. First I takes in the post office, reads your lovely letter, sighs for you, and then starts snapping. In short, I spent a very profitable $2\frac{1}{2}$ hours. Really got some good material. I don't know what it is worth to John Citizen who is paying for it, but it pleases me, and was a great deal of fun. Our organization really should be part of the WPA art project. That is my only trouble these days, getting an untroubled and respectable conscience about what I'm

FIGURE 23 | *Watching the Parade Go By,* Cincinnati, Ohio, October 1938

doing. The parade was the nuts. All the school children in town marched, with bands, costumes, etc., militia, etc. clubs, etc. a very long affair. I specialized on the people watching the parade. But the marching children were very touching, all the bright young faces, y'know. First the public schools, then the Catholic schools. There seem to be a lot of Catholic schools in town.

Each school unit carried a banner with its name; some had bands, flags; all the way from very simple to very elaborate. The schools from the poor districts, made up mostly of colored kids (though there seems to be no segregation here) were sort of heart wringing. Poorly dressed brats, tattered banners, no bands. Then the orphanages—some of them with fine looking, uniformed bands, and very nice looking boys & girls.

At the end of the parade there was a speaker's stand, which I couldn't see, but could hear over amplifiers. A voice was booming all over downtown Cincinnati about the future of Cincinnati, and the people of Cincinnati, and the spirit of Cincinnati. It was typical ridiculous stuff in the face of things you saw with your own eyes. And whose should the voice turn out to be but Colonel Sherril's? I smiled to myself, and said softly "I have a wife who used to be librarian for that man." But no one heard and I passed on.

Well I've got to clear out dearest one. What do you mean by: "I wonder if they ever hear you" (snoring) Are you trying to tell me, in my absence, that I snore? Please answer straightforwardly. Do I? Is that what you mean? I do? Why did you hope I didn't put up at the Netherlands Plaza?

My room here is a $2.50 one, but when the clerk found out yesterday that I was a govt. man, he said he would change the rate. Make it $2.00. He said I should always identify myself as govt. Nice, hey? Not all hotels, however, so recognize Uncle Sam.

I'm off my one. My love,

John.

OCTOBER 21, 1938
Concordia, Kansas

Thursday night
9:10

Dearest girl, my girl—

It's very hard to write while traveling; I just haven't been having time. We got to Salina pretty late last night and got your 2 letters and laundry. Tonight I am here, and tomorrow noon we will be back in Lincoln. I'll write you lots of letters over the weekend, and perhaps not so many during the week. I won't be traveling with Mr. Lynn next week, or did I tell you that? I will probably go around with county supervisors and home supervisors—a day with each one.

The photographic days this week have been pretty dull; I'm doing competently what this office wants done, but there is a lot of it that won't have any place in our files. Today, however, was an exception. I encountered a couple of swell families, with fine farms to photo. More damn babies, I'm seeing. I always ask how old they are, and Mr. Lynn always tells about me and my baby, and always says I should show my pictures, which I always do. There was one very cute smiling gooing 7 month old job today—a bald girl. I promised her mother to send her some pictures—my second such promise to a client. Except Mr. Lynn, on whose family I was obliged to shoot up a full Leica roll.

I got my paycheck—Jordan's office sent it down to Salina. I'll cash it in Lincoln and send you a money order for about $25? or maybe it had better be just $20.

Up to and including tonight I am due $60 from the govt. Up to and including tonight's hotel bill, I have spent $50.55, of which, $2.80 I think I can get back, that much having been spent for taxis and flash bulbs. I left Washington with $56.29, and I have $5.75 left. So I've made 1¢ some where along the line.

I haven't heard from Stryker or the office at all, yet. No official report on my negatives. Gerald's garbled account is kind of garbled. Maybe you will get some word from him on the second batch I sent in, and disbatch it to me?

I'm nearly out of film. I sent a telegram yesterday requesting it be sent to Lincoln. I must have some new blood to start Monday.

I'm taking lots & lots of pitchers, more than I ever took in my life before. I going to pare down the negatives very carefully when I get back—all in all I'm going to have a very 1st rate assortment of stuff.

We were in oil fields yesterday, between Yates Center and Newton, Kansas. Lots of those things [*drawing of five oil wells*] you know. No pix of them though, because it clouded and rained most all of yesterday. The landscape, new paragraph, has changed considerably today and yesterday.

It's really the west like you think of it. Rolling plains—[*drawing of wavy line*] all grazing land, & darkish lightish tan-brown—fustian color. This is the land that was wheat farmed and shouldn't have been—Every few miles an abandoned farm [*drawing of farm*] with expensive rusting machinery around it. Outside of Salina about 20 miles there was one of those sudden hills like outside Atlanta. Not so high or steep, but sudden. These rolling lands are really swell. You'll have to see them. It rolls up ahead of you [*drawing of line up*] and you can't see anything but sky ahead, then it rolls down [*drawing of line down*] and you see for miles and miles and miles, etc.

O you played the piano for the boys did you? and you're flattered because they tell you you haven't a 5 & 10 bass, are you? And you like to hear Hurd on my flute do you?

Thanks for the mementos in my laundry bag. Mr. Lynn saw them too. Also the box you sent it all in. He thinks you're a card. I sent home a box of dirty laundry this morning.

I very glad to learn that Sorto is in such fine health, but I must tell you that you are looney, in trying to shift her conception date. I mean I won't have it. I like Nov. 20. I like what we did that night.

I went to a movie Tuesday night in Burlington—Laurel and Hardy in Blockheads. The movie house was very old style small town—they even had colored slides saying "Welcome," & advertising things.

I look for a sheaf of mail from you, my wife, tomorrow.

Good night, m'love—
yr. gd. ld. Jn.

OCTOBER 23, 1938
Nebraska City, Nebraska

Sunday night
7:15 PM

Dearest Millicent—

Here I am writing to you again. That certainly was a long one last night, wasn't it? After finishing up on you, I went out and ate big as I agreed to—thick steak, etc. Then I went to my nightly double feature. John Boles in Sinners in Paradise and C. Aubrey Smith, Loretta Young, Basil Rathbone, Alan

Hale, and all those people we like in 4 Men and a Prayer, which was just swell. Good old intrigue in the best 39 Steps tradition. I bristled with enjoyment.

So this morning I read your second special del. with my breakfast, bought an Omaha World Herald (In Omaha, I see by the papers, they have Triple Features) and bought a LIFE, as you suggested. Came up stairs and read them both. Went to 12 o'clock Mass at Cathedral, came back, read a little, wrote a letter to Baker, sent him Sorto's yawning picture, went out for dinner, and went to another movie. This time, Algiers. Hedy is a very beautiful little sweetmeat, won't you agree with me? And now I'm back here. When I finish up I shall read C. Sandburg, and go to bed early. I'll have to get up about 7:30.

I have rethought out the financial situation. Would this method be OK—I mean I think it would be better: I'll hang on to all of this $60—because I wouldn't be safe on just $40 until my next check came. You pay the rent, cash Craig's check and live on that, not paying any Woodward bill until the 4th or 5th, when I'll money order back to you my Nov. 1 check. Hell I guess I hadn't thought it out so well. That doesn't read right. You'll probably need some more dough around the 1st, because Craig won't send his checks promptly, probably. But I'll only send you $10. I'll get a money order for that tomorrow and mail it with this. If then, I can send home to you the whole of my Nov. 1 check, and I shall try devilishly hard to do so, I shall have spent $106.29 on this trip, a profit of $43.71.

450—53.00 ///////////// [*a random jotting*]

But computation shows me that's silly. I won't be able to send home the whole 60. I'll probably have to keep at least 20.00. So our profit goes down to 23.71.

Say I guess I'd better write to Ethel tonight. Get that out of the way, hey?

I'd like you to send me a few more sets of sox to genl. del. in Omaha, if you will. It seemed very few that you sent to Salina.

The Omaha World Herald last Sunday had an uproarious front photo page entitled Margaret Bourke White photographs Omaha—about 10 pictures of Miss White in action, with very funny captions—about how 6 sea scouts carried equipment and replaced bulbs for her, about how fast she used up film, and about the characteristic squint in her left eye. It was funny enough to have been satire, but it wasn't. I sent it to Stryker.[1]

I don't think you should have shown Mrs. Denton any drawings, or Mrs. Pearson, either.

Why should you keep any life insurance, Penny? You shouldn't, I wish you wouldn't. I'm the one who should have it, and I will get it, that is a small piece, in just a short while, in a few months. so abandon your idea and sit down patiently.

Tell me in a forthcoming letter all about what the Dr. Martel says about you.

I'm afraid I won't be able to wire you any addresses for next week. Wed Thurs and Fri will continue to be indefinite up to the last minute. it is agreed, isn't it, that you'll write me at Lincoln Hotel? marking PLEASE HOLD?

Counting my letters from you I find I have eleven.

How's your weight, tell me Penny. and your figure?

[*drawing of heavy female profile and thin female profile*]

Penny gal, remember the letter I wrote you with all the sex in it? That was good stuff at the time, I felt like that, but it was awfully unwise in the event that you didn't feel that way, at the time. And it probably sounded kind of crude and silly. And if I should ever read it it would sound awful, and not make me feel good. so will you destroy it, please? Overcome what I think is your reluctance to destroying it, and destroy it.

I think Penny dear wf., that we still have the trouble I used to write to you about at Xmas in St. Paul, '36. You don't seem to answer my letters much. Always just writing on a separate tangent. But I suppose I do the same thing. Can't we overcome it? and really co re spond with each other?

You don't know how I think about you and lie in bed thinking about you near me, and how I find you related to every good thought I have and everything good that happens to me. Also you don't know about how my libido, or young animal, is up a great deal of the time, and how I look at other gals who aren't you. I want you to know all about everything, how things are not just simple. And when I see you I want to try to talk about everything that I'm unable to write about, and really give you the slant I have. So if I don't do that, if I drop back into a rut of just living in the same apt. with you and not living with you, please make me come forth. Because I've really got things to tell you, both facts and ideas.

Please dear, love me very hard, and know that when I say I want to hold you in my arms, which is the best thing I can think to say, that I want to hold every bit of you in my arms, you ever since you were born up to now, because I love all of that. I also love your lips and want to kiss them. All the times that I could have moved my lips just a few inches and touched yours, and now I can move them all over the place and not find yours. Penny Penny. J. F. Vachon

OCTOBER 26, 1938
Lincoln, Nebraska

Wednesday
4:00 PM

My own sweet wife—

I have had a very hectic frantic panic afternoon. Whew is the word for it. I got in here at 1:30 by bus—I was aboard a bus marked "Los Angeles." I left this morning from York. Well I walks from the bus stop to the hotel, about two blocks. This town is pretty small—2,000. At the hotel I wash, change my shirt, and prepare to go visit a Mr. Sykes, in the FSA office.

So I open my bag to get the camera. And what do I find? A box of Kotex, several dresses and un-

derpretties. Obviously not my bag. I went back to the bus agent and weeping copiously told him my story. Then, acting under his advice, I phoned ahead to North Platte, and sobbed my confused story to the North Platte agent. You see I had to change busses once this morning, and I had a hunch my bag was left on the first one, which was going to Montana. So I waited fearfully and nervously in the bus office for $1\frac{1}{2}$ hours. Then the agent called back and said OK. They got my bag. So if I go up there at 8 o'clock tonight they will have sent it back to me. It contained all my bulbs, exposure meter, all my film, and Speed Graphic. So I was nervous. What's more, it knocked out an afternoon's work, and I'll have to work here tomorrow morning before going on. And what is even more, the telephone call cost 75¢, just when I am beginning to save money by having $1.00 rooms in hotels.

I haven't done a lick of work, I mean photographing, all week. And the days have been phenomenally (everyone says) warm and fair. So I'll no doubt run into snow tomorrow.

I drove from Lincoln to York yesterday with a Mr. Leonard. Yesterday afternoon I took 8 shots of a group meeting of farmers and wives drawing up farm and home plans with the county supervisor and the home supervisor. The meeting was interesting as hell; I learned a lot, and hope I'll be able to impart some of it to you when I get home—all about why there's no money in wheat, etc. I've become really convinced of this rehabilitation program. It's a very fundamental thing, doing great good—no shallow little experiment like your Irwinville Farms. I didn't know before that rehabilitation is the major work of FSA all over the country.

The county supervisor at York is a swell young guy named Norton, with a wife and baby (6 mo.) girl. So we compared notes. His kid really was very pretty. This guy Norton may be a little idealized, but still he is a typical example of what county supervisors are like. He was brought up on a farm, and had 2 yrs. in an Ag. College. He's got intelligence. So he helps all the farmers in the county on their farm problems—including non FSA clients—he is sort of a public service of the govt., bringing down to the little farmer the stuff learned by the Dept. of Agri. and things taught in Agricultural colleges. And it is quite a sight to see him telling a half dozen old farmers, guys who've been farming all their lives, how to do it. They argue things out with him, and he convinces them.

So last night I went to a double feature. Garden of the Moon—Pat O'Brien very funny in it. I Am the Law not so much.

This morning I rode from York to Grand Island on the bus with a kid returning from the Lincoln Reformatory. We got quite chummy, I'll show you his picture. He smokes and drinks beer now. Says he didn't do either of those things when he went in. Football is his passion.

Then from Grand Island to Lexington, I rode with a girl whom I had to put my arm around, because there were 6 people on the back seat. She was coming from Kenosha, Wisc. and going all the way to L.A. She loves to dance.

So that takes us to the present. I won't be able to go to a movie tonight because they're showing that awful Boy's Town. I am to leave with Mr. Sykes at 8 o'clock tomorrow and go up in the "hill coun-

try," he called it, northwest of here. Here we are in the Platte Valley. I shall try to finish up tomorrow, and take the 1:51 bus to North Platte, where they have Mountain Time, and what's more, I saw Missouri Monday, from across the Missouri River. But I don't suppose you will let me count it, you cheat. I'll work out of North Platte Friday, and Saturday morning, then I'll hop back to Lincoln for the dance Saturday night, and a nest of mail from you I hope.

In a few days will you call up Toots? and ask her to send my Oct. 31 check to General Delivery in Omaha?

Dear I am collecting a swell collection of road maps. But I'm anxious to hear from you. And let Sorto look at my picture for a few hours. Or let her chew on one.

<div style="text-align:right">

XXXXXXXXX [*drawings of hearts*]
XXXXXXXXX Love,
XXXXXXXXX John.

</div>

OCTOBER 27, 1938
North Platte, Nebraska

Thursday—5:00 PM

Penny Dear—

This goddam hotel ought to be reported to the Amalgamated Ass'n of Hotel Operators. It is a gyp joint, & opportunist, & booster of rates. There are two very fine hotels, modern, etc. in town, whose rates are $1.50 without and $2.00 with bath. This dump down by the railroad tracks advertises $1 up. So there's a state teachers convention in town with 1400 young Nebraskan teachers at it. And out of both hotels I was turned out. No room. So here they say they can give me a single for $2. Obviously a $1 room—and not very clean. No bath, no soap—no good. So I had to take it. I have a room reserved though, for tomorrow night, at the Pawnee Hotel, for $1.50. But all this talk about hotels.

This is really getting into genuine West, Penny. I will be a cowboy story addict when I get home. This morning I saw real cowboys, leading, or whatever you call it, 250 fine head of Hereford down the highway. I got pictures of them, and of cattle, and close ups of brands, and just oodles of things.

Did I tell you yesterday about the country around here? Maybe I did, but I'll repeat—how all these towns—Grand Island, Lexington, North Platte are on the river Platte, and in the so called Platte Valley—and 5 miles either north or south commences the hills. In the north it's Nebraska's famed sand hills.

[*map drawing of river, towns, and hills*]

In the valley the farms are prosperous, very. Lexington is the largest alfalfa center in the world. Then the contrast is sudden, because the hilly land should be grazing country exclusively, but not all of it is. And the farms are very poverty strick. Most of the rehabilitation clients in these counties are

FIGURE 24 | *Cowboys and Cattle,* Dawson County, Nebraska, October 1938

from the hills, and they try to get them out of there, but it is slow work. This morning I got pictures of power raking of alfalfa, quite a thing, the cowboys and cattle, general views of hilly grazing land with barbed wire, and a $600 stallion, a cooperatively owned beast bought with FSA funds, who breeds horses for people. He weighs over a ton, and such a big handsome snorting whiffing animal you never did see. He scared me every time he looked my way. Last year he bred 64 mules. He is 4 yrs old, and good for 6 more years, Mr. Sykes says. Virgil Sykes was my county supervisor in Lexington.

I got my camera back OK last night, in case you're worried.

Mr. Kovall is the county supervisor here. I've just come from seeing him, and we're going out to spend the day tomorrow. I gotta be good tomorrow, it's my last day in the country.

I'm kind of not liking to turn back, now that I'm this far. I'd like to go on and see more west. But we're going to do that, me and you, see.

I went to bed at 8:30 last night, quite tired, but couldn't sleep worth a 2¢ piece all night. I'm going to sleep some as soon as I finish this.

I like this town a lot, on first sight. It's about 12,000—the size of Annapolis, to you. Very booming looking—lots of guys on the streets with big western hats, and girls in pants and red shirts. Also, you can buy liquor by the drink here. This is the first place I've been in Nebraska that offered that service. I had thought it was a state law. This town is located where the North Platte and South Platte Rivers join. So after I wake up I am going to go out and feel the town's pulse. With those sox to Omaha, Pen, you might send one (1) extra shirt—preferably dark.

<div style="text-align: right">

My love to you.

J.F.V.

</div>

Will you find out, my bird, and mention to me in a letter—whether the office received my 3rd batch of film, which I sent in two packages—uninsured—a most important batch, will you?

OCTOBER 29, 1938
North Platte, Nebraska

Friday night—

My love life:

Holy Saint Swithen I am tired. I shall perhaps fall to sleep in the process of this letter.

Today I saw Buffalo Bill's ranch. This was his home town. Mr. Covall, my county supervisor knew him. It was a cloudy day, today, and I had very poor picture taking. In fact nothing of my whole day's work will LIVE. But wait'll I tell ya about last night.

Last night I had a nadventure. Of the 1st water.

To have it I had to get kind of stiff. And I did, dear. Pretty plastered. But it was all in the line of duty, eminently legitimate and justifiable. About 8 o'clock I went into a corner saloon. It was a saloon in the grand tradition. I drank only beer, but great gobs of it. At the piano was a big huge large fat blonde woman of 45 to 50 yrs. With beautiful smeary red make up on her puss, and huge mammy type bosoms. And her voice, O that you could hear her voice. She has Sophie Tucker in the waste basket. Her piano was good honky tonk, back and forth stuff like I could never seem to make you do. The customers fed her kitty, and requested nasty songs that she knew.—one called "I wish I was a Fascinatin' Bitch" all about a girl who wanted to be a prostitute. And another about her man—pretty double entendre and dirty. All the others were legitimate—Some of these Days, After You've Gone, Blue Skies, etc. So I get the idea. I'll photograph this gal, I say to myself. So I gave her a half a buck—that warmed her—and asked her to sing Nobody's Sweetheart. She did it. Then I got chummy with her, had her calling me honey, and asks about taking her picture. Of course she would be very happy to. So I rushes up to the hotel, brings back 6 flash bulbs,—had more beer, and 6 pictures. Of her at the piano, of the leering boys at the bar listening to nasty songs, of old broken down cow punchers in the booths, of Gus, or Wes Farrell, the champion billiard player in America. Then I flashed back to the hotel and

FIGURE 25 | *Mildred Irwin, Entertainer in Saloon in North Platte, Nebraska. She Entertained for Twenty Years in Omaha before Coming to North Platte.* October 1938

got 6 more bulbs, which I used up quick, perhaps not focusing so well as on the 1st 6. But wonderful subject matter. And then I'm damned if I didn't go back after 2 more. Which made 14 in all—and I woke up this morning with only 8 bulbs left. I really must have some swell stuff though. Mildred was the gal's name. Mildred took a great personal interest in me. I took at least 6 shots of her alone. And I fulfilled my life long ambition—to sing in a saloon, when I was a boy. You should have heard me— how good I was. Mildred has only been here 2 weeks, she just came from a 19 year booking in Om- aha, and she told me all about its vices. So now I've got a head start on my Omaha story, the record of an ex-Omaha fille de joie. I got rooked a bit on the dough angle—about three bucks I got rid of in the joint. But need I emphasize, it was worth it?

After the place closed Mildred wanted me to take her out to a night club outside of town, with some friends we had picked up. So then I drew the line. That's just about all on that adventure. Ex- cept that I got awful little sleep and had a bad head and unsteady stomach all morning.

But I should go back there tonight, get more facts from Mildred, go up into her room—(she lives

in the hotel next door) photograph her there, get pictures of her wardrobe, her bureau drawers, etc. Then, I'm sure, I'd have something I could sell, with a little story. However I don't feel capable of all that tonight.

This town is really swell. I wish I could stay here longer. It has some very good places to eat—the kind you just never find in small towns usually.

There is a young new married couple—just a few days, I should judge—in the room next to mine. I can hear every word they say, if I listen. We must watch that in hotels, dear.

I sleep late tomorrow. Leave for Lincoln about noon. And I will be so damn glad to get my mail from you.

<div style="text-align:right">

Love, Penny.

Jawn.

</div>

OCTOBER 31, 1938
Omaha, Nebraska

Sunday night
9 bells

Sweet stuff—

They don't leave me much room for writing on this paper, do they?[2] I got here, you see. I pay $2.50 for this room, with a bath, that is a shower. And what a long shower I did have, 45 minutes of it. I was kind of dirty. It's a great pleasure to be in a room with your own bath and can again.

Let me see. I wrote you last on Saturday morning. After writing I took a few pictures around North Platte, but spent most of the morning reading LIFE, in my room. At 1:55 I left; didn't get to Lincoln until 7 o'clock. Traveled part way on the oldest coach in America, drawn by a gas-electric engine, the Lincoln Local, which stopped every five minutes. When I got to Lincoln everyone was feeling bad and getting drunk. It was homecoming; Nebraska had lost her 4th consecutive game—to Missouri. The hotel really was a bedlam of bad manners and debauchery. I called Mr. Lynn and he told me that the Hallowe'en party had been held the night before. Wasn't that dumb? I had really looked forward to it. So instead I went out to his house and played Chinese Checkers with Mr. and Mrs. L. About 10:30 Mr. L took me back downtown; we went in and had 2 glasses of beer each, then said a sentimental goodbye. He had another big batch of film for me from the office. I now have more than I can probably use.

This morning I slept late, went to 12 o'clock Mass, where I did a lot of thinking about you, and me, our problems and pleasures. I'm finding church, with the soft drone of coughs in Latin a very good place to think about you and me.

After church I tried to get a picture of the state capitol—I wanted a straight shot, not seen over

FIGURE 26 | *State Capitol, Lincoln, Nebraska*, October 1938

slum roofs, or through the legs of a camel—but I couldn't find one. Everyplace there was a house or a lot of trees in the way. But I think I did do something rather good—a well composed shot of the handsome skyscraper tower with barbed wire in the foreground [*drawing of same*] which was not just cute, but rather meaningful and seriously symbolic; barbed wire being the most permanent and vital thing in the state.

Then I left Lincoln, kind of feeling that I would miss it.

Did I ever tell you that Lincoln has numbered and lettered streets like Washington? [*drawing of street grid*]

I was pulled in here about 3:15, came directly to the hotel, took my long long bath, went out to dinner and to a movie. Double bill of Frankenstein and Dracula—I hadn't seen a movie since last Tuesday night, dear.

Here are the results of the figuring I did on the train between Lincoln and Omaha: Up to and including midnight tonight I have been gone 22 days, for which I have received $110.00 up to and including tonight's hotel bill I have spent $91.15. In the following manner:

3.00—transportation—taxis, street cars

5.05—tips

35.38—food and drink (includes all beers and liquors)

7.25—miscellaneous—drugs, papers, magazines, telephone calls, underwear, etc.

2.61—postage

2.53—movies

33.50—hotels

1.88—tobacco

91.20 Somewhere there is 5¢ unaccounted for.

We have then the following averages—(approximate)

.15 a day transportation

.23—tips

1.64—food and drink

.26—miscellaneous

.12—postage

.11—movies

1.54—hotels

.09—tobacco

4.14

Omaha seems to have lots of hotels—many more than St. Paul. I don't like the looks of the Hotel Keen, and I don't think I'll go there. But there is a Hotel Wellington that I've got my eye on. It looks pretty good—advertises $1.25–$2.50, and has a very good place to eat, where I got a swell meal for 55¢, which restaurant has huge photo murals of Omaha which will give me some ideas. But you address me Gen'l Delivery until I say different.

This city looked much more inviting to the photographer in me as I entered it this afternoon—there was a nice light, and I saw dozens of things I would like to get. It looked, and still seems much bigger than St. Paul, though its population is some 50,000 less.

I will spend at least all day tomorrow exploring, studying a map, making notes. It's funny how I get excited and apprehensive at the prospect of what I'm to do here—ideas keep popping into my head and going away, like how I'll manage to get into people's houses and stores, what I'll tell people I'm doing, and what I'm doing it for. I'm really going to plan it and do it systematically.

I don't know whether you've gotten the idea or not, but I'm feeling awful good about everything I've done so far on this trip—I think I have a big batch of 1st rate stuff, and I feel myself getting better all the time—more confident, better able to handle people, and having better ideas pop more often. I know that this is the kind of talk you dislike, or shy away from—you must always see the actual product before you will countenance confidence—and then you say "Ah but John you might have done

even better." You're funny, Penny. It's funny getting your angle on things, too. This morning, in church I prayed—that is not exactly prayed, but meditated on the subject of my wanting to become the big bag of male virtues that you would want me to be, because of you, or because you wanted me to. But you would always be contemptuous of such a motive. At least I now automatically think of you as saying "No NAY. Not because I want you to be." You are really odd on your motives, never quite clear, but always suspect of mine. Do you know what I mean? I think you have a high but undefined idea of the most honorable motive or ideal in life, which you ought to translate down to our mutual experiences.

You aren't quite right Penny in what you say in your letter about my ability to see you and hold you when you aren't with me. Maybe I said something to make you think that—but there is a great lot of you that gets strange and hard to get a hold of when I'm away from you. Of course your face isn't a total blank when I go to look for it (I don't believe mine is quite that with you either) I can see general outlines and a few smiles, but I do lose the reacting you which I know best.

I'll try hard to say things here that may not go across: I have a hell of a lot of respect and admiration for you, practically amounting to hero worship. I honestly think and often want to tell you that you are good, unselfish, etc. You are better than most people. You are the best person as a person I have ever known. I'm trying not to use superlatives, but that's what I mean. That all says it badly, but it does say it—when I try to get that idea to you in person you always poo poo, either lightly or seriously, so that it never gets to you. Now will you let it sink in—that I, sane, know you to be an essentially superior, good person, much more essentially good than I am. OK. I think you love me more blindly than I do you, that is with less reason. Sometimes I feel bad at the thought that maybe I love you more—in quantity, if there is such a thing—than you do me. But I can also feel that that is the way it should be, and that I should spend all my spare time making myself more capable of being loved.

Hell frau, this is goofy. The trouble isn't with my thinking, its the interval and my unadeptness with the materials of transmission.

But we should know each other better—when together talk more vitally. I guess I don't mean that we should talk this personal twaddle about ourselves—that always gets us messy, and anyone can do that. But if we'd talk about important things, the fundamentals—depersonalized religion or philosophy, why we'd undoubtedly get to better more satisfactory understanding and acceptance of ourselves. I need more satisfaction, dammit.

I'll bet this letter sounds more like an 18th century homily than any you've had since you stopped corresponding with Benedict VI.

How about my telling you this: I am very humble before you, want to be. I recall and resent in our relationship what you have called a "high and mighty" attitude on my part. And you have so often had to do the humbling thing in our little huffs and tiffs. And that is what is stupid and an outrage, as it should always have been me.

Don't, Penny, answer or talk about any of this stuff in this letter,—that is don't think that I want us to get into this style of correspondence. Your 2 terrific big letters last night at Lincoln—they took me nearly an hour to read—and that part about Sorto's smiling and gooing got me in the heart with a loud bang.

I'll have to stop this letter without covering any of the stuff I'd intended to. I've got so damn much else to say. Let me take up our birth controlling problems in tomorrow night's letter. And don't worry about it mean while. And don't worry about frigidity, or you might catch it, and don't tell me that it doesn't bother you, but I'm male. And please be female.

Or don't I know anything about sex? I so much want you to want me. Like you have wanted on any of several past occasions. Tell me a little about this. And O yes I had another liquid dream last night.

Now I'm going to bed, but first I'm going to re-read the letter I got from you today, and you should know how I'm anticipating that re-reading, with a pleasure and sexy feeling, because I remember I liked it a lot this afternoon. So good night, you and Sorto.

<div align="right">John.</div>

NOVEMBER 5, 1938
Omaha, Nebraska

Saturday—4:45 PM

Dear Millicent:

I've done a plenty hard and honest day's work, if not a very good one. It has continued dark out, and quite cold. Tomorrow's forecast is continued cloudy, colder, and light snows. It's very damn discouraging. This morning I whipped the Speed Graphic out, irregardless. Walked around downtown and took dark pictures of the city hall, etc. Then this afternoon I went south again, south of the stockyards even—discovered many more good places to go and photograph—but couldn't let myself take more than half a dozen Leica shots.

Last night I drew up a long elaborate shooting script of what to photograph in this town—I've really got a good line on it—I intended to start with page one today no matter what the weather—But it just seems wasteful to shoot, it's so far from what I want. Tonight I have a date with a bartender to photograph the very scrolled and ornate bar in his joint. It is the bar which was formerly in the famous Budweiser Saloon, mentioned by Leighton in his article. I'm going to use 3 flash bulbs in that place, which will leave me 4.

Today I went by a 7th Day Adventist Church where some dressed up young children were standing on the steps. A group of not dressed up children passed by and shouted "yah yah, ya go to mass on Saturday."

I think I will call up Mrs. Weber tomorrow about 6:30, so she can't invite me for dinner, and go out to see her tomorrow night.

Last night I saw Judy Garland in Listen Darling. As you've noted I really do like her a lot, I think she's swell. You must surely see this picture, Alan Hale, Mary Astor, too. And whether you like it or not, her voice reminds me of your voice. On the stage was a Creighton football rally. Creighton is a co-educational school, I didn't know. The band played all popular college songs, very enthusiastically, the coach was introduced, a college swing quartet played, the cheerleaders led cheers, and the football team all went up on the stage. It was very interesting, and contagious. The sort of thing you feel an outsider of, but that you could so easily be part of.

Please write to me soon and often, dear Penny.

John F.

NOVEMBER 6, 1938
Omaha, Nebraska

Saturday night—9:45

Dear Penny—

Yes I got the sox, several days ago, thanx. I washed out 4 pair tonight. They go very fast in this wet weather underfoot. But O this last shirt is getting well worn—I'd like 2 more, or have I told you.

Look at me, I didn't go to a movie tonight. I rigged up my camera with flash about 8:00 o'clock and started out—it was snowing thick, so I came back and put the camera in case and started out again, for the bar I told you of. I didn't do so well. The first shot went bad, I don't know why, but the shutter didn't trip. There were lots of swell pictures there, and the bartender was on my side, but there were also lots of drunks, and one very tough guy who kept telling me he was going to bust my goddamed jaw. The bartender told me to pay no attention to him. But I was a little heart poundy, and I took my two remaining shots in pretty much haste, and without very good figures in front of my lens. So then I bought a LIFE and came up to my room and have just finished reading it.

I got your special tonight as I went down to dinner. I'm sorry that you missed a letter Friday. I think the airplanes must be off schedule, because we've both been missing.

It is still snowing. I'll get some nice snowy pictures tomorrow, and finish this letter before I go to see Mrs. Weber.

11:30

I have been out for a chocolate soda, drawn the enclosed pictures, and read Carl Sandburg. Now I am practically in bed. Good night.

Good morning dear wife and daughter. It is snowing big handsome flakes out of the window. I don't know what about, but I feel good this morning, sang all thru my ablutions. It's kind of Christmasy here.

I had two beautiful dreams last night of finding places to photograph, quite surrealistic places, with direct yellow sun light on them, about 4:30 PM sun. All I could see was the light which I practically embraced. And then, closer toward morning, of all things to have, I had a wet dream, which would be too long in the telling here.

Now I am off to breakfast.

11:00 AM

I am back after breakfast and your hasty letter of Saturday. And now I shall shuffle off to church. The weather forecast says generally fair and not so cold, tomorrow.

Your devoted male.

NOVEMBER 7, 1938
Omaha, Nebraska

Sunday—5:20

Dear Penny—

The sun is now setting, nice and red, so I hope for tomorrow. I didn't take any pictures today. I went to a movie. Mars Attacks the Earth with Flash Gordon, and Magnificent Obsession. I'd never seen that, and expected big things of it. I couldn't like it very much.

I've just called up the Weber residence, and kind of bungled things. Mrs. Weber wasn't there, and I thought the girl I was talking to was the maid—so when she said she was Don's sister I said I didn't know he had a sister, which didn't make me sound much like a friend of Don's. However, Mrs. W. will be in about 8, and I'm going out there. I hope I am able to keep conversation going pleasantly for a few hours, and that I can mention Don a few times.

Penny I can't think of anything these days except that I love you and would want to be with you. I'm waiting for an answer from you to take away my uncertainties.

6:40

I've just learned that the name of the thing I've been whistling these past few weeks is the Lambeth Walk.

Have had a very fine chicken dinner for 65¢—good meals are so much cheaper in this town than in Wash. 1st rate steak etc. dinners for 65¢.

I'm all shaved and combed, and am putting on a good front with my dirty shirt for Mrs. and Miss Weber.

I so damn much want to write to you, not held back, and I feel so very held back, with you not even having received that letter from me yet, and then tomorrow when you get it, and are shocked or made to feel very bad—I don't know what your new reaction to me is going to be. Now I don't feel so much remorse for any particular acts, but great sorrow for an attitude I let myself slip into. Please Please forgive me that.

I'll finish this letter tonight when I get back from the Webers.

12:30 AM

Dear Spinach—here I am back from the Webers, just as good as ever. It's a wondrous beautiful night out, esp. out in the residential section—bright moon and lots of stars, numerous white clouds steering around, white snow all over everything—good bright dry cold—everything is so light that I had an awful time trying to find a dark alley for a urination after I left the Webers.

I'm very glad I went out there, had a nice homey evening. Don's sister was not a Mrs. Weber, but a Mrs. Someone that has just moved in with her husband and 2 very young kids—2 and 3—on her mother. It was amazing how I could talk on about Don as though I'd known him from infancy. Every little anecdote that I could muster up or make up about him pleased Mrs. W. to pieces. She was surprisingly old—she looks like and reminds me quite a bit of my grandmother. Don is the youngest of the family, the sister the oldest. 1 brother working for Doubleday Doran in New York, another studying for Episcopalian Ministry in Ohio. You can get to know and appreciate someone so much better, I mean so well, by such a visit to his family. With all the little details I've picked up about Don's youth I now feel as though I know him very well. He comes from much humbler surroundings than I had imagined—I somehow got the idea that they lived in a great big house and were of the 1st family order, but no. I like Mrs. W. quite a bit, not so much the sister. Mrs. W. is now in a typical old age plight, not so pleasant—evidently she would like the idea of moving to Washington, but evidently Don has lessened some of his warmth for the plan. She can't happily decide on just what she should do. I was surprised to find that Don is half a year younger than I. Tell him that his mother's teeth are in now, and she looks just like she always did in them, and that she has recovered from her stiffness, gets around well, and is in general good health.

The enclosed page of newspaper is to show you how homely some people's kids are. I showed Mrs. W. the few unchoice pictures of Sorto I have left.

Well. I may append a few lines to this in the bright sunny morning. Betimes, good night, dear Millicent, and think kindly of me.

10:00 AM

This morning is more grey and sullen than any since I've been in this damned stupid town.

FIGURE 27 | *Lower Douglas Street,* Omaha, Nebraska, November 1938

12:00 noon

No letter from ya yet today. I've spent the morning down on lower Douglas St., which as you no doubt know is the hobo district of Omaha. I used the Speed Graphic, took 9 shots, all of them mercy killings. It is terribly cold and hard on the manipulating fingers, hence you may detect a slight stiffness in this writing. I've run into an awful lot of opposition in taking pictures of bums on the street, people in front of joint, etc. Last night Mrs. W. told me the reason for that. Omaha has only one paper, the World Herald, a Tory sheet, which has been carrying on a vice crusade, exposing gambling and prostitution etc. with photographs. So everyone hates the World Herald and its photographers. Several people have accused me of being a World Herald man, and wouldn't take no for an answer.

This morning 2 plainclothesmen stopped me and questioned me in great detail, without, of course, identifying themselves. They let me get pretty mad, and then pulled out a badge. Said they were looking for someone who answered my description, but I didn't have a gold tooth in front, so I'm all right.

O how I long for the warm sunny Arcadian days of Kansas, and several letters from you.

5:30 PM

I am home from an intensive afternoon's work to no letter from ya. No laundry either.

The sun came out about 3:30 this afternoon, when I was over in Council Bluffs, Io. Where I would have wanted to be for the occasion is south Omaha. But I took 2 dozen Speed Graphic shots this afternoon. My last two shots were the first since I've been in Omaha which I think of as good. They were of 2 very old pathetic looking bums.

After I got across the toll bridge into Iowa I saw about 6 guys come out of a restaurant, then a few seconds later I saw that they were holding bricks in their hands, then as it was gradually dawning on me what was up they let the bricks fly, through the windows of a truck that was coming across the bridge. 2 guys in a car that followed the truck hollered something to them and they tossed bricks thru the car windows. Then both truck and car started to move ahead fast and 5 of the boys jumped into a car and followed. I got pretty excited during it, I fumbled with my camera but it all happened so fast that I didn't get to it. But it's just as well. I'd have probably been bricked. I started to ask questions of the one fellow who stayed behind but he just said "I don't know what you're talking about." Then when I persisted, and said I was a stranger here he said "Yeh, a stranger from the World Herald."

I'm very hot from the cold. I would certainly have liked a letter from you today but since there is none I shall mail this.

<div style="text-align: right">

husband and father,

JFV

</div>

APRIL 16, 1940
Dubuque, Iowa

Tuesday 5:30 PM

Dear Penny:

I've just moved into above described hotel. When I arrived at 3 AM this morning I went to a much fancier spot for a $2 room. Present room is $1.25. Might change rooms sometime. However. Moving to new hotels is expensive business involving 2 extra tips and cab if you take one.

Arrived Pittsburgh 6 PM. Left in 10 minutes. Lovely lunch served between Pittsburgh and Akron. At Cleveland rushed to transfer to new job, no time call Wallace. Managed another lovely lunch between Cleveland and Chicago—nonstop. Chicago beautiful business at night from up. Thought of Bigger, Studs, etc. 12 passenger limousine type cab from airport to Union Station ($1)—rode out Indiana Ave. All other passengers going to various hotels downtown, so had fine sight seeing trip—me last one out—Michigan Blvd., Edgewater Beach Hotel, etc. One man went to the Palmer House. Sometime I'll tell you what happened there.

Train ride was awful. Coach. Falling asleep to wake up with horrible taste, sweaty, crampy. Midnight ghostly bus ride from E. Dubuque, Ill. to Dubuque, Iowa. Thence to hotel up forty dank streets, walking, afraid of being robbed.

I woke up at 8 o'clock and could not return, but I lay in comfort until about 10:15. Shaved, practiced cameras, pictures out windows, gen'l delivery for flash bulbs and film.

¢ Sales tax, but apparently no liquor sold in this state.

Walked with Leica from about noon to present time. Managed to expose 2 rolls, all inconsequential of course—same old crap. Must make myself stop taking pix of signs, billboards, arrangements of unimportant buildings, etc. In fact must use Leica less and less. It's too easy.

Always the first day is discouraging. Self-conscious, afraid to take good pix when see them, talk to myself. Two young couples, very young, obviously just married came out of r.r. tracks Justice of Peace office looking like fine photographs. But I could not. Maybe in a week I'll be able to.

Tonight I must organize, not to mention sleep. I maybe should write in advance to one of the county agents I plan to pop in on. Also must draw up a plan of action for this city.

I'll be here, at this hotel, dear, Tue, Wed, and Thurs. nights. Fri Sat & Sun nights at 2171 Lincoln, but keep that quiet.[3] From there it depends on whether I've been able to do enough here. My leaving here depends on that I mean. I'm sure Stryker wants me to be gone by then.

I took pictures of men scavenging the city dump for oranges, grapefruit, etc. which they eat.

This is the biggest sash mill and door center in the U.S. Little things fly around and get in your eye all day. Lots of smoke too.

In the new LOOK, LaGuardia story, there is a picture of a baby in a bathtub which looks just like Ann. I mean at 1st glance I really thought it was one of those I took of her. Give her my and tell her about me. You I love best of all and I want to hear about everything you do, in your letters. And you know that I am your husband who loves you. Advise me on Eggnancy Pray.

APRIL 18, 1940
Dubuque, Iowa

Thursday 6:00 PM

Esteemed Fraü:

Last night I went to keep my bowling engagement but the prop. wasn't in. And there were no girls bowling, and not such a crowd as the night before. So I put it off. Maybe I'll do it in some other little town. Then I went and sat in on a service of the Dubuque City Mission, and raised my hand that I wanted to be saved. Afterwards I talked to the preacher. He is a Baptist minister but this thing is community chest financed. And it's really lousy.

They have 25 beds and serve meals twice a day. The meals smell and look bad. There are two guys

FIGURE 28 | *Shacks on the Edge of the City Dump, Occupied by Men Who Gain Their Living through Salvaging of Scrap Iron, Old Tires, Paper Which They Bale, etc.,* Dubuque, Iowa, April 1940

running the place, both Baptist ministers. Rev. Masters reads Social Justice but he wouldn't pose with it.[4] At 4:30 today I went and took pix of the poor guys who had to eat there. Tonight at 7:30 I'm going back to photograph the services and the boys going to bed, taking showers, fumigating their clothes, and being generally saved. Really it's a crime that community chest money is spent on a thing like that.

Anyway. I got your newsy little letter this morning and mighty glad. What do you mean "how is my h _ _ _ l." You had me in deep thought all day, and I finally arrived at hotel. But don't do that again.

Tonight I shall call St. Paul. 55¢. Tomorrow 6:00 P.M., probably, leave on the Zephyr, arrive 9:45. round trip $8.90.

Rec'd no handkerchiefs.

Have 1,000,000,000,000 things to do. Changing film is difficult problem, no closets, no light proof toilets. Fear I fogged some under the bed clothes this afternoon.

I must write to Stryker.

Today was a good day. I walked miles and climbed awfully steep hills and got terribly tired.

Haven't done much good stuff yet as far as Dubuque goes, but I think the city mission set may be AAAA.

They charge you a ¢ salestax with every 10¢ or more worth of food. But don't give you any receipts. What keeps them, the proprietors, from cheating the govt.? Tell me how it's done dear.

Tell me if I should stop air mailing you.

Don't I write often? Yes I read papers, so save news of national interest. Even read about Kindler & Sibelius.

<div style="text-align:right">My Love. Jno.</div>

APRIL 25, 1940
Grundy Center, Iowa

3:30 Thursday

Wifey Pie:—

I've been out this morning and early afternoon with Lew Plager, county agent. And do I smell of horsh manure, I mean all over.

It's raining now. It was cloudy dark all day. It forecasts rain for tomorrow. With these uncertain conditions I simply cannot forecast addresses. I may have to stay here a long time. If it rains tomorrow, and farmers don't work Sat. and Sun., I'll have to start from the beginning Mon. if it doesn't rain. I will definitely spend one night in Marshalltown. Probably no work, just stop the night there. That might be Tuesday night. Gen Del, Scranton might be Wednesday night.

Stryker makes his letters repeat the be back 15th note, and I've got to give 10 days to the Indianapolis man. Getting a presentable corn story squeezed into this time will be a feat.

I took shots this morning of plowing, rising, harrowing, manure spreading—all the things they do before they plant, but it doesn't count—the sky was too dark to make pretty photographs. With sun and clouds it is extra special photogenic matter.

Plager is a nice guy, pretty old, and kind of slow. He seems to be ready to pitch for me, haul me all around the county, etc. but I do feel imposing. Should have a car. He seems to have a high regard for Rothstein—this is where he got his corn pix last October—and I'm kind of cashing in on A.R.'s popularity. Was the picture of Rothstein in the Buffalo paper one of those I took?

I saw Ann Sheridan in Congo Maisie last night. It was exactly the same as that western one we saw her in except that it happens in Africa. March of Time on Our Nat'l Youth was swell.

I've been hearing about sleeping bags and hanged babies. I should advise discontinuance of former.

For God's Sake Stop Composing Crossword Puzzles.

I got the letter you mailed Wednesday morning this, Thursday morning.

Have you bought any records? dresses? hats? shoes?

Here are some False True questions for you. At least I think they are:

1. Texas is divided into more counties than any of the other (United) States.

2. There are more counties in California than in Georgia.

3. There are only 3 counties in Delaware.

4. Corn is the largest U.S. Crop.

5. No state east of the Mississippi is as large in area as any state west of the Mississippi.

6. All of the following cities are on the Great Lakes: Duluth, Milwaukee, Chicago, Detroit, Toledo, Cleveland, Buffalo, +

7. All of following are on Mississippi River: St Paul, Des Moines, St Louis, Memphis.

1. true
2. false There you are.
3. true I'll get in touch with you.
4. true Love—stuff. John.
5. false
6. true
7. false

APRIL 28, 1940
Marshalltown, Iowa

Sunday night 10:00 BELLS.

Wife of my right eye:

Marshalltown is a wonderful town. Here I am in a beautiful big modern room. I always assume that you are interested in my rooms. I am on the 7th floor, windows on 2 sides of the room looking down at the lovely little city in the rain. Great big double white bed, private toilet, lamps, regular Palmer House sort of thing. All for $1.75.

I arr. on the M and StL. at 8:30. Rec'd and read your letter plus one from ma mere. Then I called Mr. Peterson. I talked very forthright with him and made a good impression. He is the county agent. After my Grundy County experiences I know better what it's all about, what the farmers will be doing tomorrow and all that. I was pretty ignorant in Grundy Co., a green young boy. Here I gave them that "photographer from Washington, spend a few days, appreciate your co-operation" stuff and it

layed them down. I wish I could stay here a week. As I mentioned before I am too too early and have to leave too soon. With all I know about it now I could do wonders if I were here during the boom planting season. That runs from about the 6th to the 15th.

Well sir. Then I went out and had a steak. A big thick T bone steak, with potatoes and coffee, for only 35¢.

Then I took a long walk about town in the rain, getting the press out of my suit so I won't look like a dude on these farms. They have four movies here.

I would have gone beering but they don't sell it in Iowa on Sunday.

Did I tell you about stepping in 6 inches of fresh cow dung? That I did. My pants escaped but my shoes got pretty well covered. I cleaned them off some, but you know, that smell has become part of me. It goes wherever I go. People move away from me in hotel lobbies and on trains. I have begun to like it very much. I hope I can save some to bring to Greenbelt.

How does your garden grow?

Last night I went to a double feature movie. The Earl of Chicago and Mexican Spitfire with Lupe Veley and Errol Flynn. It was really howling funny and I laughed aloud. E. Flynn is always a funny guy. Do you know who he is? The Earl went over very well on me the second time around. The James Dugan assertions appear even more ridiculous. I can't understand why your thick witted friends didn't like it.

Well comes this morning. I went to church! My first unaided church in a long temps.

I had to wait until 5:22 to leave Grundy Center. Marshalltown is only 30 miles from there, but it was necessary to travel in a very roundabout way—a bus to Eldora and a train from there. Here is a little map for you to trace me on, because I'm sure you want to. My love for maps is growing in bounds and leaps. I spent most of the afternoon studying them and R.R. and motor bus schedules. Do you know there is a complete bus schedule, including all lines, over 5000 tables, well indexed, annotated, mapped, for the whole of U.S.? Also railroad, same thing? Well there is, and they are what I studied this afternoon. When I leave here I go to Scranton to see a friend of Mr. Bressman's, where I will get pix of farm house parlors, etc. Then I to Moorehead (see map) which is where I expect to get most of my bulk.[5] Great gobs of planting. Mr. Bressman's folks live there. But no trains or busses go there. No hotel probably is there. I'll have to inquire further west about hotels in Ute, Denison, or Woodbine, and bum daily rides to Moorehead. But you will address me Gen'l Del., Moorehead.

I took a long two hour walk in and out of Grundy Center early in the afternoon, and shot my share of inconsequential pictures. I got pretty tired of G.C., despite my first liking for it. But I could never grow tired of this town. It even has 2nd hand furniture stores. Which you can be sure I.

This afternoon I showed pictures of Ann to the Grundy Center innkeeper's daughter, a lithe little thing of some seventeen corn fed summers.

I had to wait an hour and a half at the Eldora depot for my train this evening. It was cloudy and

FIGURE 29 Map of Iowa, marked by Vachon; sent from Marshalltown, Iowa, April 1940

kicking up rain, a dirty little building on the edge of town, a fire in the stove in the middle of the waiting room, the ticket agent not back from supper yet, getting darker and darker. When in walks a woman of 45 with a suitcase. Sets it down and walks up and down the floor. Then in 5 minutes in walks another woman of 45, a hometown woman, no suitcase. Well sir, they shake hands in the middle of the room, look at each other not saying much, and then sit down together on a bench opposite me. Then there ensues, for a solid hour, the absolutely most engrossing conversation I've ever had the pleasure of listening in on. I took no part in it. From my corner hidden by the stove I smoked cigarettes and listened.

These dames hadn't seen each other for 20 years. Nor corresponded. They even had to ask each other their names—Mrs. McCoy and Mrs. Johnson. How the meeting tonight in Eldora was arranged I don't know. But they had been bosom pals in their girlhood chum days. They had gone to training school and been nurses together. Both had married, had two children, and divorced. Both husbands had been drunkards with other vices. Neither dame knew anything about the other's experience, and it all came out. Nothing was held back. Well isn't that amazing so far—on coincidence alone? Then the things that happened to them later. Wow. The Eldora woman had re-married a man 16 years older than herself, and had a little girl now 14 yrs. old, Mary Jane, pretty as a picture, but not right. In short, feeble. daffy. You haven't been soul rended until you've heard the mother's angle on that situation. The other woman was still nursing and having trouble with her divorced husband who kept reappearing and who is still a drunkard.

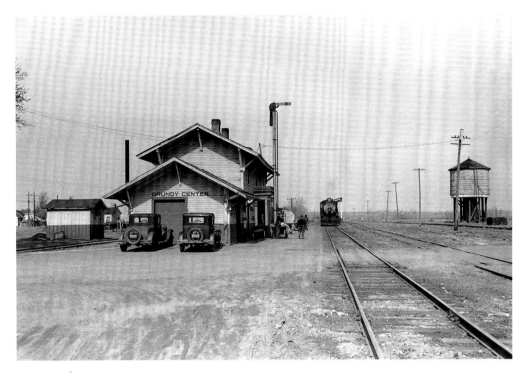

FIGURE 30 *Railroad Station,* Grundy Center, Iowa, April 1940

Well. More on this when I get home. I wish you were in this big bed over here. And I love you so don't divorce me.

Yrs. John.

MAY 12, 1940
Indianapolis, Indiana

Sunday, 5:00 PM

dearest little stuff:

Here I am on floor 14, worrying, because I have not heard from you for so long. Can't collect general delivery until tomorrow. But I'll assume that you yet breathe and palpitate, and write.

I've just finished tracing out the proper colored lines on my road maps. Being in St. Louis was wonderful. There is nothing that I like like I like going to a new big handsome city that I've heard about all my life and giving it the walk-over. I got up at 5:45 this morning, so I had lots of time to look

at our new Missouri counties from the train. Then I hobbled about St. Louis and took pictures from 7:30 until noon. I went to church at the old St. Louis Cathedral, the oldest church in the Mississippi Valley. It's down by the river standing up in the middle of several square blocks which are being torn down for a big park. The stuff being torn down is the oldest part of the city, so I'm glad I saw it before—poof. I took pictures in church, of Mass, sermon, praying people, etc. There was a 6 week old baby on the train this afternoon running thru all the standard "where's yer eye, nose, ear, fingers" gags. And it had a new angle: "where's yer heart." Have that taken care of when I get home. Home seems very far and removed from me, off here by myself all these months. Nice white Greenbelt, and frail Mrs. Beebe, and robust Mrs. Zorach—they don't have much reality to this apprehension. You and the child, now. I keep remembering I've got you, and that's fine—like Xmas coming. But you're both a little low on reality.

I don't find Mr. Stong the FSA information chief in the telephone book. I guess I'll wait until morning and go to the office. I hope he has it all planned, just where I go, when. I hope I start for somewhere early tomorrow, and I hope he goes with me all during my stay here.

I had a New York Central Salad Bowl for lunch today. That's what we had on our honeymoon, between Chicago and Toledo (2 cities we stopped at during "honeymoon"). Then I heedlessly had a cup of coffee. Two bits for a damn pewter pot full of tepid java.

Well. I love you. John.

JULY 11, 1940
Benton Harbor, Michigan

Wednesday, at night.

Fraü Vachon:

This has been a Full day.

Last night I saw the Moral Stork. It was about as stupid, stinking, crappy a performance as you could wish to witness in a day's march, including your M. Sullivan. This guy Stewart does look like me though, doesn't he?

Mr. O'Conner, whom I guess I haven't written to you since I met, is a 60 year old white haired Donald Meek of an Irishman, who has been a labor leader in Michigan since St. Croix was in britches. He started out as representative of the steam fitters local, way back when Sault St. Marie was a tight rope walker in a circus.

I met the babe who is a friend of Polly Swan's Brown. She is an investigator with Salkind whom I may have mentioned, and her name is Jean something. I also met a babe who is Ruth Peterson. She takes care of migrant mothers' infants at a nursery school here, and is from Prescott, Wisc. which is just across the river from St. Paul, so she knew a lot of people I know at St. Thomas, etc., practically, and she is quite a nice babe. I will tell you about her when I get home.

Tomorrow I must get up at 5:30, to go out and photograph cherry pickers, picking. By the way about photography, I'm beginning to see that it isn't my forte, and I'm going to turn to something other when I get back. I'm having a very difficult time this trip, being shunted between O'Conner, Salkind and his Seven, and various representatives from the Womens Council for Home Missions. And I will never again take a photographic trip without my own car.

It has been occurring to me that altho I drew $60 from U.S., I will be gone only 10 days, $50 worth, and shall have to return $10. Let it occur to only me. You forget about it.

Write me Hotel Wisconsin,

Milwaukee, Wisc.

where I will probably arrive Sunday, O I'd say Sat'y night. In Chicago on return I am going to see Al Jolson, Ruby Keeler, & others in Hold On to your Hats, at $2.75, if it costs me $2.75.

Give my love to our daughter.

Have you bought Va. Cocalis a wedding gift yet?

How is our pr-g—cy now?

I've had two letters from you.

I wrote to my mother.

What roll of film are you jabbering about in Hancock, Md.? I left no roll of film there. I had developed 2 rolls I took on our Pa. excursion, both are in excellent photographic shape and wait for me to print them, in my desk drawer.

I leave now, to sleep, dear wife, tender bud-bosomed basilica. I am your own strong pulsed Jno.

JULY 12, 1940
Benton Harbor, Michigan

Now it's Thursday

Darling drip:

One in my line of business has so little time to write. But I am getting the pictures I came out here for, in my own stereotyped way. Stryker will probably think they are wonderful. But it's disgusting, it is so superficial. I've got to load lots of film tonight, so I'll send you Old Bill's letter to fill in reading time. I bought the perfumiest after shave lotion yet. It's really a stinko. My flash bulbs are flashing away to the pt. where I won't have many in Milwaukee.

I've happened to think that it's kind of uncricket of me, putting B. Ketchum forward for a job with FSA, in as that Miss Daly is supposed, after a loose fashion, to be forming up to that job.

Tonight is a cold night in Benton Harbor.

Tell all your friends that that new book Grapes of Wrath really isn't exaggerated at all. I mean the situation is worse than you could believe. And the people, the folks, are so damn nice, good, heart warming.

Tomorrow night I must take pix of the free movie in a nearby town, and I might have no chance to write at all. But hell. You know I'm thinking about and loving of you.

Dear,
Penny.

JULY 15, 1940
Milwaukee, Wisconsin

Sunday night.

Dear Penny wife,

Yesterday I got to Chicago at noon, and roomed in the Morrison Hotel. I couldn't get A. Rothstein or B. O'Hara by telephone, so I walked the afternoon, photographing. About 5 o'clock, down State Street I felt a tug at my sleeve, and looking down there was a pretty little face asking "aren't you John Vachon?" and "I'm Mary Brennan." Well sir you could have knocked me over. She's quite a nice kid, but I'm glad I married you. She is married herself, much to my chagrin. She's married to a divorced Protestant, but not living with him while trying to get it fixed up with Mother Church. I'll tell you the angles later. Don't tell anyone like Feely because she doesn't want people to know about it. We met cousin and went to dinner and then out drinking gin, me glad handedly paying all the bills, which was more than I should have spent. But I really had a swell time. Mary's young brother Dan, whom I remember only as a small boy who built model airplanes, has a story in a recent issue of Story. I was until 2 AM getting back to my hotel. And today I had a hangover all the livelong day. So you see.

I had a long talk with Arthur R. on the telephone this morning, but he was leaving Chi. at one o'clock so I didn't see him. He has a 2 page spread of pictures in a PM which I bought today, and it is the lousiest most inconsequential photographic article I've ever seen get that much space.[6]

I went to the Chi art mus. this aft. God, I love that place. It beats all others. I spent all my time with the wonderful French, you remember—Vangogh, Renoir, Cezanne, and that big Sewer Rat.

Then tonight, I saw a double feature, Four Sons, which I thought surprisingly good. At least it was pretty good. Compared to the Mortal Storm it was wonderful. And, the jejune Judy in Andy———a debutante. Gawdamighty. She is wonderful. She sings a song Nobodies Baby which is probably the finest thing that's been done in the movies since the Great Train Robbery.

I called up home tonight, but they are out.

Tired now, I go to bed.

I love you. I want to see you, talk to you, have sex relations with you. But we must get on better terms.

Truthfully, Thaddeus.

DECEMBER 15, 1940
Radford, Virginia

Sunday night

Dear Millicent:

Arrived and all that. Spent the night in Salem. Got here about nine o'clock AM. By noon I was in the hands of the police and the army, and stayed there until about 4 PM. I got too close to their darn powder plant. They let me go and it's all right now, but it casts a bad shadow over everything. I keep seeing special policemen around town who got a line on me out at the plant, and it holds me back.

I paid a dumb boy a buck to take me around to some boarding houses. The first guy I tried to photograph in his room wanted to know how I made out with the police out at the plant. The dumb boy locked my car the wrong way and spent two hours opening it with a coat hanger. The lights went out. I bought a new fuse. We're using an awful lot of oil.

I wish this thing were done. It's awfully hard. Impossible. Discouraging. I'd hate to flunk the whole thing but it looks like I will.

Driving seems to take much longer when you're alone.

You have my address Claridge Hotel, Memphis. for Wed & Thurs. nights. Gadsen Hotel, Gadsen, Alabama for Fri. & Sat. nights. That's GADSDEN. Not Gadsen.

I guess I'll go to bed at once. I'm leaving a call for 6. I got $10 from Lenore Thomas, and my $55 advance. Haven't cashed them yet.

I love you both.

MARCH 14, 1941
Norfolk, Virginia

Thurs. night: 12:15 AM

Dolling:

Going to bed now. Rec'd your beautiful letter this morning, and I feel bad that I can not repay you in kind and length. But this is not a leisurely trip I am on. All these jobs lately have been stinkers with pressure. Tonight I photographed inside a Negro slum which I dug up myself. Swell subject, but I couldn't give it the old take-time-think-twice-Delano I thought I had learned. Besides it didn't have much to do with the story I'm here after. Nothing I've done does.

Today I drove thru some water in the street which I thought I could drive thru, and I stopped in the middle, above the running board and could not move. A truck pushed me out. Then I was 2 hours getting the car started again. Missing appointments with 2 people. Tomorrow I see the Salvation Army.

Great love to you and my best to Ann C.

Yours truly. John.

167

MARCH 15, 1941
Norfolk, Virginia

Friday night—6:00 PM

Poochie:

But one sweet letter from you, so far. And don't quite know what to tell you about addresses. But if you write any more after this one it'd best be gen'l deliv. Newport News.

Best day today. Lots of hack and routine stuff in schools & hospitals which I got into by using gumption. Not Delano caliber pix, but usable. Then late this afternoon when I had but four film left, I discovered a wonderful family from No. Car. living in a lousy house. 4 class AA pix I got. And it changed my whole outlook.

This trip I have been to see, and talk unintelligently to, more people than any ever before: mayor's office, chief police, traveler's aid, school supt., housing authority, salvation army, defense comm, social service bur., hospital supts.—but all you do is talk, listen to them deny one another, contradict themselves, tell you they will help you—and they never do, they never get their damn arrangements made. Lone Wolf Vachon, me, from now on.

Tonight, after I change film and eat, I can't decide between pleasure and business: see the Great Dictator or photograph the Union Mission.

Tomorrow I will be here, probably ending up late tomorrow night in Portsmouth, there Sunday, and Newport News Monday, maybe leaving for home Tuesday.

My love, old shirt
John.

JUNE 15, 1941
Pittsburgh, Pennsylvania

Sunday 1:00 PM

Dear Penny:

I just finished breakfast. I got your two letters, both yesterday.

I had a terrific day, yester. I started about 10 AM, and in rotation walked across every bridge from the Brady St. on one side to the Highland on another. 11 I think. And I photographed from most of them. I finished that about 3:30, then started driving up various cliffs, getting into really horrible dead ends. It's very hard trying to drive across town in straight lines. Altogether yesterday I drove 120 miles in Pgh. I know most parts of town pretty well now, but I'm still all the time accidentally getting onto blvds. that take me several miles from where I want to be. I got back here about 7:30, ate, and started out again at 9:00, D.S.T. The sun was still going down. From 9:00 till 2:30 AM I ranged all over the

damn city, Etna, homestead, and a place I got terribly lost in south of Frick Park. It's a godawful place. I went to it by map because the streets seemed to be across the river from a steel plant, but you couldn't get to those streets from where I went. At 1 AM I was a few blocks off Carson St. near a J and L bessemer when 2 cops pick me up. They take me to the J and L office, which spends an hour getting people out of bed to verify my letter and me. Then they say it's all right, everything's in order. In the dopiness of those late hours I double exposed one whole dozen, which means 24 pictures. I'm not getting any night shots worth a damn. I can't get close to anything. I left the Murn at home.

30¢ a night to park in this town.

I'm going to write to my mother, read the paper awhile. Go out about 3 or 4 and get home by 10 or 11. Then I will be through. I wish I could get just a couple of good things. But I'm afraid I ain't. It's very dark today. I didn't see a movie the other night. I read the Underground Stream Instead.

What did Barbara Fritchie say when her little grandson climbed into her lap and ran his fingers thru her hair?—"Shoot, if you mussed this old gray head—" I made that up.

I love you, but I'll probably leave for Erie tomorrow morning.

Do you know where Forward St. and Commercial Ave. are? They take a lot out of a car.

Well I'll write again.

Give Ann a lolly pop with my compliments.

<div style="text-align:right">Love stuff.
Jno.</div>

Remember Tommy Murphy—champ. The guy I met in Omaha? I saw his picture with other champs in a restaurant. He looked vaguely like the guy I met in Omaha, but definitely wasn't he. Remind me to change that caption.

I've written very unsatisfactory letters to you and my mother, but I'm worried about my work.

JUNE 17, 1941
Erie, Pennsylvania

Monday night

Dearest Lucille:

No word today, here, from you.

These damn towns have no all night parking rules, and it's expensive.

But I like Erie swell. I got here at 6:15 PM. I like Erie because it has nice wide streets, good hotel for $1.50, lots of parks, book stores, good looking places to drink, eat. Wonderful waterfront with railroads, coal, iron ore, grain elevators, places to get up above and look down.

I saw Meet John Doe tonight, and you should see it because it is the crappiest, stinkiest, bourgeois piece of palaver ever. Capra should be castrated.

Sunday, yesterday, after I finished a letter to you, I went out. To work. On 1st shot, across river from J and L, lady came and Demanded to know who I am, what I do, etc. I couldn't be nice to her because she such an ass. We're getting a crowd. I with tripod. 15 adults. 38 children. I show them my letter from J and L. I feel lynched. Four cops come in car. I show them letters. They say yeh. Pieces of paper. Better come down to the station. I come. They give me to the sergeant. He is a Hugh Herbert, and dumb.[7] I show him all the pictures I have with me, several dozen, and tell him all about them. He thinks they're dandy pictures. We get chummy. But he'd better see the lieutenant. We wait in station one hour for lieutenant. He is bastard. Passes lightly with scoff over my letters from mayor, J and L, C. B. Baldwin, Nat'l Defense Comm.—Says: "What does FBI think about it?" Must admit my visit here is unknown to FBI. So down there I am whisked. Two hours talking with special agents. It's much more fun because they are smarter, and kind of nice guys, but O such goddam Don Cooper Boy Scout Bill Hays. I half like the bastards. They tell me I understand how things are, times like these, saboteurs (pronounced correctly) subversive activity, can't be too careful, are satisfied that my credentials are in order, realize the great inconvenience to me, but I know how it is. They will not give me any blanket or restricted approval, letter of identification, okay, go ahead, etc. They don't say I can they don't say I can't. It isn't in their power. The Army & the Navy must decide. Each individual company I photograph should be consulted. I get out at 6 PM and it is pouring rain.

I am very damn displeased. I go see King of the Zombies and Lady from Louisiana. I go to bed.

This morning I spend an hour at J and L office, telling them I'm going to take their picture from across the river. Then I do it. Same place as yesterday. Smaller crowd. If they called the cops the cops didn't pay any attention to them. Yesterday was really some stuff. Down a hill at the end of one of these dead streets, 132 people watched me led away by 4 cops.

I stopped in to see Jack DeLein at Monaca on the way up.

I drove thru the trailer camp tonight—It looks swell. Photographable. And the waterfront is really inspiring. I'm going to play my cards carefully. After I'm through with the trailer camp I'm going to see the FBI agent—I met the Erie man in Pittsburgh, the chief of police, the chief of the R.R. police, the heads of all plants, the local minister, heads of various social and business clubs and the commissioner of education.

I will mail you the Underground Stream some time, and please read it because it is really wonderful.[8] Then you will be in a position to get those 2 books back to Jay Deiss.

Write to me, you log

My love. Jock.

JUNE 19, 1941
Erie, Pennsylvania

Thursday—6 PM

Round bellied one:

I'll write you even though I haven't rec'd your 5 bucks yet. O how it had better come tonight or 1st thing in morning O. I'll probably get to hell out of Erie about 10 AM tomorrow, as soon as I can talk to Roy.

What a stinkpot this has turned out to be.

Let me see. When did I write you last. Yesterday morning in my dire need. Well. Then I went out to the camp and got a few more shots. I covered the stupid thing pretty well, I opine. About noon I was all through except for a date to get in the Gen'l Electric plant at 4:30. I didn't want to spoil anything by messing with the Erie police before I saw the mayor this morning. So I relaxed. I drove all over the Presque Isle Peninsula. It's swell, just like you said. Many long stretches of sandy beach, with rocks. So much of it that anyone can have privacy. It goes out about 8 miles—like this: [*drawing of peninsula in context of city, lakefront, etc.*]

With a swell view of Erie water front at the end. Beautiful forest in the middle. Roadside tables, and half a dozen guarded beaches on the east shore. But what the hell. You've been there. So I lay and sunned and sand for an hour yesterday afternoon. Didn't water. Then I want back to G.E. plant, got my pix and was all through. Last night I ate simply and went to a double feature. 20¢ You wouldn't begrudge me those little pleasures, would you? Maisie was a Lady, Ann Sothern, and James Roosevelt's production of Pot of Gold. Both pretty thoroughly stinko. A big picture of F.D. behind the judge's bench in Pot of G. through courtroom scene. Disappointing, that our president's son should be engaged in such trash. Really pretty horrible.

Then I went to bed but couldn't sleep till very late, thinking of wonderful things I would do with booming water front.

But O my God.

I go see Mr. Foreman. He is the contractor at FSA camp. He is friend of Sec'y of Ch. of Commerce. He had told me he would fix everything for me to get at mayor, police chiefs, etc. So 1st we got see Joe Shields, Sec'y of Ch. of Commerce. About $1^1/_2$ hr. with him. The genuine hate I feel for that fat stupid arrogant bastard is unparalleled in my chronology of hates. He had been deputized to pass on my credentials and intentions for the mayor and police. He kept talking on the telephone to other fat bastards about the Ch. of C. Cruise, what a hot time they would have. How they would do things their wives wouldn't know about. Between telephone calls he would shoot stupid questions and ultimatums at me. He couldn't understand why I didn't have a letter to him, asking if I could take these pictures.

This is one of those towns where there are no unions. Mr. Shields runs much of the town. He talked about how niggers had been moving in recently. And the only solution could be that they'd have to get out, and they would.

I kept being sweet to the old fart while he shot off his arrogance. I thought he was being cajoled. Finally, after he thought he had given me enough of it, he called the mayor. He said he was sending this government man over. He didn't know what the hell he wanted or why he was here, but he'd send him over.

So then I spent an hour with a pop-eyed sportsman of a mayor, and the chief of police came in. All they could tell me was that their police had orders to pick up anybody using a camera near the waterfront. But go see Cap'n Barclay, chief of the Penn. RR police. So I did. And he couldn't understand how I could even be here without his knowing about it. But maybe if the Gen'l Mgr. of Penn. R.R. in Pittsburgh would OK me—so I should go to Pittsburgh. But I am boring you. Anyway the fat bastards won't let me near their lakefront, so I am forgetting it. I quit about 3 o'clock, and went out to a Presque Isle beach where I had a dandy swim and sun. I'd forgotten how swell it is to be in a lake where there are great big waves to throw you around.

How is Annie?

How can I call you up, you dope, when I got no dough?

This would be a wonderful town to come to on vacations—live cheap in a hotel, go everyday to a beach, sit in nice parks right downtown. But I hate the damn town on account of the fat boys who run it.

Now I will go through your last two letters and make some observations on what you have been saying to me.

Browns found an apartment, hey?

Libby sounds tiresome.

Make Ann stop calling you MaMa.

The Gvt. employees transferred from D.C. to N.Y.C. may be used to fill up Empire State Bldg., Erie paper says.

Get your money from Ilse in advance.

That's nice about the bathroom.

In Underground Stream, a man says, "Did you sleep good last night?"

The guy lies, & says "Yep."

The other guy says "Guwan—I'll bet ya didn't sleep a wink. I'll bet ya pee green this morning."

I love ya, dear wife. And let's have that 5 bucks.

I am yr. snshne.

Jno.

172

Sunday 6 PM

My Wife.

It is hot. Terribly. I am growing very lean from sweating and living on coca cola. I cannot bring myself to eat.

Last night I saw the manager of the project in this area. It looks like it will be another one of those cases. The Navy has already started construction on the land the farmers will move off of, so he (the mgr.) doesn't think I can take any pictures on the land. But the farmers haven't moved yet, so I can't take pix of them moving or where they moved to.

I am pretty sore about all the stone walls they're throwing me against. I wrote Stryker a long burned up letter this morning. I drove 600 miles to get here, for nothing. I can't put myself to any other kind of photography when I got this Army Navy crap to be worrying about all the time. I'm getting out as soon as possible—shooting the Chicago stockyards, and on to Wisconsin for a long peaceful siege of cheese and front porches.

Night before I left Erie I saw double feature, 20¢—Cheers for Miss Bishop—long epoch stuff which you'd probably like. And Eddie Albert in The Great Mr. Nobody. This was really a surprise. A hell of a good movie, I would say after consideration. Be sure to see it if it appears. Who is Eddie Albert—Did we ever see him before?

Did I ever acknowledge your 5 dollar bill, and thank you for same? I do.

I had the pants scared off me the day I left Erie. Just outside Erie I pick up a guy, who looks OK from a distance, but as soon as he gets in the car I know he's no guy I like or would pick up after inspection. He had a manner like Fahey, and a plenty wild gleam in his eye. He was pretty dirty and tired, and acted like he's been doped. He carried a sack and said he had his gun in it. He was a wild animal trainer, with many years experiences in zoos, and was going to Cleveland to get a job in the zoo there, or maybe Toledo, or Indianapolis, or wherever I was going. He'd say "Pull over to the side of the road, cap, so I can look at this map." I'd say "I don't need to stop, do I?" and he'd say "Pull over, cap." So I'd just sort of have to. Then he'd look at all the stuff in the back seat while I'd be driving and say—"You got two coats back there, hey? You must be going the limit." He'd say he wished he had a little valise to carry his stuff in instead of this paper sack. Then he'd lean over and examine my baggage pieces. I was not feeling happy, but had decided on passivity with no aggravations when the crisis came. He talked about how he killed animals in the zoo, he got $18 a week for just doing that, and he could kill for 30¢ a week, he said. Then a little later he said he'd had 30¢ this morning but he was broke now. Then studying the map, he'd look up and say "it's a good long way before another town." Then he'd sleep, or pretend to sleep—and say "get down there, goddam ya" to the wild animals in his dreams.

I took him about 70 miles—to Paynesville. There I stopped in the middle of town and told him I had to work there. He thanked me for the ride and gave me a blood shot smile. I think he was very deliberately trying to scare me, probably because he enjoyed it. I'm not so sure he would have been dangerous. But remind me to pick up little old ladies in the future.

Later that day, to get my nerve back, I picked up a 17 year old Jew from Yonkers, who was bumming to Long Beach, Calif. I had a pleasant evening with him, took him from Springfield, O. to Indianapolis.

This afternoon I drove to Vincennes and took quite a few pictures there of people on porches, picnickers in park, tennis games, etc.—hot Sunday afternoon stuff. I went swimming in a pool they have there. Two bits. It's about twice the square footage of the Greenbelt pool but the water was hot, it was full of rowdies, and I don't like the shape of it. It's round [*drawing of pool*] with diving board in middle, shallow water in outer circle only 3 feet at deepest, then in inner deep water circle it's immediately over your head. But they play amplified swing records all afternoon, and I enjoyed swimming.

I am much too hot to enjoy writing to you, but I love you all the same and will keep you posted.

I am your ardent.

JUNE 25, 1941
Chicago, Illinois

Wednesday—6:45 PM

Little flower of the shimmering Cinnamon Bush:

Two letters from ya today. One frwd. from Loogootee. (pronounced La Goatie)

I like to get em.

No word from Stryker yet. But I enjoy waiting. In fact I'm having a wonderful time. Try as I will it's hard to keep it from being expensive, though. No $1.50 room has opened yet. So I pay $2.00 while I wait. Then food, car fares, incidentals, parking—cost high in this town. I'm almost beginning to worry again. I shore hope Charlotte can shake me down a 150 on time.

This is a lovely hotel.

I've been playing Studs Lonigan all day.

Maybe tonight I will play Bigger Thomas.

I shore wish you were with me, babe. Unpregnant. I can see sail boats from my window.

I went down and listened to Jimmy Noone last night. He's in what is really a joint. Him, bass fiddle, drums, piano. He's really a wonderful guy. Then I went to several other joints which had pianos, or small combinations playing in them. There are hundreds of swell places like that, where you can sit at the bar and drink beer cheap. Usually they don't have dancing going on.

I ran into Mike Geary, St. Paul boy who is on his way to Baltimore to work in the shipyards. He is about 5 years behind me in school, age, associates, etc. I didn't recognize him, but I remembered him well.

You never acknowledged the M.O. 37. You got it, I trust?

This morning I slept until 9:30, walked with my Leica until noon. Then went into Brentanos and saw lots of my pictures in state guides I hadn't known they were in—Michigan, Wisconsin, Missouri—some very nice ones. Then on the bulletin board of the downtown library is the front cover of the magazine "Defense" with my grain elevator all over it. Very satisfying. And I went to the Art Institute. Quite carried away. All the Renoir, Van Gogh, Seurat, etc. which I'd seen many times, I enjoyed, but much more, really terribly I enjoyed a big exhibit of work of students—oils, water colors, posters, photographs, montages, things put together with cloth, newspapers, etc. Huge varied bunch of stuff by people starting at 8 or 10 yrs and on up to adults. Some very surprising, and good—imaginative abstractions in oil by a nun. Everything was interesting, and it's much more fun to see a show like that than galleries full of masters. It's easier to have your own ideas, to start recognizing the work of 2 or 3 people as it appears in different rooms and different media. In a room of 40 oil paintings for instance, many of the same model, most of them will look pretty much alike, obviously the influence of one teacher, but a couple will stand out distinctive as hell.

Many of the water colors which I thought were swell were for sale as low as 3 bucks. There was one I'd sure enough have bought but for the poverty of my circumstances. Watch the work of someone named Alice Berthold. I think she's terrific.

But all this talk. Anyway it's a very big show, and I'm going back again, and you ought to see it, and we should live in Chicago.

I took an El way up north and back again, then I spent a few hours of late good sunlight on lower State Street, getting, I think, some pretty good things. Altogether Leica I've been using.

Also an exhibit of Carl Milles sculpture at the Art Institute.

The bell boy just brought two big beautiful boxes of laundry up to this room, and my unconsidered reaction was that they were from you. But they weren't for me.

My regards to Ilsa and my daughter.

My real good love to you.

#

JUNE 27, 1941
Chicago, Illinois
[cartoon drawing on envelope of boy and girl]

Thursday night—9:30

Dear Millicent:

Tonight I am the pitiable spectacle of a man rummaging thru his dirty clothes bag looking for sox without holes to wash. And one shirt left. I'll keep it undisturbed for as long as possible.

I am very footsore from so much walking I do. I wish I were downtown because I walk there 4 times a day anyway. And they haven't found me a 1.50 room yet.

I SAW CITIZEN KANE TONIGHT. It's kind of good. I, amazingly enough, did not know that Kane was Orson Welles until the end of the picture when they gave names of cast. I thought I had read that Kane was someone else.

I got no letter from you today, whatsoever. Nor word from Stryker all day long. I was very disturbed. Then tonight ¹/₂ hour ago, I got a call from Stryker. He talked about 15 minutes. I am left very confused and generally low. It appears that I'll be here some several days yet. Hard to say, but probably thru Monday at least. He gave me the name of a guy here to see about getting pictures of cold storage fruits, vegetables, cheese, butter. Later I'll get word on who to see re: stockyards. I'm fearing when it's time for me to leave Chicago I won't have dough for hotel bill. Then he told me that a great many of my negatives— both from Pittsburgh and Erie were very bad—too out of focus to print, bad exposures—but he didn't know why—he hadn't seen them—Roy Dixon told him. It's one of those vague things that will worry the hell out of me. I can't really know what's wrong, or how much. But I must conclude that I haven't done good yet. Maybe something wrong with the camera. Maybe lots of good shots that they don't tell me about. They're going to send me the bad negatives. Then he told me Marion Post got married.

Then he told me we got two new photographers working for FSA. That makes me feel bad, I mean sore, because they're undoubtedly getting more dough than I, and where the hell is my raise? And it worries me because these guys will probably be much better than I, they will show me up, I will be a ham, they will not make out of focus negatives, I will be junior partner to some more photographers. These guys are coming in with ideas of their own—things they want to say in photography, so they'll do good work. I got no ideas of my own, I got only a bunch of formulas I've learned in 5 years, several different ways to imitate. I wish I knew some way out of this crap.

As for you, when you finish up with this next baby, I wish you'd go to Helena Rubenstein. I want you to put on some class, like these Chicago dames, up and down Michigan Ave. Glamour, groomed, chic, Not one careless of her appearance babe in a 100. I've been trying to tell you for years that you could do it. And now by gawd I'm going to make you do it.

I long walked it and photographed with Leica, coming back frequently to look for letters, until 1:00 PM today. Then I went to the beach and got plenty sun on the body until 3:00 PM. Then I came back and looked for letters, and then went downtown and ate and saw Citizen Kane. And back here again. That is what I did today.

I haven't seen the car since Tuesday night. Cameras are in the trunk. I hope it's all right. I'll probably get it out tomorrow when I go see this fruit and vegetable mogul.

I don't know what to give you about addresses. Maybe you already sent my other shirt to Milwaukee. I guess that's OK. I got clothes enough for here. I also guess I got dough enough. If I get to Milwaukee say Tuesday, and find Charlotte's check.

In the Erie public library I got out a University of Oregon catalog and read descriptions of all the courses taught by brother Robert. I wisht I was a school boy.

I wish I could settle this business about what's wrong with my negatives. It'll make me try harder, but I don't much look forward to more work until I understand. I'm going to write Stryker a complaining note about his method of informing photographers of their results.

In a big book store on Michigan Ave., in the window, lighted at night, is the Michigan state guide opened on the page where my picture of a House of David blacksmith smacks you, at least me, in the face.

I feel that the tone of this letter has been uncheerful. But don't be angry to me. For God's sake write to me once in a while. I still care, you know. In fact I love you, and all you stand for.

[elaborate scrawl]

JUNE 30, 1941
Chicago, Illinois

Sunday 7:00 PM

Mme:

I caught a spec. del. from you today. It made pleasant reading.

Letter from Stryker yesterday advised staying here and working stockyards, markets, hard until well into the week. I guess I will. I'd hazard that about Thursday night will arrive me in Milwaukee. But I can't know for sure, can I? Depends on how well I can get sailing. I'll sure have a pile of mail in Milwaukee—shirts, from Rob't, Mother, You. Suppose you get this Tuesday. Why not give me one more at address in letterhead?

Your letter today was the one of consolation. You could have done much better. You could have told me that I do have something to contribute to photography. You could have mentioned what a lasting contribution I have already made.

I got about 2 dozen negatives in the mail today. They don't make me feel much bad. None of them were any good ones I had in mind—a couple double exposures, some mistakes I'd known about at the time, some out of hand shots in gray light that I hadn't counted much on. If this means all the others are OK, why that's OK. There's nothing wrong with the camera.

I saw a double feature today, at the Studio Theatre—Rex Harrison in "School For Husbands" and Dannielle Dareux if you know who I mean, in the Virgin Bride. Very Risk, hey?

I'm shooting to Charlotte in same mail, my travel notes. Won't that 150 adv. be nice, and settle our problems prettily. I'll send you a big chunk of dough for frivolities in NY, because I'll never be able to get back to expensive living again. Why I haven't eaten in a place where you have to tip the waiter since Angelos, my first night in Pgh. It's Thompsons twice a day for me. But if I get dough, I'll allow myself just one of those big meals before I leave Chicago. Maybe 2.

Last night I sat in on an hour broadcast, Mutual Net Work, called "Chicagoland Hour" WGN

"Symphony" Orch, soloists, chorus,—light opera, Jerome Kern, nothing much good, but it's great fun watching them put it across. I hadn't known Col. Robert McCormick, ed. & publ. of Chicago Tribune did a 10 minute WJ Cameron.

I await your word on who to send dough to, and I await some checks. I'm gonna hafta put a couple shirts in the Allerton laundry bag tomorrow.

Tell me how the Mayers are.

I've taken to buying PM. I still don't see US Week, nowhere, never. Today's PM has a story about Willy Zorach, mentioning Dahlov and Tessin.

I'll mail it.

I love you.

Ramon

JULY 2, 1941
Milwaukee, Wisconsin

Wednesday afternoon 3:45

Blossoming one:

Did I write to you yesterday? I didn't. Yesterday morning I crawled about the huge market and took pictures of cabbage, cantaloupe, celery, peaches, oranges, spinach, and other things which you put on your table. Gawdamighty it's big, and complicated. I'll spare you an explanation of the set up, I don't understand it too well either. I got pix of the various commodities in very large quantities, but you can't always tell what they are, pix of trucks loading, hauling stuff away, and of the auctions, where commission merchants sit at desks in a big school room and bid boisterously.

Illinois has just effected new sales taxes which make cigarettes 17 from 15, pennies on the meals, etc.

Yest'dy aft'n'n I tramped the down town streets, photoging from steps of El. Afternoon crowds, very pictorial stuff, I think, against the sun, with a red filter. Then I ate at Thompson's as usual, and my double feature was Edmund Lowe—Wolf of New York, George Brent—Gold is Where You Find It.

This morning I was at the stockyards pretty early, and pictured pigs, mostly.

I photographed bums, derelicts, on Clinton St. during the early afternoon. These are the guys who are not the pride of America. Maybe in the better social order they would be different, but now they are awfully nasty to look at, drunken, unsalvagable looking.

I comes back to my mail box, and find govt. mail, letter from you, hotel bill.

Of course I reads letter from you first. And do I detect a recriminating note? "I suppose Baby Dodds is paying all your bills." Well, I only bought Baby one drink, and for myself, I drank beer.

But right now, even as I write to you, my wife, I am drinking from a $1.39 bottle of Muscatel. I alarm you?

Well sir, my paycheck came, and what do you think was its amount, covering the period from June

15 to July 1? Well sir it was $99.99. Ain't that nice? That's why I'm knocking me off a $1.39 bottle of muscatel.

You were premonitous, according to a letter I have from you, you old toad, but I never expected it to be that good. Why that's only 2¢ a month less than you drew down when I snatched you away from the business world.

It's unfortunate that such good news came to me my last night in Chicago, when I'm getting up at 3:30 AM to go to the market. At that time I've gotta go get pictures of table produce being unloaded from trains, and a little later merchants loading it over before they go to the auction rooms.

Otherwise I would show you a celebration that would ring memorable. I would go to the Joseph Urban Room at the Congress.

Then I would have dinner at the Palmer House, go see My Sister Eileen, go sit with Jimmy Dorsey at the College Inn, then go back to Tin Pan Alley, and buy Baby a whole bunch of drinks.

I sent a M.O. to Harvey Dairy, Inc., and to Greenbelt, addressed to: Treasurer, Town of Greenbelt, made out to FSA. Do you think that was right?

The ten which you find in the envelope, I trust, is because you must need some dough. I will send you a juicier chunk when I get my advance. I have paid my hotel bill of $14.88 incl. laundry. So I am left with $37.27.

The Mt. Ranier organization, I guess, will be paid out of either my forthcoming advance if it forthcomes, or my July 8th paycheck.

You speak of the plaid gingham that you wore all the way home on our vacation. For the life of me if I can remember it. Draw it for me.

My, this wine is good, and reaching me. Inwardly.

How sad, to leave Chicago. I have had a wonderful week, and such dandy fun, and seeing so much going on—cab drivers looking at maps of Russia, and arguing about the war, one guy points and says that's where his old man comes from. And all the snotty dames on Michigan Ave. that I want you to emulate. And a cop with a heavy Irish in the talk that everyone says—Hello Barney—to on his way home. I followed him 8 blocks. He was just like in the movies. Then all the joints are so nice, and the clean cafeterias, and living here with a radio in your room, and swimming with the sun hot. Jeez I like it. And the gal in the stockyards office who said "you can tell which way the wind is blowing by whether you smell pig shit, cow shit or hog shit."—MAP OF STOCKYARDS:—

[drawing of stockyards]

Then just walking up and down the streets, big buildings with lights on them, nice new stuff in windows, Chinatown. O give it to me, give it to me.

I have written to Elmer Isaacson, that I am coming, and telegraphed my delay—but tomorrow night I am there. It's possible that I won't leave until Monday, and God knows to where.

It must now be about 5 PM. Don't know what will do tonight. Probably eat, walk, and bed about 9:30–10:00.

Please you have a plenty good time there, where you are, and go see photog. exhibit and tell me about it, go to shows, have one or two moderate drinks befitting a pregnant woman, go see what's at 314 W. 34th St.—that's where Willie and I lived—tell me about it, and write me nice long letters.[9]

Give my dandy regards to

Dorothy

Ralph

Wayne

Clark

Janice

As for you I have nothing but uncontracting love, tell Annie, the imbecile child, she is my daughter, I am your, JFV

JULY 18, 1941
Austin, Minnesota

Thursday night 8 PM

mein dear kampf—

Got yr poverty pleading letter today, gen'l del. Trust you have received the century. Also had a waiting letter from ya when I got home last night. Now I will answer them both. Why don't you con gratulate me on the reestablishment of my raise? I sure ain't getting no 6 dollars worth of swimming ticket am I? I seen Caught in the Draft and Man Hunt, very good, Man Hunt. Has the John Ford touch. You still end your damn descriptive adjectives in ish, every once in a while. What do you feel toward the male name I suggested, Barnaby? Don't worry about your outline getting blurred. I got you spotted, and precise. You are just like your letters. You aren't a bad kid, but you need my influence, steadily.

Sunday afternoon I spent with Dan Baker, at his house, and viewing Mpls' Aquatenial in a drive around the lakes. Sunday night I saw Caught in the Draft with parents. Monday I went to Siren, Wisc., met Elmer, he's a simp, photographed some interesting families in the northwesternmost county of Wisconsin, about 16 families from Nebraska dust drought area have moved in there during past 4 yrs, most of them got FSA loans. They are different, talk and look different from native Wisconsinites. They've had to change to a new kind of farming, it's dairy, with large tracts of land, lots of pasture and hay, long winters. For them it used to be wheat and corn, smaller farms, longer season. One guy brought out a yellowed set of nine issues of the LONE SCOUT, monthly magazine which had published a serial he had written when he was 16 yrs old, "The Trail of Ithshanbar." Wonderful meal in Duluth, that

night, with good swing group of piano, clarinet, bass fiddle, at a place we passed called the Flame do you remember? And got to Grand Rapids at midnight, stayed at hotel we called Robert from about Annie, the Pokegama, do you remember? Worked around G.R. in the morning, on isolated farmers in tar paper shacks, surprisingly more cut off from civil. and backward looking than anything we saw in that country. Got to a little log cabin on big Mille Lacs Lake at 4 PM. No fisherman, I was reluctant when glassy eyed salt nostrilled Elmer Isaksen urged immediate requisition of a boat and guide. Nor was I more at ease when I had succumbed to the potent flattery and persuasion of sportsman Isaksen, and found myself speeding in a powerful motor boat, 12 miles to the very center of watery Lake Mille Lacs. For the penalty attached to fishing without properly licensed authority in Minnesota's 10,000 little lakes is 25 dollars. And to me, as to thousands of troubled youngsters in these times, 25 dollars was of grave importance. But with an eye ever cocked to spot the approach of a fine meting fish warden, I fished. No words passed as for four hours I hung my rod and reel into the wet 30 foot depth of rough Lake Mille Lacs, and fished. Of vital importance to the pleasure of the fisherman are bites, nibbles, strikes, catches. For without these no fish are caught. But the fish well know that their common security depends solely on their resistance to the line dangled minnow. Instinctive is their knowledge that continued enjoyment of the freedom of the waters can be realized only when they have ceased to bite at flecking baits. For more than 100,000 fish in Minnesota's Lake Mille Lacs, 100 miles north of the Twin Cities, organized refusal to bite is meaning longer lives, more water, a chance to raise young fish. Lake Mille Lacs Fish are staying out of the frying pan. Time Marches . . On.

This morning I left S. Paul at 9 AM, arr. Austin noon, worked the afternoon with tenant purchase borrowers in this and neighboring county. Tomorrow have 7 o'clock appointment at Hormel plant, and pretty good it looks, for getting slaughtering, skinning, packing pictures. Will likely be at General Delivery, Ashland, Wisc. Monday night, but could relish a special in St. Paul on Sunday.

I am your loving mate.

Forgot to mention, that in trying out brother Robert's new Schick, at home, last night, its efficiency slipped upon me, shaved off a vital piece of mustache, and forced me to fell the entire two months growth. All are agreed that it is a great shame, and that I have lost a handsome dash.

JULY 22, 1941
Ashland, Wisconsin

Monday night.

My dearest Millicent Penny:

I have been tardy again, thru no fault of your own. I'm in Ashland an hour, eaten. Faced with 5 dozen films to change, a long letter of explanation to write Stryker, some 100 odd contact prints to caption.

Today I had 3 accidents in rapid succession. I threw a cigarette out the car window, and 3 minutes later retrieved it from my Good Suit Coat where it had burned a hole, about [*drawing of hole the size of a shirt button*] in this part [*drawing of suit coat and arrow pointing to position of hole*]. Soon after on travel at your own risk road, I risked driving over a little ridge of rocks, which jumped up and bounced all over the bottom of the car. When I got out a loud knocking was taking place, and took place for the next 10 miles to a garage. I thought the muffler had busted. But it was the casing around the fly wheel, which got dented by a rock, so the fly wheel going around knocked loud, and took a chunk out of the casing. The garage man fixed everything, soldered up the whole, and only charged 50¢. My 3rd accident was knocking a hunk off the running board, getting out of the guy's garage.

A gas station man in Austin said he'd make me a good deal on a new tire for that right rear one. Come to look at it, it is pretty smooth. What does the guarantee say, 6 mo. or 1 yr? I think I ought to change all the tires' positions, like you're supposed to, every so many miles. We now use 1 qt. oil per 500 miles fast driving. That ain't bad of course. But maybe we should start thinking of that '41 Oldsmobile, red.

Friday morning at 7 I was in the Hormel Plant, in the hands of the plant photographer, who through a misunderstanding thought I had carte blanc, so for about 5 hours I toured the plant, photographing everything I wanted. At noon his boss got a hold of him, gave him hell, said he should only let me take pictures where everyone was in white and all looked palatable. So the afternoon dragged without much getting done, the Pl. Ph. wanting to know if he couldn't develop the negatives I had made in the morning, but I assured him it wouldn't be practical. The gory story of slaughtering I will save for one of our more intimate moments. Suffice it to say I no longer eat meat. Whether the pictures are any good I don't know. I was very confused, standing in six inches of purple black blood firing flash bulbs at dismemberment.

Friday night I went to a Norwegian dance, and *danced:* the polka, the flying dutchman, the circle waltz, and sundry old fashioned waltzes. And creditably. Amazing myself. When I join talents with a good dancer, I am damn good. The most modern stuff they played were beautiful Ted Lewis corny versions of JaDa, How ya gonna keep em down on the farm, Wabash Blues. A very pleasant night was had by me. I didn't take any dames home or anything.

Saturday I drove slowly to St. Paul, photographing many picket fences on the way.

Saturday night I had an outing with Danny Boy Baker, and Terrible Dick Gaudian. Roisterous enough to hold me for a while.

Sunday night I took my mother to a $1.35 dinner at Lowell Inn, Stillwater. Duncan Hines can have it.[10] Today I drove uneventfully, except as described, to Ashland.

My hunch is that I will either be here, or be coming back here for some several days. So send 'em here until more notice—better keep 'em General Delivery rather than the hotel. The PO is across street, and I'm getting Stryker stuff there. There is probably mail from both of you over there, which I will open in the morning.

Tomorrow I see the Indian Supt., and get a line on what I can get and where I can. I'm awfully vague about the Indian deal—don't have notes like I did last time. It's also pretty much scattered around top half of Wisconsin, making much driving.

Letters from Stryker say probably no boat trip. But include good letters of intro. to pres. of Duluth Board of Trade, Pres. of Iron Range Railroad.

Also wants me to catch the wheat harvest in Red River Valley.

You never told me any more of my pix in NY exhibit.

Naval cousin Schulstad, whom I ain't seen since borrowed 2 bucks of me.

I had lunch at the Hormel Plant—just me, a laboratory girl, and the Hormel Chef, who cooked it. He says he's the guy who opened the Mayflower in Washington. Also was at the Astor in NYC. The modest little lunch was pretty damn nice.

My Chicago contact prints have been coming to me, and are satisfactory.

The enclosed letter came to me from Stryker. Will you look it up in Nation 7/12/41, and quote comment to me?

Do you find Ashland on your map? It is north woodsy lumber country.

I should like to give you my love personally. Have you heard from James?———

AUGUST 1, 1941
Shawano, Wisconsin

Thursday at night—11

Short one—

follows. Shawno, this town is pronounced. I love you you old gazelle. Better than anyone—loves you or I love.

Didn't get your Antigo letter frwd. to Keshena today, but Doubtless I will tomorrow.

Wisconsin, as you might know, is the one state, or one state, countenancing open slot machines. At least northern half of Wisconsin, has them in every joint & bypass. I've learned a way to play them without losing at a greater rate than $1.00 per hour. Also, I've had $1/2$ dozen Old Quakers over the course of this cut short evening. Really, I'm about even on slot machines. This old Wisconsin does something to me. I'm having a wonderful time in a summer people sort of way, plenty gay, every day. It's pretty delectable. And engaging. But I am always unhappy, and thin confused bewildered. I want my girl all the time. That's Penny, pretty and snappy, with her glasses in my pocket.

The Keshena Menominee Indians aren't like any Indians you or I ever saw. The Chippewa don't hold a candle. 1st, this is one of the very few, only 1 in middle west I can safely say—unalloted reservations. All tribal land. No white man owns nothing. 2nd it is big tall beautiful virgin pine, with Wisconsin's largest lumber mill operating in middle of. Hence Indians here are fairly prosperous. Then,

183

they don't look like other Indians. They are all very coppered. Dark. But beautiful features. Handsome guys. Lovely girls, like berries. Really, like berries. Makes ya think of Bali. Balinese. Everyone cordial, happy. No sullenness among the young men like you find in even finest Chippewa.

Bought my first Indian a bottle of beer this afternoon.[11] No one ever raised an eyebrow.

I went to a barn dance tonight held by the stupid whites. I didn't dance—old waltzes and circular 2 steps mostly—but I enjoy watching them, Heaps. I didn't take any pictures at the Norwegian dance I went to. And I wasn't invited. I paid 50¢ at the door.

I must reverse my films.

I am G.D. Duluth beginning Mon. morning until further word can say other.

Tender my tender to my little Annie.

You are a sweet babe.

I am tall & sardonic.———————————

AUGUST 11, 1941
Duluth, Minnesota

Monday night

little soda cracker—

my ink has given out, and there is none within armpit. So I take out my trusty.[12] I rec'd here a letter from yu, frwd frm. Ashland, this morning. That was nice.

I am quartered tonight in one of those elgant rooms provided at the "Club," for I.S.[13] employees. Spacious, cool, pine trees out the window, large clean private bath, many towels, copies of Harpers, maple tables, lots of lamps, You remember. You've been in the Indian Service. If I wasn't so tired tonight it would be a different story. There is a very beautiful, sensible type, blonde WPA weaving instructor here, who is just cooing for my attentions. A little of them would not be ill spent. She is really an awfully good kid. But I will tell you why I am so tired tonight. After one whole week of no double features, no folk dances, no beer drinking, change film and early to bed stuff, last night I had one of those rare experiences for which I am famous. Yesterday morning,—get out your map. Never mind. I will enclose the corner of mine I shan't be using again. Yesterday morning I left L'Anse, f2 [*on enclosed map*], at 10 AM and spent until 5 PM driving through Taylor Junction, Alberta, Covington, Watton, Sidnaw, Kenton, and Trout Creek. A very short distance as you can see. Much photographing of old lumber towns, present day lumber mills, old jacks. This was the heart of the Great pine woods section. Then I got to Bruce Crossing and would finish up my day's work with a bottle of beer before barreling into the Indian Reservation. Well sir, I met a young Finnish boy. Bill Taival. Finnish as haddy. spig. Well he and me got to drinking beer and talking. He didn't know much from nothin. He had never been no place. He talked real slow and blonde, with peculiar pronunciations. But my he was a

good boy. He is my fast friend. With him I met lots of other people, all Finns, talking Finnish about $\frac{1}{2}$ the time. They are awful good people up there. They want Russia to lose though. So about 8:30 Bill and I drove 12 miles out northeast to pick up Dora, his big hulking Finnish girl friend. We took her back to town and sat around in a joint full of people singing Finnish songs until 12:30. Then I said goodbye to Bill and Dora and several Jans and Imars, and set out on my way. I was not beery, deary, as you might think. But it was too late to drive to Lac du Flambeau, especially as on my way down, when I got into Wisconsin, I found myself in the resortiest, lakiest, prettiest piece of country I'd ever seen. Wisconsin beats Minnesota, hollow, I will say. There were all these great big luxurious hotels, bars, gambling dens, protruding over lakes, with tall pines dripping, and ski slides. So I stopped at a few and watched some gambling operations. Barefoot Charlie's place we must spend a weekend at sometime, you and me. I never before caught the real flavor of summer resorts and summer people like I did last night. Unlike anything we saw in Minnesota, even if it had been summer. Then I got to Eagle River, Wisc. kind of late, and had to sit up for an hour changing my five little film magazines, so I got to bed late, and unfortunately awoke at 8 AM, not knowing the time thought it was probably noon, so I got here by shortly after Nine. And was tired all day. I took the usual stupid pictures of Indians. I paid 50 centimes to get into a pageant they are holding here for the tourist trade, 50 centimes to wear a little red ribbon which would entitle me to take pictures at the pageant, 30 centimes for cigars for 3 old buggers who were building a birch bark canoe, 20 centimes for pop for little boys and girls. And with all that cash outlay I couldn't get pictures with any freedom or worth a damn. Some old goat of a chief gave me a line of double talk which Sam Whitefeather told me meant ugh, I'm gonna make money off pictures I take, so he wouldn't let me photog. him and his boys putting on their dances, which were really pretty good, good music, different from the Sioux we heard, and lots of little boys 10–12 yrs old dancing dandy. Also old women I sneaked a few from a distance, but couldn't get very close.

The sup. of this reservation is an Indian, and a very able boy. His name is Owl, and he looks like Tessim. Young, Jewish looking. He said the real reason for my trouble was that they saw me with him, connected me up with the govt., and didn't like it. 30 yrs ago, he says, Indian dances such as these were absolutely forbade by govt. and the old boys, he says, remember well. He also doesn't think much of the Indian-liquor law. It certainly is a damn stupid excuse of a way to run things I think too.

Don't you really like Barnaby at all? I do.

I will probably get to Antigo tomorrow night. I love you, sure enough.

<div style="text-align:right">

I am,
Sibelius.

</div>

FEBRUARY 2, 1942
Cape Girardeau, Missouri

Sunday nite

Dear Penny:

Now I'm down in this damn part of the country, 12 miles from Chaffee where I work tomorrow. No heater yet. Can't get one in this town. Froze my very viscera today, and I'm going to stop it quickly. I'll get a heater if I have to pay cash. It'll save money in the long run—won't have to stop so often for coffee—won't hurry frozen to 1st hotel I see but will patiently search out tourist room.

300 miles to Neasko where I go when I finish here. Then 100 to Butler. Then about 400 to Burlington. Then Chicago. All this damn driving is wearing me down.

Pants knees gave out today.

Speedometer passed 40000 today.

I drove 20–25 miles out of my way today to go through towns of Colp, Bush, Herrin, Zeigler, etc.—southern Illinois coal towns which Arthur photographed about three years ago. They are very dirty unpainted looking places. There was nothing for me to photograph unless to prove that Arthur wasn't lying. I haven't been pulling the trigger much lately. Tomorrow will doubtless be a great trial.

I do not feel like writing letters tonight.

I am tired from the cold.

I wish I heard from you more often.

Be a good girl.

Johnson.

FEBRUARY 3, 1942
Poplar Bluff, Missouri

Monday nite 11:00 PM

Baby mien:

I only get occasional tantalizing peeps at Terry & Pirates.

Enough to know something terrific is going on, but never the group. Is that child Pat's?

Today, driving along peaceful, not taking pictures or anything, I am stopped by highway patrolman in auto. Where do I live. What is my occupation. Identify myself. Thank me very much.

I got to Benton early this morning, contacted my man, and spent day until about 5 PM getting 16–18 pictures of 2 doctors—their offices, rural patients, farm call, sick child. Good satisfying day's work. In the doctor's office at Chaffee was a pretty 18 yr old girl on crutches. She had broken her leg jitterbugging in the drug store.

No group meeting until Wednesday, so I left for the west.

Sikeston says "the friendly city" outside it. Just looking at faces of guys on the street made me sick at stomach. I had forgotten, or we never really saw, what "niggertown" is like in these parts. Not subtle and blending like in big cities, but a segregated area, definitely away from the rest of the town. Like slave quarters. They don't talk about their lynching to you. When you say you read it in the paper they say "yeh?"

I had a coffee at the Homestead Hotel where we stayed and gloated over our records out in front of.

You didn't see enough of this part of the country to get its feel—how these 7 counties comprise Southeast Missouri, richest land in the country, perfectly flat. In northern half of Scott Co. it's the corn belt. Southern half cotton starts. I think it's the only place in Mo. where cotton grows. It's the only part of Mo. that is "South." It's really got a feel.

Still hot on the tail of a heater. Probably tomorrow in Springfield.

Where should I send Brown's mileage telegrams?

Look up my last batch of letters to you, in your trunk, one from Benton Harbor, Michigan in which I gave you a figure which was my daily average expenditures, please. Then I will forward this trip's d.a.e.

Excellent hotel, this, at $1.25, with a Duncan Hines dining room—good baked chicken for 75¢. So then I saw a movie—no. 3. I am slipping, I hear you say, but my conscience doesn't bother me yet. 4 Daughters with the Lane girls. Also a long, excellent 1912 Mack Sennett Comedy, and a 1933 Artie Shaw short. Played Lady be Good, with many close ups of the clarinet doing it. It sure made me itch. You've probably got it all fixed up and waiting for me, hey? Movie only cost 17¢.

I am changing some film, writing some notes for captions and going to bed.

I love you plenty. I miss you and Ann plenty. I even miss Brian, almost.

<div style="text-align:right">

Yrs. Sincerely,
John F. Vachon

</div>

FEBRUARY 5, 1942
Neosho, Missouri

Wednesday night.

Dear Penny:—

I was feeling pretty awful last night—pneumonia on the chest or something. Had been low since Sunday. Had long drink whiskey and slept from 8 PM till 8 AM. Fully recovered today.

My heater is a humdinger and throws a whale of a heat. But today has been not only beautiful and sunshiney (1st of present trip) but positively shirt sleevey.

The Ozarks are wonderful country, I always reiterate. I would sure like to vacate here with you sometime.

Today the car took a horrible beating. I would say the worst it has ever had—up roads that were all sharp rocks, through streams, through stumpy fields, and places where no sign of road was. Nothing happened, but it probably brings the tires much closer to the end. It wasn't to much good avail either, except that I saw beautiful country and some very isolated farmers and cabins. A damn fool Co. supervisor and a woman were going to show me farmers moving, but we never found any. And best of all to make me happy, my flash gun stopped working. I can use it with certain extra manipulations, and hope it synchronizes. I think it will take only a slight adjustment which I shall have done in Chicago.

Why in hell don't you ever write to me? I know. Because I don't give you addresses. But it preys on me.

I'm not in very good spirits about all this—photography, etc. So damn much driving. Nothing like the good solid thoughtful work I'd planned for myself. The closest I came to it was at those Civilian Defense Meetings in Portsmouth. There I really figured it out, took my time, got what I wanted. Today was very hard—I shot lots of film, but too hurried and pre-occupied. Confused by great mass of material—story I can't comprehend in one day, sent by regional office to get quick. I should stay weeks here—it has everything—isolated rural areas—Camp Crowder, huge, extending over 2 counties. Neosho, pop. 5000. Construction workers alone—20,000. Hundreds of trailers, cabins, night clubs, bawdy houses—crowding into the primeval land of hill farmer with cabin by a clear brook—So the bad sense of wasted time when I realize I'm only shooting random films around. My heart ain't in it. I want to get to North Dakota and understand.

I have spent up to now $39.80.

You write to me and I will write to you.

I love you. I hope things look up soon.

How is your pregnancy?

John F. Vachon

FEBRUARY 10, 1942
Mendota, Illinois

Monday night.

Dearest Leeper:

God knows why I am here. I shall try to tell you. Woke up this morning to much snow in the sky, which has continued all day. Impossible to do anything further on trailer camps. That's all right. About noon I left, after having tried a few snow storm shots with my ailing Graflex. Had lunch in Galesburg.

Got gas in Kewaunee. Roads were quite slippery under the snow. The car began to appear quite ill. It would stall whenever I'd stop it. It lacked power. It was convulsive. I couldn't drive over 30 MPH anyway, but it would be hard to get it up to that. Then the throttle would stick to the floor and it would dart away at high speed. I was pretty worried. Pretty sure this was either the end or where that $150 job came in. I stopped here—90 miles west of Chicago—about 6 PM, went to a garage and told the guy I wanted an investigation and analysis. He listened to my symptoms sympathetically. Said he was awful busy right now on a truck—if I come back in 2 hours he will give me a complete check over. So I am back in 2 hours and the guy doesn't even remember me. He is all tied up with 2 trucks and a load of cattle that's got to get out, and doesn't want to talk to me. So I stand around for an hour and then go. Nothing seems wrong with the car now. But I fear it has an inner disease. I hope to hold everything until I get to St. Paul—Wednesday night. Then have it gone over thoroughly and the universal joint encased, etc.

This morning in Burlington I got letter from Mother, Brown, Stryker, and Seven from you.—3 mailed to Indianapolis. I spent an hour reading them this morning, and an hour re-reading tonight. I shall go through them hurriedly now to take up various points with you:

Yes. I got the heater on credit card. It doesn't work so well either.

Do have prints—contacts—made of these 2 negatives, for 5¢ apiece at any E.K. store. I can't diagnose them but I'm damn sure those black spots aren't due to non light tight packing on my part. Fosnight I have marked as careless workman.

I hardly understand all the letter dearths you speak of. I have written you every night except over past week-end, when one letter went for Saturday and Sunday. Have you rec'd that many? Perhaps you should preface your letters by noting which one you got from me last, so I'll always know how much you know about me.

You told me the same vitamin story in two different letters.

I am sorry you were not successful in your election campaign. What you must have been through. And all alone.

You should not tell Ann she won't see me for 4 months. We plan to meet in April.

You don't want me to pay that Lansburgh bill too, do you? I hope you have enough money to get on on until I can send you some—probably Thursday.

All of Ann's letters are highly pleasurable. I hope they will keep coming.

Do not be so disturbed with Peggy's "GRIM." Mary Rita said "GRUESOME."

I quote directly from your letter of Jan. 29th: "—to hear Francis Joseph Spanier play 'Jazz Me Blues,' need I say, very much like the record." Now, may I ask, like just exactly what the hell record? We have it by Mannone, OD.I.B., Bob Crosby, and you've heard it by Beiderbecke, but how any of those could be confused with the individual tone of Muggsy—I do not understand. By all means study Tessin's accountancy books, but leave music alone.

My letter from Stryker was very disappointing, disturbing, and it makes me sore. That is usually the effect of his letters on me. Full of foggy references to things I want to know about. Says he has sent me a book which I ain't got. His stupid cliches: "maybe you can work something out on this." No mention of whether they've even received the film I've sent in. I'm supposed by this time to have a telegram telling me about it.

This whole job is a pain in the abdomen. I feel like a WPA ballet dancer, or an animated non-essential expenditure turned loose on the country. I feel guilty, I don't know how to represent myself. The people in the country are unfriendly toward guys with cushy Washington jobs, as they look upon mine. Me and Melvyn Douglas. As the guy in the gas station said: if what I'm doing is important enough that I should be doing it now, it's important enough that I should be able to buy new tires. That sure as hell is sound reason. Not to be over idealistic: I don't like to be spending all my time doing something which I think is a waste of money. I mean what good is it to who? I do not mean that I would be happy building shells, or in the army, either. I wish I could get a hold of something. I don't get much reading done any more. I'm driving and changing film too damn much of the time. The writing I have tried to do since I've been away has folded, and I can't do anything satisfying that way either. The best thing I've seen, and most liked, since I've been away were the two kids of Cecil Patrick yesterday, who live in a trailer.

Tomorrow maybe I will get a haircut. I hope to have a good time tomorrow, to get my cameras fixed, and to not have my car fall apart

Please write me St. Paul until otherwise notified.

Let me have anything you get a hold of.

I wish we lived together.

Love.
John.

FEBRUARY 27, 1942
Hebron, North Dakota

Thursday night

Dear Penny the Wife:—

I'm in a wash basin-pitcher room here. Hebron is disappointing for all its 1200 pop. Bare outline of a hotel, no movie, no local color. It's mostly just buildings on U.S. 10, no life of its own. Now Dickinson was a rip snorting western town with bars, 10 gal. hats, friendly people, etc. Here I am right over a bowling alley with a juke box. Since I got in at 4:30, with awfully uncomfortable soaking wet feet, I have read 4 stories out of the Thrilling Detective which was in my room, and had meatballs for supper.

At Gladstone today there was a splendid photogenic meeting, some 40 farmers, in a pretty cramped room. I'm of the opinion I got some good ones. I barged into a one room country school-house and frighted the pretty little school marm out of 14 yrs. growth. I didn't get very good pictures there. I look on it as practice. Tomorrow I propose to find another, get there shortly before lunch, take lunch pictures, snowy games in the yard, etc. More of the usual roadside stuff today, with noth-ing remarkable.

I'll be running out of film and bulbs soon. Probably enough to take me to Williston.

Maybe I will go to the high school glee club concert tonight. Or read North America.

I wish it was summer and I was just home from work at 4:30, and it was hot and me and you and Ann went down to the pool only you couldn't go in because you were pregnant, so me and Ann went in, and she popped right into the big pool without batting an eyelash, then we went home and I drank some beer and listened to my records and bugs buzzed around our yellow lamp, and it was night in Greenbelt in the summer. Only it ain't. Besides, of what usefulness is that life, anyway those days are gone forever. Remember Pearl Harbor.

V.

FEBRUARY 28, 1942
Bismarck, North Dakota

Friday night.

Wife:

here I yam in that hotel which has square holes in its bathrooms through which you can look into your bedroom. This is a mahvlus hotel. Room and bath a dollar and a half. First bath for a long time. Pink bathtub. I don't think this hotel was ever completed. Looks like it was built about 1929. Unfinished fixtures all over the place. Elevator is a freight elevator. Those square holes I'll bet were for radios.

No mail forwarded here from Dickinson today. Gawd I am wrath with my office. I will be very broke when I get to Williston and if my check ain't there I will be in a pretty pickle.

This morning it stood at 17 degrees below zero in Hebron. The car barely grunted. 75¢ worth of pushing made it move. I got a cardboard radiator cover, and it makes a tremendous difference in the effectiveness of my heater.

What I did today: early in the morning some rather nice cold snowy farm scenes, farmers at mail-boxes in wagon, etc. Then twice I stopped at rural schools up county roads. None are on big US 10. You go 6 miles up any county road off 10 and there sure enough is country 1 room schoolhouse. At one of the schools I got good pix children playing with snow fort, sliding down hill, and playing snow

game: cut the pie, which I too played as child. You make this figure [*drawing of wheel-like figure*] with paths in the snow, etc.

I also took classroom shots, one with a lunch pail. But I've got to go after that again. Still haven't got the feeling I want: snow outside, cold lunch in a pail, pretty Dorothy Ekvund with blonde pigtails sitting in front of me. I get all my country school feeling from a library book I read about 4 times when I was in grade school "Jolly Good Times at School (And Some Times not so Jolly)." It was written by a woman. I'd like to read it again. It filled a definite gap in my life back there.

Bismarck puts me an hour closer to you. I got here at 4:30, perhaps—Sunny and thawing when I came in. Not nearly so much snow here as 50 miles west.

I admire that state capitol a hell of a lot. I shot at it again tonight, with horses in front of it.

I saw a movie tonight. Chester Morriss, Jean Parker: "No Hands on the Clock." The kind you would never go to. But jeez it was good. Thin man stuff, a little High Sierra thrown in, and stuff all its own: unusual characterizations done lightly—a beautiful blonde with a very ugly smile.

I'll probably loaf around here until sometime Sunday, then head for Williston, spending Sunday night at perhaps Dunn center, or Grassy Butte, or Watford City.

Tonight I load up the last of my film. I'll use most of it Sunday. Don't plan to do much tomorrow except wait for mail, see FSA and OCD.[14]

Two little kids—boy and girl—out of class of about 10, in rural school this morning, began to *cry* when I shot off first flash bulb. And sobbed piteously for the next 20 minutes. Scared I guess. There is really something very remote and touching about those schools and farm kids. It all seems so far away from civilization and education I mean education in the frilly sense of your damn nursery schools. These are so human. The teachers are all timid little farm girls themselves. But the kids crying about the flashbulbs, that got me at the heart.

I'll bet you need money badly.

I saw a Don Winslow serial tonight. Don and Red look very much like the guys in the funnies. Clair Dodd is Mercedes.

Write to me when you are feeling stronger.

Give my best regards to Ann.

Your last air mail letter came postage due.

You never commented on my accounts. Why didn't you inquire about that 2.05—liquor? I finished it in Hettinger. Now in North Dakota, the same bottle would cost about $4.00. And it's very cold here. But I'll wait till Montana.

I'd sure like to see you, see if I remember right. You are my girl.

[*incomprehensible set of symbols, numbers, etc.*]

MARCH 3, 1942
Williston, North Dakota

Tuesday afternoon.

My sensible girl:

No letter this morning from ya, nor Stryker. But perhaps this evening. I got some more contact prints. About 50 mostly from the McRaith farm. And a few more negatives they deemed undeserving. I'm now looking at the whole batch of prints a little less blackly. I guess the main trouble is that they are all just formula pictures, they look like Farm Security stuff. And I have no reason to hope that anything I've done thus far will look different. And I am so damned anxious to put new blood in them, new ideas, approaches, and to say something different with them. Please think about it all: U.S.A., the Great Plains, Winter and Spring. War going on. And send me some suggestions. Both subject matter and approach, angle. Seriously, please do that.

I went to see the county supervisor. He is a stupid old son of a bitch, and I wouldn't work with him if he were workable. From his point of view nothing is going on. I went to see the editor of the Herald. He doesn't know of, but he thinks he may find out of, a farm boy on furlough, and let me know. I went to see Mr. Dahl, the hardware merchant who is in charge of defense savings campaign. They don't do anything special at the schools, except rural kids buy stamps from the teacher whenever they want to. He'd willingly arrange me anything, but I can't think of any way to make a good picture out of it. He told me of a meeting Thursday in Epping to promote sales. Maybe I'll go to it. I went to see Mr. Palmer, att'y at law, who is chairman of county defense council. They just aren't doing anything in this county. No mass meetings, no mass registrations, they aren't guarding anything. But suppose they did have a mass meeting. How could I put anything into it? Just another bunch of people sitting around being talked to. I went to see the tire rationing board. They are just 3 men sitting there. So is the selective service board. So there you are. I am dry. Please don't just dismiss me as a griper, but think. What would you do?

What I did photograph today: is little. 2 shots of a tire for sale in a grocery store window, with canned beans and soap around it. That wasn't much. And about 8 shots of a Farmer's Union meeting in the library, with the county commissioners, protesting the way land is being sold to corporation farmers in this county, and viewing with alarm the future of William Co. family size farms. But the punchy part of that couldn't go down in pictures.

So there you are again. I hope you can help me solid. Or do you have just a vague idea of how I view my job, or what I think my pictures should put across?

Now it is snowing fast and wet, very wet, and it's no pleasant day.

What does H.D. mean in the enclosed clipping?[15]

I guess I'll leave early tomorrow morning for Crosby. Work there, look around, spend the night,

work Thursday, get back to Epping by 3 PM Thursday for meeting, Thursday night again in Williston. Maybe about Sunday I'll head for Glasgow Montana. Maybe Monday.

This town is noticeably more expensive than any since I left St. Paul. $1.75 at the hotel, and I couldn't pay less without living in squalor. Meals up, milk shakes 20¢ and not too thick. This is more nearly in the concentrated spring wheat area than any other part of Dakota I've been in except Aberdeen. Last year was the most profitable year for farmers around here since 1928.

Perhaps I'll caption my damn pictures tonight. I wish I could send them to you so you could give them a gander.

I shall mail this now at the PO where maybe I'll find more from you. Had a letter from brother Robert yesterday. He is a good sort, and not nearly so tight and opinionated as he seems on first rub.

Count me in, and pat the young ones on their heads for me.

Yours all right. J. Felix.

MARCH 20, 1942
Butte, Montana

Friday—5 PM

Dear whoever you are—

Now I am sitting on my dead butt in Butte, regretting a very abject and cowardly performance of about 3:00 PM this afternoon. Everyone has been telling me about the Big Hole Basin, that is where you find 12 feet of snow on the level, and herds of cattle 6000 head being brought their feed on sleighs. Lots of hills to climb up and photograph down on them. So today I made out for the Big Hole Basin.

From Dillon I turned left off US 91 at Divide. I got as far as Wise River. I would have had to get pretty close to Wisdom to be in the Big Hole Basin. The road, between Divide and Wisdom was one lane bumpy full of puddles holes heavy snow hilly and *cliff hanging*—I got to Wise River which is a gas station and asked how the rest of the road to Wisdom was. The guy says the mail stage makes it every day. It's about the same as it was from Divide. So I sit in the car deliberating for $^1/_2$ hour at the only chance to turn around I had seen in a long time. I buy some candy bars for lunch and deliberate some more. Then I turn around and go back to US 91. There was some wonderful scenery in there. And an awful lot of snow. I am demoralized from my turning back and going into the soft comforts of Butte. Maybe I'll do it tomorrow, and delay Kalispell until Monday. Or Tuesday.

This morning I was at a big sheep ranch where there were numerous little lambs born last night. They start walking and frolicking as soon as they are born. They really frolick.

They are the cutest damn things I've ever seen in my life. They don't seem to have any fears; one kept following me around and mugging up to me. About one in every ten seems to be black, but in a

big herd of sheep there seems to be only one in 1000 black. I guess the black ones just don't get saved. When a lamb is born the lamber, a guy, has quite a busy problem keeping him alive. I don't know all the details, but he has to pull its wool over it, and force its mother to pap him. I think maybe as many as half die. They are so goddam cute and lovable, following after the big old smelly sheep trying to get a pap. And they keep saying "maaaaa" in a high pitched little voice that gets you right in the heart. There are "lambing crews" going around the county, specialists in saving lambs. Lambing proper—I don't know how they control it—doesn't really start all over until late April and early May. This place this morning was an exception. I should have stayed there longer. But I started for the Big Hole Basin, and rescinded, and resulted in having a flop of a day.

Tonight I guess I'll write to Stryker and go see Sullivan's Travels.

I've been wearing a uniform for two weeks now of my well patched and well worn taking an awful beating suit, my brown tie with spots on it. Also the same sox and underwear for two weeks. I am very smelly. I am very happy this way.

<div style="text-align:right">

Yours sincerely,

John.

[*drawing of lamb*]

</div>

MARCH 24, 1942
Kalispell, Montana

Dear Wife,

This is a hell of a life. I was in good spirits. Buoyed by Stryker's kind words about my pictures. Developing interest in my new assignment. Even beginning to look at my contact prints and think they looked pretty good, that maybe I was too particular. Now. 11 of my contact prints had Stryker's initials "usc" on them. I figured it meant he was sending them to US Camera annual. They looked all right to me. Not the absolutely best of the contacts, but pretty good ones. And if Stryker liked them, o.k., I said to myself. This afternoon I get a big package containing all these prints enlarged to 11×14, a note from a girl in the office saying Stryker wanted me to see them, and to send them back right away. O MY GOD THEY are awful. Fuzzy, out of focus, and unsharp. Totally lacking in the real photographic quality, depth, crispness, sharpness, good color—qualities which contact prints will deceptively indicate. I wish you were a photographer and could know exactly what I mean. It is no secret to me why they have come out lousy thus, though I had hoped I was avoiding it. I have not used a tripod since I've been out. Do not air that fact. It's been cold or windy or snowy, and I got all out of the tripod habit. Now I can expect every damn print to enlarge, even to 8×10, fuzzily. No respectable US Camera annual would ever look twice at these prints. So there I am. O sister ain't that hot. I will probably use a tripod from now on. But great damage is done. My photographic reputa-

tion is permanently lowered another notch. Stryker will have instantly retracted all his kind thought about the work I am doing. These were mostly long shots, you know the kind, that show my wonderful feeling for the great plains. I see some contacts of close up subjects, portraits etc. which I will write and suggest to Stryker as substitutes though it is now probably too late. I am a bastard and especially a stupid bastard.

Next item. My next address, starting about Saturday will be G.D. Hamilton, Mont. Letter from Stryker this morning tells me about special job I am to do. One of these COI ones.

I go to a clinic at Hamilton where they have discovered a new serum for typhus and a new serum for rocky mountain goat spotted wood tick fever. I dramatize it. Laboratory shots, emphasize the doctor who discovered it. Fancy lighting, etc. etc. I think I will enjoy that sort of job for a change.

He said to me, Stryker, "before you will be able to do this job you will have to get inoculations for tick fever and typhoid." So this morning I went to a dr. and turned my case over to him. He gave me 1 shot for tick fever; I should get another in one week and then I am immune. Typhoid shots take 6 weeks, 3 shts, 2 wks apart he said. Anyway, he said, you don't get typhoid in this part of the country, much, and anyway typhoid ain't the same as typhus. So I got no typhoid shot like Stryker said, because the dr. wouldn't give me both on the same day anyway. But now come to think it over, I don't know what is the difference between typhoid and typhus. Maybe if I work in a laboratory where there is typhus whatever that is I will get typhus. So I will ask them when I get down there.

I am waiting in Kalispell until I get film and further letters of credential on this job. Meanwhile I will finish up the project here. Today I went out with the mgr. and photographed the project sawmill, using no tripod, of course. Tomorrow I go all over two counties with him and another guy getting pics of the families on the project. Then there can't be much more.

Thanks for the pictures.

Did you worm out of Irene where Jack is,[16] and will you betray her confidence to me? How is she?

I am quite unable to give you the two months forecast schedule you ask for. I thought you knew that, had gleaned from my letters the approximate state of my knowledge of what I am doing why and how long or where. Hamilton Mont. as I said before. "If you don't want me to talk to anyone about your whereabouts can't you give me some idea of where you think you'll be in April and May" you say. Such a stupid question, I say. Your late letter writing indicates a need for me around you to leaven you. I disapprove of cant, pettishness, intolerance and humorlessness.

Where do you keep the telephone? where does it sit? And what do you mean about the stack of PM's on the desk? have you bought a desk?

Say something different in your next letter.

Sincerely.

6 PM Saturday

Well dear Millicent I am still in Kalispell and I am angry again. Why does my goddam office never do anything they say they will. A week ago yesterday a letter is written telling me stay here, further instructions and letter of credential will be mailed Monday. Wait for them. I even get steamed up about getting a definite assignment and start putting my whole heart into the test tube pictures I am to make. Now I must keep waiting in this goddam town. Not getting any more letters from you either, like I didn't today because you probably wrote to Hamilton.

All I did today was caption all my contacts which was quite a bit, all of No. and So. Dakota. About 4 PM I went out and made half a dozen farmers in town shots. I am slipping away continuously. I can't take good pictures any more. I sit in my room and think, look at US Camera, and my prints. I figure out all the rules and right approaches. I know good pictures from bad. I have ideas of what to do. When I'm out without my camera I sense wonderful pictures and know just how to make them. But every damn time I get into action I seem to fall way short and hurry out of my situations. It's mainly in my approach to people. I don't seem to have anything to tell them, any reason why they should cooperate. I am a timid fumbling son of a bitch.

Irish Whiskey is the best whiskey.

Tomorrow I will have to take Sunday dinner with the goddam Harper family and that is another reason I wish I could have left this goddam town this afternoon. There is now too much of a good thing.

This afternoon while I was going up and down the main street looking for pictures I turned down a side street and a young man with glasses, new green suit and hat, awfully clean shirt and appropriate tie whizzed by me on a brand new bicycle. Then he circled 2 or 3 times out in the street, then he went back the way he came from. I thought I should have hailed that guy for a picture, he is a sign of the times. Pert sissy looking young business man of Kalispell on a brand new bicycle. As I start walking around the block up pops this guy again, wheels past me, looking at me, turns and wheels by again positively watching me. So I accost him and tell him I want his picture as a sign of the times. Jeez he gets a nasty look. Where's your license he says. You gotta have a license to take pictures in this state. We get into some little discussion about that and I am very unkind to him. Finally he decides that I don't need a license. He turns out to be the town photographer, in a studio, and he'd been watching me, and thought I was taking pictures of people to sell to them, at personal profit, and he didn't like it. So then I took his picture on his bicycle, and we part, reconciled, but sour.

The goddamnest thing ever happened as I walk back the main drag. Honest. It's all quiet and you don't hear nothing, when hrrrryhhhhnggggggg! An airplane, not over 200 feet above me goes straight

up the main street, fast as hell. US Army it says on its wing bottoms, and then it's gone.

Today I still wore my sheep skin but I looked funny and was not comfortable. Tomorrow I'll probably put it away for the duration. Nor can I wear my overcoat anymore. It's warm. Spring. Sunny. But I can't wear my suit anymore either. Without a coat to cover it my seat holes and patches are too much. So I now go into my new suit. And unless I buy myself a pair of side pants I'll just wear the pants right off my new suit, because I am being very hard on clothes this trip. Shall I buy a side pants?

Please buy Ann lots of Easter eggs and accoutrements. Give her the real McCoy with baskets, buntings, eggs hidden under the bed, etc. I would have wanted it that way.

In the enclosed test I score 85. I think I'm pretty damn good. What do you score?

Coronet is a real stink of a magazine, but I should think awfully easy to write for. Readers Digest type articles that aren't good enough for R.D. Why don't you nail them with something in your spare time. I'm sure you could succeed.

In a thinner letter I will tear out the 12000000 black voices pages and mail them to you.[17]

I find the blot test very interesting; I would like to see the book. What do you find?

All of my love baby.————————86

MARCH 29, 1942[18]
Kalispell, Montana

Sunday aft.

Dear facts and figures:

I get very worried and uncertain, sometimes, about what is happening to my life, what is going to happen to the rest of it. That is the immediate future of it, not the moral or intellectual aspect of it. When do I finish this trip? Then what do I do? Go out again after 23 weeks? And so on. Likely yes. So of course one problem is that unless my photographic goings out hold large measures of photographic enthusiasm, eagerness to make pictures I think are good, and a degree of ability to consummate ideas, I will very soon lose even the initial enthusiasm with which I greet each new trip.

But here I lie thinking about Greenbelt, home life, what I'd like to be doing, and all that. Pleasant thoughts to dwell longingly on, and what adds to the nostalgia or bitter tenderness with which I think them is the ever present fear that that stuff is all gone, those days are past, no more of it. You might say foreboding. For instance nothing is so pleasant as to think of sitting on the front porch drinking cans of beer, late spring, nice familiar sun at Greenbelt, little Annie poking her head out the screen door. That sweet life never seems so very much while it's going on of course, but it is contented, good level contentment. But when do we have that again? I've got to be home settled to really have that, and I'll always be making these trips, or getting home and being drafted, or moving out of Greenbelt, or you

will be getting pregnant again, or Annie will be a damn gangling homely child when I get back to her, outgrown the part I like to think about.

Almost as pleasant as thoughts of the front porch, beer, sun etc. are those of you and me in sex activity. I watch us running all over the place with no clothes on, going through repeated tireless variations. Thorough exploitation of our good thing, really using it to every possible shade and advantage. Gawd how I want some of that now, real vigorous taking you in all over. I don't suppose you ever feel that way, do you, or get burning up about it, or even think about it? But what will happen, I'll get home for my hurried 2 weeks between trips, and we'll have a few orthodox between the blankets in the still of the night when everybody else is doing it go's. Then off I'll trot to make more pictures I'm not interested in and live in more hotel rooms and live the life that is not the life I would mold myself.

If you had taken that house I wanted, with the dining room, I would not now be working for FSA. No. I would be working on my 2nd novel, my first novel already published. But no it was too far from the nursery school.

I have advance glimpses of your reaction to what I say here. I even see the mold of your lips as you mutter "malcontent." But I am a smart and capable guy. I want to do lots of things, and also be around you and the children I had something to do with getting.

I certainly love you, don't I, whatever that is? I wouldn't spend so much time in writing letters to you but that I love you very much, because I married you, and you are strong natural part and end of my life.

Well write to me sometime. Jackson.

APRIL 4, 1942
Missoula, Montana

Saturday night

Dear harlot:—

This is, beyond all doubt, the finest hotel I ever stayed in my life. Everything big, beautiful, modern. Glass doors on my shower. Luxury. $2.50. So I had a large steak meal, bought a new tooth brush, tooth powder, olive oil. Clean shirt. I put my brown one in the laundry bag for keeps this time. My 2 overcoats and boots are getting dirty in the trunk. But they'll need dry cleaning anyhow.

No mail today. Are you going to read only the picture captions in North America? If you find difficulty in getting excited about the book read Chapter 10, Appalachian plateau and upper Ohio valley. That is one of the first ones I read, and it sold me.

Thinking more and more about your coming to meet me. Don't get me wrong. It's for you to decide. But it does not look very good to me. Why don't you compute the cost? Remember I couldn't

be justified in driving any large distance to meet you. Even an annual leave, I would be using up too much time. So there is a healthy railroad fare, a doubled per diem. No doubt a wage to someone hired by my mother. So with all that money we could take a very pleasant little New England vacation after I got back, hiring someone to care for children, disposing otherwise of them, or taking any or all of them with us. A *very* pleasant New England vacation. Quiet, relaxed. Vermont. Maine. Quebec. You will have your western fling, dear, some day. But you think this over, do your own figuring and make your own decision. If you decide it is wisest to come on out, I will greet you with open arms.

Today I practically gave birth to a lamb. During the lunch hour, I was waiting for the lambers to get back, and I waited all alone in a big field of about 100 pregnant ewes, the last of the herd to come through. Most of them were just lying or walking around slowly, looking awfully fat. But I come upon this one old girl lying down and going through the motions, which I took a picture of. Then I see this thing coming out, looks like bananas encased in lemon jello. It's the head, which she has a little trouble with. Once that got out, she stopped and rested for a minute, then stood up, and as she walks away all the rest of the lamb in this lemon jello just slides out and drops on the ground. The ewe turned around and took a smell of it, then walked off and left it there. I missed a picture of it dropping because I didn't know what was going to happen—it all came out too fast. I went up to get a real close shot of the new lamb, and that made the ewe go off much further and turn her back to us. The lamb stayed perfectly still, dripping and gazing ahead like a tombstone lamb for about a minute. Then it seemed to be shaking the goo off its head and trying to stand up, just putting its legs out and straining. No sounds yet. About 5 minutes it tried and then it got itself stood up on all 4 legs. Stood perfectly still for a minute, and then tried to walk. He'd fall down altogether at first, but pretty soon he'd take 3 or 4 steps ahead, then fold up on one or two legs. At this time he started his piping maaaaa, which gets me right in the heart. He made for me, and started licking and rubbing up against my pants leg. Then as I'd move away he'd follow me just like I was his ma. So I felt responsible, especially, as I had scared his real ma off. Supreme effort, I picked him up—he was shaking too, cold—and I carried him over to the ewe who was lying down. She moved off when I came up but then went back to the lamb and everything went off as it should. She licked him all over and soon he was poking around underneath her. I got lemon jello all over my hands.

One of the lambers at this place was very disagreeable at first. He talked broken english and snarled and said department agricultursh piczurs bullshit goddam horshit bullshit all it is. I didn't like him at all, but instead of being nasty I was full of smiles and agreeableness, and pretty soon he became quite co-operative, and told me much about himself, and it was quite pitiful and damn near made me cry. He hates wars. He is a Russian born, was in the cossack army in 1904. He had 6 brothers killed in the Boer war. Now his two sons are taken into the US army. He tells how that makes him feel with real Russian emotion. He made very strong beautiful statements in parkya carcass english about young men full of happiness getting all blown in pieces, about God made enough for everyone to live happy

and we don't need wars. He says he thinks about these things and wakes up in the middle of the night with tears in his eyes, not for his sons but for all the young men. That's the way he meant it too. I was pretty damn moved.

I have a few pictures planned around Missoula tomorrow, but mostly I will read the Sunday papers in my luxury room, and check out about 5 PM for Hamilton. Hope to find public health authorizations there Monday.

When I finish at Hamilton I plan to really go to the Big Hole unless something else comes up. I've heard still more talk about how wonderful it is. I saw the road to Wisdom that goes east off 93 yesterday. It went in about 10 feet, then it was snow piled about 10 feet. I'll go back to Divide.

Write me much, Hamilton.

<div style="text-align: right">Yours. Johnson.</div>

APRIL 7, 1942
Hamilton, Montana

Monday night

Old twist:—

Two letters from you today, and one from Stryker mailed March 4 to Williston to Glasgow to Lewistown to Helena to Kalispell to Hamilton. Had I received it when I should have there'd been a different story sung over the past month. It was full of the kind of advice and ideas I languished for back then.

Today I have seen everything. Little lambs being castrated, ears slit, tails cut off, paint brand put on. I ain't kidding you, this is how the castration goes: a guy slits off the end of the scrotum with a razor, then he gets right down there with his mouth and sucks in the testes which he comes up with a mouth full of and spits out, then spits again and proceeds with the routine. He's bloody all over the face. Isn't that awful? The owner says there is a machine to do the job, but most people do it this way, as the machine kills too many lambs. I now remember the expression "anyone who would do that would suck sheep" to which I never attached any meaning.

It hasn't been a very sunny day, and those lamb pictures were about all I got. I am definitely through with sheep now. I don't want to see any more of them. I want to get a lot more cattle pictures, especially rounding them up, driving them into the corral, which I got some of, but aim to do in the Big Hole Basin. That road you see on your map east from Hamilton toward Anaconda is also closed. The only way I can go is Missoula-Drummond-Anaconda-Divide—a couple hundred miles I guess. So I don't want to go until I am through with Hamilton for good. I have no more ideas of what to do around here, and I'm waiting for the further information and letter of introduction that were promised for this public health job. I don't understand Helen's telling you I would make my own contacts—I don't know

who to contact about what. But probably if no mail comes tomorrow that is what I'll do. Where, also, does she, Helen, get the dope that I will be in Hamilton 2 weeks? I provide no schedule for my office force. And if this public health job begins I daresay it will end in 2 days at the most. Then I will be off to the Big Hole. Later I will give you a new address. Do not write to Wisdom as it might take too long getting in there and too long getting forwarded. Also do not write to the Hamilton Hotel as you suggested. Use only the addresses I give you. I prefer to leave a forwarding address but once in each town.

Do you really think a new advance is necessary and should be applied after immediately? I don't know whether I left any more signed requests with Charlotte. Do you know Charlotte well enough to talk it over with her? If you do, why go ahead and make all the arrangements.

I'm sorry you didn't see the Dakota prints at the office. There has been almost no Leica work, although there should be. Your comments are interesting, I suppose—about the pictures you saw.

I'll send you as much of the next paycheck as can be managed, also of any travel check which might filter into me. I have now left 30 dollars. Plus 25 silver ones which I am saving for Ann to play with, in the glove compartment. I hope I'll not have to disturb them.

Why is Silagy leaving? Will you have him perform that minor operation he suggested before he goes?

I'm so happy that you are training Ann to listen to Red Skelton. She needs a father.

Perhaps you are seeing too much of Peggy. Your letter style smacks of her.

I grow weary of how you make no intelligent recognition of problems or moods I strike in my letters to you, and shortly I shall break off my correspondence with you.

By all means,
Gaston

APRIL 11, 1942
Hamilton, Montana

Friday night

Dear Penn:

I got a headache.

While you were probably having a chocolate sundae this noon where was I? I was in the dentist's chair. At breakfast a large segment of tooth came out in toast and left a nasty hole. I just had the dentist put in a temporary cement filling which may or may not last until I get home. At that time there will be plenty of dental work for this Apple. Let's have it done and just not pay for it like we do department stores.

I finished just about everything at the institute today. A few more shots tomorrow morning. I shall state that I think I've done an excellent job: careful, painstaking, tripods, well lighted, thorough. A few places where I was imaginative, directed and made up my own pictures. Not many such places.

Not as many as Delano would have found. Mostly I just took good pictures of what I saw there. At least in some 70 shots I didn't deliberately make any which I knew were no good. And there is something to think about. That's what I so often do. Deliberately make lousy shots knowing they haven't a chance, just because I can't see or can't put together good ones.

Honest baby I got so much headache that I'm gonna stop. I'll mail this in the morning if I don't have a free headacheless period beforehand to add here to. Tomorrow afternoon I'll leave. Probably arrive Dillon Monday night.

<div style="text-align: right">

Love yr [*scrawl*]
John

</div>

APRIL 22, 1942
Wisdom, Montana

Tuesday 5:30

Solid Sender:

I've got to come back here again. I want to live here and raise my children here. It keeps growing and growing. If I stayed 2 weeks I wouldn't even leave to go home and pack up, I'd just send for you. Once you see this place you can't really Love any other part of the world. Absolutely the best squarest people on the whole goddam earth. If you're a heel or a bastard you just get run out of here, and there ain't any.

I shot around today on two ranches and in a general store. But not much—there's only that one feeding picture to keep taking. Any other time of the year would be wonderful for photography. I had lunch at a ranch today. Swellest goddam people. Nobody gives a damn about money either. All the bartenders buy you a drink every time you go in—whether you're buying or not.

Last night 2 soused cowpunchers had a real slugging knocking down rolling on the floor fight in the joint next door. People sat around playing cards and talking, not even noticing there was a fight. After a few minutes I ran and got my camera, and when I came back they were buying each other drinks and lighting cigarettes. They wouldn't fight again for the camera.

But I've got to go on. Get my check somewhere, wonder where. Don't think I can wire here. Sometime tomorrow I should wire office Idaho Falls address. You write me when you know where my check was sent will you. I'm going to be busted as hell and will probably starve a few days if my check misses connections. Don't know why in hell I'm going to Idaho Falls. I don't have to shave here either, and nobody's feelings are hurt.

Well I got to eat now.

<div style="text-align: right">

Love,
John

</div>

APRIL 25, 1942
Idaho Falls, Idaho

Saturday night

soda jerk:

I am not pleased that I rec'd no letter from you today. Only 2 all week. And no check.

Ernie Pyle divorced that girl last week Time tells me.

I had a haircut and shoeshine this morning. Talked with the chairman of the Selective Service Board, who doesn't think my request for pictures makes much sense, gruffly. But to come around Monday and we'll see. Then I worked arduously until dinner time on captions. The Hamilton job is looking sadder and sadder to me. I'd almost like to go back there now, because I'm in a position to do it much better. But I'd rather go home.

Last night I saw the double feature of Conrad Veidt "Nazi Agent" and Robert Young "Joe Smith, American." This last in good patriotic American way propaganda which I enjoyed very much.

Salt Lake Tribune is a good paper. Much like the Washington Post in appearance and smell.

It's been a pretty unpleasant day with snow blowing in the air.

This is perhaps the sort of town one's parents would like to settle in. It's very clean looking. But I don't like it. I never seem to like towns in the midst of prosperous fruit growing areas, or vegetables or potatoes. Something about all the people, businessmen, the looks of guys on the street, that turns my heart the other way. These patioed towns, like Erie, Pa., where almost everyone in town fits into the C. of C. view of life.

Japanese are quite numerous here. They have recently closed a Japanese language school. And again I can feel what a lousy rotten thing is happening to some people from the brutal bitchy senseless attitude of the citizenry. Two little Jap kids in the barber shop. The barber cutting my hair says "some of these Japs around here get to thinking they're white men" and the Negro shining my shoes agrees with him that that's bad. There's a columnist Henry McLemore I never saw before but he's been in papers ever since Portsmouth, Ohio. He honest to god thinks all Japs in America should be shot.

This hotel, it says on the soap wrapper, is "a community enterprise operated and built by 450 active businessmen and representative citizens." It's a very fine hotel, and now I'm in a good comfortable bathless room at 1.50.

I have still a heap of captioning to do tomorrow. Monday follow the registration. Tuesday and Wednesday to Wyoming. Wednesday night and Thursday morning back here again. Then I have no idea.

I hope you've had the decency to write me some letters which I'll get Monday. And maybe tell me what you know about my check. I am nightly short, Evangeline.

I sure want to get to hell home.

You be a good girl.

Master.

Idaho Falls, Idaho

7 PM *Wednesday*

dear sweet girl whom I am privileged to call wife:

A letter from you this morning and a letter from you this afternoon. Now I can expect no more I fear. You are waiting for my new address as I am. These wires to wait for important news followed by long silences make me blind with rage. I am impatient, unable to proceed with my functions in any orderly fashion.

I am losing my color for library pallor, which is where I spent all of today. I read through the entire year 1928 of TIME, following most closely letters to the editor, the presidential campaign, cinema, and books. More extremely interesting, touching, amazing things turned up that way than I shall ever think to tell you. Because of knowledge of after events and TIME's goddam know it all attitude, it was the most thoroughly engrossing type of history reading. Much more exciting than reading a present day TIME. It would be wonderful to own a file like that. Subscribe to TIME will you? And we'll save all our issues for a year. Really do that.

There were letters to the ed. from John H. Hammond, Jr.[19] (1928) a sophomoric sounding kid, urging TIME to devote a section to phonographic record releases, especially the "modernistic" releases of the Okeh label.

"Able sensible prime minister of Italy, Benito Mussolini."

Reviews of old movies were wonderful to read, especially the cracks at "sonucinema." Also a picture of Norma Shearer who looks exactly like you. She's 39 years old now. Forgotten movies and impressions of them I'd had in 1928, at 14, came to me very strongly. Esp. The Crowd, and one called Beggars of Life with Louise Brooks, remember her. And 14 year old Loretta Young with Lon Chaney in Laugh Clown Laugh.

Most amazing thing of all though was the really unbelievable anti-Jew and anti-Negro stuff, flooding the letters to the editor, and getting editorial support in TIME couched phrases. "TIME deplores comparison of Nordic Stefanson with a Bermuda Negro, even by himself" "wily little Jew."

The whole Smith-Hoover campaign made wonderful reading, particularly about Franklin D. Roosevelt, whom Smith begged to run for governor, but who refused on account of his physical condition, but finally accepted. He's even called "a Franklin D. Roosevelt." References to his wife read funny too. She contributed $200 to the Democratic campaign. She was teaching school at the time.

Jesse Jones, wealthy Texan, handled that 1928 convention in Houston.

Bishop Cannon I never knew about before. Also did you ever hear of a New York minister, John Roach Stratton? He had very strong views on Rum and Romanism.

The 10 point platform of the communist candidate has almost all become law—40 hour week, social insurance, child labor, etc.

Germany seemed to be having elections every week, which I didn't understand much about.

Also how about the US Marines in Nicaragua?

Hoover and Coolidge were bastards.

All in all it was a pretty lousy country back there, not at all the country it is today.

Now I am back, after having had dinner.

Slot machines are very evil.

Just think, we could've sold at 5¢ a throw for 10 bucks those records we traded in one night for six.

I hadn't heard about Arthur.[20] I wonder what he is going to do.

Do you know what is Manny Gerst's new job, or has he one? I'd like a new job, too.

How would Silagy go about keeping Berenberg from a Greenbelt job, after he had resigned? I will vote for Berenberg's reinstatement. Did you get your operation yet?

What are these birthday cards like, that Ann is all the time making?

I don't understand whether this jealousy of Ann's you mention is possessive jealousy of brat Brian, or just personal feeling neglected jealousy. Clarify.

I don't know what the hell you're talking about, me and Patty Beebe putting our choices in exact order. What did she do? I didn't really mean anything by it. Just an expression of reaction while fresh from reading them all, and of course it can't be exact. But I'm sorry you weren't moved with that Anatole France story. It still stays with me and is sort of stinging, the sweep of history from various perspectives, and the futility of Jesus.

As to Paul's Case, that was a wonderful adolescent story. It's almost exactly the story I had outlined and ready to write once, the one the secret service found on me in the basement of the White House. Doesn't Paul look just like Ted Jung, junger?[21]

Now about those Oregon guerillas, I did use the word fascist loosely, but I thought you always used it that way and wouldn't notice. What I meant was that with their guns and their unpleasant faces they'll never do anything but harm. They just looked stirred up, and blindly emoted by a wrong sort of leadership. They looked like lynchers. Did you see the picture?

If I don't get my letter from Stryker tomorrow it's another day at library for me. I'm just in no mood to go looking for photographs. He should have told me to go to wherever this special assignment is, and sent the letter there. Unless it's right here which I hope not. I'm awfully satiate of this stinky town.

Do you want to know what I think are my favorite places in the US, for liking, and wanting to live at? This is that Patty Beebe game, only they ain't in order: Big Hole Basin, Wisc-Iowa driftless area, New York City and north up Hudson, Chicago, Missoula, Minneapolis, Ozarks, Pennsylvania area of Chambersburg Mercersburg Greencastle, etc., Iowa cornbelt in Spring anyway, and of course Ver-

mont where you and me are going to go and spend a month together before we get married or have children, living on farms in adjacent valleys, not seeing each other or having any sex relationships but figuring everything out together and having much relationship. Also Greenbelt is one of the places I like and most want to live.

Now I shall tell you who are my favorite writers: Thomas Wolfe, James Joyce, Farrell, Proust, Shakespeare, Whitman, Robert Herrick.

My favorite music is Louie Armstrong, Jimmy Noone, Jelly Roll Morton, Muggsy, Beethoven, Al Jolson, La Valse, me singing for myself, A good man is hard to find, and you playing the piano the way I wish you would.

The very best movies I've ever seen are Night Must Fall, Stars Look Down, Plow that Broke the Plains, The Crowd, Modern Times, I Met a Murderer, Jazz Singer.

The people I like best in all the world are you, Annie, Feely and Kennedy.

But also very fine people are all the people in the Big Hole Basin, Lou Gitter, Phil Brown, Drs. Silagy and Berenberg, Arthur Rothstein, Jack and Irene, George McMillan, F. D. Roosevelt, Henry Wallace, Dan Baker, and Ed Locke.

I am very fond of cheese, wine, beer, whiskey, rum, brandy, Renoir, Manet, Van Gogh, Rousseau, Gauguin, Picasso, Matisse, and many others whom I cannot recall at the moment.

I also like the incense, candles, doctrines, and everything Papist and Roman Catholic except the priests bishops sermons and people who are Catholics.

My favorite fruits, in order, at this time, are 1. pear 2. orange 3. apple.

My favorite ages for people to be are male: 10, 11, 12, 20, 21, 24, 28, 29, 35, 58.

female: 3, 7, 8, 11, 12, 13, 16, 17, 18, 19, 20, 21, 22, 28, 29, 30, 31, 32, 33, 34, 35, 36, 37, 38, 79.

I am predisposed to like all Jews, Negroes, Scandinavian women, Mexican women, or people from Iceland Labrador or the Northwest Territories.

Thursday has always been my favorite day of the week. October and November my favorite months. These are things I've never told anyone before.

All in all Montana and Wisconsin are my favorite states.

I have no favorite colors because I like all colors very much except certain purples and lavenders which I almost never like.

My greatest ambitions which I reasonably hope to fulfill are to play the clarinet, trumpet, and trombone creditably. Write several novels and plays. Have extraordinarily active sex life with my wife. Acquire many many more records. See my daughter turn out favorably and be on good terms with her. Visit extensively all of the U. States.

I do not wish to belong to any clubs organizations or parties at any time.

I wish to gain 20 pounds and maintain that weight, have my teeth fixed, and grow a mustache or beard occasionally.

I wish never to play bridge, pool, tennis, golf, handball, or My Old Lady is a Funny Old Lady.

I wish to be separated from my wife for periods of approximately six weeks, twice a year, till death do us part.

I wish within a few years to find a remunerative occupation other than photography.

I wish for a private room at home.

I wish to live until the age of 96.

I stand for the abolition of wars, exploitation of peoples, and the means thereof.

I wish to know many more people than I do now.

I will defend Russia, Catholicism, vegetarianism, obscurantism, sentimentalism, and all literary movements.

<div style="text-align: right">

Sincerely
Johnson.

</div>

MAY 8, 1942
Lincoln, Nebraska

Friday 6 PM

Dear penny girl:

Well what do you say today? I say I love you, that is sure. I sent my mother a Victor album for M.D. Paul Robeson singing that ballad[22] of which I am a little dubious. I also sent her a bunch of posies for Easter, if I didn't tell you that. But to you I sent nothing for either occasion. You don't mean much to me for such festivities. You are neither my resurrection nor my life, and your capacity of mother— well in that I have some interest, but no real absorption, and I cannot sing you any mother songs. You are mostly to me, right now, someone I want to lie down with, who smells good, and interpenetrate with. And then I want you in a companion way too, that is looking awfully good, and not having a soul too completely within my understanding and comprehension. But my God. I haven't seen you for as long as some people know each other. What are you like? You can't really write letters, I think I see. It must be only you yourself, otherwise it is A went to bed at 6:24 after a 19 minute nap B woke up at 6:49 whereupon I washed two slips and a toidy dydee which took until 7:04 followed by a fertile dinner of brisque lamb, tomatoe chops, filets of grapefruit, potatoes en shreds, boiled meringue, beef tongue, whole wheat biscuits, and mint tea. Now Pennykins, I am not passing judgment, I am only making observation, like water. I know there is no one as wonderful as you. And we all know men and women are different, perhaps sometimes not different enough. Maybe if you read Ulysses you would understand woman as she is, then Time and the River and Web and the Rock to see how one likes to think of her.

The only mail I got today was from US Camera, requesting my usual 200 words to accompany my picture in the annual. South Dakota farmers standing in front of a grain elevator, do you remember it? Twice South Dakota and thrice grain elevators. I am marked. This one is exactly like the one that said union:

[*drawing*]

I talked with Floyd last night. Sad. He is no longer head man here. A Bob Ryan is, which is confusing, as he is altogether as stupid as Floyd, but in his own different way, and I was all ready and set to work with Floyd. Floyd couldn't come in today. He'll probably call me up tonight. Ryan and I talked over the situation end quote all morning and afternoon. At least I successfully discouraged that he should come with me. The upshot is that I'll leave, probably tomorrow, for Grand Island, Kearney, North Platte, Scott's Bluff way. Parallel to the way I've just come from. I'll spend a week with sugar beet planting, corn planting, gardens, cheese factory, chickens, other nonsense. Then come back here and probably wait a long while for further Stryker orders, farting meanwhile around with regional boys. Next week will work out OK, and produce, because I'll be alone, but it won't be what these boys expect me to get, and I fear for after I get back. Here is the contrast between the straight thinking of these guys and the loose thinking of Stryker. Ryan and company think straight from A to B and back again in a flash. This is the Farm Security Administration, therefore I should take a picture of a cow and a farmer's new barn. They will never have any possible use for it, but it will be photographing what FSA does. These guys are really useless to the nation, I think. The program, fine, but not these salaried bastards who only sit. While the ramifications of what I do for the vague Stryker program, including the Ed Stanley uses, appear of at least some relative value, a reason for doing them. Even though a gravy train goes around that track too. Almost whichever way you look I don't like it too much. I would most like to engage myself wholly as an observer and reporter—probably to myself. Or next I would like to be in it somehow instead of driving a car. I'd like to be in the army or the navy, not because I want to do my *bit,* but so I can be part of what I feel is my time, age. I'm jealous of the birthright which is denied me. I'm forced to keep on living in 1933.

I'll likely visit with Jesus Christ Fahey, who is working at an ordnance plant in Grand Island.

I'll write Stryker tonight to tell him I must have Oklahoma and Texas stuff all straight by the time I get back here at the end of next week. There is no staying here. You keep writing me G.D. Lincoln. Tomorrow I hope letters from you and money from FSA.

Shovel me up,
J. Vachon

MAY 19, 1942
Lincoln, Nebraska

Monday: 7:30 PM

My little stilleto:

Have I informed you that I have become a confirmed anti-duncan-hines man? Where he likes to eat or sleep, I don't. Every town in Nebraska is full of him. Really he means absolutely nothing.

I might have to be buying some more clothing, one day. My black Montgomery Ward pants are all right out at the farm, probably in the oil fields, but not very pretty. I wear my Good suit continuously. So I might invest in something sort of haphazard and presentable. Shirts. I have only two shirts I can countenance. The blue, and the pinkish—Arrows my mother gave me. The others are frayed or I don't like the look of them. I shall only buy good shirts henceforth. Underwear. I don't know what happens to underwear. I must lose it. I wear one set for three weeks, yet I never have an extra pair in my bag. This afternoon, as I finished my typed statements to you I got a call from Mr. De Brown. He had a student lined up for me. I went to see him, John Cockle, who lives in a fraternity house. He is an L.A. boy. Reserve commission and going into the army in June. Good looking but sort of soft looking. I took three pictures of him in his room, studying for tomorrow's examination. 2 or 3 outside in front of his fraternity house. Tonight at ten o'clock I shall go to the University Drug Store, where he will be having a coke with a "date." He can give me no time tomorrow. He is all through his exams. He is going home Wednesday noon. So Wednesday morning I may photograph him on the campus, in the library, playing tennis, and he will try to get posed in a class where an examination is being given. So far I have done it pretty clumsily. Made very stiff unimaginative pictures of him. But Time marches on.

I'm tired a lot lately. The return to lower elevation has taken its toll on me. Sleep more. Eat less hearty breakfasts with less relish. Already I'm sorry I sent that letter to you this afternoon, Penny, you old fart. You probably aren't taking it the way I want you to. I love you Penny. And I don't want you to stop loving me just because I tell you a few things in a letter.

I've got to go photograph a guy having a soda, jerk. I've had a nap.

11:00 PM

Gawd it was a bungle. I go into the crowded University Drug store. There in a back booth is my John with his girl and another couple. People jeering, in the way all around. All I could do was shoot two fast flashes flat. John was embarrassed too. Really impossible to arrange lights around, or to take time enough to get at best possible angle, or even to think it out right. Just blind shootin'. My score so far is zero, and I've got my first man half used up. I've got to put more mastery into this stuff.

[*see figure 22: drawings of animals, baby toys*]

Tomorrow I'll go see Mr. De Brown again. He'll probably have another guy ready for me.

Just think. A week from today I'll still be here.

[*drawings of squiggly bodied ladies*]

What does old Phil say these days?

Does Ann draw anymore?

AbcdefghijklmnopqrstuVWXYZ

watch these [*arrows pointing to* p *and* q]

I must go to bed now.

Good night dearest old FART. Keep my love always before you.

———————————————————###

MAY 20, 1942
Lincoln, Nebraska

Tuesday night: 5:30 PM

My own special petal:

Jeez what a life. Just now I sat in the barroom with a traveling salesman from Buffalo, a big greying rich pompous looking bastard, a little drunk. He wanted to know what I was selling.

I got your Saturday-Sunday letter late this afternoon.

I keep thinking about that damn letter I sent you, hoping you don't get too sore, or decide I am a big ASS.[23]

Today I worked with Bob Aden, another fraternity boy, handsome as hell. He's really married but we're calling it his girl. Took pictures of him outside, with no sun or pleasing light, on building steps, with pillars, asking Marion for a date. In his apartment, studying. In the library. Then I nailed a Jesse Younger, pre-med student, who lives in a rooming house. Shot him at study in his room and arranged to spend tomorrow afternoon with him on the campus. Big difference in his type of guy. These other two boys were good OK boys, I liked them both, but subtly, insidiously, they were snobbish. The way they say, "I didn't know he was a Jew, he doesn't look like a Jew." I don't like fraternities from nothing. I have various well spaced arrangements with my three boys for the rest of the week, with a 4th boy coming up tomorrow. Sunday and Monday for baccalaureate and graduation. I did better today than yesterday, but the light was lousy. I'm not settingtheworldonfire in this job, I see now. I still haven't been inside a class room.

Last week in Lincoln, Sabateur, King's Row and My Gal Sal were all here at once. Three I want to see. This week I can hardly bring myself to go to a movie. Red Skelton. Twin Beds.

I appreciate all the news you gave me in your letter about lab, mural, photographers, COI file, etc. I had heard none of it before.

Stop calling me Roy's Boy or I will call you "old frayed pants."

Your writing style misuses parentheses too frequently. Why parenthesize? Nothing you say is that much less important. Good hey?

I can't imagine what Rosskam is doing around there these days. He must be doing something. Hope you bought a lamp.

I was just going to mention Wallace's speech to you. I'm surprised you hadn't read it. It's the solid sort of stuff that bucks you up, and makes you respect Mr. Wallace tremendously.

Which, please tell me, de Maupassant stories quiver your sex palate. And how? How do you feel? What do you wish?

I am going out to eat. When I come back I will tell you what I had to eat.

I had rolled rib roast. Carrots. Cottage cheese and onions. Rolls. Tea. Raisin pie. At a cafeteria.

Twin Beds is the tripiest hunk of junk I have ever seen.

Happy Birthday to myself.

I must up sort of early tomorrow. Meet Cockle at 8 AM.

[drawing] John

MAY 21, 1942
Lincoln, Nebraska

Wednesday: 6 PM

My own sweet sparring partner:

Guess who I had a letter from today. I had a letter from Peggy Zorach! I also hadaletter from yo. In addition I got my Big Hole basin contact prints, and a letter from Frank Lee. You don't need to answer my questions about Frank Lee now. I know. He enclosed a letter addressed to Lincoln's Rationing Board, exhorting them to give me tires. And is it a lousy letter, and if I couldn't do better on a letter with my genitals chopped off I would give up my employment. But what can I do but submit it with my application for tires. I don't give really a DAMN whether I get permission to purchase their stinky old recaps or not.

All morning I worked with John Cockle, in classes, in tennis garb, at bookstores, on the campus, and taking a train for home. The medical student with whom I had an appointment postponed it until Friday.

The afternoon I wandered the campus making background and atmospheric shots. One I like:
[drawing of building, baby buggy in front]

Then late this afternoon I invited Mr. De Brown, the publicity director, and Bob Aden, my subject, to my room, where we have had drinks and conversation. I don't know about guys like these. Probably if I lived here and were part of the community and of the University. De Brown is sharp, slightly fairy, but able, humorous, score knowing. Bob Aden is a guy I really like, but still he isn't strictly

FIGURE 31 | *University of Nebraska. Bob Aden and His Wife Marion.* Lincoln, Nebraska, May 1942

from my side of the fence. He is getting his masters this year, in business administration. Personnel Administration in Nebraska Industry was his thesis. He was a student council man, editor of the Corn husker. Natural leader type, look something like Louie Cassava, but handsomer. Deliberate, intelligent way of talking. A guy you take to, and must agree has lots on ball. Yet he bears just the amount of snobbishness, seeming unawareness, to make me be against him. The way he talks about the place to get a good steak in Lincoln, the only really "good" place to eat in Lincoln. The way he talks about the "new deal." Not even nasty, but just with quotation marks. Such a good guy, you want to see him right. It's slightly disheartening about our "American College men and their part in the war effort." I have still not nowhere met people who are so good, and honest to God, as the Big Hole basiners. They, of all the people, are the squarest goddam people. My prints from there by the way: are not only a disappointment. They are really lousy. They bring back nothing of the Big Hole. Mostly it looks like scattered cows, mountains in the distance, a town with false fronts, a card game. Nothing of the real story. I shouldn't, I'm not, really disappointed. I knew all along I wasn't getting any pictures of what I really saw. I was laying ground. That is the place I must go back to, of all the places.

I still haven't my science or engineering student who is going into a job with a war industry. Tonight I'm going to see a boy De Brown has just told me of, who has a job with General Electric when he gets out.

This assignment is pretty all time taking. I won't have time to fool around the agri. school, or look for food processing, unless it's while I'm still waiting for tires after Monday.

My man Robert Aden has just now called me. I am to have dinner with him and his wife tomorrow evening at the "University Club." That's what I mean. The way he said "University Club."

I must now go eat food for I am of a hunger. I wish I had some smart boys like Feely or Kennedy around to talk with tonight.

Your letter which catalogs the places I have been, the things I've seen, the attitudes I've been able to sense, etc., re: the war effort: I knew all that. I was reciting it to myself long before you wrote about it. In fact it is what I am very proud of, and think ought to mean something. But What. And so what? More and more I decide the people with opinions, who know something about something, are, to use a very vulgar expression I get from the boys in the army camps, and from the boys in the high school toilets, are: SHITHEELS.

Out of the Big Hole Basin the very best pictures were the Sunday School. There are about twelve, and they are all good. Some might say freedom of worship, to a certain type of mind. Some are gentle, kindly. And there are beautiful bitchy satirical ones which I think come closest ever to saying what I wanted to say. But mainly my Big Hole pictures didn't tell what I should want to about the Big Hole.

De Brown and Aden looked at my pictures of wife and family, and so spontaneously agreed that Ann looked like me there must be something to that. The eyes they said.

As I said several sentences ago, I must go eat. Perhaps I shall append, later. I'm your devoted hodslinger, Jason.

#

I ate, baby, as I always do. Then I went to see Jim Hillman, chem. engineering student, going to work for G.E. at Davenport Iowa on June 20.[24] Jim is a fine but goofy looking young man with nervous twitches and spectacles. I'm very glad to put his type into this series, but I think to be safe I should have another more corn fed looking boy in the same classification. And it's getting late. Little time left, few classes. Everyone is so damn busy. I work with Jim tomorrow afternoon.

Then, after seeing Jim I went to Jack Alley's bar for a bottle of beer. Jack Alley's bar is where I got into mischief some years back. No mischief for this apple this year. Then I went home and at 10:30 AM in bed. When what do you think happens? I am long distanced from Junction City Kansas. And believe me I am dumbfounded. It is the Delanos. Only 150 miles south of here. It was wonderful to hear their solid stolid voices. Irene and Jack boy. They will be there they say at least through next Thursday, and if goes as I plan I will be leaving for Oklahoma maybe by Tuesday, so I will join up with them for a few short coffees, which is glad prospect to me.

Now I must sleep down. Never forget that you are the baby I love. Nor that we will take, as you suggest, a New England Maritime Canada bus vacation this summer. Just the two of us.

Johnboy————

[picture of setting sun]

MAY 22, 1942
Lincoln, Nebraska

Thursday night: 11:45 PM

You calculating little schemer:

The morning's mail bore two letters from you and my goodness I was glad to learn you weren't in Reno. The turning other cheek attitude you give to my critical appraisal of you makes me feel even heelier about it. Now look Millicent, I asked you to destroy that letter. It is not just or fair for you to say you will keep it to "study" my remarks. I stated it was not a true testament of what I think, that is it's not what I would wish to stand for an all time estimate, or even for 3 weeks, or the day after I got home. It was what I wrote one afternoon. You will destroy it. Of course I have all your letters. And you keep all of mine. That is what we do with each other's letters, except where one of us makes a special exception.

About that money salted away for tires. Possibly I won't need it at all. What I meant was if I shell out 25 for tires next week I might run short again before my next check caught me and it would be nice if you could send me some. But I will let you know. I'll still try to get 1 or 2 new ones though I don't think there is much chance. Also I don't like the waiting, with no car, I might have to do.

Where do you get that $211.47 figure you say I received without noting in my accounts?

The University's roughly where you place it, but it's a very nice school, with fine fraternity rows of modern architecture. It's also very big, bigger than I'd thought—6,000 pop.

You never mentioned whether you read the sheaf of notes I sent you a few weeks back, or what you thought of it all. Do mention.

About child no. 3—all I say is I'm ready for it when and wherever you are. No hurry, no compunctions. Just you tell me. Or, the way I'd like to see things go off, you wouldn't even have to tell me. That's how oblivious of diaFRAMS I think husbands should be.

I notice I didn't get one of those famous birthday cards Ann is always making for every other tramp. Tell her she is a young fart.

I shall write no more about music or pianos. But I have a hive of ideas about it all, concerning you, and shall attempt to foist them on you when I am next with you in our little white apartment. Particularly about "jazz" as you call it piano.

FIGURE 32 | *University of Nebraska. Jim Tillma at the Juke Box in the Grille in the Union.* Lincoln, Nebraska, May 1942

This morning I photographed Bob Aden taking an exam in an economics seminar under a Dr. Le Rossignol who, they all tell me, is quite the economist, I should have heard of him, etc. Then I got Aden and the Dr., a very old white haired gentleman, in his office—pictures meaning the wise old teacher influencing the young mind.

This afternoon, 1 PM I went to the apartment of Jim Tillman, our electrical engineer, from David City, Nebraska. He is the slightly goofy looking boy. I think perhaps on him though I've made the best, most real, earnest, etc. set of pix. I got him in his room studying, relaxing. Then on the campus, building steps, in the electrical engineering laboratory with various fancy machinery, with one of his teachers, his young mind being molded. Then when I was all through he modestly averred that he was going to be married right after graduation, and take his new bride to Davenport with him. So I says where's the girl, and sure enough she's here on the campus, graduating in music. Voice. B. of Music in Education. So we made a date to meet at the student union at 9:30 tonight, where I have photographed the two of them having cokes, playing the juke box, sitting in the spacious lounge.

He, Jim, is a good earnest goofy young man. She, the girl, Antonette, is so unexpected. Sort of pretty, but light and flighty. Makes you think you could make her in 26 minutes if you had a mind to. Doesn't look like a wise match to me. Too bad for earnest young goofy Jim in his serious spectacles. Of course I didn't let either of them know that I thought they were mismated.

I am learning all the current college expressions. "YIPE" said calmly, is one of the most frequent. I love all this stuff, wistfully wish was part of, and feel Old and aged as hell when reflect. The Student Union is really wonderful, big building with luxurious lounges, ball room, dining room, cafeteria, soda bar, reading room, record collection room, art gallery. I'd like to be associated with some goddam college somehow dammit.

Another funny thing: how happy, really delighted, all these boys are to be having lots of pictures taken of them. They gobble it up, feel selected—expressing it in different ways. My John Cockle was really nauseating in his love of it. He is the *most* handsome, fraternity, sweet young man of the lot. All are that way but Jesse Younger, the pre-med, the guy I've only photographed in his room so far, but have appointment with tomorrow. He is really only doing it to oblige. He is the boy of all these for my money. He's without a trace of rah rah. He's a good to look at young man, with seriousness about medicine all over him. Today I learned that Mr. De Brown, of publicity, class of '39, John Cockle, and Bob Aden, are all of the same fraternity. So the fraternity vice has had its influence on the pictures I take here. Tillman and Younger are non-fraternity boys.

Tonight I went to dinner, buffet style, at the University Club, with Robert Aden and wife Marion, graduating this year, an ENGLISH major. My it was wonderful food, and manifold to choose from: cheeses, stuffed celeries, luscious shrimps, red rare hot roast beefs, chicken a la king, huge plump olives, herrings in wine—all this and more, I ate. You know something. I seem to get on better, personally, with men's wives than with the men. Me an Marion almost developed a community of spirit, interest, etc. Robert being the husband, gruffly ascribing stomach ulcers to account for what Marion thought the "delightful" eccentricities of her English prof. Her World Literature prof. They, the Adens, have me baffled, about myself. They are as fine bright young leader a couple as you will meet in a day's march. They are the kind of people who would be most prominent at say Greenbelt. But they are a crappy young couple.

I wish I could make clear what I mean. They're the kind of people I want to like, and do admire for so much they've got that I haven't. Yet I must finally call them crappy. It's the instilled intrinsic snobbishness, aloofness from the honest to god world. I hate preachers, proselytizers, ax to grinders too. I don't want my people to be social reforming all over the place, or anything like that, but I resent, hate inside, the other extreme of these Adens, the inner smugness, excluding superiority, the somehow in total count other side of the fence-ness. From me. Maybe they're something like Lois Adams but not so obviously. I guess my favorite couple are still the Delanos. They think and talk like I like, so I am exceptionally happy that I will soon be seeing them.

After dinner Marion had to study for her examinations tomorrow. Robert and I repaired here to my room for drink and conversation until 9:30 when I had to photograph goofy Jim Tillman at the student union. Robert is really, essentially, the industrialist. He comes I gather from a banker family, in Sioux Falls. That is his fence side. He will, eventually, aside from the war, end up as chief of personnel for the Nebraska Power Co. or something like that. What I most feel is that he is the kind of guy I would like to like, a lot, but can't. Must actually stay away from. And that makes me sad. Really sad. Because he is so many of the finest young men in the country, the smart boys, the college boys, the boys who will have the chance to run things. And it looks no good for the future when you see their complacency, their willingness for instance, to leave the Negro situation as it is. Nothing about that moves them at all. They are part of the backward pullers, they want to be status quoers. They want to be associated with the "men who made AMERICA." Maybe I haven't made this clear.

Another thing. Important to me is how I am unable to put across, eloquently, to people like the Adens, how I feel about everything. Harking back to my old trouble, my inability to talk well, or at least the way I want to. My non-Dale-Carnegie-ity. That is what I've got to, I've really got to take care of. So often I've felt that you should be the one to help me on that difficulty. I don't know why. But that is now the situation I am going to remedy if it takes all summer. I Must master the knack of facilely, fluidly, convincingly, unoffendingly, coherently, putting before people, when I choose, the substance of my thoughts on the situations where I have thoughts. That urge stems from my conviction that my thoughts about many things are solid, and deserve being expressed. I might as well think that. You will still be my wife in August 1987.

JNO.

MAY 25, 1942
Lincoln, Nebraska

Sunday night:

My own Millexir:—

Spashial Delival from you today. So sweet. So nice to get. That is fine about Jimbo, economic analyst, wow, and $2600. Old Jim making more dough than me requires a total readjustment of my thinking about him. How is Mrs. E. and what did you do, and what other new things did you learn?

I had a really wonderful time last night—from 10 till 1. I went to the Elks to photograph Jesse playing his sax. I took him and a few others of the band, but most the time I just sat in with the boys, quashing my urge to take a chorus. My Goodness I love to be there. I am going to become a band hanger on. I learned a lot, saw how they work etc. It's five pieces. Jesse just plays sax, tenor sax. The leader doubles on sax and clarinet. Really 1st rate sweet pure free jazzy trumpet. Piano (girl) and drums. They have

arrangements for all numbers—some the regular commercial ones you buy, others look local, written down, but I don't think they're home made. During many numbers however each of the 3 boys who blow stand up for out of their head choruses, and while they're doing it the others often make up real swell stuff to go with it. Jesse is definitely the least inspired of the players, except the piano which is strictly from hunger. Jesse plays very intelligently, stylistically. I can clearly see his classical training when he does an extempore chorus on Exactly Like You, let us say. He isn't corny, he fits in well, with something all his own. He just doesn't move very far out. Now the leader, playing clarinet, probably comes closer to corny. He grates once in a while. But every time he stood up, let out those first familiar notes of a clarinet about to take off, I would get it in the spine. He used an awful lot of stuff from other people. But that trumpet is really good. Some one should hear him. He would do one with Sweet Georgia Brown, swell, and then surprise everyone by going right into another one with Sweet Georgia Brown, really flying, all the boys riding. He sounded very much like Beiderbecke, really. Except a little sweeter tone. The drum boy I guess was good. He sounded good to me. But I never seem to hear a drummer to my dissatisfaction. He looked the part very much, goofy gesticulations, dopey face like a coke fiend. He was very young, the others were all "college men" types. He thought I was a talent scout I guess. Every time he would hit some extra fancy licks he'd look to see if I was watching him. He liked awfully having his picture took. Why can't I go all over the country sitting on band stands with my camera? It's sure wonderful to be so close to it. I've got to learn to play something. Get my clarinet fixed and buy a trombone. That's for sure.

I attended Baccalaureate today, photographed Jesse and Tillman in caps, gowns. The Baccalaureate sermon was pretty shocking. I had thought the big State Universities were different, wouldn't let anything so putrid, puerile, get by. But the 800 graduates seemed to accept it pretty calmly, as though that was what they'd expected to hear, had been hearing a lot of. I even heard girls remark "wasn't he wonderful?" He was a smooth faced white haired and handed wealthy side of town minister type, and the namby pamby he gave them—anecdotal stories about a wealthy man he knew, an executive, who had suffered reverses, and was forced to take a job as a $35 dollar a week butcher. "But he gave himself to his job, as a butcher he wanted to be the *best* butcher he could possibly be. The lowest motive you could possibly have is to want to seek a job in order to make a living. Of course you will want food, a roof over your head, but the important thing is that you find for yourself the job which is your vocation, that as a partner with God you do in life the job you will put your whole heart and life into. The most miserable man in the world is he who does not have his heart in his job. That man is not Holy. By holy I mean wholly completed." Much much more, for 40 minutes.

I don't study not talking about moving to a house. I just never think of it. I think it would be good if we could move after I get home.

I am glad my son is a Selagy baby and I am glad his picture is in the Selagy collection.

Please straighten Ann and tell her she is not "almost old enough to go to Sunday School." I will take care of her religiously as soon as I get home.

Tomorrow morning is Le Graduation. Then I am free. Whee. To wait for oily word, or mix in with those awful Farm Security People again, or sit on my butt in anguish.

Recent letter from mother says Ann O'Hara's car is still on the block if I'd like it. $785, radio and heater. Mother repeats she'd be "willing to help." What do you advise? Depends on terms, I guess. What can I get for Plymouth? Consider how wonderful Plymouth has been all this trip. 10,000 miles. Not one piece of motor trouble. And right now responsive and purring as a kitten. Can I turn in a car like that?

OCTOBER 16, 1942
Bartlesville, Oklahoma

Thursday night

My particular friend:—

I am now at perhaps the very lowest ebb of my brilliant young career. I have had altogether enough of all of it and want to go home and get another job. This morning Capt. Gillette had still no word. I could do nothing. Then my heart leapt for joy when a telegram came. And within the hour 2 more. 3 altogether. But they were the same ones I had received last week. A piece of governmental stupidity. A cruel jest of fate. Then my contact prints came. All the pipe line. And O God how bad they are. Absolutely hopeless. Unsharp, as I had been warned. But in addition, totally lacking in picture quality. Don't remind me how they always look better when I get back, and I find people like them. I tried for hours to consider these from that attitude, but it won't go. This is without doubt the worst job I've ever done, though I feel it's only the beginning of an era of even worse jobs. Then, after an uninterrupted ten days of beautiful southwest clear sunny weather, today was dark and rained all day. The paper announces the rainy season is here. And the refinery not photographed. So I came to Bartlesville. The man I was to see at Phillips is out of town: Back Monday. No one seemed to know anything about a photographer expected, and they clucked amusedly at the idea of one visiting their refinery or oil fields.

Well I will return to Tulsa tomorrow. Doggedly carry on my fight over the wires until some rainy afternoon I am allowed into the Tulsa refinery. Then I shall go back to Bartlesville and Phillips, and begin my struggle here. Not yet have I seen an oil well. One month now I've been out. In that time I've spent approximately 3 mornings and 3½ afternoons making photographs, at an approximate cost to the govt. of $600 exclusive of equipment, supplies, processing, telephone and telegraph.

Moreover, I shall be out of money again in a week, with what prospect of more arriving? I've yet signed no advance blanks. Will you have ten in reserve to send for an emergency? Keep writing to Tulsa.

Kindly,
John

Tulsa, Oklahoma

Friday night

Dear Penny—

Yankee Doodle Dandy is here. Maybe go see tomorrow night. Saw Norma Shearer in We Were Dancing a few nights ago. Very good. Great girl, Norma.

Got back to Tulsa about 1 PM. Raining all the time. Went to see Capt. Gillette. He had word. OK. I go to the refinery. It stops raining, a beautiful sun pokes out with clouds. The refinery is a wonderful place—3 square miles, tanks, tubes, pipes, stacks—photographer's paradise. I get driven all around. The two hours while the sun is out I spend arguing with my hosts—a vice president, chief engineer, etc. Frankly they don't want their place photographed. There are only a very few areas in which I can photograph with impunity. So, as it starts raining again I go to work on one of these areas. It is very disgusting. I can't do any more. The good light is gone. I am expected to finish up everything in 5 minutes and get the hell out. Then the chief engineer, who has to be by my side for every shot anyway, decides it isn't a good idea at all, and he's going to talk it over with the president tonight. I can come back in the morning and he'll let me know what's been decided. I fear after all this I'll end up by not getting much at the Midcontinent Refinery. And it's so full of wonderful material that one feels bad. Refineries are the least photographed, least publicized of all industries. Chief reason being that it's a very progressing industry. Every plant has something new and special that no other plant has developed yet. Keeping secrets from competitors is what makes photographers anathema. I can't put very convincing twists on why the govt. needs such pictures as I would take to these boys. Moreover none of them like the way the war is being run. This country, at least the Tulsa papers, are the most bitterly anti Roosevelt of any I've ever read, incl. Chi. Tribune. You probably don't know a thing about Oklahoma politics, or the coming elections. But I do. I am embroiled. There are some awful bastards running, likely to get elected. I'm a Josh Lee man myself.

I'm not so hopeful about Phillips 66 anymore. Doubt that their refinery will be anymore open to me than this. I'd like to get far away from all this end—get a good tooth hold on the fields, drilling, etc. But I don't see how I'll establish that. Maybe Alan will be my salvation. I'll go back to Bartlesville Mon. or Tues., depending on when I finish here, if at all, then to Okmulgee if I'm to photograph Philips refinery, then to Oklahoma City, which will be my next address. I'll tell you when to start writing there. No letter from you awaited my return here.

Yrs truly, Jon.

Friday—6 PM

Corrine—

My what a full day I have put in.

This morning I had a letter from you, forwarded from Tulsa. A letter from Mr. Rice of Bartlesville, outlining where to go and whom to see in the Phillips industries. Oklahoma City, Dumas, Midland, Borger, Amarillo, Pampa, in Midland I'm to see a Mr. Schlosser, head of the exploration and seismograph? Stuff. Maybe he is Alan's assistant. Tomorrow I expect from Phillips the necessary letters, with signatures, to get into these various places. Then I went on a four hour exploratory tour of O.C. That sure is fun, taking a town and a gas station map, and mastering both. I now know O.C. and environs as well as the next fellow. I drove around Phillips two plants here—very pregnant they look, indeed. I saw lots of swell railroad, oil derrick, storage tank, etc. locations. Noted same. The field here was only discovered in 1931. It covers maybe $1/4$ of the city—the eastern quarter—around the capitol but off the business district. There may be 3 or 4 thousand derricks in all. In some places they're awfully thick together. They are all "on the pump" as we say, and little or no sign of activity around any of them. I visited the locations of some of the shacktowns as I remembered them from Russell Lee's captions—like under the May Ave. Bridge. It's a very strange sight—obviously much thinned out since Lee made his pictures, still huge and sprawling, with many cleaned up, that is torn down sections. It looks like the remains of some horrible monstrous picnic—lived in shacks, knocked down shacks, old cars, garbage, scrap, sewing machines. It's quite a sight and I stood and considered it, thinking of all the people I knew who had been there—children who had grown 3 years since Lee took his pictures, the old man with the Bible. These were really the most gruesome and stricken with pure poverty of any pictures we'd ever had you know. This place caught the Okies on their way to California. Something like the Appalachian hollow took in the weaker of the pioneers moving west, maybe. Now it looks like 75% of the people have moved on to somewhere. It would be mighty interesting to go in and talk with some of those still living there, see why, who they are, etc. But that ain't my line this season.

I found an immense fenced in stockpile of used tires—about 15 acres, piles 30 feet high, under the RFC.[25] It invites photographing but permission isn't given in O.C. I wired Stryker to obtain me such permission from RFC in Wash. D.C.

O.C. has 4 or 5 very tall good looking buildings which strut and gleam all over the landscape. Then it has the section of oil derricks up in front of everything you look at, and lots of sections of little new houses, wood and brick, all painted and colored. But mostly the impression of this city is miles and miles of road concentrated in tourist courts, gas stations, 2nd hand furniture, 2nd hand hardware, 2nd hand drilling equipment, pipe, auto salvage shops, thousands of these all done up with hub caps

and old tires, barbecue, chiliburger, beer. Everything is painted red and yellow, big painted signs—the kind of stuff Walker Evans and I used to dream about. Essentially it's a hell of a junky city. Completely different from Tulsa.

This morning I got my Elmer Davis letter notarized.

I called on the Santa Fe R.R. man this afternoon. He is going to fix me up—nice and cooperative. I don't need too much from him. I'll also see the Frisco man here.

Then, everything going along swimmingly—seeing so much good stuff to do, getting fixed up everywhere, and today being grey and cold—Ah for those two wonderful wasted sunny weeks in Tulsa—every thing taking shape nicely, I say, I decided just for the hell of it to go call on the chief of police. Tell him about me, ask him for a letter of identification, try to minimize trouble and delay from O.C. cops. So I went [to] see him. O what an unwholesome character he is, when I get to him, after going through the pimpled sneering assistant chiefs, chiefs of detective bureaus, etc. Why are police universally such bastards. Why don't we do something about this? Then I remembered these are the very guys who put people in jail for having Das Kapital in their book shops. Well I spent at least an hour talking to the chief. But I am smarter than I used to be. I catered up to him as the great man. I licked his boot. I silently swallowed his bluster, I showed him all my papers, meekly and good humoredly going through the same explanation 16 times. Of course it was his duty to doubt the authenticity of all my credentials, examine water marks, say inane things about the notarization not being quite correct. But for all this I am the genial humble young man. I want an identifying letter from him see. But at the end he can't see his way clear to give it [to] me. Finally he decides I better see the FBI, which is what I most of all don't want, knowing that they never give you anything and spend hours doing it. Then I wish I had let well enough alone and never came to see the chief. But the chief calls up the FBI to send me over, and the FBI says has he got a letter from Elmer Davis, with such and such a serial number on it, and sure enough. So I'm perfectly OK and don't bother to send me over. Well sir the chief gets just as nice as pie and pats me on all parts of the back, and tells me if any of his men question me, just tell them to call him up. So now I got everything. I should expect to be here at least a week yet. Address me at the Biltmore if you wish.

I got a second letter from you at G.D. just now. No check yet however. I'm glad to know it's en route, but I can't understand the money situation as you outline it to me. I have it this way:

I got a 180 advance.

I am owed	
	50 for NY trip
	45 for Detroit
	85 for Sept per diem
	40 for Sept mileage
	220
	40 to the good

October is already 50 mileage

and 138 per diem

188 to the good

So why should an advance only be 132, why start with Oct 10. What has Oct 10 got to do with it?

If I get a 110 paycheck tomorrow I will send you a reasonable amount, you may be sure. But only reasonable. To mother, nothing for a while.

This hotel, in this dry state, has a nice bar for army and navy officers only.

My battery, a garage man tells me is definitely inferior to the one I had before, and probably won't last too long, he adds. But what can I do?

What Dorothy Sayers book did you try to read once?

Sure I got your hunk of drapery. But you're always doing things like that—a piece of your red dress, or a KOTEX, and I just don't have the goods, material attachments like you do. They have but limited sentimental significance for me.

But yours truly,

Jno.

OCTOBER, 1942
Oklahoma City, Oklahoma

11 PM

Dolling—

I wrote to Stryker tonight. And for ballast, I lifted some sections from your letter and put them in his. You don't mind do you, as long as I wrote them to you first?

I had the 2nd traffic violation ticket of my career this morning. For parking all night. How was I to know you shouldn't? No sign. But I took it promptly to the station and was indignant. They said it'd be alright this time. Shouldn't happen again.

Did you see the pipe line pictures in this week's LIFE? Let me tell you about them, comparatively. Page 53—top picture: I got better of this, but this isn't a LIFE picture. 2—didn't get this at all. 3—didn't get this 4—got poorer of this. Page 54—1—got better dramaticer here, but not so much sharpness. 2—got something 3—nothing this good—muffed it. Page 54—1—maybe better. 2—probably got about this 3—not a shot of this operation.

Now. Isn't that interesting? My long suit was portraits of the workers with pipe near them.

Cordially,

John

Oklahoma City, Oklahoma

Saturday 4 PM

Dear Penny—

Happy Halloween baby. Our anniversary, hey? We don't celebrate it any more like we used to.

I am just come from the Doctor and I must write in a hurry because he says in a half hour or so when the anesthetic wears off I will begin to have a burning eye like I have not had ever before.[26] I am improved, nearly all better. Only have to see him once more—next Tuesday. Today he did awful things to me like bending my lid away back double and painting silver nitrate or something there, also rubbing stuff right on the eyeball. I was anesthetized and of course did not feel it but the idea was extremely awful to me.

Do you realize the total cost of this thing, prescriptions and all will be some $21 bucks? A year's membership in the Greenbelt Health Ass'n?

Yesterday afternoon I attempted to start work again but I got nowhere and quit after driving around the block a couple of times. It's beginning to burn.

Today I had a letter from my mother. She says she has instructed Rob't to appear on Kay Kyser's program next week which will be broadcast from Blythe Air field.

Today for some reason or other I got a haircut and had it cut short, clipped way up both sides. I sure look different. Maybe it looks good, I wish you were here to tell me. Strangely, it makes me look much older, dignified. It looks like grey hair.

[*self-portrait*]

Did you say you sent those color films to Borger? You didn't say. O Otherwise they are surely lost in the mail. And that is no joke. $12 worth.

Have you received all the books I've been sending? You haven't been mentioning.

I got Wednesday written letter from you today. The sun shines beautiful again today o alas.

I'd say about Thursday, if I'm feeling proper, I'll leave O.C., if I have received some dough. I will give you addresses in due time. Don't write to General Delivery Borger. That address has been spoiled because I wrote the postmaster there to forward stuff here. My 1st Texas address will doubtless be G.D. Amarillo.

I have 24 bucks left. I wrote Charlotte my mileage today and told her for godsakes. Had I better not prepare to touch mother again? What the hell can we do? Things are awful. But it looks good when you realize as of right now gov't. owes me $300 for back mileage & per diem.

I wrote Stryker and told him about my bad eye and no work. It still isn't burning very much.

I sure get lonesome for Ann in great waves. Have her picture taken and send it to me or have her write a letter or something.

Nothing much burning happened to my eye. It must be over now. The doctor is a fake. But no I think he was very good and did right well by me. Dr. Shaver. He was recommended to me by the mgr. of the Phillips gasoline plant as best eye specialist in town.

As we've observed often enough before, this being away from home does make me love it and appreciate it and yearn for and idealize it, so goddam *poign*antly. I get good and homesick, all eye brimming about how wonderful it is back there, with sweet white breasted you and the two little toddlers. Everything I remember with longing, like the kitchen and the bathroom and all that. Being away so much I really do appreciate it more when I get home. Seven weeks ago today, I recollect. Listening to records and drinking drinks with the Parks.[27] Walking down to the outdoor dance with Ilse. Seeing Leslie Howard with you. It all seems like a few days ago, and all this time in between a few moments of wasted nonsense. And everything about Washington seems so glamorous now. Just to be walking up 14th Street for my street car among all the pretty girls and bright young Jewish faces, to be away from the Oklahoma Chamber of Commerce life I must live out here, papers and radio all the time saying Send E. H. Moore to the U.S. Senate, a man who will vote against wasteful government spending. Don't let a rubber stamp represent us. This is a very interesting campaign. Republican Otjen and Democrat Kerr for governor. Democrat Phillips, present governor, called Possum Red, Turncoat Phillips, etc., has come out for the republican candidate. For Senate it's Josh Lee present incumbent against Democrat E. H. Moore running on the Republican ticket. I have now heard all of them plus other minor fry, talk on the radio. Except Lee. I haven't heard him yet. They're all such hammy name calling demagogic unintelligent old bastards. It's awful that people like these should represent other people. It makes me want to get into this stuff, and put a stop to these stupid politicians. Couldn't I conceivably run for senator sometime? From Minnesota? Or maybe Nevada? I'm sure that I could be a good senator. The whole theme of course is anti New Deal, and the papers print such awful vicious stuff. I'd like to hear Lee talk. He might just possibly be a good guy. His "corny wit" is frequently hurled at him among other charges. But I'm afraid he's probably another chump. Oklahoma is the very driest state of my experience. Moreso than Kansas for instance. To appear in public life at all you've just got to condemn liquor in every speech, address WCTU groups twice a month, etc.

I heard a good Cleveland Symphony program this afternoon.

Very truly,
John F. Vachon

Stratford, Texas

Tuesday night
Stratford, Tex.

Lame duck amendment:

Tonight I have been gloating over my maps. Where have I not been, where shall I have been not?

Last night temperature was 22°. I froze all night in my unheated room. Tonight I am in a genuine hotel, though meagre. The car's shimmy is getting worse and worse. Doing the tires no good I fear. I must have it tended as soon as I get Amarillo money. I haven't had my tires inspected for gas rationing yet.

This morning I worked on drilling operations. Did some good perhaps, but I'm not getting at this phase definitively enough. This isn't very good country for it—they're mostly gas wells around here, and the rigs are portable, not the big outfits, no real derricks. Midland will offer more of the real McCoy I learn. This afternoon I worked in a carbon black plant. Do you know what a carbon black plant is? It's where they burn natural gas with insufficient oxygen and make carbon which is powdery black stuff in big bags worth 3¢ a pound, used in making tires, paints, & numerous other places. The panhandle is the seat of the carbon black industry, and on any given day in any given spot you can look all around you and in 6 or 7 corners 40 miles away, no fooling, you see little black places above the horizon. These are the C.B. plants. Then as you get nearer, naturally, the little black place gets bigger and bigger. From 5 or 10 miles it's a huge black cloud out there ahead of you. Then you drive right up to it and it's just exactly like driving from a sunny day into the middle of night. They make wonderful backgrounds for pictures for quite some distance, and look exactly like dust storms I've seen pictures of, and I'll bet that's just what they were mistaken for by some dumb FSA photographers I could mention. The one I worked in today had 300 what they call hot houses. Each hot house has several hundred gas jets burning. I went in one that was off, then they turned it on for me and I got a picture before it got very hot and got out. It's a beautiful weird sight inside. High mass.

[*drawing of carbon black plant*]

C.B. Plant [*arrow up*] Typical of Panhandle landscape. Anyway, in working there, I got dirtier, that is blacker, than I have ever been in my life. Really black all over. Right through the clothes it goes. I washed carefully my face and hands, but I'm leaving the rest for a while, it's really kind of beautiful. It gets very shiny when you rub it. About the best pictures I got this year, I think, will prove to be the portraits of some of the black faced workers there. I got so excited about these guys that I shot up all the film I had with me, and didn't get pix of the buildings, and various operations. So I'll have to go back again. And I'll sure make some more of those portraits.

today had 300 what they call hot houses.
Each hot house has several hundred gas
jets burning. I went in one that was off,
then they turned it on for me and I got
a picture before it got very hot and got
out. It's a beautiful weird sight. High
mass.

inside.

SMOKE

C. B. Plant ↑ Typical of Panhandle landscape.

Anyway. in working these, I got dirtier, that is
blacker, than I have ever been in my life.
Really black all over. right through the
clothes it goes. I washed carefully my face
and hands, but I'm leaving the rest for a
while, it's really kind of beautiful. It gets
very shiney when you rub it. About the
best pictures I got this year, I think,
will prove to be the portraits of some
of the black faced workers there. I

FIGURE 33 | Letter from Vachon to Penny, November 11, 1942

FIGURE 34 | *Oil Company Production Camp with Smoke from Carbon Black Plant*, Moore County, Texas, November 1942

Tomorrow I'll find my core drilling man, I hope, and work north of here with him. Maybe all day, maybe just morning. Then go back to carbon plant—tomorrow afternoon or Thursday morning. Then go back to Amarillo Thursday night. Friday and Sat'y work in Amarillo RR yards. Sunday rest and pray. Mon. Tues. maybe Wed. work at Borger refinery. About Thursday through Amarillo for last pick up of mail. Then on to Midland about Friday night, Nov 20. That is all a rough draft of a schedule, of course. Could easily vary with later or sooner in any particular instance. Write me *only* Gen'l Delivery, Amarillo. I shall call for mail there *only*.

Give all my love to our little friends in the settlement house.

All my love,
Jno.

NOVEMBER 17, 1942
Borger, Texas

Monday 4 PM

Dear Penny—

A very sour day. First of all it's cloudy all day—dark, with those damn winds blowing sand in your teeth and through your lenses. This kind of country gives a camera quite a beating.

The Phillips properties are in two distinct separated locations I discover, which look like all the same thing when driving around it. It's a town called Phillip, about 3 miles from here. Lots of new white company houses, located on what is practically badlands. I have 2 letters—one to a Mr. Bender of the refinery, one to Mr. Paris at the fractionating plant. For picture purposes it would be easier if I could work this all as one thing, but I can't. Anyway I saw the refinery man first, and was turned over to the company's Harry Bennett, a strong dopey man who answers questions $\frac{1}{2}$ hour after they are asked. Today was quite unsuccessful. I couldn't expect the outdoor shots because of no sun, but the ground work doesn't look good. This one guy is going to be with me all the time, everywhere I go. You may not see the great disadvantages of that, but they are, great. I can always do best when I can stall and wander and wait by myself. These guys expect you to go from one thing to another promptly, and expect you to take shots you don't want, and can't understand why you take the ones you do want, and it's quite a strain to keep them patient and amicable. I made some silly laboratory flash shots, and a couple of the dope he picked out for me as typical worker, whose home I am to go to to-morrow. Nothing good. I quit because of bad light and general dead end reached. If the sun shines to-morrow I'll finish everything at that part and turn to the other division which has perhaps better look-ing equipment.

I want to go home. How is our orange hassock? Is it serving any useful purpose? And how is our red leather chair that Pierre Laval Atkins is going to get us? Last winter, in the snows of Hebron, No. Dak, my dream of home was sitting on the front porch drinking beer in the summer time while you busily prepared dinner. Now my dream of home is sitting in my red leather chair, surrounded by books, a volume of Proust held loosely between my fingers, a bowl of fresh peaches and a bottle of Old Grand Dad by my side, in my den, you and the children upstairs in bed long since.

The Texas papers carry strange stories and editorials about a poll tax fight going on in the senate. What is PM about these days? It is never for sale in any of this country. I would like to see a copy or two, perhaps one right after the elections, if you have any around.

I have been thinking, about an attitude, or assumption, which seems to be taking place in our house-hold, if I remember it correctly, whereby Ann is my favorite, and Brian yours. Don't you think per-haps some of that has developed? It should be erased. There are definite causes: the fact that I was called upon to give extraordinary attentions to Ann about a year ago to prevent jealousy. That Brian

I hardly know, probably haven't spent 20 hours with him in his brief career. And there are circumstances which turn you to Brian too. So I think there should be some bending over backwards on our parts to reverse and rectify this situation.

I have spent 25¢ out of my lunch and carfare money, for a little book, The Pocket Book of America. With a very fine introduction by Dorothy Thompson, some good short stories including The Man Without a Country which I had never read before, speeches by Wallace, Roosevelt, Washington's farewell address, Jefferson's inaugural speech, Constitution, Decl. Of Ind., etc. all these I find surprisingly interesting. The Constitution is all right, and I think I've figured out some new angles on it. But I still don't understand what is intended by the electoral college system of voting, or how it can be construed to work as it does from the constitution.

<div align="right">

Love.

Sid.

</div>

NOVEMBER 20, 1942
Amarillo, Texas

Amarillo—Thursday—5:30 PM

Dear Baby—

Here I am, in a tourist court. Paying 2 bucks again. I needed a bath. I'm also having my brown suit dry cleaned and my KAKI pants washed, to be ready 11 AM Friday, which is the day I leave. Proposing to get ½ way to Midland tomorrow night, and all the way sometime Saturday.

Your cheap rooming houses have caused me to lose, have stolen probably, my favorite necktie. The brown one you gave me [*sketch of checks*]. It was there on a chair yesterday afternoon but just wasn't there today, no where. Whoever took it probably opened up all my film magazines to look inside, too.

What does Sam mean by permanent inflammation of the eye? Maybe that's what I've got. Vision is perfectly normal, but it gets itching a couple times every day, and it remains somewhat bloodshot.

Food in this part of the world is pretty horrible. In Borger there was no where to be found a tasteworthy morsel. Lousy dirty brown meats gravies and potatoes with inedible puddings for dessert. Nor was it unexpensive.

Okla City, Amarillo, and Borger have all had in them Borden's ice cream shops. These I have been frequenting frequently, because they are nice clean white little shops offering extraordinarily thick rich malted milks at 15¢, and sundaes for 6¢. Well sir, last night after the movie, Bob Hope in My Favorite Blonde, very funny, I made for Borgers' Bordens, proposing a sundae. But it was closed, though bright lights still burned within, lighting up its clean white interior. When lo. I see a *rat* scurry along the counter. Then I see 2 or 3 more, and presently at least a dozen. I stood and watched them, fascinated,

from 11:03 to 11:30. They were from 3 or 4 to 8 or 9 inches long, nasty nasty looking creatures. They climbed in and out the bowls and silverware, climbed up the malted milk mixers, licking, and ranged all along the soda fountain, *sucking* from chocolate, strawberry, vanilla, etc. spouts. And my god the malted milks and sundaes I've had there. Isn't that discouraging. About restaurants in general. Those that don't have their lights on all night. This place was in a rather old looking building. So moral is always go to restaurants in brand new buildings maybe. Rats carry disease, don't they?

I had a hard working day yesterday at Phillips, worked this morning in railroad yards, and left. I guess I did OK. Practically nothing on people however.

Four letters from you here. My Phillip prints. A $25 check from that cheapskate I work for—but no paycheck for godsake. Maybe the dumbies sent it to Midland. I hope I don't have to cash Stryker. I have about 11 left. And you I note are expecting money Friday. That's tomorrow. Well you see how it is. I'll have to leave tomorrow, check or no. Will wire office Gen Del Midland as address. Will send you dough soon as I get it.

For Godsakes Who are Joan and Carl?

Do mention that 15 if you got it, so I can throw away the m.o. receipt.

Zorach is a stinker, not co-signing because he is moving to Brooklyn. That is what I call really a stinker. Glad he's moving to Brooklyn.

What is Mary Poppins? Where'd it come from?

The "one good suit," you remember: I only had the coat dry cleaned. The pants have long since been thrown away. My best shoes are now a shambles—muddy worn torn etc. New shoes needed. My brown suit—latest—had taken quite a beating. Now I am having it dry cleaned, and hope not to wear it much any more. Except for Sunday dinner at Alan's house, and things like that.

Have you heard whether Jim Feely is back?

Did you write to my bro. Robert?

I registered today, and got an A book.[28] You must wait until after registration dates before applying for supplemental.

You may have the tan corduroy jacket for any purpose you wish. It was a very silly unwise purchase—would be useless to me even if it fit. I wish I had a good short zippered pocketed jacket, to wear instead of a coat with my KAKI pants.

You are telling one big lie when you say you pieced together that torn up material I sent you.[29] That would have been impossible. And if you did, you are crazy, and don't have much to do with your time.

I sure miss my Graflex. There are some pretty fair things in my Phillips set—compositional crap. All in all though they disappoint from what I had expected.

I was sent by mistake a couple hundred contact prints that don't belong to me. They seem to be Delanos—mostly railroad yard stuff—around Chicago I would guess. There are a few humdingers

among them, but Bye and Large, they don't make me feel bad, like I would expect a set of *Delanos* to make me feel. In fact I can't but feel that I'm turning in some rather *better* approaches to railroads, etc.

I don't want to see any more refineries for a long time. I must organize now. Write down what it is Alan can help me with, what I must get in the Midland area. And devise ways to get lots of pictures of oil workers off the job—at home, in the saloon, in church, etc.

You don't make enough comments on the things I tell you in letters. And dammit you don't answer questions.

The oil tank car [*drawing*] has not won my warm personal affection like the grain box car [*drawing*] has. Tank cars are black, dirty, smelless, low, impersonal. Every once in a while I still find a nice red box car to climb on top of, pick hunks of wheat out of. I sure like them.

What I would like to do is the following: Arrive Midland Nov 21. Work Midland-Odessa area through Dec. 3 or 4. Drive slowly to Houston, working on route, arrive about Dec. 9 or 10. En train for Wash. About Dec. 11 or 12, leaving all the Houston work to be done upon return. Don't know whether I can handle it so or no.

I have sure passed by a load of good record buying opportunities this trip. I hate to come home without a one. Why don't you write a wow song that will sweep the country.

If I ever get some dough, I might be able to Christmas shop in Houston. What'll I get Ann & Brian? You'll handle Mary Ann and Robert yourself, won't you dear. Because I won't be home by Dec. 1 when you should mail them by.

10 PM

I wrote Stryker and told him he should tell me to come in about Dec. 10, 11. I assume my paycheck is in Midland. If you learn different let me know—

I love ya,
Jon

FEBRUARY 1, 1943
Lancaster, Pennsylvania

Monday—6:30 PM

Dearest Wife:—

I will leave for Columbus probably 6 PM Tuesday. Please write me G.D. there. I will get my check there. I have worked today and yesterday, will again tomorrow. I am absolutely doing the best I can with this pipeline business. I'm sure it won't redeem the past, or please my superior. I'm disturbed as hell, I don't want to be a photographer anymore god dammit, can't anyone understand that. I talked with Stryker a half hour ago. He's a foolish old man and I don't like to work for him.

Can you understand how I look at the prospect of being drafted with some contentment in the heart, because it will at least pull me out of this damn life's mess I'm in? The disruption of my home and family won't be so total, because we're so damn disrupted now. And I might come out at some future time with a chance to start over somehow.

If you can possibly get active about me, be a dominating woman, do so, dear. I will be cooperative. I want someone to make me do things, good things.

All this is so foolish. Trotting off to Columbus so foolish. But the most foolish thing, from my point of view is the idea of Stryker, and his photographers, who are supposed to run around and find welders from Iraq. If I don't want to do that I don't have to, do I? Tell me that I can be a worthy citizen away from this Stryker life. Help me get away from it. Christ, when I get home again, let's not play Wining Boy[30] or Thumb Vogues, let's you and me get together and get some good permanent answers worked out. If I am a dope or a bastard with you, slap me to some sense. What I have got to figure out has got to be figured out with you.

I bought 4 pairs of sox, and I finished Memoirs of a Midget.

Now I'll go eat, and see about a railroad ticket for tomorrow night.

I'd like to get home about next Sunday, but I fear it is later. Don't know how long I'll be in Columbus, probably not long, go to Kentucky soon.

Keep.
John

MARCH 23, 1943[31]
Burlington, North Carolina

Monday night

Dear Penny—

I haven't got to Charlotte yet and I haven't got any mail yet, so I don't know what's going on with my little family bosom or to the great world in which I move. Also I am all mixed up on time. Today seems tomorrow and yesterday this morning, etc. It seems I left Bristol at 10 o'clock last night and stayed awake all night until Winston Salem at 8 this morning, then there was much moving around with baggage by bus, transferring at Greensboro and getting here about noon, still awake all the time. I slept until an hour ago when I ate. It's very good for you, these long stretches without sleep, sharpens the acumen, and I am pleased with my stamina. The ride last night was most wonderful—snowing most of the way, deep snow and cold blowing on the mountains, stopping to put on chains, getting stuck half way up a mountain, going through the little towns, and then morning coming on. At 5 o'clock every little mountain cabin starts having a light in it. Truck drivers get mellow, earnest, philosophic, deep and seeking in the long lonely night. This is really the most wonderful thing I've ever done, meet-

ing each of these guys, and knowing them for ten hours in this strange allegorical setting. Sometimes the whole thing seems too perfect and unified a dramatization to believe it's really true—I'm sitting drinking coffee at a mountaintop store and station, juke box making atmospheric hill music, people moving around, dancing, truck drivers with their coffee—it gets like a wonderfully directed movie which I'm just watching.

I hope to leave for Charlotte tomorrow, probably get there late. Maybe stay there Wednesday and Thursday. Greenville Friday, Atlanta Saturday, Montgomery Monday, maybe Tuesday. But that's rough. When you've addressed me enough at Montgomery, let me have G.D. New Orleans, Ah. I will try to stay there oh a day or two, and seek a little of the good gay stuff we all seek.

I wrote to Willy Kennedy. Last night I was like a hero taking pictures on the Russian front, I romanticized myself—cold numb fingers, snow blowing in face and lens, walking into deep drifts, but always hugging the camera—the picture must go through. Maybe I got some.

<div style="text-align:right">True love.—Joe.</div>

MARCH 28, 1943[32]
Bristol, Va.

Saturday afternoon—

One's dear wife:—

Now it is time I should write to you, tell you about it, consul ya. Where to begin, my goodness. I am stuck in Bristol until 10 PM tomorrow, when I take a truck to Winston Salem, arrive in the morning, some time same day truck to Burlington for Monday night, Charlotte probably Tuesday and Wednesday nights. The next address I want used is gentile delivery Montgomery, Ala. That is where I'm also getting film and bulbs. Then I'm hopping down to Pensacola, just to have been in Fla. you know. I'm quite sure I'll truck from New Orl. to Houston, and train from there. I'll be in Midland April 6, 7 or 8 it would seem about.

Now other things: life is very irregular: eat, sleep, etc. I like it that way. The riding is sheerest pleasure and excitement, truly great experience. It is hard, maybe even impossible to photograph. Anyway I'm not doing it. The drivers are wonderful guys. The day I talked to you I went right smack by my office in a big super Horton. I felt so superior, but alas, no one saw me. That night was in Lynchburg, as you know, no doubt. About money, maybe you'd like to know. I cannot keep it back. I guess I've just lost my thrifty nature. With all my baggage I just must go to the 1st big hotel I see, and my rooms are costing me lots. Also two cab trips in every town, and lots of eating. Then of course, what I spent in New York would send your parents to the holy land for two seasons. I'm a bad boy. But money isn't everything, and you be just as lavish as you can with what you get your hands on. Money really isn't everything. In fact it's

nothing. I would like to work out something else with you. I wish you could be in New Orleans with me, without les petites. Maybe you can. My hat and overcoat are shames and curses on me. I don't know what to do with them. Maybe I'll mail them to Alan. The overcoat has really gone to pot now, it is like old men are given at the S.A. I should perhaps leave it in a hotel room. I am going to buy some shoes, shirts, hat and new suit sometime when I have some money which isn't everything. It will be awfully happy to have my own roomy spacious car again, and I will never let it go again, come Stryker high water.

This is one Sat'y afternoon town, so full of those faces long and brown and spitting. Personally I love everybody but I miss seeing Jews most of all.

This time I got more out of New York than I have ever before, and Nothing is going to keep me from living there a couple of years. I took long walks and rides to all parts of the city, sat on benches and talked with old men, went to Yorkville, walked through Italian districts at night, listened to the union square guys Sunday morning, ate and drank in little places I found myself, went to the Bronx, really saw the Irish people and their part of town, saw all kinds of new streets, parks, slums that I hadn't known about. I went three times to Nick's, one night Billy Butterfield was there. PeeWee carried me off like it hadn't happened before, the most ecstatic music I ever heard. I went to a Mexican restaurant where they had fine hot food, terrific Mexican waitresses, and new beautiful music. Poor Muggsy, at the Arcadia ballroom. The Arcadia is not a taxi dance, it is an elaborate plush chandeliered blue lighted place with two large bands playing constantly, half hour each. $1.10 admittance, mostly couples go there, but they have hostesses, Muggsy has about 12 pieces, they play all the tunes in smooth ballroom style, and lots of Spanish-American music during which Muggsy with a pitiful grin stands knocking two hunks of wood together. He directs the band with a wand, all the time, and only about once every half hour session does he himself play that thing. Then he plays good, he can't play bad, but it's not a good setting, and the customers don't like it too much. He played Jazz Me Blues in the big elaborate way, and a very beautiful More Than You Know chorus. The customers aren't jitterbug types, they are mostly young men with mustaches or glasses, and girls who read love stories, people who like to dance the way they know they can at the Arcadia. There are tuxedoed bouncers constantly moving among the dancers, setting right anyone who starts cutting in the jitterbug fashion. But anyway, standing as close as I could get to Muggsy, and looking at him with love in my eye, he smiled, winked, gave me a hand movement. A sad smile, true. But no one but me got such recognition that night. He could see that I knew, see? What a face the guy has—not what I expected, or thought I remembered from Ted Lewis days—he's really beautiful, sad, saintly looking. I couldn't talk to him there. It's hard to get even very near the band. But some day I will talk to him. I will establish a human relationship with him.

I hope you make a good decision about driving a car to Texas. I hope we do each other a lot of good when we meet in Texas. I wish you could have brought my clarinet along, I miss it more than I thought I would. I feel these days in good form to start doing things and not letting any people or circumstances stand in my way. So I'm really going to, and I want you to come along.

I have nearly completed a brief factual descriptive catalogue of all my traveling from infancy—

something to go with my county map and compilation of days and hours spent in what states. I'm sure you will find it of interest.

Let me know more fully what Jim had to say. Did he give a writing address?

I must write to Mother, Robert, Kennedy, Baker. Maybe Stryker.

I hope you have a good time at home, being happy, and all. Catch your family spirit and see its true relation to yourself, be objective. Be your own good psychoanalyst. Go back to 8 yrs ago when you lived there, and trace yourself a logical development until now. Then move off from there as an independent growing self ordering baby. Have something happen to you. Let the girl of a few weeks ago who bemoaned being stuck with children, the harpycritical girl who said her husband was the free agent making all the friends and having all the adventures while she was subjugated to domesticating children, let her be someone you grasp and understand, but don't let her be you. And figure out this business of whether you want to be always the mother, the holy guardian of the hearth, or whether you want to move among some other lights. Throw out vague discontents, know your correct answers, and order it the way you want it. I don't subjugate you, do I? No woman should stand for that. And remember the old Miller adage, you taught me, about strangling vines, or were they clinging? I should not have discouraged your seeing him, but I myself did not want to see him, at that time. Shouldn't you have been enough the independent woman to have acted as you chose in that matter? Anyway— let's really get it done, Millicent, and do away with the crap, inhibitions, doing like other people think. Maybe that's not clear, but I got a meaning. I'm ready to throw away anything I've got that I see I don't want. I want most of all to know what I really believe in and want to be good and happy about, and sometimes, like now, I seem to be making progress in that direction. I want you to go whole hog too, and not have any closed doors. We've got to do it separately.

The Human Comedy has some great stuff in it, a modicum of crap.

What shall we do about your brother Alan's racist notions.

Last night in the dream I am having the most wonderful conversation with Henry Wallace.

If I am drafted shall I say I wanna be in the marines so's I can be with my buddy?

Please be my happy beautiful girl. I love you, but I am nearly 29 years old now.

Mooglia.

MAY 26, 1943
Beaumont, Texas[33]

Tuesday night.

Dear Roy——

to hell with Roy, I'll write to you instead. I'm in a stinker. If they want photographs made why in hell don't they make it possible to make them. But you wouldn't care about all this. This morning, af-

ter an argument with the nasty housekeeper who wanted to know why some dirty linen had been on the floor in my room all night, as though it was my fault, I got your post card and had breakfast. Then I saw Lt. Peck and the provost marshall. They say if they get authorization from their commanding officer in San Antonio they will cooperate, help me, do things for me, be nice to me. Although nothing I want to photograph is under their jurisdiction or the navy's or the coast guard's, they advise me not to photograph any of it without their cooperation. Their cooperation means they will send a city policeman with me when I take pictures of workers leaving the shipyards, of railroad yards from a bridge. And that is essential. Then I telephoned Mr. Sisk in Dallas. He had no ideas whatsoever to offer me except what Stryker had already told me about women in civilian jobs. He had never heard of me, did not know I was around here. I asked him to arrange wire from San Antonio to Lt. Peck saying I'm ok, go ahead. Late today I get wire from him saying army in San Antonio says shipyard not under their jurisdiction. Says I should get Stryker to arrange it. Today I saw the creosote man again. Everything is ready, company agreeable, go ahead, except would like some sanction from local military authorities, although they are under no one. Lt. Peck will give him no such sanction until someone higher than him tells him I am all right. migod I hate this job. This afternoon I photographed a laundry truck driver, woman, in her truck, making a delivery, at home in the evening with 2 kids and husband and colored maid. All very dull. Can't make a woman driving a truck into a good picture unless she's a woman with a good face, and she wasn't. I sent a wire to Stryker tonight but couldn't make it very clear what he should do. No one should authorize me to do anything that is under their jurisdiction, someone should just tell some dumb Lt. to be nice to me and that I am legitimate. o cripe.

John O'Hara is a great writer. Best short stories I've read since Chekhov. Have you ever? I didn't know about him. Confused him with John Cain,[34] but not at all.

The car is being greased and oil changed tonight. I am starving to death in this stinking town. I've got to write to Stryker, but I am so damn mad, mixed up now, I better wait. I am much fonder of you than this letter indicates but I do not wish to write letter any longer.

Very,
john

MAY 29, 1943
Beaumont, Texas

Friday 4 PM

Dear Millicent—

Arrowsmith is swell. Never read it before. Wonderful girl in it, just like you. wife. brings tears to my eyes. I still don't get no letter from you. This is too long to have waited.

Wire this morning advised all clear for Pennsylvania shipyards, and so it was. I spent all morning

over there—talking, waiting, and then walking all over yards, without camera. Then with everything fixed I came back to hotel to wait for sun to shine. Maybe in 2 or 3 weeks. Always it's beautiful weather when I got no clearance and then goes grey on me as soon as it comes through. Or maybe I don't notice otherwise. The creosoting man is out of town today, but I think I can get in there now too. I talked to Major Haddaway of the Civil Air Patrol, and I will wire Stryker tonight asking him to transfer clearance from Corp. Chr. to Beaumont. All in all I suppose I'll be here a week yet, maybe. As usual the car this morning hadn't had anything done to it. They hadn't got a chance to get at it, so I pay storage and take it away. This is the most terrible town. I will let the car go until I can stop over night in some sleepy village east of here, if it will go that far. I still pay 2.50 here. I'd like to move but I doubt if I'll be able to. In fact you can address me here if you wish. If it ever occurs to you to write to me. Got laundry today, 2.88. Will not open it until I get back to Greenbelt. I wish you were with me. In fact why don't you come join me in Beaumont? I miss you. I still have got no toilet paper. Somehow it doesn't matter much anymore. On days like this, when I sit in the hotel all afternoon with perfectly good clearance in the shipyards, I feel worse than when I can't get clearance. Like I should do something about it anyway. I just decided I won't go messing in the shipyard until I have wonderful light, but then I feel guilty. And anyway, with all the clearance in the world, I know now that I won't really get the true incisive pictures of what this town really is, or the fine glossy ones of beautiful smiling bus drivers that the OWI would welcome. I'll just mess around in this damn field that doesn't suit me. I think I could even be a good photographer someplace, but I don't like this job, as I may have mentioned to you, and I must get out of it. But we have decided all that, and I will. I hope you get up to see bro Robert and give him my good wishes. I certainly have little liking for Saroyan as I read his 48 short stories. I guess he's all right. I just don't like him very much anymore. You must read John O'Hara and tell me what you know about him. I will send the book to you.

6:45 PM

I am the most unmitigated damn fool. let me tell you. after a slurp of this tawny sherry I have bought in commemoration of my damn foolishness. At 3:30 or so, cloudy afternoon, I called the shipyards and told them to forget about me, I wasn't coming around until the sun shone clear. So Mr. McLaughlin called off all the guards he had posted for my arrival. Then at 6 I went over to watch the men go off work. It was not bright sun, but nice even light for pictures this evening. Very reasonable of them. Damn fool of me for having called it off. Because: I witnessed the most photographable 45 minutes of my life. Today was payday, and 6000 men, 4 abreast, all dirty and sweaty, smiling jumping singing laughing, moved real slow across a little pontoon bridge getting their checks. A shipyard hillbilly band played for them to keep them back, slow them down, prevent shoving. Guys would dance out of the lines waving their checks. Really it was beautiful. It won't happen again until next Friday. The regular nightly exodus only takes about 12 minutes against this hour when they are all really lined up. You

have no idea what a line 6000 guys make. Maybe I will be here next Friday. [See plate 77.] Anyway every night I am here from now on I must be at the gates of the shipyards at 6 PM. Where I bought my tawny crowds of guys with paychecks were getting them cashed for liquor. Beautiful sight. Why don't I take pictures like that.

<div style="text-align: right">love john.</div>

you write to me damn you

JUNE 4, 1943
Corpus Christi, Texas

Thursday 5:30 PM

Dear Emily—

Happy to get a letter from you upon arrival here I, also from Stryker. I am a dog, I suppose, for coming to this hotel after you wanted to stay here and I nayed you. I'm paying 2.50. I had to go to a hotel because I am practically broke and cannot afford to pay in advance. It is very wonderful here, nice people behind desks, etc. Beautiful room, overlooking bay. So, I guess I'll stay. Address me here.

I just discovered my B1 tablets. They are very good. I shall eat them. When did you think to put them in my brief case?

From now on I will always make laundry lists. But I didn't in Beaumont. You got back 2 sets sox, 2 handkerchiefs. Any complaints? I got 6 shirts. Can't remember any missing. Also a great blue and white bandana handkerchief, and nearly half my sox. I hate Beaumont. I am glad I am in Corpus Christi. I like Corpus Christi. It's a terrible hot day all day, but breezes blow here, strong right through my room.

I will tell you what I have been doing: I wrote you last on Monday. On Tuesday I worked hard all day, both creosoting and the shipyard. Wore my self out. Nothing much doing at creosoting. No good pix at shipyard because of rush to get all over place and with guide. Photographed again the leaving men, but no good light again. Have some hopes for at least one or two good shots of that wonderful scene. Yesterday morning, heart singing, 9 AM I left Beaumont. 5 miles out in the country I was disturbed—the wobble. So I changed two tires, thinking I could re-establish balance that way. I was wrong, and I got awfully hot and mad. Not like I get mad mad when you are with me, just my own personal quiet mad. I wish you had been with me. I love you, and I like you to be with me. I drove on another 10 miles away from Beaumont, stopped in a town to see a garageman, then I became convinced I'd have to go back, so I did, and went to a garage, and was told I needed a "front end job," which I got. It cost $21.75, and it did the things which it says on the enclosed sheet. [*receipt enclosed*] I guess I am a sucker. I don't know. The car was in horrible shape, shaking like an as-

penleaf at 28 miles per hour. The guy said rebalancing the wheels would last me another 100 miles unless I did this other stuff. He was an overcharger I guess. But what the hell Money isn't everything. Now the car needs lights fixed, brakes adjusted, horn fixed, loose steering mechanism fixed. It still is awfully jumpy and unsafe feeling. I don't drive over 30. When I get some money I will do these things. When I get home I would like to buy 3 or 4 new tires. Then, if it seemed advisable, we would get a ring job. It now uses 2 qts. of oil per 150 miles. The blue smoke is getting awfully noticeable. Of course if I'm not going to be using it, it's a nice car for city use as it stands. I'd leave it to you. On the other hand, how about selling it here in Texas? Should be good for $135. We could use the money to go home with, how about that? I got $4 and little change left right now. We hope for the check tomorrow. Things standing as they stand, I think I will send you 60 and keep 70. I got to do it that way Penny until I know whether they are sending me more advance. You can write an apology and skip the rent can't you, if you need to? As soon as I get an advance I will send you $150. Please acknowledge last week's money order for 20 if you received it. Otherwise something has gone wrong. Maybe I will send you more out of this forthcoming check at that. You get panicky that's all. When you got 4 bucks left in Corpus Christi. I got out of Beaumont at 6 last night. I deliberated as to eating before I left, but then I said nay. I was so happy to be leaving the stinking city—it really does smell awful, like Mrs. Meyer said, when the wind sends the non incinerated garbage dump thru the town. So I put a vision in my mind of that Mexican restaurant in Houston, and drove non stop to there, arrived 9:30, and had the wonderful 1.25 dinner, with 2 bottles beer. They sprung a new one on me this time, I don't know what it is called, but it was prunes, maybe, with egg wrapped around them, and crab meat inside. Chili sauce over the whole. Very good. Our (Your and mine) favorite Mehican rest. is just down the street here from the Nueces. I drove on to Rosenberg last night. Applied at the place where we stayed, remember the lousy 1.50 cabins for assignations, and all he could offer me was 2.50 for me alone. So I went to a side street hotel. 1.50. very dirty. I had breakfast at that place where we ate at night and heard a Duke Ellington record. Then I drove onto Victoria where I went to the courthouse for what we went there for. I had a malted milk where we had one. Then I picked up a soldier and drove to here. I like it here. I get so damn sad baby, going back to all these places where I remember you with me, and I wish so much you were with me again. I was all set to write you, setting forth when and where you should rejoin me with Barnum. But now I get Stryker's letter and I don't know. I will quote you therefrom. He writes me a very long one, 5 pages hand written at home, then a typed paragraph from Helen. He tells me all about the reorganization, assimilation, of the news bureau. The 3 new photographers and 12 other people. He draws me diagrams of our new quarters on the 1st floor. He tells me all about where everyone sits, etc. The people he leaves out makes me wonder. I guess maybe Paul Vanderbilt and Polly Wilson ain't there anymore. He says Jean Lee has taken over the files and has a unit of people, among whom he doesn't mention Polly, or Paul. This must be boring you but you know how it is, One and One's office. What I see between Roy's lines is all the

filthy bearocratic mess, Roy wanting to run things his way and having another of his famous fights with the big outfit being assimilated under him. He wins I gather.

Then he tells me about the photographers. Jack Delano is back, just got there. John Collier is in Maine—potatoes, logging, lumber JILLS, Civil Air Patrol at Bar Harbor. Helen's paragraph says quote by the way John Collier is married, or I suppose you know about it since he married a girl from Greenbelt, Dorothy Trumbull. unquote. Can you imagine that. He really did. I honestly never accepted our theory, and I am very amazed. I think it is fine because they are both nice people. But it is very amazing when you stop to think of it. Poor Toots. Really she will never speak to me again. Marjory Collins is in Pittsburgh—women in industry, civilian jobs, nationality groups. She has been working intensively in Pgh and Buffalo all this time. Everybody but me works intensively someplace. Me, I wander. Arthur Siegel just did a shipyard story in Baltimore. Roy calls it "very swell" and is now working the Ohio River getting river transportation. Is 1A and will be inducted soon. Gordon Parks is in Gloucester, Mass. Going out to sea on a fishing boat. Has done a fish story in New York, pier to consumer. Howard Hollen, New from News Bur. is in Ill. Ind.—war industries. Ann Rosner—good girl, I've seen her pix—"will stay around office and do local jobs" he says. Roger Smith—Negro—has been covering Negro news. Going out soon. Then he says, I quote so you will see what I see, he says "Oh yes—there is a John Vachon who desires to come back to Washington. And he soon will I think but working up as he comes. As soon as you have finished Civilian Air Pat. we'll start on clearance for Higgins Boat Co. You'll have Sulphur in La. You had better check on oil wells in the bayous. We will want some general scenic material in the Louisian area. Your route will probably be up the Mississippi River for a ways, getting some river and contiguous areas. We have many calls for Miss Riverpix and I want to add as many as possible this summer. As soon as you get into New Orleans I wish you would give time to locating ways and places to get pix." This is what he says. How does it sound about my getting home? Not as soon as I had figured. Can you and Barnum join me for a deal like that? I do want you to if it seems plausible to you. But I do resolve to do something photographic before I get home. And wouldn't you 2 get in my way? This is my last trip for Roy, I'm sure. I sit around and wait for something to be "cleared" or for orders, these other good photographers like Marjory, Siegel, Parks, are out looking around, deciding what they want to photograph, and doing it. My method is bad. I got to change it. Maybe like I was telling you before you went away, we will go into some little old town and give it a workover like San Augustine only better.[35] [See plates 23 and 24.] Figure it all out ourselves and do it. Get something good. Can you and me and Barnum do it? I want you to come join me and amble back with me if you think it will be ok. Write me here. I may be gone, then I will leave a forwarding address. Maybe I will call you up some night when I got some money. Helen in her paragraph says she hopes you will call her up when you get back to Greenbelt, and that she would like to come out and see you but on account of Gas Rationing which she capitolizes she guesses she will have to come out by bus.

Nobody mentions my San Augustine pictures. Or any other pictures of mine. Stryker doesn't even mention this Corpuschristi CAP business.[36] Helen says we will ask that clearance for Corpus Christi is

rushed right out. It all makes me damn mad. I sent a wire tonight telling them for god sake let me know who to see what to do right away. I didn't sound as mad in it as I was. But there you have it. This waiting for Stryker to fix you up isn't the way Stryker figures on his photographers operating. On our way up the Mississippi we will stop at Crumpersville, Tenn., or Sleezy, Ill. and make a wonderful set of pictures about the town or the Lions Club or something, hey? Why don't you help me more on things like this?

While I was waiting for my car in Beaumont I went to the library and I read Homer Catullus and Horace in the Loeb Classical Libr. editions. Amazing how I go back to that stuff. I can't read Greek or Latin intelligibly in original, but with literal translation and text on opposite pages I like it so damn much. I got to get back to that. You must buy me some Loebs for some holiday or other. Mostly Homer, Catullus, Horace, Ovid, Apuleius, Aeschylus, Sophocles, Euripedes. And Virgil.

Is Brian smarter than Charlie? Does it come out anywhere?

When did you read 2 books by John O'Hara? Where was I? Why didn't you tell me about him?

Such crap, your San Antonio friends tell you. Getting a knife in your back because you go to the Mexican section. That is the bourgeois press fed fear of being at ease among the non Kiwanis sections of the population.

Are you going to church every Sunday? Wasn't Marsh a nice guy. But wasn't Mr. Webb a dirty bastard. You must read Elmer Gantry. Your sister Dorothy should not have gone to all that trouble. You should have told her that we were going to leave little Barnum with her when we went on our New England trip with you and Ann. Now of course she is out. Who can we turn to?

About the Orange pictures like you ask. No they are not all bad. They are just not any of them good. Do you understand? A few shots like the high school girls reading stories to the Nursery school kids may be rather fetching, the old lady by the picket fence in Galveston is good, some of the downtown Houston crowds Rollicord are good. But none of them present fine grasps of the situation.

What did my mother have to say? Today was a holy day of obligation, I think. tch. Tell me about Robert. Did you hear from him, etc.

I am going to have a shower now before I go out to eat. I will eat sparsely at the eat a bite shop. Then I should write to Roy or Phil, but maybe I will go to a movie. This is a no all night parking on the street town by city ordinance I find. What shall I do. I will go to the Pleasure palace and put in a nickle to watch that girl laugh.

Isn't that peculiar about Collier. They will probably always think of us as the people who brought them together. You and Mary will have much for common talk about won't you, on account of me and John both work for Roy. Only I won't very long will I?

I did not find the described slip in laundry.

I must go now. Write to me.

love love john john

SEPTEMBER 1, 1943
Chicago, Illinois

Sept. 1—10:00 PM

Dear Penny:—

Ann and I just got in after a little fling of night life. This is the real stuff. I am having the best time of my life, and Ann is being the most intelligent, reasonable, entertaining companion I've ever known. The one and only trouble is that damned hair situation. Twelve times a day I fix it up, and all the time it's strewing down her pretty face: We both slept very comfortably last night, and she seemed to enjoy the whole business a lot. Today on the train was long and tiresome but Ann remained even tempered and only pleasantly restless. She talked with the porter and two MPs a good bit, played up and down the aisle with an MP's club. The twittering elderly lady who shared our seat Ann didn't like and showed her so in a very nice way—not unkindly, but firmly. She does things like that very well, I think. We had much good conversation about moving to New York, etc., and good talk and observations on coming into Chicago. The train was an hour late. We came directly to the hotel, took showers, dressed up in her ironed dress, combed the hair with extra care, me a clean shirt, and went out to dinner at a place you and I once ate—Old Heidelberg or something. A $2 dinner she had. What she couldn't eat I did. $2 dinner me too. She was very wowed with everything and sat perfectly quietly in her chair for the hour and a half the whole business took—an orchestra, ladies singing off balconies, 8 guys dressed like Cossacks in bright colors singing Russian songs up and down the aisle, burning fire dishes of food coming in with red jack-eted waiters, women in long dresses, which Ann said were "gowns." She said everything was terribly "fancy." She thought it was snowing outside because there were snowy mural windows. A lady glamour girl photographer was shooting off flashes all around our table, the waiters and Filipino busboys were very nice and attentive to her. It was all a fine exhilarating look into a new life for her, and I liked being with her, seeing to it that she saw how funny it all is, seeing her realize it's just a lot of "fanciness." She's a great kid with a right mind. It won't do to have any harmful influences come to her. Today she ate: 1) orange juice, rice crispies, milk, toast; 2) soup, vegetable plate—peas beans beets spinach potatoes—bread, milk, ice cream; 3) apple juice, marinated herring, salad, poultry livers risote, ice cream, milk. Tomor-row I will simple down the fare more, and Friday she'll go on Mrs. HP's wholesome diet. I don't yet know when we will leave tomorrow. We might even miss the train and not go until Friday. We have a very nice room here on the 16th floor, fine double bed, outside view, $3.30. We could be happy here for a long time. I'm sorry if it runs into money, if you're sorry, but no money of mine could be better spent. You spend all the money you want on any of the things you like spending money for.

Ann is asleep already. Last night after she went to sleep I lay awake thinking of all the things I should say to you in a letter, but because they weren't wrote down last night they're all gone now except as bony structured frameworks which don't seem warm or vital.

It was a wonderful time of day when we got here—late bright yellow sun, very busy, people moving around. Ann was impressed with the city aspect, tall buildings, etc. Also the vertical view from our window, little taxi cabs and people crossing streets. She now knows that this is the 2nd largest city in America.

This is a fine window view at night too—bright lights. I'd like to catch the Brass Rail and Jimmy Noone, etc. But I guess that would be taking Ann too far. In New York be sure to walk on lower 5th Ave, near Wash Sq. at night, and on side streets, get the dark ghostly feeling with activity all around. Also ride a cab with no lights.

I hope you are getting your health thing taken care of—through regular non psychiatric channels. I have no resentment or displeasure about Sam and his place in Our Case. I do have a sadness for your weakness—more or less—of feeling constrained to drag him in by that horn. Unable to cope with something you should be able to cope with, I say. Everyman his own good psychiatrist, I say. But then, people are different.

Myself, I'm a bastard. If I am a bastard, and have no interest or care for you, or my family, you should still want your health taken care of shouldn't you? When a man tells his wife, about an un-marital affaire de coeur, or penis, he does it only because he loves her so much and knows things can't be right or complete without her knowing. Or else he does it because he wants to break off any last vestige of respect or affection—then he does it glibly, in order to get away the sooner.

For me, tonight, the primary important thing about life, living, are: in order of importance:

1. to accept all of life.
2. to understand, or at least interpret personally all of life.
3. to express the understanding and personal interpretation to yourself, and for yourself.
4. to express these things for others.

Anyway I got no. 1 under control and you ain't.

I love you.

I want to do good for you, and for you to do good for me. But our love must get active.

I love Marjory too, and have *decided* not to love her actively any more. Such decisions do not filter by casually. She has done me good Penny, in things that stay with me, even little local things like self confidence. She brought about the good whole feeling I've had with Ann since I left home.

I reasonably and emotionally most want to be with you, Penny, and insofar as I'm not I have failed you, yet I am totally determined to accomplish being with you to the end of all my powers. Actually I am with Marjory, now, so damned strongly—that is why I wake up in mornings sometimes feeling what the hell am I trying to do. I think you understand all of this—still you probably say why did you do it in the first place, why did you accept or create that first jumping off place?—Your query is right and

reasonable and I don't know the why answer fully, but we got the facts. I don't even know whether to disagree or not with the idea that I am a bastard—maritally, paternally, integrally—but we got the facts. I hope for you to know more fully some day about Marjory. Unless you do I haven't got a chance with you. Right now I want to tell you and tell you things.

In these my soul purging days I think I shall tell my mother about my Catholic University affair and about the time I fell out of a tree.[37] Those things are perhaps still active psychological burdens on my progressive spirit. Also about the time I was peeping in windows at ladies undressing. That would probably free me.

This writing of mine, and the more clear concept and movement thereof, comes to me strongly on days like these—in the early morning smoke smelling small towns in Ohio, and with Ann seeing the ten thousand red freight cars in the yards at Gary and telling me about it, and walking with her from our Pullman car through the long black Union Station sidings with many people, red caps soldiers sailors, big engines hissing up along side of her, 2 feet from her, and she letting go of my hand and laughing and telling me she likes Chicago, and goddam you I'm going to do it and I'm close to it and nothing is going to stop me including the Holy Family by Raphael and I'm happy because I know that. Write to me and tell me. I love you. John.

Morning—

dear gal—

Things won't work out the way I had figured them, and I've had to make a lot of 2nd best choices, fast, in ticket offices. Anyway now I can tell you exactly my movements:

leave Chicago 4 PM today, arrive St. Paul 10:30 PM
leave St. Paul 8:30 AM Sept. 9
arrive Chicago 3:00 PM Sept. 9
leave Chicago (lower) 10:00 PM Sept. 9
arrive Wash 5:00 PM Sept. 10

That is what I had hoped to be able to avoid—a whole last day on the train, and that's a hell of a time to arrive in Washington anyway, and what will Ann and I do with no hotel from 3 PM until 10 PM? But I'll figure out all those things. This afternoon I will take her to the lake and to the art gallery. We had breakfast in a big juicy cafeteria.

[*what follows is a breakdown of expenses (cab, hotel, etc.) while in Chicago, which total $43.86*]

love John

ADDITIONAL WRITINGS

THE SELECTIONS REPRINTED here include a variety of genres—journals, essays, letters, literary pieces composed on the run. All relate in one way or another to Vachon's FSA years, with the exception of the excerpts from Vachon's journals, which encompass a broader period. Vachon began his introspective diary in 1933, when he was eighteen years old, and for more than twenty years it served as the record of his thoughts, ideas, ambitions, doubts, and desires. Given the trajectory of his career, the volumes of his journal constitute a kind of bildungsroman, tracing the development of an artist. "When I was younger," he wrote on December 13, 1941, "I spoke of 'Beauty' often enough. Now I am washed and drained of any ability to use the words themselves, or any conceptual substitute for the actuality. . . . But I will give my whole self to becoming a good photographer, a good painter, and a good writer." Indeed, Vachon's ambition to become a writer runs like a leitmotif throughout these pages, and the act of writing in the journal was itself training, and perhaps ultimately a substitution, for the public writing that Vachon dreamed about. Reflecting one night on a conversation he had had with a stranger in Las Vegas, Vachon came to an important realization about this long-standing ambition:

> In explaining myself away, I said one night to a girl that writing is the thing of most importance in my life. I have always had to say that, get that on the consciousness of whomever I've liked. Joe Roddy, Esther Bubley, Brian Moore, Lew Gittler—all must be indoctrinated by me with the idea that nothing is so important to me as good writing, great writing, my own writing, that is. Even to those who know me best, or can no longer be fooled—Penny, Phil Brown, Jim Feely—I attempt the constant reminder, or suggestion, of my worth as a writer, subdued and slightly humorous though I must make the suggestion. This girl, Trish, heard the theme, and then asked the unexpected and most cruel question: "Do you write, or do you want to write?" So that was the first time I have outright lied on this subject. I could not stand up to that cold light, and I said that I wrote—novels, short stories, humorous pieces. And now my shame is not small. Perhaps this is the end of my writing career. (September 27, 1952)

Realizing the surrogate function of the journals, he resolved, from that day forward, to cease writing them and to channel his creative energies more formally into fiction.[1] Not until April 26, 1954, however, does he actually declare his independence from the journal: "Upon finishing these last few pages, this type of book will be forever finished for me. I should then perhaps keep a notebook, for the notation of any ideas or arrangements of words which I fancy."

Yet Vachon also knew that the journal had served him, along with his letters, as a vehicle for ru-

minating on his own life and for observing the scenes he moved through. And certainly the daily chronicle of his thoughts was consistent with his extraordinary and perhaps compulsive habit of record keeping, the oddness of which he recognized himself:

> I have spent a great part of my life, the past 15 years, chronicling myself in charts, maps, records. There is my map which indicates every county I've been in, and my world maps. There is the mammoth undertaking which tells how many years, months, days and hours I've spent in each state or country, the total adding to my age at any given time. I have records of hotels I've stayed at, all airplane and train rides, cities in which I got haircuts, rode streetcars . . . (September 27, 1952)

He could have added to this catalogue of catalogues the many notebooks he kept consisting of lists of recondite words (one page reads, "ambagious, ambient, ambry, amentia, amerce, amercement, amort, amphibolous, amphiboly"), all with brief definitions. In a moment that glows with relative sanity, Vachon paused to consider his habits: "I wonder whether to give up the records and charts and maps. It isn't altogether good to feel I must count every pullman car and every county and every hour for the rest of my life" (December 20, 1949). This strange mania, whatever it means (and however much it would have fascinated Borges, the author of "The Library of Babel"), seems oddly congruent with Vachon's career as a journalistic photographer—a visual scribe of the quotidian, a recorder of passing images, events, scenes.

Toward the end of the journal, Vachon began to see it as part of the composite representation of the self that he had seemed to aim at all along. "I'm glad I have all that I've written down, and my maps, charts, and several hundred letters to Penny, because someday when I'm sixty, and that's a long time off, I'll read it all over and that will more or less be my life." And he added, with self-deprecating irony, "Less, I guess" (July 8, 1950). That the journal was also in some sense a performance, an object to be communicated, seems clear as well: "I have a new view of myself, what I am, who I am. I hope someone even will sometime read all I wrote, and in such an event, perhaps Brian, my son" (December 17, 1949). The selections offered here represent about a tenth of the complete journals, which continued on and off until May 1954, when Vachon was forty years old.

The other pieces reprinted here relate specifically to Vachon's work with Roy Stryker's picture agency. "Standards of the Documentary File," from the Roy Stryker Papers, articulates in lofty terms (quite lofty) a vision of the FSA project that transcends its immediate political and strategic uses and raises documentary photography to the level of monumental cultural record. It is striking how clearly Vachon formulated his sense of what the documentary is or could be—eschewing the melodramatic or merely topical, aiming for a representative quality that would provide a social record of lasting historical importance.

Every FSA photographer in the field had the benefit—or the constraint, depending on how each

one looked at it—of Roy Stryker's shooting scripts. Usually they were tailored to the specifics of the assigned region and its social and economic characteristics, as in those written for John Vachon. They reveal the systematic nature of the FSA effort as well as the extent to which Stryker's vision, sometimes remarkably detailed and prescriptive, dictated the contents of the archive. But words are one thing, pictures another, and the specific embodiment of Stryker's language was the product of the photographer's individual vision. Along with the scripts for Vachon, I include here the general script for all photographers that describes the perennial subject at the heart of the FSA vision, the "Small Town."

The selection of letters exchanged between Roy Stryker and John Vachon offers a glimpse into the friendly teasing and mutual respect that seemed to underlie their relationship. It also reveals the utter dependence of the photographer in the field on dispensations from Washington—for equipment, for instructions and assignments, for arrangements for interviews, and, above all, for letters and certificates that would open doors to the civilian industries during wartime. Vachon, unlike the anarchistic Walker Evans—whom he admired enormously and from whom he had learned so much—could identify (at least for a while) with the purposes of the FSA, merging his own personality with the goals of the Roosevelt administration: "I've really become sold on the rehabilitation program. For the first time I see that it is the fundamental and important part of FSA, and that county supervisors are in general pretty good guys, doing good jobs" (Vachon to Stryker, October 1938). On his part, Stryker would send out elaborate instructions, critiques, and words of encouragement to his young photographer in the field, sounding at times like the sagacious spymaster instructing his agent:

> You will always have sufficient information so that you will be able to do an intelligent job, but there will be plenty of times you will wonder what it is all about. Our general advice in those instances is that you check your curiosity in the car and wait until such time as we can give you further information. The main thing is that you will always have sufficient knowledge of the job so that you will be able to proceed on an intelligent basis. (Stryker to Vachon, March 18, 1942)

The section called "First Day Out" is taken from a manuscript dated January 1942 that begins with an account of Vachon's leaving his comfortable family in Washington to go out and talk with farmers and former farmers as he observes and photographs their rural lives. With its vignettes, character studies, acerbic observations, and disciplined irony, it is more "literary" than the writing we find in the letters and in the journals.

In a lighter mood, Vachon wrote to his friend Philip Brown a whimsical account of his typical day as a photographer on the road. Vachon loved seeing new places and having new experiences, adjusting well to life on the road; but this self-mocking fantasy, with its extravagant indulgences and pleasures, belies the many hardships, the misery and loneliness, that were also part of the job and that are recorded in the letters to his wife Penny.[2] The letter to Brown is undated, but it may have been writ-

ten in late 1943, perhaps after Vachon had left the OWI. Stryker had retired in October of 1943, going on to work for Standard Oil Company, where he initiated a massive project documenting the impact of the oil industry in North and South America; Vachon joined him soon thereafter, working with him until the photographer was drafted into the army, in 1944.

"Tribute to a Man, an Era, an Art," published in *Harper's Magazine* (September 1973), looks back on Vachon's entry into the FSA project, his FSA mentors, and his earliest photographs, which began as imitations of the work of Evans, Shahn, Lange, and others and gradually came to exemplify Vachon's unique style and eye. Vachon focuses on the shift that came as the United States entered the war and on his love for the midwestern prairies. His attitude toward Stryker was always somewhat ambivalent: admiring and grateful, but also at times—given his condition of dependence—resentful and critical.

These additional writings, together with the letters to Penny, reveal multiple perspectives on Vachon's work as an FSA photographer. Behind the pictures, we can hear Vachon's most private voice in the letters he wrote to his wife; we hear the backstage voice of the photographer when he is talking to Stryker; we hear the subjective transformations of his working life in the letter to Phil Brown and in the quasi-fictional narrative "First Day Out"; and we hear the public voice in his "Tribute" to Stryker. These documents form, in a way, a multifaceted documentary picture of Vachon's FSA career and provide a uniquely valuable resource for students of the era.

FROM THE JOURNALS

JANUARY 31, 1933: 4:00 PM

In this eighth month of my eighteenth year, I'm suddenly enveloped in the entirely novel idea of maintaining a record of impressions, or shall I say, diary.

The idea came late last night, and after some few hours of thinking, even ascertaining phrases which were to appear in my diary, I fell asleep. And tomorrow afternoon, which is, now, now, I'm dribbling over the first page of these to be treasured annals.

I'm afraid this is all brought about by a feeling of disgust for myself, and of contempt for others. Lack of freedom is giving rise to a longing to express myself somewhere, with absolute freeness. Thus, I've sought this paradise, where thank God, I'll write on and on, unconstricted. No thought of Moynihan's appraising eye, my mother's devoted eye, or any of those damned eagle eyes. Of course in keeping with my all consuming ambition, I'll strive herein after literary worth, though I've so far made a miserable mess of it. This literary worth however, my dear John, must as nearly as is possible, flow. Flow, run all over the pages, but don't stop to grunt, or force. It was that evil which stained my beautiful nine pages on the Seminary, and even now I'm having a hard time avoiding it.

It is probably my lot that after spending much valuable time in planning the requisitions and the

embellishments of this book, I'll be stopped, unable to think of events or thoughts worthy of notation. But no. That's because I'm writing now in the afternoon. Wait until those tiny glowing hours before and after midnight, when innumerable curtains shall be removed, and the flame of my mind will burn steadily and brightly, forming strange fantastic shadows on the stones and rocks above.

Even now, damned hypocritical demons which lurk among the obscure passage ways of my mind are counseling me: "how would it appear in print?" "won't you . . . " I've just been interrupted with uncouth vehemence. But picking up the damaged thread of thought, I find that I was deriding myself for my ungovernable hypocrisy. As I write, with most upright intent, I keep wondering how future readers would take that last passage, when all along, I so honestly intend that these pages shall never be seared by eye than mine. That's why I want to write so freely, so unconstrainedly, so into the gentle morning breeze of early summer, as it wafts through the treetops. If even now some inquisitive fool is reading this, which is not for him, I ask him, I implore him to desist, to destroy it. At this moment, I do so ardently desire that I may write, may phrase impressions and chance fancies which will be a treasure to me in futurity, and to me alone. To safeguard integrity, I'm tempted to cover a page with cursing and a defiling parade of scurrilous filth. This would positively prevent me from ever allowing my firm grip on the book's safety and security to loosen for even a moment, but it would give these well-loved pages a horrible stench; besides, what if my mother, what if anyone should chance open this book to that page. What a barbarous and lecherous leper I would appear.

JULY 5: ABOUT 8:45 IN THE EVENING [1934]

This is me again. Pop left this afternoon on his long five week trip. Last night we saw picture from novel "As the Earth Turns"—very good, almost ennobling. Today, downtown to the dentist's. I visited John Barrymore "Long Lost Father"; very dull. Very dull, indeed. Tonight, I've read some of S. Anderson's short things from "Winesburg Ohio"—how more searching, how truer than such stuff as "Main Street." Man. Sherwood A.'s light presents him, a pitiful fellow? Man. These grim stories, man and woman, married for years, and silently hating each other. It is, I'm forced to believe, fact. In variously modified forms take married people I know. Still it gladdens me to think of my own father and mother. Though father's misdemeanours (God grant they have ebbed!) thrust ugly gargoyles into my parents' married life, scarce to mention bitter arguments which wrangle with quiet hours, yet between them there is a living spark, love never made ashes. It is doubtless his tenderness, agreeableness, perverseness, and above all humor, which meets and reveres her sureness and practicalness and blind affection, that will never let them sink into a dull and unresponsive toleration.

When just a few more things have been cleared up, I'll prepare a story for submission, but tonight, I must write, Helen.

APRIL 7: 9:45, SUNDAY NIGHT [1935]

The symphony concert this afternoon was made up entirely of American Music. Again, Gershwin's "Rhapsody" crept obtrusively into my blood. It is so comprehensive, so mad, so rhythmic, brazen and blaring, nervous. It seizes me and tightens me and loosens me; it cannot be forgotten when it's got you; it cannot be forgotten.

Ramona Gerhard was the very competent pianist with the orchestra this afternoon; she was very vibrant and arresting.

Some pleasant but less living selections were played from Frial's "Firefly," and Sigmund Romberg's "Blue Paradise." Gertrude Lutzi lilted lovely; but the finest of the program: an "American" Concerto for Violin and Orchestra by Gusikoff. Heimann Weinstine was the soloist. This is the first music I have ever heard to actually stir sentiment and love of country in me. This was superb. It seemed highly expressive of my country. It showed me all America: New York in those oft used Manhattan strains; Iowa, all the west, the south—the people, not low and suffering classes, but the people to whom we can open our eyes—all erect young men and women who in their own companionship are self-contained and superior to the rest of the world. My variegated throbbing homeland became for almost the first time dear to me. I knew it, and was pleased to know it as a masked country, a land of millions of masks, a great carnival where the shrill calliope makes all other sounds less. I felt confident and brave; I felt ready to set out. Set out! It seemed I had gained her and was proudly with her; that she was even now by my side! We were together! Proud, brave, and setting out! But I all the while knew she was not by my side—I was without her—I was alone and sad. Only my good, simple friend Pates sat next to me.

It is nine days since I've seen her. Nor did I reach her at our last meeting. I could say or do nothing of myself. How can I see her again? There are no more concerts. Will she, whom I have wanted more than anything, fade from me forever? What hope have I to attain her? I cannot speak, or even give the faintest glimpse of my heart to her. My heart to her. But God, there is nothing so loathsome as he who resigns himself to a silent love. Herein, I hope: yesterday I took my examination for my fellowship. It was much harder than I had looked for, and in many ways I'm sure I bungled it. Yet mayhap the gods, the fates, the stars, are with me. Before the examination I followed along swiftly in the rushing winds of hope—now, in a changed simile, I am sailing my desperate vessel of hope feebly over stormy seas of futility. Yet if I win! How it would change all aspects! How my scene and scope would widen! How then I should feel that I had done something which was of worth, that I was not to be accounted inert nothingness. Somehow my future with Mary Jo seems to rest with that fellowship. The summer would be one of day after day with her. o, somewhere in there I should have spoken, and we should know each other! Even the leaving would bring us closer. I should be "setting out" for Washington, not merely going. I would kiss her in parting! Our letters would be frequent and immortal. And my return! To see her before all others. How all my life depends on winning that which I'll not

despair of! If I do not win it, I shall be snagged for ever in the swamps of mediocrity. That, I know. And it is now too late to do anything to further my case, I have done all. I can only wait. Perhaps the next time I write in this book I shall know! I shall be happy beyond hope, or hopelessly hopeless! I must wait, wait, wait.

Inscrutable face!
Civil smiling smile
Of the unknown place—
The doom and the death
On the life, and breath
Of man's deep cast hopes.

APRIL 27: 11:25, SATURDAY NIGHT [1935]

And tonight I am smoking my pipe. Prince Albert tobacco, a very fine brand. Comfortable and quiet. Bathed. Alone. I have had a full day. A good day. A memorable day. I have within myself a good deal of identity. I am John Felix Vachon, that no one can deny. And there is nowhere else on God's green earth another John Felix Vachon.

However, this happened yesterday: I received notice that my suit for a fellowship had been unsuccessful. I had felt certain of success and visioned accordingly. There are many types and degrees of disappointment. Perhaps the most rending is that which destroys an expectation of going somewhere. Disappointment is deepened when it shatters with its bolt that very gallery of pictures one has painted, pictures of the place one is going. This was the greatest and most altogether disappointment I have ever known. In fact, I can even remember no other in my whole life worthy of the name. A disappointment must, I now see, come all at one time. It cannot be gradual. Its effects must extend both forwards and backwards. It is most perfect when preceded by a rising scale of hope, the attainment of confidence, and a period of expectancy and violent happiness. Then may disappointment come and be a masterpiece. So it came. I had never before, I see now, experienced it.

Last night I couldn't, actually couldn't, realize that the thing was past. Tonight I quite can. Continued reflection on my perhaps too high opinion of my quality and of the quality of my examination, together with constant plans and pictures of the future combined to give me a confidence amounting to certainty. Truly I was sure I could not lose. Then there are the things I was going to do, which are even yet interesting; I had left no angle of the future unscrutinized: first my mother and father were to be so delighted with me that I should have free and lordly reign. I should be given great sums of money to go out and spend on the one whose pleasure and favor I most courted. Among my fellows I was to become pleasantly cocky. I was to be pleasantly envied, and damn well respected. I was waiting till that time to seek the friend-ship of Peter Murphy—a brilliant young sort of fellow. During the Sum-

mer, sure of my next year's engagement, I would sport and study. I would dismiss for all time the trivial scholastic affairs of STC [*St. Thomas College*]. (Well, I shall still do that.) But then would come my day of departure. No need to tell of the thrill of that first leaving my inland home. The passage through cities I'd never before seen. Set up in Washington, I would live as a true man—buy cigarettes and whisky freely. I should have my books and papers with me, I'd write, and for once and all that question would be settled. My stuff would be accepted and I paid. Then my correspondence. I had already outlined mentally the letters I should send to M.J., to Baker, Feely, to my mother, to Robert, to many other people I've been afraid to talk with. I'd now be a young man of great expectations. They would be flattered to be written to. In Washington were (and still are, I suppose) the theatres, good shows, the libraries, the art galleries, the streets, the people, the book shops, the Potomac River whose banks I'd make my own. All this and much else had been mulled over, reveled in, played upon. But most of all had the theme been Mary Jo. To me it meant Her. She had been part of that period. Without that I could not imagine her. That was the very key of the thing—my having won an honor. Not the going or the being there so much as the distinction of selection. The honor. I should have done something. I should be marked. Somehow she can only be thought of after gaining some signal honor. The waiting maiden whom only the hero, the bravest and greatest can seek.

"Well," said the colonel, smacking his lips and laying down his glass. "That was thought through the threads of the Tiber." "You, too," she exclaimed. "You, too, you, too." The children were already growing noisier, and the doctor deemed it syphilis. Oh ho. brekekekex koax koax BREKEKEKEX KOAX KOAX you too you too you too.

But now I must set it down, as it befell. I had been daily returning from school with a thumping heart, my first question to my mother being, had it come. And on this Friday when I returned, I did not ask my question, for she turned her eyes upon me, and was very happiness, and pride itself. "It's here," she said, "it's here." Never can I forget her look of pleasure. She thought her damned no good son had done something worthwhile. All over she smiled with joy and pride in me. The letter had come, and she'd not opened it. But who on earth would expect them to send me a letter informing me I'd not won? She was sure. I know she had prayed for me—and that. Then for that brief ecstatic time was I also sure with an elation such as I'd never before tasted. She handed me the unopened letter. I shook. It became opened in my hands, and I read the first sentence. Only the key word fastened onto my mind—"unsuccessful." I recall groaning once aloud in a sobbing manner. I threw the envelope to the floor, then sat down and read the letter. At that time I did not know it, but now I see how it was my proud mother who was the most pitiable of all women. She had been sure, I remember how she spoke my name and looked at me in utter lack of understanding. Then for an instant of absolute disbelief. Then she came to where I sat and over my shoulder read the letter. She continued to do what she had been doing, I picked up a booklet advertising Ex-Lax and began to read it. My brother talked, talked a lot. I went to the store a few minutes later. Those minutes had been those in which a grief has

dulled, absolutely deadened the senses and thought. I just sat and my mind moved nowhere. I looked at a picture of a woman examining Ex-Lax. The time was so wholly heavy, I can remember no thought which was in my mind. There was none. I but sat arid stared with dull eyes. My mother was standing still by the stove preparing dinner. I think I know well what was in her mind, too. I did no thinking on the way to the store either. I don't know why I went; she had told Robert to go. It is true literally: I couldn't realize it. Then, of course, I talked when I'd come back. I ate, and discussed the thing in a detached tone. I laughed at some peculiarly humorous phase of it. I whistled, and then came in and diligently applied myself to playing a piece on the piano, a piece I'd never seen before. Then I went back to school. All the afternoon this dullness, and absence of thought stayed with me. I studied in the library for two hours. Then I walked down by the river to a place I seldom go, not to the familiar paths but through a ravine to a bench where the ground is of wet clay and mud. On the bench I sat, and smoked my pipe. Now I was thinking—a little. Later I walked home. It was a strange feeling—to feel that it was gone. To feel as I felt. The afternoon and night left and came. I read "The Frogs" in the evening, and then about midnight I took out this book and wrote in it. I just wrote. But then I began for the first time to weep. It had been very, very long since I'd wept. One feels the eyes grow hot, then wet. Tears come out and fall down. The predominating motif of weeping differs in an indescribable manner from grief, or sadness or dejection. It is a bitterness, but different from bitterness. It is extremely personal. One is weeping for oneself. Tears are of self pity, but weeping is not self pity. It is not contemptible, but it is queer when you've not wept in a long time. So suddenly I knew I wept. I didn't stop it right away, but watched it carefully. Then I laughed. Not aloud, because I'd have attracted attention, but with all the grimaces of the laugher aloud, I laughed. And I picked up a mirror and looked. Then I laughed more, and tears shook out and splashed. God, that was a strange sight in the mirror!

So I went out to my bedroom and prepared for bed. It was late, very late, but I had regained much. I felt, not better, but more aware sensibly. I felt all spirit. So for half an hour I talked to myself, gesticulated, and looked in the mirror. I acted. I was a superb actor. Then I smoked a cigarette and held my head out the window for some time. The night of course was out there. Later I addressed God and slept. The weeping had had great effect on me. I wonder, does it strengthen the eyes?

Today was a good day. I took an examination in Mythology at 11:30.

About three o'clock I went downtown and saw a movie, "The Scarlet Pimpernel"—Leslie Howard, Merle Oberon, Raymond Massey. I so admire that damned Howard fellow. The story was like a Dumas tale, but it was also much like a movie tale. Still, it was apt. And Leslie Howard is damned good. I, too, can act. Quitting the theatre, I visited the James J. Hill Reference Library and browsed till nearly nine. I've neglected that place, and had quite forgotten its vast resources. I'll surely visit it often now. What Latins and Greek in complete editions! Callimachus, Ausonius, Petronius, Tibullus, Hesiod—those whom one does not see every day. And English Literature, there to take down and hold in your own hands! Beautiful editions of Coleridge whose covers fall together slowly and noise-

lessly, thick covers, golden and heavily embossed—thin, precious papers of pages. The works of John Webster, Heywood, and Lyly. Nor have I even half completed mere looking about—not begun examining. I came across a four-volume set from the Loeb Classical Library—the letters of Saint Basil translated by Roy J. Deferrari. Roy J. Deferrari is the man who has written me four letters from Washington, the last spelling finis and awakening. Interesting curiosa.

Thursday last I saw HELEN HAYES, Philip Merivalle, and Paulen Frederick in Maxwell Anderson's blank verse labeled "Mary of Scotland." That was a new experience, wonderfully new. Helen Hayes held me as no woman ever did before. There can be no more completely feminine and charming person.

Sunday last I visited Father Folque with Baker. We had an interesting evening of intelligent conversation. I was largely silent. After leaving him we picked up two girls—nurses. I'd never do that again. Ha, I did. Regret it? Of course, I always do. Our course of action was the routine—we drove, parked, and then kissed our women and handled their breasts as do peasants.

I had intended tonight to tell of what I shall do now. Future—life stretching before me—you know. My dissolution with Washington must result in more and new foppish plans for a supposed future. When in hell does this talk of future begin, anyway? But it has grown late. Later.

APRIL 28: 2:08, SUNDAY AFTERNOON [1935]

It was a wondrous, windy day, the skies their richest blue, when I started out an hour ago. Now it is stiller, and the sky is crowded with many black, grey, and dark blue masses of cloud. I left the house after a fight with my father, who had raged most ungovernably, and totally without reason at my brother. His white face shook like a deified beast's as his stuttering anger shook out at us. I trembled when I hollered back into his face. Oh, he has a damned, a cursed black and unreasoning temper. I shudder to think that I, too, possess an unreasonableness which is like his, but tempered perhaps by a sense of self shame and of humor to a less violent expression. I shudder, but one cannot despise what blood is in him. What an evil, godless thing is a man heedless to reason and unbridled in anger.

SEPTEMBER 23: MONDAY AFTERNOON [1935]

Why I now feel that I should write is truly a great riddle, for I have nothing to say, nor shall probably be any future time in my life when I'll have something to say. But always I'll feel that I should write. And probably write. I sicken when I reflect how I've written on and on, on myself and my crawling lusts and discontents. I long for resurrection.

The events of today, dramatically unbelievable, forever must turn my life and conduct. Here words can only fly: my fellowship has come. How much more lies in that miracle no words could fashion. This is resurrection.

OCTOBER 2: WEDNESDAY NIGHT, WASHINGTON D.C. [1935]

Such a realization as this, after so all destroying a disappointment as that—I am, now, in the city of Washington, am I not? And furthermore, I am appointed a fellow at the Catholic University of America? Such a realization quite taxes all my powers of acceptance. But this is true. This news which I learned now eight days ago, only eight days; how greater a change than eight years used to work. This news had robbed me of articulance. I could not be cocky as in the spring of my hope preceding the horrible night of my disappointment I had intended to be. I could only be dumb. I had suddenly fallen heir to the greatest distinction I could wish for, and in 36 hours was to leave my home for the longest period I shall ever have left it. To return in a triumph to the city which only a month before was the scene of my very depth of disgrace: where I was jailed and drank black coffee; where people looked gingerly upon me as handcuffed I was led about, where the law told me never to return again. And now I am here, thus (the law, however, is unaware. I shall no longer worry of it; God is good, though his ways are beyond the mind of man. God knew of this when an unshaven lout I lay on my iron bed in jail!)

However incomprehensible, it thus fell out: on a Tuesday, a wretched Tuesday when I performed house chores and pined for Federal Aid to attend Minnesota's prosaic university, I was taken by a telegram "K.C. fellowship open at C. U. Wire acceptance at once." Only that and nothing more. I wired, I prepared, and I went. Before going, I saw Father Moynihan, Jim, Will, and Dan. My mother was proud as only she can be proud of me. She was gladdened for me, and sorrowed to have me going. It was a classical parting.

Coming east again, retracing the recently traced paths I indulged with keenest pleasure in that reflection which is so natural to me, reflection of what other people were thinking of me: people I don't like, those who don't like me, those who thought me a dull dolt! Ha, how surprise and forced respect must seize them. This is the truest of inferiority complexes at work. Nonetheless, so it worked, and I was pleased.

But now I am here, and all, even I above all I am different. I can never but think of this great fortune as God's wondrous working. My mother had prayed and hoped. I truly believe she blindly hoped long after reason declared hope could be no more. This great mercy of restoration has taken me from the mediocre borders of sin and lifted me. I might soon have been lost. Now I am forever strength-

ened. I have new faith, and my sickened ideals have become immortal. I feel gratitude and love toward Him who has opened my way to decency and respect of self, a life working for His honor and glory. All the great goods of life have regained their proper values, religion, accomplishment, love. And again I think of air, music, light, poetry and Mary Jo, in the manner of sanity, I think?

NOVEMBER 4: NIGHT [1935]

I have enjoyed wonderful snatches of reading tonight, ranging lightly through a few of those ancients I so love and languish curiously for—Petronius, Catullus, and a hitherto unknown Longus' Daphnis and Chloe. Ah, what great patches of reading I have in store: It is a treasure of anticipation as pleasurable as one of remembrance. I am striking about in the skies of literature, so far as I can reach them, for an apt subject on which to dissertate in the thesis that must merit me a Master's Degree. I favor most of all something associated with the Elizabethan novels as affected by, or as similar to, the Greek novels. Then I consider Swift and Petronius as contrasted or compared, again Herrick and Catullus, but damn the rigid forms of these pedantic institutions, these useless and arbitrary rules of self styled scholars: I know not how to carry on such work, what I may, or what I should do. A day or so ago the precise and scholarly Speer Strahan (my teacher), whom I, despite my convictions, admire, had almost me won, had I believe won me, to the joys and superiorities of the straight screwed scholar as against the alleged superficialities of the broad appreciator. But today I had a letter from my insupportable, my dear, my humorous friend Black Will. And it so breathed of the ancient joys of living which if I've never known I've at least idealized, that I throw all else to the winds, in happily realizing this spirit of looseness, this human stuff of wit, this non-conforming genius, the freedom, the fibers of life and green fields and girls, the elevated intoxication that is Will's, and mine. And Shakespeare's and Marlowe's.

That became a little rabid, riotous and inane, of course.

I'm wakened out of it all, at any event; I refer to that which held me the first few weeks of my coming here: a lethargic ignoramus of where to go or what to do. And if I die, what? I shall have lived. I mean merely lived—no jumping joy of the pleasure seeker attached to the term. But black heavens! It is close to twelve, and at twelve my lights are darkened by a hand not my own. And so I must prepare myself for bed.

MARCH 7: SATURDAY AFTERNOON [1936]

The feast of St. Thomas Aquinas. A year ago this day I attended a banquet at my alma mater. I was happy that day. Father Moynihan and Archbishop Murray addressed us. I was then hoping for my K.C. fellowship, hoping so hard. I now have an almost desperate love for St. Thomas College.

I suffer homesickness. It can be nothing else. But so piercing is it that I sometimes despise people because they do not know my friends at home, or because they are not like them. I hate things which have an unlikeness to things at home. This, I feel, cannot last very long. All that past which was must somehow be renewed and carried on from where I left it. Of course, I cannot go back, at least not until summer, and then not unless I have proved myself worthy. I have written to my mother, telling her I've left school. It was a hard letter, and I pray that her disappointment may be the least possible. My reasons to her were careful—because I tired of and despised the scholarly life and because I had a golden opportunity to get a good government job. From now on I can be truthful to her. My greatest dread, though I feel it cannot happen, yet I fear it, is that I shall be severed. That I shall go back to my city, my home, the river, the haunts, and the boys, and find all have gone off in a line alien to me. That things will never again be as they were. If that compatibility, that atmosphere of easy movement and knowing should be destroyed, I should feel death close. But it can never go. There is too much. Whenever or wherever I might be together with Jim and Will, something would rise out of it that rings of eternity. Anytime with Dan, thoughts would direct us to the same things, there would be an indestructibility of friendship. Or alone with Will, that easiness could not but arise, that very finest essence of wit and superiority. With Jim alone, can that go? Can it have gone? I have not been with him alone. Always he has come into the chord with Bill. Half losing him, yet appreciating him fully in the combination, I have retained him always in mind as my sole, truest friend. But if any of this should depart forever, I think I would be irreparably lessened. The letters I have from these boys are flavored with themselves.

I've read considerable Chekhov recently. He is warm and subtle. He is kindly, but ruthless in baring his characters. A pessimist? So he must seem, but he is so true and so lacks bitterness that I cannot call him pessimist. The atmosphere, the essence of days, the air, the sky, the feel of all nature runs through his stories as pervadingly as in Hardy, but more effectively.

Now I am known. Perhaps. Fully? Or to a degree. Or maybe hardly at all. But Ryan Beiser has started from the beginning and read all these three books through, omitting none. That is something I have never yet done. So now, am I known? And if so, am I known as contemptible? I have had but little time to discuss the books with him, as he visited me here after finishing them, and here one had to play penny card games and drink tea and talk insignificant talk with insignificant people. That is damned and vile of me to say. It is not my true feeling, but it is my immediate feeling upon realizing how intrinsically and wholly I've become part of this family. Love and appreciation cannot overcome the differences of worlds. At all events, Ryan read them throughout. He professed to like my poetry. He noted and found interesting different phases and developments as portrayed. He thought me as a "humanitarian" in ever embryo. He suggested the feeling of unimportance, of too great words and phrases over too small "soul stirrings." I was sincere he thought, but only so sincere as at 18 or 19 I could have been. There are now many things of which I wish to talk with him; the unity, the humor, the philosophy, or the poetry of any-

thing which I have written, the literary possibilities as he can see them. He is a fellow whose mind and judgment I greatly respect. I was undoubtedly a fool to show him all that, but I had an uncontrollable urge that someone should see all I had written. And now someone has.

Of Ryan I have made scarce any mention herein. He was a fellow I knew the first three months of school, but thought little of. Then on the night I received my pronouncement of doom from Rev. Dr. Cassidy—it was about 5:30, already dark, and raining with lights everywhere shining in rain—on that night. I went into my last supper at Catholic University and sat at the table with him. I was half dazed, but more fluent than usual. Perhaps I felt heroic. It was there I first talked with him and seemed to strike a friendship with him. Later that night we drank—how damned fitting—he and I and Vince Giacommini, the chap with whom I had most friendship at school, a good fellow, but never, I now see, at all close to me. We drank beer, and Ryan and I buzzed and talked a lot, about ideals and such nonsense, life, love, achievement; good talk, but built on beer. I began to feel very close to him. He seemed one of us. In the morning, cold and wretched, disgraced, dishonored, early and dark, a miserable day, we set out for Davenport, Iowa, in that damned Ford, four of us. On that journey I came to know him well, and there existed a mutualness between us that set us off from the rest. The trip home and back again was a little epoch deserving of an epic. Coldness, dirt, and coffee, whiskey and cigarettes and pushing, laughing often and talk while moving on, pushing in silence. Snow. Coffee. Mountain tops and mountain bottoms, and towns. Cold, then warm. That was comfort. Sometimes snow, and early morning, and even all night pushing with lights ahead of us. Thinking and talking deeper with the solitude and black of night, pushing. The sun would be setting, orange yellow winter sky, dirty snow, uneventful dirty towns, but never stopping for this setting sun, just moving on, pushing, getting west, always the place ahead of us, and at last we were there. That was a horrible and heartbreaking night. I boarded a train in Davenport. I looked dirty and tired, as of no importance, but the bitterness was that so I was, and none knew where I was going. The train took me into my own city again, St. Paul, but my return had not the heart I planned for it. Triumph, Mary Jo, my heart to her, those things passed bitterly through my mind, for I was coming home silent, my mind grim and grimy. I had a secret to keep and I kept it. My mother and father were glad that I was there and I was, too, but I had a secret to keep, and I would dream I had delivered it, and there was always that horror of awful black to which I would come back. I didn't see Mary Jo those two weeks. I didn't want to. I saw all the boys, and we drank and I drank greatly. Girls, too, I had them three times, one a nice girl I won away from a fellow on New Year's Eve. She I hardly had physically, but I was triumphant in winning her. There were many girls and drinks that night, New Year's Eve. I thought of the last New Year's Eve. We settled in a suite at the Hotel Lawry. There were many little adventures that night. Another night, my last night out, Bill and I had two girls in an apartment, and there was darkness and sin. And still another night, an earlier night, Bill and I in an apartment, another one. A girl undressed. And those are the days of last Christmas season. The nights and days of my wait and suffering, while I waited and prayed and hoped for a favorable verdict at Catholic U., those nights I called on God and Mary. I came close to Divinity. I promised that however my future

fell, I would be won forever back to purity and clean living, to devoutness and depth of religious feeling, and I was sincere in my sorrowing. But in my release I was bitter and sought pleasure. Perhaps I found it. It is pleasant to think on it now.

But I left my home and my city and friends. And now I am here, and God knows when I shall see all these others again. On the return journey I spent the night in Davenport, and there with a girl and Ryan and Ryan's girl, Marie, I went out, and we drank and danced and sang. I was very happy and wished for that forever. Again no doubt, feeling heroic. Ryan I envied almost bitterly, for his happiness which was not mine. He has Marie who is beautiful and good and who loves him. She will be his wife, and he has life to live for.

Again driving and driving, day and night, back to this city, I felt a certain comfort and pleasure with Ryan and talking and not thinking of what was to come, but that last day, and those last hours of being closer and closer to Washington were horrible. Again I was moving into blackness, and not fearing so much as despairing, regretting and grieving. Then to leave the others, they to return to the school that had awarded me a fellowship, to the place I could never again be near without discomfort close to horror, and I to be set in the city. That night the little things, like seeing how carefully my mother had packed my trunk, which I could not even unpack, the fruitcake and candy she'd put in it, those little things made me know tears again.

But now, I am here. Two months here, and not a new thing has come into my life. It has been as wholly drab, same, and unheroic as I'd imagined it would be struggling, adventurous, and achieving or dying. It has just been living. Two months of nothing. I've seen many movies. I've heard concerts, and gone to galleries. I've read a lot. But nothing has stirred me. I've scarcely had an emotion except lonely longing for home, and an animal urge to express myself physically. I cannot seem to return to God. I seem unable to go fully into the life of these people. I cannot set off alone and achieve, or even work. Yet I write colorful letters to Bill, not describing, but hinting at great strides of life and fine turmoil.

Now my mother knows I'm not in school. She had the letter today. I shall feel freer and better from this time, after two months of a deception which often caused me deepest pain. I anticipate nervously my next letter from home, and all of my being asks God to spare her sorrow or disappointment. Let her be proud and hopeful of me forever. Let me fulfill her hope.

I am now two months and 12 days from being 22 years old. I close and shall open another grey book. What things will have happened before the next is closed?

APRIL 24: FRIDAY NIGHT [1936]

We certainly should be ashamed of ourselves, foaming wild asses.

Reading lots lately.

Got a job today. Now isn't that the damndest thing? At last, unless something unlooked for looks in, I shall become a "government employee."

I wish there were a piano here, in his house. Jack is a hell of a good fellow. I wish I could be on his plane, sometimes I wish that.

I have a feeling that I should do something external, so I shall describe my room.

My room is a capaciously compact little compartment in the front of the house. A big, theatrical pink and white curtained window breaks smack through the center of the front wall. Then plop in the center of the square little floor is my bed, comfortably big bed with pinkish-orangish bedspread lending pinkish-orangishness to everything else in the square little room. Unobtrusively through the center of the ceiling and out through a lightly nasty colored, ornamental piece go two light bulbs in different directions. When you press the button and turn them on they light up. That is electricity. Now the only other domineering thing in this my room is the ordinary, practical, unlovely bureau with a mirror and a drawer that sticks. But I forget the wallpaper: it's on all four walls, and good God! Flowers. Wild roses maybe, pink and white ones with lots of green leaves and y shaped stems, running up and down and all around, all over the damn little room. So the room is mostly orangy pink and white, with for some unaccountable reason a vague golden yellow. I suppose it would do that. There's a closet, and also a door that you come in by and go out of. A tiny wobbly table presses up to the tiny bronzy radiator, and that weakly holds my typewriter, my symbol of secure well being. It looks uncomfortable now. What stately personally appointed desks and rooms it has of old been past! Well, two anyway. My books stack dustily beneath the wobbly wooden table. That is about all, except that I lie in the middle of the pinkish orangish bedspread and write, and that my clothes are some here and some there.

That was as well as I could describe my room. I gave it everything I had. I should certainly be able to give a more atmospheric and essential picture than that. But I guess I'm not. Well, I certainly should learn.

When are we going to write about the shoe salesman? What is this wanting to write in us? It certainly is more wanting to write just "to write" than to write for impelling necessity, to have to say.

SEPTEMBER 6: MONDAY AFTERNOON, MY MOTHER'S BIRTHDAY, LABOR DAY [1936]

I write while I sit off a rock, bathing my feet in the Potomac, near the roar of Great Falls, canyons of stone rising all above me, hot sun steady, silent shadows black, laying upon the water, kids shouting from far off, a trickle down the great cleft wall. There is no noise. Nor can I make words in any of all this which is.

Night I am sunburned today after a long morning and hot afternoon of it with Chris and Jack. Woods, water, stones. I thrust my head into the water and spluttered, I bathed my legs and thighs right up to my mortal parts. It was a fine day. I am very tired now, and will at once go to sleep.

My mother went home Friday night. She came back here for a week and then went home. My father.

Bill is in Albany writing a silly column for the Times Union—which is really pretty good after all. Jim is planning perhaps to come to Washington to work. I well want him, but I know his advent will in no wise lead me to the thorough betterment I so need, and am failing. That is false; his presence would quite probably help me. Dan is home making soap. I think often lately of fine times, pleasant scenes, sunny, flip afternoons, romantic nights by lakes, that I've known with him. Andy is in Alton, New Hampshire. He'll be back the first of October. I hope to have some good winter nights with him.

I've gone out quite a bit lately with Gerald—new boy, work with him. Good enough fellow, friend. Norwegian. Not thick at all, just limited. Has an apartment. Has also a night job in a fashionable fuel office where are sofas, radios, gaudy oil burners. I have met, and been with three times, and been drunk with, and read my poetry to, and made ardentest love to—Millicent, or Penny, as she is called. Milly, I call her. She loves me. Well, damn it, am I not pleased? She positively adores me. She is like Joan Crawford, in appearance, and manner, somewhat, though of course not nearly so beautiful. She is supple thighed and slim. She is very pleasantly backgrounded—music and literature. She is passionate. She loves me.

Well then, where then with all of this?

I love so much in her, seeing her as of all humanity. I wish I could but feel as I have felt before—Mary Jo, Helen—but I cannot. I haven't for so long. How achingly I visualize the girl I want so damned badly, the girl I need so despairingly. That girl who will release me, who will make me better, whom I will want nothing but to please. Oh damn, how I love her for herself. Like Mary Jo could have been. But, my dreamed of ideal, really there must be many who could be she, non-romanticist that I have become. I do love her. Someday I might have her; unless I am destroying myself, even now. How much of me is gone. The truth is: I am now one of the far lesser; I am personally, physically, completely, inferior.

But I shall go to sleep.

OCTOBER 1, 1936: THURSDAY NIGHT

Today is her birthday.

All I have written about Penny in this book, hitherto, has been false, direct, forced out falsity, or obscured vision, color blindness, failure of apprehension. Only now can I begin to write of her, and now how inadequately I can express the thousand feelings which passed through me today. For one thing, there is no other expression than to say I love her, tenderly, joyfully, gratefully, hopefully, freshly. And of course, dearly.

How I am taken out of myself! What a great good it is to lose the morbidity, the death, of living alone to oneself. All things have new aspects. I see buildings against the sky more clearly, more meaningfully. All things assume their utmost individuality and blend into the clearest universality. I am made so altogether better that I am nearly living my ideals. I am happier than I have ever been before.

Tomorrow, I have her afternoon. She will view my drawings. I am so anxious that she should know all of me, yet I need not be: each time I see her I come closer to her, I know her more; surely she is coming to know me more each time we meet. Great shades, but it is hard to satisfy myself with anything I am able to write down about her! There is no beginning. I have known her about six weeks. Two weeks ago my eyes were opened, and they have since seen more each time I've seen Penny. But my eyes cannot be opened wider now; I could never love more than I do tonight. God, I am displeased with the twaddle I write. I am displeased with myself, yet very proud, and happy in myself. But I see that tonight I can express nothing of it.

I will begin from the very bottom next Monday night, at the Corcoran Art School. I am somewhat unnerved with it. Penny has bought two season tickets for the National Symphony. I must pay for mine; I wish I could pay for hers. I am in a terribly straitened financial situation. Tonight Kit asked for a five dollar the month increase. School, clothes, and essentials sap so much away that there will never be enough left to do a small part of the things I want to do with Penny. The sun was warm today; I hope it is so tomorrow. We will sit on the Lincoln Memorial. Today I sat in the sun in Lafayette Park and pondered on her. O, it is so damned evident that I've never known one, or loved one before. I hardly know for which I am the more happy—that I love her, or that she loves me. I want her to be my wife.

OCTOBER 4: SUNDAY [1936]

Great God, I am in love, I am in love, I am in love! I am in love with Penny. Penny is in love with me. I am going to marry her. She looks like Norma Shearer. She is a Phi Beta Kappa. She has hardly any breasts, to speak of. She plays the piano, beautifully. We have season tickets for the National Symphony. O, she is clever. O, how our humours and clevernesses meet! I have decorated her room with my drawings. How compatible we are! I think she is beautiful. How she excites me! She oozes with surrender. How well I know her! How she loves me! When I have no money, she gives me her money. She is the girl I am going to make my wife. So glad a prospect before, I wish Jim and Bill were here to share it with me: winter's nights, soft snows, Penny, music, cocktails, oysters, crackling fires, hot drinks, dances, warmth, walks through snowed streets. Yesterday afternoon we walked the banks of the Potomac, lay in the grass, basked in the light of the sun off the water. Last night we frolicked off the sofa. She lives in the Kappa Delta house. Her home is in Pittsburgh. She graduated from Oberlin when she was but 19.

MONDAY NIGHT, MARCH 14 [1938]

At Christmastime, 1936, I went back to St. Paul for a vacation. I carried on a daily correspondence

with Penny, and loved her very much. It was good to see my parents and friends again, but not as good as it would have been if I had not known Penny. I went out with Dan Baker one night, and found that in a year's time I had altogether lost him—he was no longer my intimate, we had nothing for each other. We attempted a recapture of the old by doing what we used to do. We picked up two Minneapolis girls, Swedish. I necked with mine, kissing her, etc. She was the only girl I've kissed since I met Penny. It was an expression of myself, an exercise of a faculty of mine.

Bill Kennedy and I talked enthusiastically at Christmastime, 1936, of the book we were writing together. Bill I still loved, but we have never since had the intimacy we cooked up during Summer, 1935.

Jim Feely, my life long, with whom my contacting points had been growing fewer and fewer, but still strong, was freshly out of a job. So I induced him to come back to Washington with me.

He did, with no money, and remained unemployed until May, 1937, when he got a $15 a week job, the salary which continues to this day his. I supported him largely. We left the Sheahans after a week, lived two weeks at a rooming house operated by Mrs. Kimberly, and then moved to the Prince Karl Hotel, only a block from where Penny lived. We stayed at this hotel until June 15, 1937.

During this time Jim and I established good friendship, but not of the same order as our older. We didn't get drunk very often. My every night spent with Penny kept us apart, sometimes we hardly saw each other for a few days.

Jim grew friendly with my co-worker, Gerald Hanson. We spent many memorable nights in our Prince Karl room, however. We talked unrestrainedly together, telling each other very personal things. Yet we never had anything to give to one another; we had no common interest. Our friendship—I'll call it love—was one based on the single bond that we were both male beings on this earth, that we had known each other for a long time, that we liked each other. We did have another common bond—a very well-shared sense of the funny.

In January I stopped attending the Corcoran Art School. My drawing has advanced nothing since that time.

In February, on Washington's Birthday, Penny and I took a bus to Winchester, VA., in the middle of the night. We went to Mass there in the morning. It was the first time we had been in a Catholic church together. We spent the day exploring the town, visiting a cemetery, an apple storage plant, a fire house—it made a memorable day in our lives.

In April I first began to use a camera. I took pictures around Washington first with a $12 Agfa, then with a Leica, then with a Recomar.

In April, Mr. Stryker, my boss, sent me to New York City to work a few days at the library. Penny came up two days later. Then Bill came down from Albany, and Jim bummed up from Washington. It was arranged as a historic meeting. We met in the Beer Garden where Bill and I first met in New York two summers before. Bill met Penny. We stayed at the Hotel Lincoln. Penny and I, mostly together, Jim and Bill. Penny had become a tremendous detaining influence—for my own good, un-

questionably. I met her sister and family who live on Long Island. The last night together for the four of us in New York was hilarious, and a little drunk. Penny played the piano, and we all drank wine in a French Maison Bill and I had known our former stay in New York.

Back in Washington Penny and I were moved still closer to each other. I loved her very wholly, unreservedly. Admiration now took second place. I loved her, the girl herself, and melted in my heart when I thought of her. It is evident that I still do.

In May, Jim and I bummed up to New York, thence to Albany. It was my final fling—the last time I jumped into it all; I saw a whore naked, Jim and I cried with our arms around a pig woman with a rosary, we all watched a sexual Negress's dance, we shouted in the streets, "The Holy Pope Elopes," we panted and stared, it was dark, dark night when we got to Albany. It was weird and unholy for the two days we spent there. We bummed back, Jim and I, were tired in New York, subdued, took a bus to Washington.

On June 15 we moved to a small apartment in the Bradford, a very swanky apartment building. We stayed there until October 15.

Over the July 4 weekend, Penny and I went to Fredericksburg, Va., and stayed together in the hotel there. We walked all over the town the next day, and talked a lot. But it was a quiet thing that we did, and I cannot remember stark details like I remember them in Albany. I remember mostly tenderness.

I began to use a camera nearly every weekend now. I became more proficient technically. In August Penny and I took vacations and went to Cleveland to spend a week with Polly, Penny's friend from Oberlin. It was a swell week; I remember enjoying meals and sights, and liking Polly and liking to like her, feeling a new sort of relationship, an independent liking of a girl that I hadn't known before. Steve, Penny's other good friend from Oberlin, was to be met too, and I liked her, too. We went to the Great Lakes Exposition! I took several pictures this trip. My pictures are improving about this time. I am widening, increasing the camera's flexibility in my hands. On the way to Cleveland I had met Penny's mother in the Pittsburgh bus station. We had a long bus ride home from Cleveland. We like to go by bus.

During this period, August, September, October, I began to apprehend the idea of "documentary." It was beginning to have importance for me. I was in complete charge of the FSA photographic files, and came to know them as something of vital importance. My interest in photography expanded. I began to have a valid reason for wanting to take pictures, though of course social implication never meant as much to me as final aesthetic pleasure—until perhaps recently. I began to consider myself as a professional photographer. I would have no objections, at least to such a status. In October Ed Locke left our organization. I thought then that I would be offered a job in New York within a few months. So I prepared my mind that way, and Penny's mind. Ed Locke, however, quit his new magazine job, so that thing of importance which loomed subsided.

During the past summer of which I'm writing, Jim and I were one night jailed for drunkenness and disorderly conduct, and fined $10 each. It was one of the few nights of the past year that I did not see Penny.

APRIL 26: 10:00 PM [1938]

In October Jim and I moved out of the Bradford into a rooming house on I Street. Over Thanksgiving Penny and I took a bus to Carlisle, Pa., for Thanksgiving dinner with a friend of Penny's. During October, November, and December I used a Leica considerably, and also became fairly proficient at printing and developing.

On the evening of Hallowe'en, an important anniversary for Penny and me, I left on the boat for Newport News, Va. It was my first photographic trip: it lasted three days.

At Christmastime I went home again to visit. I received a Schick electric shaver for a Christmas gift, and I use it to this day. I was unable to re-taste much of home. The river was good one late afternoon. I saw Ray Collins; he is becoming a priest. I went out with Baker. I also went out with Kennedy, Feely, Gaudian, etc., and drank a lot, and had false merriment. I told my mother I was going to get married.

SATURDAY NIGHT, JUNE 4, 1938

Penny came to Saint Paul a few days after Christmas. My family liked her well; she was very likeable. We went to visit Mr. Slatery, who was greatly weakened and changed. He was on his way to death then, and will probably die very soon now. On Tuesday, January 4, we were married by Rev. Terrence Moore, my longtime pastor.

Then we started back, spent the first night at the Palmer House, Chicago, the second at the Commodore Perry, Toledo, the third at the Statler, Cleveland. There we saw Polly and Steve, nice kids. Next night we spent at Penny's home near Pittsburgh where there was a stormy scene, her parents just learning of our marriage, and grieved and angry because I was a Catholic. It blew over though. The next night we stopped at Bedford, Pa., a nice town. Next night we were back in Washington. We lived separately for a week, then moved into an apartment which we sub-let, furnished. March 1st we moved into the apartment we now occupy at 3809 Alton Place, and have been buying furniture since. We have a bed, a chest of drawers, a couch, a bookcase, and a Minipiano, solid white. Also other smaller things.

We are going to have a baby in August, by virtue of which I will become a father. He is already quite noticeable, and has assumed some personality. We call him Sorto.—SORTO.

I still draw the low salary I drew a year and a half ago, $105 a month. I have made two photographic

trips this Spring—one to North Carolina and one to Georgia. I have some feeling for photographic work, though I think our particular brand a little over-rated. I might be able to do something with it sometime, that is something worthy, something of value. There, as in everything my life long, I need a theme.

I still go to church, but only to avoid the complex. I never pray, or use the sacraments. I am truly out of the church. I have the intervals of fine feeling about being out, but now I am just unmoved. O I guess not, I'd like to dig myself up a religion sometime. I'd even like to be able to use it in the Catholic Church.

I occasionally think of the writing, drawing and painting I long proposed to do. I have never given up the proposition, but, of course, I've done absolutely nothing. I even write bad letters now.

I greatly enjoy travel as it can be afforded me by the U.S. Govt. I would like to be in Minnesota sometime for summer or autumn. I have seen only its winters for three years.

Penny has a "graph paper" on which is a complete record of *everything* we two did from the time we met until our marriage. It is a day by day record. That, I would say, is very valuable to us. We are having no record of these past five months.

Now then, I would like to write often in this book. It will be hard to form the habit again. I want it for a record, I want to facilitate my writing ability, and I want to cultivate and nurture any possible seeds of creativeness. Probably I won't write again for three months now.

Anyway, at next writing I will try to go on as though nothing had happened. The past has happened, and I have related it to the best of my quick ability. I will dwell no more on it—I am up to date, caught up to my present feeling now. One last thing is to list the most important (to me) books I have read the last 18 months. They are few: Bellamy "Looking Backward," "Equality"; Carrell "Man the Unknown"; Rabelais I am reading now. At once I go to bed.

Also read [*entry stops here*]

THURSDAY, JANUARY 12: 8:10 PM [1939]

In order to make myself write:

Last night I fell asleep while finishing writing in this, and read nothing last night.

But I'm getting along a little better in my reading than I was two or one year ago—or six months ago. I've read considerable Shakespeare. Two nights ago I read about Spenser, and a little of him, and was very warmed to find that I want to read him. There is a great amount that I want to read, that I must read yet; Shakespeare, Spenser, Shelley, Keats, Tolstoi, Dostoevski, Joyce, Bible—I guess that is what I most want to read, to read well. With Chaucer, Don Quixote and hundreds of other things interspersed. And Homer up in that first list. I wonder if it will take all the rest of my life. Of course, it will, but I must have none of that. Read everything complex. Next I am going to read Stephen Crane's

"Red Badge of Courage." But so much for my reading. It should not be particularly hard to accomplish well. I must not permit myself to wait until I've finished my reading before doing other things. That is why I am writing this down tonight, before I read. I want to get something done tonight. Maybe even solve something.

My photography: I am mediocrely successful. But I am in an inferior position in the organization which claims me. I have a miserable pay. My underdogdom harries me very much during the average working day. So why not realize that I really am in a very high, fortunate position in the whole scale of today's photography. A much better position than I deserve, I am one who has never given it, photography, his whole heart. However, with the very good opportunities that I have had, I have not made as much as I might have, as I yet feel capable of. In the Spring of this year, I shall have another photospree into Minnesota, my home state, mistake not. I doubt whether I shall do much else before then.

But it is still, lingeringly, to write that I most will. Years ago I said "I have no theme." Obviously I still have none, or I would be sounding it. But maybe I don't need one; maybe I could manufacture one. I have the last year and a half fallen under the spell of the anti-art-for-arts-sake group, representing the worthiest critical thought of today. But maybe I've been over-frightened, frightened into thinking that no thing of intrinsic worth might be done unless it were either (a) an urgent need to tell the world something, to push people into an action or attitude, or (b) a useful creation of great utilitarian value to other people. I have forgotten that a man may legitimately present what he sees, and that that may be of value in itself even though it have neither usefulness nor the property of stirring into action.

So, I should demand activity of myself. Before any of my experiences, thoughts or impressions could be of any value outside my own mind, I would need to regain some writing ability. That I once had it, and lost it seems to be true. Kennedy, who still admires things I have written in the past tells me that when I write to him now, my letters are evident slippings. The reason for my sliding back is, of course, practice lack. And I cannot very well blame the black cameras, the sweet-voiced daughter, or the fair and airy wife for that. No. I can blame only myself. Not a day of the year goes by that would I, I could not write 1,500 words. And if I made myself take that practice, why look how fast and how far I'd progress.

But to our matter: I even have *two* ideas, ideas for stories that I've carried around in my head the past week. One is brand new, the other is an old one I had before, [but] thought up again. Very well. I have two ideas, and they seem good ones without being closely scrutinized, or taken out of their cases and put to use. But I know, that within five minutes after I've begun to actually use them, they will pale, and I will be stuck writing, turning out empty stuff which would have in advance my critical disapproval. And I can't bear the hard work and the humiliation of being stuck writing, writing something I don't care for. I don't mean that The Two Ideas, as they are now, are not good. They are good in my head, though superficially thought through. But transcribed into a medium I'm not handy in, writing—in writing they would vanish. I would follow them through with such difficult steps. Still there

lies my solution, to write out words daily until I've come into some facility—more than I've ever had—and then I will not get ideas which cannot be followed through.

So do I think I'll do that.

Shoved into this photographic corner I so damned want to show them. I want to write for pleasure and profit as well as for purpose. My pleasure and profit motives are well established. All I need is purpose.

Here I could go into long words about the waviness of my purpose. How today I am thus and tomorrow I am so. But I will not, and I will spare it.

I would be so self-conscious if I bashed right in now, and wrote my story from here forward. O the only way to do it will be on another piece of paper, on which I've never written any of this crap. I shall write it on my old writing board with the steel clip, when I write it.

Without looking back, this is what I've brought up and what solved: Don't worry about reading; do all you can after you have first done all you can of things more important. That will make you well read. Of photography, think up good reasons and apologetics, improve yourself in the practice thereof, and constantly hope to one day make it a sometime pastime to the more congenial work that you were born to do. Of writing, you must do more, else you will get not to first base, but like the grey pigeon which sheddeth his feathers at the eclipse of the moon, you will throw off your better ambitions soon, and settle down to quiet decrepitude in the unenergetic noon. Of others, let you bear no man a malice or an ill will, and bear at least each man an external composure and an inner friendly will to understand, which will boil down to tolerance. And of your wife, love her best of all for she is most of goodness. However, try kindly and earnestly to make her see more things more your way.

And that concludes tonight's adjuration to myself.

SATURDAY NIGHT, JANUARY 14: 11:00 PM [1939]

Muffled in his contented brain lay dead ambition,
 dead vigor, dead poetry.
But he grew fat, and lined his cheeks with smoothness,
 not remembering the dead things.
Then one day while he was smoking a cigar,
 the smell of the dead carcasses came into his nose.
He sniffed in a nervous fear.
He unbuttoned his vest and told himself he was not fat.
A baby at the pap in such a breath catching hard, sighing, heavy,
swallowing, gulping, choking, eager sound as a frozen motor on a winter morning.

Things of America: things built and put together to serve purpose, things packaged and parceled, passed out to many for money, things displayed, looked upon, admired, wished for, had. This is the chronicle song of the many things, weathered, boarded things, things leaning in the wind, things built to loom high in the night and last long, things to be bright-colored today and used up carelessly, many many things.

Now that much isn't bad, perhaps, unless that word things is ridiculous. I got something here I could go on with, if I could go on with it. And pictures.

I'm going to read Huck Finn again.

All are made by people for themselves and not for other people.

This building is a railroad station, we call it the depot. Here they come singly and in groups to sit and wait or stand around and wait for trains to come and go, carrying them.

More of this another day.

MONDAY NIGHT, FEBRUARY 20: 11:35 [1939]

Seek to know the cotton robin, he said, putting two and two together, using his fingers. Stars are thumb-tacks on the black chart of night.

SUNDAY NIGHT, MARCH 5: 10:30 [1939]

I am married to a good wife, I have a beautiful daughter, and I earn enough money to take care of us all. Penny, my wife, is pretty to look at; she is intelligent to talk to; she understands and loves me. She and I like many same things. She is musical, and I hope she will become more so. She is a most wonderful bedfellow. Our sex life has been high flung and happy, and we expect it to become more so. We two already have rich stores of the kind of memories which give to a past time the tag of happiness, and daily we are making more. The whole business of courtship, marriage and my wife herself as a commodity has been a successful venture of the kind commonly supposed to bring happiness.

MONDAY NIGHT, MARCH 6: 10:30 [1939]

My daughter, Ann, is as pleasant a baby as you would meet with in an eight-days' cruise through a maternity ward. She is a smart smiling baby. She is a thing of permanent joy for 27 years of the future. And there are others of different complexions, to be had from where she came, God and I willing. So then, in both my issued child and in my yet unsprung joys, I have great cause for the common property of happiness.

TUESDAY NIGHT, MARCH 7: 11:00 [1939]

I must set down for myself wherein I have discontent, wherein I find life stale.

I make a very small amount of money, a menial sum, which makes my station in life seem menial. Often I am blindly rebellious over this circumstance; seldom am I constructively active. I do make enough money to live decently; my future will probably never see me making less. Although in a semi-menial position, I am employed in a worthy enterprise, one which I can admire and appreciate. My future in this enterprise is acknowledgedly good.

I've come by the camera accidentally, and now it is perforce my chiefest interest.

I must succeed in making photographic brilliance but a minor side issue of my talent.

I feel like a guy who has started off elaborately on a speech, and after he has used up all his elaborance, discovers he has really nothing in mind to say. I no longer have that to say which I had two nights ago when I began this little series.

FRIDAY NIGHT, MARCH 10, 1939: 11:00

Perhaps when I have finished this volume (No. 5) of my grey books—and I will one day—I shall get busy in life. I'll not start another one—at least for some long time. I don't know whether there is any value in them or not. I mean any good thought or poetry. I was pretty convinced they had such value three years ago. Also entirely convinced of my super-capability as a writer, plus confident in my painting, drawing talent. No more convictions or confidence, today. Even I doubt my general intelligence, ability to learn, etc.

MONDAY NIGHT, MARCH 13, 1939: 9:40

My pretty wife played piano for me this evening. Piping tunes of Bach, low moaning pelting Cesar Franck, and interwoven Tchaikovsky. It is a wonderful thing to have a wife who can play music.

O Godling I felt empty in myself today—of no courage, no capability. An untalented drudge. And I grew hot and muddy in anger at what little money I make. But nothing outside myself is at fault for any of my own misadjustments.

I could become happy if I could once settle into enjoying the enjoyment of life, and forsake my blind, dull paining craving to create. Then I could be elevated always in books and music, forgetting the unfruitful part of myself. Well, well, well, this early, dewy morning, all is sun and blue. These white, classical buildings wet, shining before me, and this wide concourse thronged with hurrying faces, shaved faces, powdered and creamed faces, my moving mass of clerks and under clerks, my stenographers, and secretaries, assistants and chiefs. All these are of my Bureaus, for I am administrator of Tax and Secure Credits Administration, TSCA. And these, my well-combed men and women with

hot coffee in their stomachs, are hurrying to their desks and chairs, their cabinets and cases. They all think highly of me, these hurrying men and women, for I am the Administrator, and therefore a very great man.

Good morning Dr. Closet. You are a very great man.

Yes, Negro elevator boy. But a kindly man in addition. I have no prejudices against your race.

FRIDAY NIGHT, MARCH 24, 1939: 11:30

Vulgar sugar. There need be no hardship or sorrow in life. Knowing well the meanings of things dissolves to nothingness the personalized evil in them. Quiet rooms in which the thrumming of a machine hidden from sight makes no pauses. The whole show changes.

SUNDAY NIGHT, OCTOBER 15, 1939

Wow.

Since March 24th, last time I wrote: me and my family have moved to Greenbelt, the beautiful, white and bright-colored little city 15 miles out of Washington. We are all very happy here. It is the finest place any of us have ever lived.

Ann, my child, Sorto, has grown some larger, but not much. She is a good, happy, intelligent, little beastie.

My Bill Kennedy has taken into marriage a good girl whom he calls Suz'n.

I have been given a financial increase for my services to the government. $150 a month I now draw.

Last month I spent on a photographic trip in Wisconsin and Minnesota. About two weeks in St. Paul with Penny and Ann. All the old people I saw, too numerous to mention, including the three Baker boys, disappointing me. The River, on the banks of, walking, laying, not much thinking. Two days traveling with my father. My brother Robert, my grandmother. But all this is another story.

I've read Thomas Wolfe, "Look Homeward, Angel." He is the great enthusiasm of my later life, and I shall go on immediately to read the rest of him. He writes like I would like to.

You are an old, dead man.

Helen, the girlchild sat sitting on the night summer night front porch among green night bushes in summer, seventeen years old, the blonde girlchild with small, straight trunk and young, green, sprout breasts. Alone, Helen on the dark, front porch, white legs Helen's swaying from the railing of the summer porch among the bushes dark front porch.

Life, condition of extension into existence and total realization of the present to be. How different from three weeks ago in a ceiling, globe-lighted restaurant on the wide graveled main street of a small Minnesota town, eating steak and potatoes with my father.

Still, frozen, broken bits of sounding footsteps. White shouldered piano. Evoke aimlessly. Interpret. Great old oaks. A great, gnarled, branching tree. Great storm standing tree. Old oak, wildly gesticulating, leaf lost, black branched oak.

I haven't noted in here that now my wife and I own an Ansley Dynaphone, a species of combination phonograph-radio, and now much music is at our call. My collection of fine, old, jazz recordings, both intrinsically good and reminiscent, sentimental, valuable, brought from home St. Paul, is now augmented with the second-hand, two for five cents, records which it is now my spare time avocation to hunt for and purchase. Ted Lewis and Al Jolson, the two great names in 20th Century jazz and song— also Wilbur C. Sweatman, Original Dixieland Jazz Band, Sophie Tucker, others.

Two nights ago I drank and was drunk with pulpy Jim Feely and his sylph-bodied, bright-colored, on again off again, immeasurable, female accompanist, Kitty. Old material Jim, he is my good, true, strong, loyal, faithful, fine, wise, staunch, steadfast friend. I beat steady of the pulse for him.

I can't begin my writing while I'm reading, and there is yet more reading I must do. Supposing I set the limits here and now of what I will read before I begin to write. What after having read I will stop *all* reading for at least six months and concentrate on writing. The following I will read and then stop:

1. Thomas Wolfe; to finish "Web and the Rock," and read "From Death to Morning" if I can find it.

2. James Joyce; to read "Ulysses," and "Finnegans Wake" if I am able to.

3. "The Communist Manifesto"

4. "The Old and New Testaments"

5. Walt Whitman

6. "St. Augustine's Confessions"

7. Shakespeare; two plays I haven't read, the poems, sonnets, and then re-read "Lear," "Hamlet," "Macbeth."

8. Finish reading the "Modern European History" I am two-thirds through— Carleton Hayes.

9. Proust; all that follows, "Swann's Way" and "Within a Budding Grove."

10. "Education of Henry Adams"

11. "Don Quixote"

12. "Moby Dick"

13. Homer

14. Sandburg, "The People, Yes."

15. "Dante"

16. Thomas Hardy; complete, re-read.

17. Ernest Hemingway

18. D. H. Lawrence

19. Robinson Jeffers

20. Dostoevski

There is more, but I will stop there because I reached the bottom of the page, and that is a good way to decide vital issues. I am not being flippant; I seriously intend this. Then I shall be able to say my career started on a caprice. I shall read what is listed on page 92 of this book, plus some critical and factual matter relating to it—nothing else. Then I will seriously, tediously, begin the writing for which I have prepared myself all these years, the writing I have so awfully long delayed. Meanwhile, I shall write on occasion in these books. Perhaps three or four pages a week, mainly so as not to lose anything that may come to me during my days. My list is random enough. There is so much more I would add, or wish I had another line for. But no. I have waited long enough to begin my own work and I will brook no further delay. It is fortunate that I will have Thomas Wolfe farthest behind me at the end of this reading, because I would be too liable to be too much influenced by him. I regret that Milton could not have been on the list.

Now I must estimate the amount of time it will take me to read that much. Not much of it is good streetcar reading. Perhaps I can read the critical material en tram. I must remember next time I write in this book to write about the fainting lady.

In figuring the reading time, I will use the most conservative guesses, plus two days between each work to account for time spent in procuring the book, as this will involve libraries, perhaps even purchases. Therefore:

1. 9 days	2. 30 days	3. 3 days	4. 30 days
5. 12 days	6. 12 days	7. 10 days	8. 16 days
9. 30 days	10. 10 days	11. 10 days	12. 10 days
13. 20 days	14. 8 days	15. 10 days	16. 30 days
17. 10 days	18. 30 days	19. 20 days	20. 30 days

That is 340 days, plus half that time to account for days and nights I will not read at all—which is 510 days, divided by 30 is 17—17 months. On June 1, 1941, I should have begun my work. I hope I can make it before then.

Now there is bed with my dear, good, lovely wife, while the clock tocks and our daughter, Ann, sleeping.

Here we go again. Writing on New Year's Eve always did give me a slinking, sentimental pleasure. It's so goddamn. And what have I got? I got with with and wooth [*sic*]. Like last New Year's Eve when I wrote in my great, grey books, I got a wife, a wife sleeping again. Sleeping sullen draughts of breathing sleep. And I got a daughter, a girlchild, also sleeping. She is a piquant-faced, little short thing, with hair, a navel, folding little lips, small vocal noises, wet chapped legs, occasional teeth, and some dresses and toys. Then, too, I've got a job. A job as a semi-photographer, a picture clerk, a photographic flunky, a clod of government clerk, a hangnail on the great toe of Uncle Sam, presided over this year by F. D. Roosevelt. And I've got $1,800 every year in the form of $150 every month. And a home, a ducky little white apartment of a home in a model community, with furniture, several sticks of it, among thousands of model dwellers in a model community. I've got two friends and I don't see much of or have much to do with them. They are Jim and Bill. Then I've got this old hung together operating fogged self which I recognize as my own. God, I am a bedraggled semblance, a walking operating functioning piece of human flesh in actu [*sic*].

Everybody is very happy.

This is the year in which I will be 26 years old. 26 of them stretched out, gone through me. How many more before I close it up and no more. How frivolous, and what could it matter? Once I was deathless, life lay ahead with no need for or possibility of stopping. Now it's one year, ten, twenty, fifty, and it's all one. Any gay pattern of years to come, dancing years, neglected following, composed, formed for me, ready to unwind the written order I've prepared. But I'm the guy, the only guy for me. I am the Loeb Classical Library. And none can unseat me.

O Wintertime in Saint Paul, where thick, tramped down snow is under every foot, drunken in cold outside night air, headlong into fuming music heavy smoke interiors, warm air to stamp the feet in, good sexually appareled girls with sweet, reeking smells and soft cheeks. A communal beating, throbbing unsteadily rhythm of thought, love.

Nothing will come or transpire in this corner. Forget this corner. There is no future.

That writing writing writing writing writing writing writing writing writing writing: how can there be writing in all this music.

Does old Jim now reel the narrow brick built streets of St. Paul in snow?

None will ever forgotten forgiven having wasted ruins and shattered, ghosts, burnt outlines. Life abandoned, hopeless, passed on.

I old sotted body with appurtenances drop this all and off it to the bed I sleep in. All is not as it gives appearances. I have my past somewhere, inside, it can get out, it might. Sometime perhaps it will.

This this this this this this this. John Felix Vachon, who all things change but. God, hey? Of course I'll bring it out. Because dying is distasteful to me. I draw back from the possibility.

I should put this down right now while it is happening. It has come very suddenly, it seems, only during the past few days. It will be hard to give the full, true significance of what it is. It is a realization I've never had before, in quite this true, clear way, that I do not personally total the fine sum of talents, perception, awareness, brilliance which for so many years I have unthinkingly but very sincerely attributed myself. From about the age of 16, until actually last week, I have borne sincere conviction of personal greatness. Often this conviction had been shaken, and during the past five years it has seldom assumed conscious seriousness in my thoughts, but it was always there. And now it is so clearly gone. This very week of November 1941 then is probably a turning point of much significance in my life as I have known it. I know that I can't write well, and there is some heaviness in knowing that I have never written anything good, or had anything important to write.

It is goddamned awful worthless and blubbering and why be here. To make nothing of my sucking, wasting self. Even with your pure, revealing, confessing lacerations, what are you.

I bind myself to finish it.

I'll bring it out, will I? God and I, huh?

Maybe there'll be only eight more nights of this life, and I'll never masturbate again, nor destroy to ashes five years of life, nor spend thin ecstasies nursing unfulfillable hopes.

Eight nights more to set me on my way to 28 years old and worth getting there.

Eight nights yet, old father.

There can be fulfillment.

Even the church and its clergy could not have been this ruinous.

FRIDAY NIGHT, NOVEMBER 21: 10:40 [1941]

Listening to the antique shrills of the Original Dixieland Jazz Band tonight. Then finished the fifty odd short stories of James T. Farrell. The washed out glory of his Irish boys hit me personally in my emptiness.

I'm going to buy a camera, a Graflex. I've now accidentally got myself into a pretty secure niche as a photographer, accepted as good. Four successive years in U.S. Camera annual, represented in some pretty good books where the photographs were important, in shows and exhibits, like the Grand Central Station mural—all wonderful things happen to me. But I have never done any really good, or even above average work. Nothing with sincerity, or incisiveness, or deep conviction. Jack Delano, Lewis Hine, Dorothea Lange, Walker Evans—they are some who have done great work. Now I want to. It is my familiar wish appearing across a background of nothing to say. I feel no people, no social scene, no physical view of my country in such a manner as to want to make meaningful pictures of them. I only want to do great work. I should at least, and perhaps will do better work. My $2300 salary I want to rise to $3200.

SUNDAY NIGHT, NOVEMBER 23 [1941]

The frowsy woman fingers her pathetic cards, tired blonde hands and soiled undergarments. A queen of clubs to take the trick if Mrs. Nance doesn't have the king. She had it though. Little contraction of her slightly potted stomach, tight clad in silk brown. Now throw off a diamond. But now I can't do it. No chance is left, and dark outside. Jim coming home.

Which is the rub. This is the rub.

Male child suckles on great, round breast.

The end is not now very far off. And how little I thought, that snowing afternoon in 1933. I think it was 1933, and I know it was snowing. I am bringing one of my life's works to a close. This five volume book. It ends exactly five nights hence, on the perhaps healthy note that I can no longer consciously or seriously or lengthily or determinedly write about myself. At least I can't do it in simple confessing words without turning my stomach. But perhaps I should try again. Perhaps tomorrow night I should give a statement.

SATURDAY NIGHT, DECEMBER 13 [1941]

It has fallen out differently from my plans. The conclusion forever of this journal writing period of my life (1933–1941) has been stayed a few weeks longer. It will end this year, however. Surely.

My age is $27\frac{1}{2}$ years.

The United States is at war with Germany, Japan, Italy.

I'll probably never go to war. I have a wife and two children.

I was quite right about the important change I saw in myself a few weeks back. It seems a permanent breaking from what I used to be, and as a personal realization at least, it has come to me very suddenly—so that I find it hard to believe. It is a good and blessed thing, if only it could have happened to me ten years ago. Now so much of my life has been molded.

What I want to do most, for the rest of my life: work for ideas I believe in, ideas having to do mostly with justice for all the people; and contribute to my own happiness and experience in music, painting, reading, perhaps writing, and friends. These separated attitudes toward my living will, I hope, form a unit.

I am trying to be better than I have ever been. But I have such difficulty in using words. I cannot speak of Freedom, or Truth, or Justice, or God, or the people, or of a real and strong desire to be honest with myself, or of kindness, or humility in a sense. When I was younger, I spoke of "Beauty" often enough. Now I am washed and drained of any ability to use the words themselves, or any conceptual substitute for the actuality.

I am trying to be better than I have ever been before, and to lose my characteristic of fear for what

people think of me, and longing that they think I am talented or great or eccentric. I shall try to ridicule and spit on my love for and counting of flattery. But I will give my whole self to becoming a good photographer, a good painter, and a good writer.

Once I seriously entertained that I was Jesus come back to earth and was only waiting for my Godliness to become superimposed on my sinful manliness. I was about nineteen or twenty, and felt inspired with the knowledge that I was the new divine vehicle.

There are many whose names I would write down as I look on the sum of experiences which have brought me here.

Book. Catholic Church. Russia. Wife and children. Negroes. Photographs and paintings. Jack and Irene Delano.

By God and by Christ I will be honest and bring myself to some good.

<p style="text-align:center">JULY 8, 1950</p>

Tonight I've read "The Basement Room" by Graham Greene.

If I were a writer, these past few months would perhaps have been a fertile time for me—I've had many good thoughts and beginnings of stories.

I was in Michigan last week, photographing berry pickers, just as I did in 1940.

But there is no reason, or satisfaction to me, in writing down such information. My continuum, that I write about, and worry about from time to time, is what I think most important. I'm glad I have all that I've written down, and my maps, charts, and several hundred letters to Penny, because someday when I'm sixty, and that's a long time off, I'll read it all over, and that will more or less be my life. Less, I guess. I hope Brian will read it all sometime. Because I love him, but it's terribly hard, I think it will always be hard for me to communicate with him. Probably something about my relationship with my own father. And I'd like him, Brian, to know about me more. He really is more of an extension of me than Ann, naturally. I wonder what he'll be like. I wish we could be something other than strange son and strange father. I hope, not alone wish.

Dreams keep coming. The one that recurs about school, grade school, or college, the long forgotten class friends back alive and moving, and fear with sudden realization of how it will be over soon, and I hadn't known, I hadn't been to the classes, I would have got nothing from it, it was all a terrible waste. It isn't so much fear, but sadness, and the terribly unhappy realization that it was avoidable, I could have done differently. Is school my symbol for all of life? And do most people really feel that way—that they didn't do what they could have with life, and the saddest thing of all is that it's always nearly over and it could have been different?

He lied quietly. Will complete this "notebook" tonight, sixth volume, isn't it? Just under five years on this one, about four years on the first four, three on the penultimate, eight years in between not conducting a "notebook." Now I think it decidedly best not to commence another. I'll write disciplined prose instead, and maybe an occasional turn at verse.

Full breasted, average age girls walk enticingly on Madison Avenue, their lips sullen with lipstick. I, too, walk through the crowd with other men in grey suits, seeing the girls and considering my fortune. At the corner of Fifth Avenue and 51st Street I stand among the rich, towering monuments—the symbolic and the real centers and representations of the wealth and power of civilization. The money, the clothing, the religion, the ideas, and all forms of the desires and lusts as well as the comforts of the whole world are here, arranged for on this very spot. I am in the middle of it all, and I am moreover part of it. I contribute, through my work with the magazine, to the thinking and forming of values which spreads out from these stone buildings to the pliant acceptors of this false, refined civilization in all parts of the world. I am indeed in an envied position. And though I say, truthfully, that I reject this civilization, and had rather been no part of it, and surely am so by chance and no wish of mine—I nevertheless rejoice in it, and pander to it, as I fly out in early morning airplanes to photograph a famous ballplayer in Evansville, Indiana, or to see a senator in Washington or Maine.

And I doubtless tell myself that I'll take five more years of it—I'll only be 45. In such a time I might make much money, go to Europe more than once, and certainly to many other remote places not visited by the ordinary. And I'll ride the expensive trains, live at the resorts of the wealthy, eat on the richest tablecloths, meet those who are known and admired by millions. Will I do those things for five years? Will I read this page in 1959 and know I've done so? And will I have been able to do the real writing, anyway?

No. You haven't read. [*Last entry in journal.*]

"STANDARDS OF THE DOCUMENTARY FILE"

The documentary urge is the most civilized manifestation of the instinct for self preservation. It was always Everyman's desire to talk about himself, to publish his poems, to show his pictures,—but today man is striving to make a true and adequate picture of his times, to preserve a record of the age he lives in for a future age. The documentary urge which is abroad today is a deliberate, intelligent, and intended thing. Unlike the incidental picture of 13th century Italy which may be seen in Renascence painting, unlike the incidental picture of 20th century America which may be seen in the movies of Hollywood, we are today making a *conscious* effort to preserve in permanent media the fact and appearance of the 20th century.

True documentation cannot, of course, be sentimental. There is in wide use today an adolescent device of picturing our times, which is sometimes referred to as documentary. It is introspection of the wishful thinking variety, and should never be confused with true documentation. This device, this supposed turning the mirror on ourselves, is marked by excessive dramatization or glorification of things typical of our times. It is found in the slick, the *"Grand Hotel"* type of writing. It is found in the limited universality of the *New Yorker,* in the inadequate "surveys" which the picture magazines make on various subjects, in the over-glorification of Paul Rotha's *Night Mail.* The document, the true record, will not be composed to pander to the false romantic or dramatic leanings of those who are to view it. In itself it should be unimpassioned. The truth and intrinsic interest in such a document will be sufficient to arouse emotion in the intelligent audience.

The statement that photography is the medium best suited to true documentation can no longer be challenged. Still photography, not cinematic, is the most impersonal and truthful device yet perfected for factual recording. It is able to include the widest range of subject matter and employ the least plastic materials of all the arts. In still photography the artist's material is one simple phenomenon,— the splash of light on a sensitized emulsion.

The camera, then, intelligently used, should leave for the future a very living document of our age, of what people of today look like, of what they do and build. It should be a monumental document comparable to the tombs of Egyptian pharoahs, or to the Greek temples, but far more accurate.

Such a body of work is the well organized, intelligently selected and edited file of photographs. The most important, perhaps the only important file of this sort is the FSA collection in Washington, D.C.

The FSA collection is as yet in its formative years, but it will always be forming—always expanding, changing, perfecting the type of its content as long as the civilization it reflects changes and grows. In view of this impressionable nature of a file of documentary photographs, it is well that the founders of the FSA collection should lay down some dicta as to what it is intended to be, and what it should not be.

Because a collection must observe some limits, and cannot encompass the whole of the existing world in detail, the nature of it should be carefully considered and intelligently defined.

It should not be a "picture collection" like that of the New York Public Library, including every possible picture of every possible article of the past and present. Such universality in a photographic file would soon reduce to absurdity.

It should not be an art collection.

It should not be an antiquarian's file. There are valuable documentary photographs of the past fifty years, but these a collection of today should not attempt to assimilate. As the FSA file seizes the scene of the changing today, it will have within itself, and in proper perspective, the scene of yesterday.

It should not be a technical collection. There is no place in the FSA file for a detailed story of the experimental farm of the USDA, or for series of architectural plans.

It should not be a picture agency competing with competent Wide World, Acme, etc.

It should not be the variegated assortment of a man with a collecting mania.

The collection should be considered as a thing in itself, not as a supplementary file for layout men. Slightly different pictures of the same subject should not be added in the hope that they will one day fit well into someone's layout.

The FSA collection should not be formed with any ulterior motives. It should have no purpose other than the honest presentation and preservation of the American scene. If this is done it can be drawn upon like dependable statistics to support or refute. If formed only to present, it can be used to propagandize.

While accepting limits of detail, the documentary file should accept no general limits. It should not portray exclusively either the rural scene or the urban scene, lower classes or upper classes. It should be like the philosopher, who without a profound knowledge of all special sciences, yet includes and understands them all.

The FSA collection should not be repetitious. It should not be sectional. There is no excuse for its being poor in technical quality. It should not be frivolous. It is not the unique which should be photographed, but the typical, all the essentials of the typical.

The FSA collection should be the forever evolving picture of humanity in time. Men, women, and children. The things they do and the things that happen to them. Rothstein's picture of stark burnt-over forest in the Northwest, the boy in the South standing by his cabin home on the ruined land he lives and toils on, Russell Lee's abandoned Texaco gas station leaning with the wind on a North Dakota prairie, the faces of beaten down resourceless farmers in Iowa, Walker Evans' indignant looking patriot. The American Legionaire, his pictures of symmetrical, hill-climbing industrial towns, Dorothea Lange's intense faces of the suffering, her pictures of rhythmic earthy bodies at work,—these are the things which should be in the true documentary collection. But they are only a few of the things,—there are other people, other places, seen differently,—unlimited.

To undertake to photograph any section of the country, any town, group of people, or group of workers, the photographer's first qualifications are general intelligence, the ability to correctly expose for sharp, clear negatives, and a certain innate sense of composing a picture—the intuitive, spontaneous approach, not the studied artistic approach. With such qualifications a photographer can produce an honest, competent set of pictures. But for the standard of the FSA collection much more than this should be demanded.

To photograph any American people, phenomenon, or locality, the FSA photographer, in addition to the qualifications mentioned above, should have a thorough knowledge of his subject, both information acquired beforehand, and knowledge gained through actual contact. Then he must have a *feeling*. Despite the fact that he is going to use an impersonal instrument to record what he sees, yet he must be intelligent enough to place what he sees in a true perspective of the American scene, to *feel*

the humorousness, the pity, the beauty of the situation he photographs. And lastly, the photographer must have an impelling desire to record what he sees and feels. He will want to freeze instantaneously the reality before him that it may be seen and felt by others.

For instance, the highways of America which run through the body of the country are lined with stations, stands, markers, signs and advertisements. To photograph the American highway, the cameraman must know it, and have an attitude. A definite feeling about it. He may see it as a gay, bright colored regalia, the folk art of America, the carnival of America's people; or he may see it as a sorry manifestation of a decayed culture, a greedy civilization destroying America's natural beauty. But however he feels about it, he must be impelled to make a strong, honest photographic comment on it.

The photographs in the FSA collection then, should be of excellent technical quality, they should be drawn from all the states and peoples of the country, and they should be exactly what was seen, understood, and felt by an intelligent photographer.

As a picture of our country, the separate photos should be divided into the concrete units of our country, the states of the United States. They should be kept in a well organized file of states. And this file should be considered the things we are building. It is not the uses or publication of the various pictures that is important, but the actual existence of the pictures in an organized file. Pictures should become part of this file only through a rigorous selective process.

—John Vachon

SHOOTING SCRIPTS [1940s]

FIELD NOTES FOR JOHN VACHON

Farming

I. The Farmstead (the homestead).

We must get more pictures into the file which will help to identify geographical sections. One way of doing this is to take pictures of representative farm unit, e.g. in the better farming sections of Wisconsin, Minnesota, Iowa, the spacious barns, silo or silos and corn cribs will be dominant figure features. In the Great Plains, the farm unit will look entirely different as to buildings and to the relationship of buildings to landscape.

Closeup pix of barns, silos, corn cribs.

Be sure to relate the house to the barns.

II. Food. With the present emphasis on food (especially "protective" foods) we should get good pix of the following:

(1) Dairy and dairy products.

Pasture—cattle grazing; under trees in pasture; coming in from pasture at milking time.

(2) Handling raw milk, cooling—bottles—putting in cans.

(3) Butter. A good series in a creamery churning, working the butter. Packaging. Butter in storage.

(4) Cheese.

Cover from receipt of milk to the cheese in storage.

(5) Pork products.

Pigs—portraits of hogs, pix of lots of pigs—a shot taken straight down of hogs in a pen to give the idea of a pattern of backs. Mama and babies. Lunch time.

Packing plant (J. V. Hormel, Minn.). Processing beef, mutton, pork. Quantities of hams, bacon, etc.

III. Power Farming.

We need more tractor pictures—tractors used for various crops.

Hay-cutting, raking, loading, baling, grain combining, plowing and fitting.

Tractors pulling loads on road. Filling silo.

Threshing operations

Closeup of grain pouring from chute
Men washing up for dinner
Men at dinner

IMPORTANT

Because of bottleneck in transportation much grain will probably be piled along tracks. Try to get some shots of this which will give an idea of the total amount of grain in the pile.

We need a few more pictures of grain being hauled to elevators.

Elevators.

More pix of elevators in all parts of the country from the single to the huge combinations at Buffalo, N.Y.

Loading grain on boats. (Duluth)

I. Weather (We very much need pictures which will give a feeling of weather.)

Rain (hard to get pix which really "show rain")

 1. Window pane in hard rain. Water running down glass in side of car.

 2. Water in ruts of dirt road.

 3. Water collected in furrows of plowed field.

 4. Water running from down spout on house—would be well to show rain barrel. Rain barrel is important in the Great Plains area.

Wind (really depends on movie technique)

Heat (It's hot) Any idea to indicate temperature.

II. Recreation and amusement.

Back lot baseball, softball—day or night, small town professional teams—we must have good pix of these.

Golf, tennis, croquet

The Old Swimming Hole

Fishing, river, lake, mountain stream. Boy digging worms.

Picnics, suppers on lawn.

[ANOTHER SHOOTING SCRIPT]

John Vachon F. S. A.

Roy E. Stryker April, 1940

FOR VACHON TRIP TO IOWA

General Suggestions:

 1. Little used parlors in many farm houses.

 2. Town water tanks.

 3. Barber shops and their habitues.

 4. Courthouse squares.

 5. Courthouse architecture.

6. Peoria, Illinois (distilleries, Department's chemurgic laboratory, river, and Caterpillar Tractor Company).

7. Large drainage projects and ditches.

8. Hybrid corn posters.

[ANOTHER SHOOTING SCRIPT, 4/13/40]

RANDOM NOTES IN IOWA FOR JOHN VACHON

Iowa

I *Rich, level farmland:*

 a. the heart of the Corn Belt.

 b. prosperous independent farmers but with plenty of debt, tenancy, eroded lands on all sides.

 c. dominantly rural, no large cities.

 d. outstanding for the spirit of social equality which pervades all walks of life.

II *Your pictures should emphasize:*

 a. the level rich farmland.

 b. good buildings, particularly barns and silos.

 c. good roads.

 d. corn and hogs.

 see corn script.

 e. an overtone of uniformity running through the land.

 f. the towns dependent upon agriculture rather than on industry.

III *The land:*

 a. unplowed land, the stubble showing ragged.

 b. plowed fields.

 1. a shot in early morning or late afternoon to accent the pattern of the turned soil.

 2. show contrast of newly-plowed damp soil to stubble-covered unturned land.

 c. plowing and fitting. Try different angles for plowing pictures.

 1. low (almost on the ground with camera) and up at plow from "land side."

 2. dirt rolling from mold-board. Do *not* shoot too fast. This picture should give some sense of the motion of the dirt coming off the mold board.

 3. several pictures of the plow and motive power from different angles.

 4. fitting.

 A. harrowing.

 B. discing.

 1. watch for chance to get pictures with early or late light showing *land texture*.

 2. picture of implements at work.

IV *Planting:*

 a. corn being poured into drill or corn planter.

V *Around the house and barn:*

 a. getting machinery ready for work.

 b. hitching and unhitching horses (if used).

 c. any pictures of general activity.

VI *Landscapes:*

 a. trees against a late afternoon sky.

 1. setting sun.

 b. man and team or tractor and equipment against sky-line.

 c. tree-lined lane.

 d. fences and fence-corners.

 e. cattle on pastures.

VII *Watch for pictures that indicate spring in the country:*

 a. See "spring" script.

 b. wet land.

 c. Fresh vegetation (early flowers).

 d. house-cleaning.

[ANOTHER SHOOTING SCRIPT]

John Vachon F. S. A.

R. E. Stryker July 15, 1942

PETROLEUM INDUSTRY [KANSAS, OKLAHOMA, TEXAS]

The Country—pix color and black and white which give a "feel" of the country. These should be representative of the whole country, not just of the oil country.

Landscapes—Oil derricks (against the sky, etc.) oil tanks.

 (More pix which emphasize the plains. We now need more pictures of the "High Plains.")

Derricks

 Get some angle shots (clouds and sky included)

 Details around the derricks

Drilling machinery

 Informative pictures and some "pictorials."

Workmen

 Faces men and machines

 men and jobs

Tools and Equipment

Details

 The pix of the "little items" which will enhance the total set.

Pipe Lines—*Important*—

 Men at work on new lines

 Piles of pipe

 Trenching

 Hauling

 Pipe laying

 Pipe Connecting

 Fix of old established lines

Refineries

 Pictorial shots of refining apparatus—tanks—men in and around refinery equipment.

Tank Cars

 Get pix of a lot of tank cars in freight yards loading tank cars

 Trains of tank cars—long shot with as much of train on negative as possible.

Gulf Coast

 Loading tankers

 Local Delivery

 Tank truck filling local station tanks

 Trailer-tank trucks on highway.

[ANOTHER SHOOTING SCRIPT]

THE FARM SECURITY PHOTOGRAPHER COVERS THE AMERICAN SMALL TOWN

The small town is the cross-roads where the land meets the city, where the farm meets commerce and industry. It is the contact point where men of the land keep in touch with a civilization based on mass-produced, city-made gadgets, machines, canned movies and canned beef.

Inevitably any attempted coverage of our Farm population must include the Farmers' place-of-exchange, an exchange of produce for cash, for manufactured goods, an exchange of gossip and ideas. A thorough country-wide picture of the American institution SMALL-TOWN is bound to illustrate regional differences in agricultural methods, living standards, crops, clothing, folkways, local government, architecture, climate, etc.; at the same time, it is sure to accentuate similarities of a national rather than a regional character.

Because of the importance of the Small Town in American rural life, every Farm Security Administration photographer carries a permanent small-town shooting-script. Whether he goes on assignment to cover projects in Ohio or Migrants in Texas, that shooting script is in his pocket, and, often read, to a large extent in his head. As he drives along, through hundreds of towns, he cannot help but run into items on the script. He stops the old bus, shoots, and goes on. Only occasionally does he remain overnight when some special event intrigues him. For, to him, the Small Town is a perennial rather than a special assignment. That shooting script in his pocket is an environment for his curiosity and ingenuity as long as he remains on the staff.

SAMPLE ITEMS FROM A SMALL TOWN SHOOTING SCRIPT:

Main Street

 Stores, theaters, garages, barber shops, town hall, jail, firehouse.

Fire hydrants, traffic signs, hitching posts.

Cars and trucks, parked and in transit, wagons and horses, loads on trucks to show the nature of the products grown or produced or sold in the neighborhood.

People on the street. Show faces, clothing, and activities.

Men loafing and talking. Women waiting for the men, coming out of stores, window shopping, tending children.

Menus in windows, inside pictures showing posters, show-cards, and "restaurant life." Workers in restaurants and stores, methods and habits of serving customers.

Pool halls, ice-cream parlors, saloon, notion stores, hardware stores, and seed and feed stores, drug stores, funeral parlors.

The church, the cemetery, the railroad station, bus terminal.

The editor, the town marshall, the postmen or rural mail-carrier, the butcher, plumber, blacksmith, filling-station attendant, clerk, harness maker.

What keeps the town going? A study of local industries would be of great value.

General

Ice Cream parlor—If possible photograph this sign on windows or building.

Courthouses—A few more good photographs.

Post Offices—Unusual—humorous.

Squares—Watering troughs, band stands, hitching posts and racks, benches (people "sittin'")

Movies—Fronts of theaters, children.

Lodge halls—The lodge is very important in the life of both the white and black of the lower income group.

Funeral Parlors

The Cross-roads (Important)

 The store (and post office)
 The garage
 The loafers

Saturday Afternoon in larger towns

 Street corner groups
 Tired women & children waiting to go home
 Carrying supplies to car
 Windows of stores (signs in windows)

Medicine vendors

Auctions—Country or in small towns

Churches

> People leaving church—visiting on the steps
> Churches in the mill towns

Railroad Stations—We need more good pictures of the station in the small town—views inside and out. Remember that the R. R. has played an important part in the life of these small communities.

CORRESPONDENCE WITH ROY STRYKER

SUNDAY MORNING [OCTOBER 1938]
From Lincoln.

Dear Mr. Stryker—

Today I shall leave for Omaha. I have received the second batch of film, and now I have plenty. A whole damn cornucopia full. But tonight I am going to wire for about 2 dozen more flash bulbs.

This past week I did the following: Monday with two home supervisors, nice homey women, in home, showing ladies how to can, how to sew, etc. Tuesday, at York, a group meeting of six farm couples drawing up farm and home plans. This was really swell. They were so absorbed in what they were doing as to not notice me at all. I've really become sold on the rehabilitation program. For the first time I see that it is the fundamental and important part of FSA, and that county supervisors are in general pretty good guys, doing good jobs. Wednesday I spent $\frac{1}{2}$ the day traveling by bus, and the other $\frac{1}{2}$ worrying about my bag containing 1 Speed Graphic and all of my film, which had got mixed up with a lady's bag containing several dresses and under pretties. But I got it back that night, sound and safe. Thursday I went around with VIRGIL SYKES, county supervisor at Lexington, Neb. Got pictures of irrigation, big herds of cattle, cow boys, grazing country.

Thursday night I hit North Platte, the home of Buffalo Bill, a swell town. I'd liked to have stayed on there a few weeks. It was the first and only Nebraska town I've been in that sold liquor over the bar. So Thursday night with a clean shirt and a shave, I goes into a corner saloon, a saloon in the grand tradition. At the piano was a big fat blonde woman of 45 or so, with a beautiful red smeary paint job. She turned out to be an ex-Omaha prostitute, and very proud of it. She'd been in Omaha 19 years—now she's reduced to a mere entertainer in No. Platte.[3] She played good honky-tonk piano, and sang like Sophie Tucker—only very nasty songs. So I told her I was a Broadway scout and would like to take her picture. Of course she thought it a swell idea. I made 3 trips back to the hotel for more flash bulbs—

got shots of her at the piano, and at the bar, of the bartender and customers, of leering farmers listening to dirty songs, of a couple of broken down cow boys drinking beer in a booth, and no doubt other things that I won't remember. I was probably a little off focus in my last half dozen shots, but out of the whole I think we've got something. I wasn't in such good shape the next morning for my day's travel with my county supervisor, but it was a grey day anyway. I got more of the usual rehabilitation stuff, a little on sugar beet workers, and some filling station murals of buffalo. Saturday morning I worked a little around No. Platte, and left for Lincoln at noon. When I got here I found that the Hallowe'en dance I'd come back to photograph had taken place Friday night. The dummies had assured me it was Saturday night—otherwise I wouldn't have come back here at all. So tomorrow I will spend the day walking and riding around Omaha, taking notes and learning the map. Tuesday I'll go to work on it. Sometime in the middle of the week I'll break it up to get that weather bureau stuff for K. Smith. I hope to have the flash bulbs by Thursday or Friday. Are you going to send me a list of definite things Leighton would like from Omaha?[4] Address me Gen'l Delivery.

Sincerely yours,
J. F. V.

FARM SECURITY ADMINISTRATION
November 1, 1938
IF RES

Mr. John Vachon
General Delivery
Omaha, Nebraska
Dear John:

I have gone home for the last several evenings full of good intentions—one of these good intentions was to write you a letter. It seems as though this method isn't going to work so I am going to dictate one and let Toots type it up.

You are so damned lucky to be in the field. Imagine this last week the crowd of regional information men in Washington! It is an occasion long to be remembered.

Paul Jordan brought excellent reports of your cooperation. You have served the Historical Section nobly, sir! At least there is one region where we will be in good standing. Judging from your letter it wasn't done too willingly, though I might say they don't know that.

Things move on as usual, with the duplicate files daily becoming more empty. By the time you arrive the files will be in great confusion—California is now snugly fitted into Alabama; Wyoming resides peacefully in Pennsylvania; half of Missouri is in the dup files. I know damned well we shouldn't have let you out of town. We have decided to welcome you back with the Marine and Navy Bands, and if we can get it, the Army Band as well. We are making a special hooked rug to roll out on the street for you to walk on.

The laboratory is completely snowed under. We got a crowd of WPA workers the other day and finally shoveled them out. Jerry was the only one still able to kick. The other boys were in bad shape but we were able to get them back with artificial respiration.

I hope the weatherman has been as decent to you in Omaha as he has been here—lots of good photographic weather. I would be very interested to know what you are finding in Omaha. Judging from your early comments your stuff ought to be pretty good. Thanks for the Bourke White roto page. Sorry we neglected to have you properly ushered into the city.

We are expecting to see you back here not later than the morning of the 10th. As you know, your authorization to travel is up then. I should like to have you stay longer but there are too many things to be done. Regards from all of us.

Roy E. Stryker 3000 39th St. NW

[Dubuque, Iowa]
FRIDAY—APR. 19 [1940]

Dear Roy—

This is the biggest sash mill and door center in the U.S. Little things fly around in the air and get in your eye all day. Lots of smoke, too.

I think perhaps part of the "other side of the tracks" you told me of has been torn down. The city burned a hundred or so shanties which were built around the dump about a year ago. A few new ones have sprung up however. There is a community of 4 or 5 single men who live in these shacks and scavenge the dump daily for paper, cardboard, etc. which they bale and sell. They also dig around for oranges, grapefruit, etc. which produce companies have dumped. They are all fairly old. One guy boasted that he has "lived right here on this dump for 40 years, wouldn't live no where else." One of them has a magnificent sense of humor as you will see in forthcoming pictures. He is a W.W. veteran. I'll try to get more dope on their histories.[5]

I've had two dark rainy days on which it was impossible to work outside. So, I did a pretty complete story on the City Mission, community chest financed and operated by a Baptist minister who is quite a little stinker. Lodging and meals for 25 men. It really breaks the heart to hear this little Baptist say "all right men, upstairs to bed" after the hymns had been sung. They go up, fumigate their clothes, take showers, and go to bed about 8:30. The first night I sat through the services and raised my hand on the third call that yes I want to be saved. I never realized before what a lousy situation it is to have "charity" operated this way. I'm going back once more to get shots of children coming to get pails of the stew that's left over.

I also did some stuff in the lobby of a 35¢ hotel.

There's an awful lot to do here yet, even to sample the town. But I guess you want me to get into the corn. On account of the bad weather I think I will skip Clinton, George Leighton's town down the river, and put the extra time in here.

The rich houses are up on the cliffs around the rim of the city but so far they haven't seemed to photograph.

There are 4 Walker Evans type R.R. Stations in town. C.B. & Q., I.C., C.G.W., & C.M.S.T.P. Also river front with barges, tow boats, etc.

And I got the polluted stream picture *exactly*.

I'll send the stuff in in a few days. Please let me know how the double flashes look: whether I should keep on using them, go back to single flash, or go back to barbering.

Here is a rough outline of where I expect to be, when: Mark "please hold" on all mail, and I will arrange for forwarding.

April 23, 24, 25, 26
COLUMBIA HOTEL
GRUNDY CENTER, IOWA
April 27, 28, 29
TALLCORN HOTEL
MARSHALLTOWN, IOWA
April 30, May 1
GENERAL DELIVERY
SCRANTON, IOWA
May 2, 3, 4
GENERAL DELIVERY
ONAWA, IOWA

Please send my check to above address.

Let me know any developments from Stong. I will wire in plenty of time for ½ *case* of flash bulbs to be sent me, care of Stong.

S'c'ly.
J. F. Vachon

Washington, D.C.
APRIL 23RD, 1940

Mr. John Vachon
Grundy Center, Iowa
Dear John:

Your letter of 4/19 arrived yesterday. I am glad things are going so well. I am particularly pleased to know that Dubuque is an interesting town and may be worth continued effort. I am anxious to see the samples, and I am particularly anxious to see what you found along the waterfront.

The Mississippi River towns have interested me for a long time and I look forward some day to seeing a good set of pictures in our file on these towns from Minnesota to the Gulf.

The City Mission story sounds good. I hope your pictures portray the real character of the Baptist minister. I know that type. Will save my comments about them until you get back.

Okay. Skip Clinton, and put it on the list for some other day.

I am delighted to know that you got the polluted stream.

Earl Pressman has probably already written the letters which you requested.

I have had no other word from Benton Stong except that he was glad that the trip there had been postponed until later, as the weather will be better and there will be more things to photograph.

On any of our projects I wish you would watch for people putting in gardens. We need those pictures badly in making up our various panels, etc.

Things are going as well as can be expected here. Terribly busy. Ed has just about completed the nine panels for the University of North Carolina. It is a swell job, and I believe we'll convince some of the academicians that the photograph has something to offer in the way of presentation.

Don't forget our Springtime On The Farm—breaking clods, plowing, harrowing, etc. in the immediate foreground—lots of shots.

Well, best of luck to you. We'll take care of the flashbulbs.

Best regards,

[JULY 1941] THURSDAY—5:30 PM

Dear Roy:—

I think I got a raise. Cannot interpret check for $99.99 in any other wise. I am gratified. I am extremely gratified. All my constituents will be gratified.

I arrived Milwaukee about an hour ago, and got your telegram regarding 4th of July celebrations. Will handle.

I have mailed a 2nd package of Chicago film. There is more to follow which I haven't had a chance to unload yet. I've covered the following things: Cold storage plants: butter, eggs, meats, poultry. Stockyards:—cattle, hogs, trucks, long views. Fruit and vegetables:—unloading trains, loading trucks, commission merchants examining produce, making notes, and auction. Also much leica work of crowds on street, heavy traffic on boulevards, people going up El steps, etc. I spent from 4 AM to 8 AM this morning at the fruit terminal. Then I went home and slept.

I got on very well in everything but the packing house—slaughtering aspect. I only talked with Swift and Co. but was convinced that they spoke for all. Slaughtering pix are absolutely tabu. On anything else they would gladly furnish me prints, but couldn't allow me to get anything myself. However, there remains the Hormel Plant at Austin, Minn., which may work if well planned. I think it very

important to send a letter to the head man at Austin, *before* I get there, saying I'm coming through, and announcing *specifically* what I'll want to photograph. That is the way they like it done, I've learned. Can it be arranged? I don't know for sure whether they slaughter at Austin or not. If they do, could you give them some justification for my taking pictures? Otherwise I don't think there is much chance of ever photographing that operation. Please let me know about this soon.

JULY 5 [1941]

Dear John

Your letter arrived last night and I had no time to answer it today at the office. Another batch of your film arrived today and will be developed first thing Monday a. m. Your film marked Ind. and Ill. July 2 is all O K.

First let me requote answers to your questions as listed by C. A.

(1) Film requested in your wire was mailed on Thur. AM. July 3 Milwaukee, c/o Hotel Wisconsin

(2) Yes, there are still some #2 flash bulbs Also the new reflectors should be by Monday next.

(3) Your advance will take several days yet.

(4) You and the other photographers will not receive continentals L. A.[6] this year or not at least until we have tried out a new system. BE SURE YOU NOTE STATES LISTED ON YOUR L.A. AND DON'T GO IN ANY STATES NOT LISTED UNTIL YOU HAVE TAKEN IT UP WITH WASHINGTON.

(5) Yes, you did receive an increase. I'm glad your constituents will approve. Looks like I could keep my office a little longer this year.

I am anxious to see your Chicago coverage. Sounds like you did an excellent job on markets and food storage. Not surprised about slaughtering pix. As you remember Time Life printed gore and details of prize 4 h steer slaughter. Well the packing companies caught hell for this and so did Life. I have been busy this a. m. trying to get letter from Wash. office re Hormel Plant. So far advice is to get Reg. Director to handle your credentials from Milwaukee office. I'll continue on Monday but everyone thinks Reg. Dir. is best bet. So if Reg. Dir. can't fix you up let me know by wire and I'll get wires through by hook or crook. I quite agree special and specific letters are best. I am at work on Iron Range lake boat credentials. Should have this o. k. by end of week. If Hormel won't o.k. slaughter pix then we may be able to get into packing houses in Iowa or Nebraska. You'll have to get the Iowa pix.

We sent contact prints Pittsburgh & Erie. Please caption and rush back particularly Erie. Your Erie Trailer pix were fine and will prove most useful. Will be able to place them in N Y C Buffalo papers

Marion took F S A defense housing at Hartford, Jack same at Caroline County Va. also displacement.

O K to get part of Elmers pix soon especially that which is conveniently located near Milwaukee. You are right this will be "Training" for real dairy pix. I would arrange most of his work to fit your own time. Get his pix when they come along with other things. Not a bad idea to get some items rushed out of way and then make your own schedule on balance.

Portraits of cows and calves also horses.

Milking for folks who don't know how milking is done

Farmers car milk cans in luggage section with Wisconsin license place
Americas dairy lands.

Pix on how milk is handled cooling, putting in cans. hauling

Close up of silo filling.

Portraits of farmers We still need more pix showing what do farms look like and what work does a farmer do.

Recreation.
Swimming "Old swimming hole"
Fishing
digging worms.

N. B.

Soft ball a good series on this game is most important
Watch for soft ball league games
Vacant lot base ball kids playing.

Customs the American way. etc. Weddings. Please remember we have not one wedding pix in file.

Lodge a series of lodge pix would just be perfect for our file.
Would please the file a lot. I don't know just how one gets them.
Better snoop about and see what you can do. A lodge in session
parades with costume and regalia.

Meetings of all sorts indoor and outdoor.

Wish you would check over defense industry in Milwaukee How about Allis Chambers. If not defense. How about tractor mfg. and assembly. I'll check O E M[7] Monday for their ideas and get letters from them. O E M letters would be best I think. When you get to Minneapolis and St. Paul remember some of the items on your old check list of items to be done.

More trucks loading and unloading
Minneapolis is still a great distribution point)

Wholesale groceries

Used truck for sale used truck lot.
additional pix of Miss. L. transportation loading barges or river boats.

pix of gin Hill mansion
 Weyerhauser and other of that bunsh.

New pix in wheat exchange if possible.
addition to R. R. yard pix.
More portraits of railroad men
Portraits of truck drivers
More flop houses, employment agencies
(Help wanted signs. Get details.
Portraits of racial groups.
Finns
Scandanavians.
 These should be of workmen and white collar workers also business men. Don't forget the female of the species too.

Saloons and beer halls.
Watch for poker games.
Athletic club golf links. You would be both a gentleman and a scholar if you could add to these two subjects to the file.

Add the "tough" side of St. Paul. it will be an addition to our "tough" section
 Don't get shot doing it.

Wisconsin, Minnesota

Long shots. view camera sharp for murals and other use which show the rich farm lands of these two states. There are beautiful spots. beautiful farms rich land prosperous farms, very

pleasing vistas. Farm steads showing "lush" acres, good houses, barns and silos. Cattle and pasture trees in pasture streams and rivers.

In detail.

Cows going down lane to pasture Boy and dog bringing cows in for milking
Cows under trees hot summer day. Cows in river, drinking cows waiting at pasture gate waiting for milking time.

continued at the office.

Didn't get this finished yesterday at home so am giving it to Helen and will get it out in the mail today. Unless I can find or dig up somebody here today, I think that you will have to make your own arrangements to get into the Hormel plant. The regional Director should be able to help you. If that doesn't work, please wire me.

Mark's wife has been very seriously ill. Had an operation. Russell was out for a week on a AAA job in Idaho. Mary Rita is out on leave for two weeks. You don't know how close I came to calling you in but we decided to brave it through. This is the first time that the files have gone for such a long period of time without an official custodian, but I guess we will be able to make it somehow or other. The two new gals have reported for work. Betty Mininger is working on captions and duplicates. Alice, whom I believe you met, works with Clara. Two new people in the laboratory and one new photographer, John Collier, Jr. son of John Collier of the Indian Bureau. John is from California and has spent some of his time in the South West. Marion is still trying to get her equipment straightened out. Jack will be leaving for New England. Marion will probably leave in a week or so for the High Plains.

I am inclined to think that you will not be ready to go to the iron ranges on July 28. Anyway, I am going to start working on your credentials. Flato of the St. Lawrence Waterways is going to be very helpful on this. I will have you thoroughly covered on this job you can be assured. I am inclined to think that the Indian Bureau job will take a little longer. If you don't finish it at this trip, you will have to come back to it. It is my impression that they wanted ten days to two weeks, and I would like to have you do that much more if you can. We will check on your schedule along about the 20th.

I am afraid this will have to do for a letter now.

Sincerely yours
Roy E. Stryker
Chief, Historical Section
Division of Information

Dear John:

I know that you feel that you are very much neglected but still there are only 24 hours in a day and you know that the demands on my time are insistent and especially these days. But I am sure better days are coming as far as time to write you photographers is concerned, and we will have a little more leeway. I ain't apologizing—I am just telling you facts.

Plenty of things are happening here. First, we will be doing (as I indicated earlier) an awful lot of work for the Coordinator of Information. We will be doing all kinds of picture stories which will become part of our overseas propaganda. This is not to be talked about. You will have your special assignments with letters signed by the Coordinator of Information which will give you entree and clearance. In all instances, you may say that this is a project being done by the COI but you don't know of its purpose or how it is to be used. Further information will have to be obtained from the Coordinator of Information. You will always have sufficient information so that you will be able to do an intelligent job, but there will be plenty of times you will wonder what it is all about. Our general advice in those instances is that you check your curiosity in the car and wait until such time as we can give you further information. The main thing is that you will always have sufficient knowledge of the job so that you will be able to proceed on an intelligent basis.

If everything goes well, we will go on a "partial security" basis, that is the FBI will investigate the field photographers very carefully. You will then carry proper identification as well as have a letter of specific authorization for each assignment. As you will realize, this will help us on some of our problems.

We are anxious to have at once a very thorough coverage on cattle and sheep industries. Some stuff will be done for COI and some for ourselves. At the present time, they should be feeding sheep and cattle in that Section. You will find this where they have surpluses of sugar beet pulp accumulations. If you have any trouble finding it, you can contact Mr. Jack Maynard, Western Sugar Corp, Billings Montana, and he will give you all the information you may need. Mr. Kelly of the U.S. Sugar Beet Corporation was in yesterday and gave us this information. You get your camera out and begin to work right away on anything you can find which is going on at the present time. There is one basic idea which you must present, namely, that the sheep and cattle industries are very important in the United States. Sheep produce wool and food. Cattle is food and we have lots of it. There is plenty of drama in all aspects of these industries regardless of season or weather. I imagine you will be doing quite a little of this, and we may have other photographers at work also. Your pictures are to show lots and lots of sheep and cattle. You are now in a section where they are finishing off the winter season, probably still feeding cattle and sheep and will soon be ready to drive the cattle off into the hills.

We need more pictures of *"Mrs. America."* Mrs. America is all over and often hard to find. To be specific, let us have more pictures of woman in the home, women in the kitchen, women gardening, women working. I think you have some feeling already for the type of pictures these should be.

As fast as possible, we will be sending you additional contact prints. Incidentally, I am very well pleased with the things you are sending in. You certainly do have a feeling for the Great Plains, and I have noticed from your pictures that you are finding some snow. Do you have any chance to get into the businessmen's homes in the smaller towns—the family reading or playing cards or something else would be very useful in the file. We are short of the middle-class American white collar and small business groups.

The town is a mess. Rumors are all over the place. You have undoubtedly read about all the attack on Farm Security. We are going to get a cut on some of our budget but we may get it back in the Senate. We will go on as far as the Historical Section is concerned because we will be operating more and more on other funds.

What are you finding in the way of public attitude on the war in Montana. I would be very much interested in getting a letter with your comments. If you get into Bozeman, Montana, I would suggest you call on a very good friend of ours, the librarian, Mrs. Lois Payson. She is a long standing friend of the Strykers and quite an admirer of the photographic work which you are doing. Her husband, now dead, and I grew up together in Colorado.

What about tires. I make no promises. There is a chance that we will be able to get some kind of priority on tires since we are working with the COI—remember this is not a promise yet.

Regards.
Sincerely yours,

APRIL 10, 1942

Dear John:

I am all behind in my correspondence with the photographers. You have been neglected for business letters. It is not a nice thing to do, but things have put on more pressure. Judging from your last letter, and from the pictures, you have been taken in by the West. I am expecting any minute to find that you have traded the car for a horse. You may have to in the end. Your last letter about the visit to the sheep camp stirred up all my nostalgia. Not the sheep camp, but your feeling about the great open spaces. There are days when I wonder if anything we are doing here in Washington is worthwhile. Your letter happened to arrive on one of those days when I was thinking about such.

The last two bunches of contact prints were most pleasing. Some were mailed to you the other day and we are mailing the others to you today. I am very happy with the types of things which you are picking up. Incidentally, I can see the influence of "Storm" in your last set of pictures. Telephone lines, roads and so forth. You didn't get any blizzard pictures, but you have made a very excellent contribution to the winter stuff. Now if you will just turn your camera loose on Spring in the Rockies and do the same thing, I will be happy. You will probably already begin to run into the area where there are still snowbanks; where the ground is damp and wet; where you can begin to see the fresh grass springing up at the edge of the snowdrifts; trees just beginning to come into leaf; gardens being planted. Don't forget the clumps of willows down along the little stream. I like the pictures you had of the ice and snow at the edge of the river. Too bad you had to turn back, but when a native tells you that the roads are bad, you can bet your life they are. So get your saddle and pack horse and you can go through those roads next year, or perhaps your idea is better, drive in in the fall and remain until the snow melts.

You are really having a very interesting experience, John, and I am glad you are getting a taste of the good open spaces. Your pictures are expressing your reactions a lot. I am wondering how you got along at Hamilton. We wired you today to be sure that you would send in the negatives. It was a terrible job trying to get you a release to get in there, and then I guess you didn't get it after all. I don't think there would have been a great deal of trouble anyway.

I hope to be able to get a clearance so that you can buy good rubber tires in the next week or two. We have also asked the COI to check on each of you and give us an official title. The FBI will probably carry out the investigation. It will take quite a while to get it done, but when we get it, it will be useful to all of you to have especially while you are in the field. Incidentally, we finally got our first battle won with the Civil Service. We have obtained GAF9 $3200 classification for photographers. As you remember, they took 3 cases first, Russell, Delano and Post. We have already put your name in and I hope before long that you will be notified of your new status. $3200 will help quite a little.

We want to do a lot of pictures on the cattle and sheep industry this summer. I want you to carry on quite a lot of it. There is a chance that we will get Charles Belden, of Pitchfork, Wyoming to do a few days for us now and then. The Coordinator's Office is anxious to have a big round-up of picture material of sheep and cattle in the Rockies.

John, I think you ought to try to keep us a little better informed of your advance stopping points so that we can get mail to you, although you have been doing pretty well the last three or four weeks. A little later on, I want you to come back to Lincoln and do a series of Kodachrome slides on some of the field activities. At the same time, we may want you to do some black and white pictures for slide films and special information panels. I think you ought to be trying your hand on another roll of Kodachromes. Put it in and see how you come out. I liked your other ones very much. They were a lit-

tle off on exposure, but keep your hand in on it. I will also send you some $3^1/_2 \times 4^1/_2$, and I think you ought to try some of that.

I will write you more later John, and I'll try to make it more often.

<div align="right">
Sincerely yours,

Roy E. Stryker

Chief, Historical Section

Division of Information
</div>

"FIRST DAY OUT"

JAN 24 [1942]. ROMNEY, WEST VA.

First day out. Now I've left behind my wife Penny and her two small children. Night now, and many Saturday night people on the main street of this little town of dark West Virginia. The gaunt brooding state of the U.S. The West Virginia people have lean angular faces with dark seamed wrinkles. The bony women have thin breasts and strange sweet straight lips. Black Sunday suits on the men with combed hair, and shapeless color printed dresses on the women.

I rode a soldier today—into Winchester. Fred. He's been in the army a year now, and he's a 1st class private. When he gets near his home town he remembers better all the things he did as a boy, and when he was in high school. He talks more, and with light in his eyes about his uncle's cream truck which he drove over this road, the time he nearly hit a Greyhound bus. He tells with keen remembered pleasure of how on summer nights he used to sneak into the country club swimming pool and plunge through the dark water.

He tells of dates with wealthy farmers' daughters and girls in a neighboring town; he had a little old car & he rode the wheels off her. He remembers the icy winter of 8 years ago when ornamental ice clung to trees, wires, and buildings for several weeks—how he skated down town on the streets—transportation was stopped, communication crippled—Early American winter. A John Greenleaf Whittier winter in 1933 for a young high school boy who lives in a protected place among the pretty Eastern mountains—near apples and horses, and fine old Virginia families who'd lost their money. Difficult Run, or Great Bear Gap, or the mountain you saw on the other side of Purcellville might have marked the edges of his familiar world to him. Now he says his outfit is going to move pretty soon. Any day now. Maybe overseas. When he got out of my car a block from his home a woman he knew stopped to ask if he'd seen her son Charles lately.

Clarksburg, West Va. Jan 25.

Today I crossed a hundred miles of earth rump in West Virginia. Down in the cracks between

brown hills the dirty towns string along. Unpainted, smoke blackened, inadequate—these are poor towns. The look of poverty has fallen on the people's houses, the movie theatres, the hotels and stores. It has fallen on the cut hills that surround the towns, and on the people's faces. It will take many years of prosperity security and easy access to the good things to erase all of that look of poverty. Then perhaps the heritage of these thin hard straight eyed West Virginia people will bring forth a new American culture. They are the strangest of all American people, these West Virginians.

I drove two high school age girls ten miles out of Grafton today. They were dressed in poor worn bright colored clothes, holes in their silk stockings, and lipstick on their mouths. They talked of Johnny, Huck, Hiram & Sleepy—boys they know. And of the chocolate meringue pie eating contest which the boys had engaged in last night at a church party. They said to each other several times "Golly aren't we having a lot of fun!" and giggled and laughed when they said it, each understanding the other.

Marietta, Oh. Jan. 26.

Heavy skies today in the highlands, and dropping temperatures. Light blue smoke going up from the chimneys of hill farmers cabins. In dirty old Parkersburg I talked with a county commissioner, the fire chief, the tobacco chewing proprietor of an old photo studio, and several second hand furniture dealers. Every one modestly assents and defends his way of doing things. From Parkersburg to Marietta along a rainy road up the Ohio River. In Marietta there are vast avenues of fine old columned houses and elm trees. I am staying in a house on Front Street, along the river, and I can hear a rat in the wall of my room.

Ladies in the Civilian Defense Registration office in the basement of the court house are asking old ladies and men what they think they can do to help, what are their hobbies, what do they collect.

For a dollar I have entered into these people's home. I can listen to their conversations downstairs, use their bathroom, sleep in the dead husband's bed. I could go downstairs and talk with them in their parlor if I liked.

They are just like rats those Japs. I wouldn't mind having 500 of them lined up and taking a shot at everyone of them. Too bad for Kimmel and Short. I guess they deserve it. How's Mr Hood?[8]

This is the first settlement in Ohio.

FEB. 8

Burlington, Iowa

Damn those who think they are better. Damn those who have aquiline noses or white collars or high foreheads. Those who speak of a better class of people, those who make clumsy bourgeois suggestive conversation with each others' wives.

God bless those who do not think they are better, who have children, and believe you if you are honest—who speak a medium truth, and never try hard to make you believe something about themselves.

FEB. 9, 1942

Mendota, Illinois

His eyes hurt with bewilderment, hairs and body growths appearing on him, he stands naked and lonely—all about him the world rushes, whirls, operates, with swishes and clicking noises. He can no longer make a comment on any of it—much less interpret, synthesize, mold it. He is stripped of all he had—some fell off him, some he cast off, some was wrested from him. Stripped he finds himself to be nothing. So now he is staring at the world about him for a few minutes, and his eyes hurt.

"NOT A CARE IN THE WORLD"

[1943? OCTOBER?]

several weeks later

dear friend Philip[9]—

Well sir, you get up about 8 oclock. Beautiful clear sunny day, dress and shave leisurely, put on some old pants and a shirt. Then you have a big breakfast down in the coffee shop, bacon, hotcakes, strawberries, 2 cups of coffee, plenty of time to read the papers. Upstairs for a healthy satisfying morning function with the editorial page, then you check out. Drive down to the filling station where they still wipe off your windshield. You tell the pretty station attendant (who wears only shorts and a flimsy brassiere) to fill er up. She takes 13.8 gallons. The oil and water are all right. Then you coast down the hill, and zoom out of town on your thick new firm luxurious tires. Whip her up to a comfortable forty, and knock off 50 or 100 miles. Singing as you drive. Not a care in the world. Nice country to be passing through, each little town, etc. Then maybe you stop for a pepsi cola at a highway junction. Have a little chat with the man who sells it to you. Tell him yep, you're a long ways from home. So then you study the road map. Remember road maps? And you see that by taking county road B, and going 60 or 80 miles out of the way down a back road, you can go through a town called Starving Horse Falls. Well that would be interesting. So you do it. What's 80 miles more or less, 4 or 5 gallons of gas. Well at Starving Horse Falls maybe you take out the camera and shoot a few pictures preserving on immortal celluloid the fleeting images of an October morning. Thus carelessly are accomplished a few of those perfect photographs, those photographs that will live forever, that will be seen by millions, influence the course of public opinion, shape the destinies of nations. So now it's nearly noon, and a good morning's work behind you, you are hungry. So you whip off another hundred miles down the straight broad American highway, and stop for lunch. You have the veal stew special, with coffee and homemade apple pie, 35¢. Then maybe there's a county fair going on out at the edge of town. So you spend the afternoon there, walking, smiling, watching, playing games, viewing the prize pumpkin, perhaps knocking off a few more immortal photographs. You don't even notice whether the Farm Secu-

rity Administration has an exhibit, because you don't work for them any more. But you win a kewpie doll by making a score of 125 at Toss the ring on grampa's nose, and you give the kewpie doll to a little 19 year old blonde girl who happens to be passing by, and she is so grateful that she insists on bringing you home to dinner with her. She lives in a nice apartment over the beauty parlor on main street. But then you've got to be getting on, so you roll off another 2 or 300 miles in the cool sweet evening, with your windows all rolled down, singing. Then you check into a hotel, see a movie, listen to a band concert in the town square, eat some popcorn, have a few drinks in the red leather bar of the Waving Cornstalk Hotel, strike up a conversation with a traveling salesman from Wichita who tells you what a fellow told him over in Arkansas City last week. And so you go upstairs for a warm bath in your fine big clean modern mid-west hotel room, using four towels. Then between clean white sheets you read a detective story until you fall asleep.

Yump. that's how it is.

Well my pen is getting dry and I must close now.

Best regards to you and Mrs B.

Very truly,
Orson.

"TRIBUTE TO A MAN, AN ERA, AN ART"

In the summer of 1935 large blue streetcars clanged along the tree-shaded streets of Washington, D.C., and FDR lived on Pennsylvania Avenue. Boy and girl government clerks lived in rooming houses on K Street, and some people were laughing at the antics of those two comic figures over in Europe, Hitler and Mussolini. It was a pleasant, somnolent city. Cattle were dying out on the drought-stricken plains of South Dakota, and jobs were hard to find all over the U.S. of A. Roy Stryker and I arrived in Washington at about the same time that summer. He was forty-two and I was twenty-one. He had come down on one of the new streamlined trains from New York City, and I had hitchhiked out from Saint Paul, Minnesota. We didn't know each other.

Stryker came to Washington with Rexford Tugwell (one of FDR's original brain trusters) to head up the Historical Section of the Information Division of the new Resettlement Administration (soon to be renamed the Farm Security Administration) in Henry Wallace's Department of Agriculture. He had a half-formed concept that it might be appropriate to gather together a collection of photographs of all aspects of American rural life, with emphasis on what had gone wrong: deforestation, soil erosion, migrant fruit pickers, and hungry children. These were the things Stryker thought should be recorded by the government. The word "documentary" wasn't yet current when Roy began to recruit photographers.

Walker Evans, Dorothea Lange, Arthur Rothstein, Ted Jung, Carl Mydans, and Ben Shahn joined

Stryker's staff, and soon they were working in the South, in the dust bowl, and in California's migrant camps. Along with publicity shots of government farm projects, they were sending in pictures of a destitute family walking down a highway in Tennessee, of a sharecropper's pregnant wife in the doorway of her Arkansas cabin, of a desperate face in a West Virginia coal town. There were also pictures of country dances, small-town main streets, barber shops, circus posters, riverboats. I'm not sure that Roy Stryker planned it exactly this way, but that's how FSA photography began. Later Russell Lee, Jack Delano, John Collier, Marion Post, Gordon Parks, Arthur Siegal, and Marjorie Collins became part of this unique project, and it lasted for seven years.

I had been in Washington several months looking for a job when I heard of an opening as assistant messenger in the Resettlement Administration. The next day I went to the Barr Building across from Farragut Square to be interviewed. Roy Stryker was a gray-haired man with thick-lensed glasses, and there were a lot of photographs spread over his desk. He seemed amused that somebody wanted a job with the title "assistant messenger." He wanted to know where I came from, and he laughed when I said Minnesota, but it seemed to please him. Then he asked me if I was interested in photography. I hid *my* amusement at that ridiculous question and told him no, not at all. "Fine," said Stryker. "Just what we're looking for." Then he laughed some more and told me about my new job. I would get a free streetcar pass, but I would carry very few messages. Most of my work would involve copying captions onto the backs of 8×10 glossy prints and stamping them with the name of the photographer. My salary was to be $1,080 per annum. I grabbed it.

I didn't meet any photographers for a while. They were all out working. But I began to look at their pictures as I stamped them, and a whole new vision of my country opened up to me. I had never been to California, or Florida, or hardly anyplace else except Minnesota and Washington, D.C. Now I would look long and hard at a picture of black children playing a game outside an unpainted schoolhouse in Alabama, at a displaced family staring out from a rain-soaked tent in a California fruit pickers camp, at a dreary factory town in Pennsylvania, or a snow-covered church in Lancaster, New Hampshire.

I came to recognize the distinctive styles of the photographers: Rothstein's pictorial approach—he specialized in cumulus clouds—Ben Shahn's incisive, unedited perceptions. "Well," he would say, "I guess you can call it documentary. That's all right." Dorothea Lange looked at people with a compassion and simplicity that was different from all the others. And the pure, classical presentation of Walker Evans—the "thingness" of his quintessential picture of a gothic railroad station was somehow the most meaningful of all to me.

Dorothea Lange was the first photographer I met. She came back from the West Coast and talked with deep indignation about the families who had to leave their farms in Oklahoma to pick lettuce in California. Ben Shahn came to town and brought a lot of joy into the office. He was a painter, no photographer at all, but Stryker had the good sense to send him down South to make great photographs. Finally I met Walker Evans. I learned that he had been a friend of Hart Crane and that he preferred

Bach to folk songs. It was these three, Evans, Shahn, and Lange, who had the strongest influence on Stryker in the early days while he was forming a concrete plan out of the undefined ideas he had brought to Washington.

Who, what was Roy Stryker? He was a blend of old-style Populist and New Deal Democrat. He was a kind of friendly and effervescent tyrant from whom I heard, for the first time in my life, that the American economic system had some imperfections, that the Negro hadn't been freed by Abraham Lincoln, and that it wasn't necessarily true because you read it in the Saturday Evening Post. He is said to have been, at one time or another, a cowboy, a farmer, a social worker, an economics instructor. He was certainly never a photographer. When I knew him he was a forceful, garrulous, earthy, cantankerous, impressionable human being who could recognize and nurture talent, who could absorb and assimilate ideas from others, and disseminate them. A catalyst, he's been called.

I received a promotion from assistant messenger to junior file clerk, and Stryker gave me the job of organizing into a coherent system the thousands of photographs that were coming in. My head was filled with subdivisions and cross-references. All FSA pictures came under my scrutiny, and I came to know this vast collection of photographs better than anyone else in the world.

Then, inexorably, as in Greek tragedy: one day I told Stryker I thought there were many scenes around Washington that should be photographed for his files. "Why don't you borrow a camera and give it a try?" he answered. And I did not hear the portentous bells tolling.

Ben Shahn showed me how to focus the Leica and which button to push. On that weekend I roamed the numbered and alphabetized streets trying everything I wondered if a camera could do. I shot through restaurant windows, into dark bus stations, from moving streetcars, and on downtown streets at night. Many of the frames were out of focus and badly exposed. But somehow they had "turned out," and Stryker was interested in them. He continued to look at my weekend pictures and to discuss them with me. I began to understand what he was getting at. Stryker had a keen sense of what kind of ordinary street scene in 1937 would be interesting in 1973.

Walker Evans reproved Stryker for letting me begin with a Leica. To learn what photography is all about, to understand what a splash of light does to a sensitized emulsion, to know how to guide and direct that light, Evans said, I must first use the 8×10 view camera. So for the rest of that summer I carried a heavy case and tripod around Washington, photographing architectural oddities after the manner of Walker Evans. I remained a weekend photographer, but many of my photographs were accorded the consummate honor: they were added to the File.

About that time Archibald MacLeish was writing *Land of the Free,* a work in which poetry and photography were juxtaposed to complement each other. He spent several weeks looking at FSA pictures, writing lines around them, and writing lines for which he sought a picture. One of his lines was, "We looked west from a rise and we saw forever." He wanted to see a rough pioneer cabin, a clearing

in the wood, with limitless ranges of mountains dissolving in the west. Stryker decided that I should go out and get that picture.

Such frivolity—a picture for a poem—could not be undertaken openly by the government. So I was sent to Norfolk, Virginia, with Arthur Rothstein to photograph what in those days was called a Negro housing project. It was my first photographic trip out of town, and I stayed in a hotel. (For some quirky reason I've kept track of my photographic trips out of town, and I've since made 456 of them.) Rothstein and I spent two days photographing the project and then drove back to Washington by way of the Blue Ridge Mountains, along the Skyline Drive. Late in the afternoon we found a promontory off a side road with a view of a deserted log house and a splendid vista of mountains fading away in the west in variegated hues of deep and misty blue. It clearly said, "We looked west from a rise and we saw forever." I set up the 8×10 view camera, went under the black cloth, and spent several minutes focusing, adjusting the rising front, composing on the ground glass, waiting for the sun to just glint the edge of a cloud. Then I emerged, cocked the shutter, inserted a tremendous piece of emulsified film enclosed in a wooden film holder, withdrew the slide, and holding my breath, I squeezed the cable release. Rothstein thereupon pulled out his Leica and snapped three variations of my scene. "Just to cover you, in case . . . " he said. Of course I forgave him. About sixteen years later.

A few months after this, Stryker sent me to Georgia for a few days to photograph Irwinville Farms, an FSA project of little white houses with a community center and a co-op. I went alone, and it was my first immersion into the mysterious South. I remember the lean, angular face of a farm woman with sweet straight lips, and a ten-year-old boy drinking from a fountain marked "Colored Water." I drank blueberry cider at a country dance. I haven't seen those pictures for thirty years. On the way back I had to change trains, and there was a three-hour wait in Atlanta, where I'd certainly never been before. I hired a taxi for five dollars to drive me all over the city. I was looking for something. In 1935 Walker Evans had photographed two identical weathered frame houses with ornamental woodwork, half-hidden by two large billboards, on one of which was Carole Lombard's face with a black eye. I found the very place, and it was like finding a first folio Shakespeare. The signs on the billboard had been changed, but I photographed it, and it's in the File.

In October 1938 I was given my first long, and sought-after, assignment. I was gone four weeks. I left from Washington's Union Station on an overnight train. I sat in the smoking car with important government officials who smoked cigars and told smoking-car stories. First stop: Cincinnati, Ohio. Mission: to make pictures of Greenhills, an urban resettlement development fifteen miles outside the city. This I did dutifully for two days, and when I had a chance I roamed the streets of the strange city of Cincinnati. I photographed a parade, a man standing in the doorway of a burlesque theater, a couple sitting on a bench in Fountain Square. I wonder what ever happened to those people.

In a few days I pushed westward. Ah, to be eating breakfast in the dining car while crossing Iowa's undulant acres. In western Nebraska I had my first glimpse of a part of the world I came to love, the

ecstatically magnificent Great Plains. I got inside dozens of farmhouses (what a wonderful job I had: how else could I have ever been in a farmer's house in Red Willow County?), and I photographed the whole family sitting down to dinner. And there were the towns! I was twenty-four years old, and this was America before the Holiday Inn. Seneca, Kansas, had a hotel with a huge balustraded and polished staircase rising out of the lobby. I went to a church supper in the basement of the Methodist church, I saw ladies quilting, and I talked to the editor of the *Yates Center Gazette.* In North Platte, Nebraska, I met an ample forty-five-year-old blond lady who played the piano in a bar. Her name was Mildred, and she said she was a retired whore from Wichita. I told her I was a talent scout from Broadway, and her picture is in the File.

Before I left Washington, Stryker had told me when I finished my assignment, I should go spend a week in Omaha. To do what? Just photograph Omaha. My only clue was an article in a recent *Harper's* by George Leighton. It was a socioeconomic study of that city, somewhat in the manner of the later "Inside" books by John Gunther. Leighton's book *Five Cities* was about to be published, and Omaha was one of the cities. Stryker, who worked wondrous miracles, had arranged that this book should have an appendage of photographs from the five cities. These were to be government photographs, furnished at no cost to the publisher, and certainly no remuneration to the photographer. In those days publication was its own reward. Maybe it still is.

I spent a cold November week in Omaha and walked a hundred miles. Was it Kearney Street where unemployed men sat all day on the steps of cheap hotels? A tattoo parlor, and the city mission with its soup kitchen. Men hanging around the stockyards. One morning I photographed a grain elevator: pure sun-brushed silo columns of cement rising from behind a CB&Q freight car. The genius of Walker Evans and Charles Sheeler welded into one supreme photographic statement, I told myself. Then it occurred to me that it was I who was looking at that grain elevator. For the past year I had been sedulously aping the masters. And in Omaha I realized that I had developed my own style of seeing with a camera. I knew that I would photograph only what pleased or astonished my eye, and only in the way I saw it.

In November 1940 I was officially appointed "junior photographer." I now made $150 a month. I bought a car and took off for the West, photographing my way through Maryland and Ohio and Indiana.

The Dakotas in winter were a revelation to me and became one of my favorite places in the world, like Paris, or the Italian Riviera, only different. It was cold, and my second-hand Plymouth had no heater, but it was my first totally exhilarating photographic experience. I loved the wide emptiness, the fact that there was nothing whatever to photograph. This trip marked the beginning of my affection for that land of vast space and wild blowing snow, and the winter that I don't check into the Great Northern Hotel in Devils Lake is an incomplete winter.

Back in Washington, D.C., it was still that easygoing border city where you got good seafood by

the waterfront, but war was proceeding in Europe, and Charles Lindbergh and Sen. Burton Wheeler were warning us not to get tricked into it. The country was beginning to ease out of the Depression, and there was something different in the air. The draft had started, and new plants were being built everywhere. Soon all the FSA photographers were out photographing "defense activities" and the changing rural landscape of burgeoning trailer camps.

A month after Pearl Harbor I started out on my last trip for the FSA. This was to be the longest, most eventful grand tour of the U.S.A. I ever made.[10] I was gone nearly six months. There was now a thirty-five-mile-an-hour speed limit imposed all over the country to save gas and tires, which were rationed, and I drove leisurely westward through the mountain towns of Maryland and West Virginia, and down the Ohio River through Parkersburg and Gallipolis. Saturday night people stood on the main streets of these brooding towns, black suits on the men and shapeless color prints on the women. I gave a ride to a soldier on leave, a private first class, Fred. He said his outfit was going to move soon. Any day now. Maybe overseas. When he got out of my car near his house a lady stopped to ask him if he'd seen her son Raymond lately.[11]

I was on my way out to the Great Plains again, but along the way I was photographing Selective Service boards, Red Cross ladies making bandages, the National Guard drilling in the armory. We had been attacked by the Japanese, and we were at war, but hardly. In the Civil Defense Registration office in the basement of the courthouse an elderly white-haired man was asked, "What do you think you can do to help?" He raised his right hand and was sworn in. There were sky watchers with helmets and people with armbands who knocked on your door if a light showed during a blackout. Draftees were training with wooden guns, and farmers were being moved off their land where Army camps were to be built.

The look of early American antiquity, as in colored lithographs, was on the old river towns. I drove through southern Illinois and Missouri. There were red brick buildings and high curbstones in the towns at the edge of the hills, and on Saturday afternoon a farmer's wife, waiting in the pickup truck, ate an ice cream cone. The United States is at war, thank God, and an American flag, red white and blue, flies unfurled in front of every place of business on the square. A glorious sight on a good warm day in January.

Up into snow-covered Wisconsin and across Minnesota. I spent a night on a dairy farm and got up at 5:00 A.M. to watch Elaine, the farmer's daughter, milk the cows. Food For Freedom was one of the slogans to be photographed. In February I reached the eastern edge of my beloved Plains. Stryker's directive had been pretty general; he trusted me by this time. For ten weeks I traveled this exalted rolling land and photographed what pleased or astonished my eye, what I saw and wanted others to see: winter sheep camps, creased faces of cattlemen, a poker game in the back room of a bar, buttes, and wild black horses on the Bad Lands, silver jukeboxes and waxen bowling alleys, a snowman holding a flag, and a Flexible Flyer leaning against the back door.

Our pictures were being used by the Office of War Information, and I was supposed to show that this was a great country. I was finding out it really was. This was a sparsely populated area, still least affected by the war. I didn't know it at the time, but I was having a last look at America as it used to be.

As spring arrived I crossed the Continental Divide, and I was the farthest west I'd ever been. Snow was melting off the Rockies, and early violets popped up in Pocatello, Idaho. I photographed Spring—clothes blowing on the washline, kids playing marbles, women planting backyard gardens, blossoms on trees.

There were confused and frustrating days when the click of the shutter seemed senseless to me, and I wondered what I was really doing, and why. There was the rancher who looked at me with incredulity and said, "There's a war going on, and the government's sending you around *taking pictures?*" Or the resentment toward my A ration card, which allowed me unlimited gasoline. I was uncomfortable around uniforms. I hadn't been drafted because I had two children (pre-Pearl Harbor children, they were designated by the draft boards). But an overnight visit to a winter sheep camp, or coffee and cake with the ladies of the WCTU, would always restore my confidence in the validity of what I was doing.

I'd been away from home for a long time, and in June I headed back east. Most of the photographers were now in military service, and Roy Stryker's photo section had been taken over by the Office of War Information.

I stayed on for a while with Stryker and his reduced staff. We photographed shipyards, steel mills, aircraft plants, oil refineries, and always the happy American worker. The pictures began to look like those from the Soviet Union. But I still knew what Stryker and I liked, and I couldn't just drive past a lonely mailbox on a Texas farm road or a farmer with a mule pushing his plow past high tension wires.

In September 1943 Stryker left the government. He left behind the File, which is now in the Library of Congress: 270,000 black-and-white visions of ordinary America mounted on gray cards. If it is not the single most monumental photographic coverage ever executed, it is certainly the most monumental ever conceived.

Roy Stryker went to New York, to the Standard Oil Company, to try to do the same thing all over again for the oil industry. Well, he tried. I joined him for a while. He sent me down to South America to make pictures of oil. Then my pre-Pearl Harbor children let me down, and I was drafted into the U.S. Army. I spent the rest of the war making movies of pigeons in Central Park for the Signal Corps.

When I got out of the Army the FSA was no more, and I wished I could call it back. I got a job in private industry, as we used to call it in the government. A job as a photographer, because that's what I was now. That's what Stryker had turned me into, starting that afternoon I walked into his office and told him I wasn't interested in photography.

I telephoned Roy a few weeks ago to wish him a happy birthday. He's eighty. He lives in Grand Junction, Colorado.

NOTES

INTRODUCTION

Parts of this introduction appeared in an earlier version in my essay "Portrait of the Photographer as a Young Man: John Vachon and the FSA Project," in *A Modern Mosaic: Art and Modernism in the United States,* ed. Townsend Ludington (Chapel Hill: University of North Carolina Press, 2000), 306–33. Copyright © 2000 by the University of North Carolina Press. My thanks to UNC Press for permission to use parts of that essay.

1. Vachon probably started working on April 27. He recorded in his journal for Friday, April 24: "Got a job today. Now isn't that the damndest thing? At last, unless something unlooked for looks in, I shall become a 'government employee.'" Vachon's letters, journals, notebooks, and manuscripts have been in the possession of the Vachon family and are committed to the Prints and Photographs Division of the Library of Congress. Vachon's unpublished writings are quoted here with the permission of Ann Vachon and Brian Vachon, to whom I am indebted for invaluable assistance.

2. The best discussions of FSA photography appear in James Curtis, *Mind's Eye, Mind's Truth: FSA Photography Reconsidered* (Philadelphia: Temple University Press, 1989); James Guimond, *American Photography and the American Dream* (Chapel Hill: University of North Carolina Press, 1991); F. Jack Hurley, *Portrait of a Decade: Roy Stryker and the Development of Documentary Photography in the Thirties* (Baton Rouge: Louisiana State University Press, 1972); Lawrence Levine, "The Historian and the Icon: Photography and the History of the American People in the 1930s and 1940s," in *Documenting America, 1935–1943,* ed. Carl Fleischhauer and Beverly W. Brannan (Berkeley: University of California Press, in association with the Library of Congress, 1988); Maren Stange, *Symbols of Ideal Life: Social Documentary Photography in America, 1890–1950* (New York: Cambridge University Press, 1989); and Alan Trachtenberg, "From Image to Story: Reading the File," in Fleischhauer and Brannan, eds., *Documenting America, 1935–1943.*

3. See, for example, Beverly Brannan and David Horvath, eds., *A Kentucky Album: Farm Security Administration Photographs, 1935–1943* (Lexington: University Press of Kentucky, 1986); Michael Carlebach and Eugene F. Provenzo, Jr., *Farm Security Administration Photographs of Florida* (Gainesville: University Press of Florida, 1993); Walker Evans, *Walker Evans: Photographs for the Farm Security Administration, 1935–1938* (New York: Da Capo, 1973); Scott E. Hastings, Jr., and Elsie R. Hastings, *Up in the Morning Early: Vermont Farm Families in the Thirties* (Hanover, N.H.: University Press of New England, 1992); Therese Thau Heyman, *Dorothea Lange:*

American Photographs (San Francisco: San Francisco Museum of Modern Art and Chronicle Books, 1994); F. Jack Hurley, *Marion Post Walcott: A Photographic Journey* (Albuquerque: University of New Mexico Press, 1989); *Just before the War: Urban America from 1935 to 1941 As Seen by Photographers of the Farm Security Administration* (New York: October House, 1968); Robert L. Reid, ed., *Back Home Again: Indiana in the Farm Security Administration Photographs, 1935–1943* (Bloomington: Indiana University Press, 1987), and *Picturing Minnesota, 1936–1943: Photographs from the Farm Security Administration* (St. Paul: Minnesota Historical Society Press, 1989); Constance B. Schulz, ed., *Bust to Boom: Documentary Photographs of Kansas, 1936–1949* (Lawrence: University Press of Kansas, 1996); and Marta Weigle, ed., *Women of New Mexico: Depression Era Images* (Santa Fe, N.M.: Ancient City Press, 1993).

4. For previously published selections of Vachon's photographs, see Paul Levy, "Picturing Minnesota: John Vachon and the Photographers Who Searched for the Heart of America Fifty Years Ago," *Minneapolis Star Tribune Sunday Magazine,* November 26, 1989, 6–11; Miles Orvell, "John Vachon: On the Road in Iowa" [Letters and photographs], *DoubleTake* 3, no. 1 (winter 1997): 102–13, and "Portrait of the Photographer as a Young Man"; Reid, ed., *Back Home Again* and *Picturing Minnesota, 1936–1943;* and John Vachon, "Omaha," in Fleischhauer and Brannan, eds., *Documenting America, 1935–1943.*

5. Vachon, talking about the roots of photojournalism, said, after alluding to Eugène Atget, Lewis Hine, Mathew Brady, and Jacob Riis, "But it really began in Germany—in the '20's—a man named Dr. Solomon. . . . He simply somehow became the man with a 35 mm. camera who was present at numerous important meetings of statesmen, etc." (Vachon, Teaching Notes, University Note Book [1974]).

6. See Ann Vachon, ed., *Poland, 1946: The Photographs and Letters of John Vachon* (Washington, D.C.: Smithsonian Institution Press, 1995).

7. Sean Kernan, "John Vachon—Profile of a Magazine Photographer," *Camera 35,* December 1971, 71; Thomas B. Morgan, "John Vachon: A Certain Look," *American Heritage,* February 1989, 97 (quotation).

8. Vachon may have come close to a signature picture with his photograph of a Great Northern railroad car parked in front of a white wall crisscrossed with broad black lines. The image, not especially typical, is reproduced in Roy Emerson Stryker and Nancy Wood, *In This Proud Land: America, 1935–1943, As Seen in the FSA Photographs* (New York: Galahad, 1973), 40.

9. For biographical information, I am drawing on the letters and journals (with brief citations given parenthetically in the text and full information in the bibliography), in addition to the following published essays: Brian Vachon, "Assignment: Chicago," *Chicago Tribune Magazine,* February 24, 1991, 10–15; Brian Vachon, "John Vachon: A Remembrance," *American Photographer,* October 1979, 34+; and Ann Vachon, afterword to *Poland, 1946.*

10. Richard K. Doud, interview with Roy E. Stryker at his home, Montrose, Colorado, October 17, 1963, 5, transcript in Archives of American Art, Smithsonian Institution, Washington, D.C.

11. The complementarity of intellect and passion that Vachon sees in Joyce is a defining characteristic of modernism, according to Daniel Joseph Singal (*Modernist Culture in America* [Belmont, Calif.: Wadsworth, 1991], 14).

12. Another hearing of Gershwin evoked this Whitmanesque response: "Again, Gershwin's 'Rhapsody' crept obtrusively into my blood. It is so comprehensive, so mad, so rhythmic, brazen and blaring, nervous. It seizes me and tightens me and loosens me; it cannot be forgotten when it's got you; it cannot be forgotten" (April 7, 1935).

13. See Roy Stryker, "The Photographer and the Focus of Attention," in Roy Stryker Papers, University of Louisville Photographic Archives, Louisville, Ky.

14. Richard K. Doud, interview with John Vachon, New York City, April 28, 1964, 4, transcript in Archives of American Art, Smithsonian Institution. On Vanderbilt's organization of the files, see Trachtenberg, "From Image to Story"; also see Hurley's judgment, with which I agree, that Vanderbilt's system was of more immediate use than Vachon's in retrieving images, but that Vachon's would have been better in the long run for the needs of the social historian (Hurley, *Portrait of a Decade,* 186 n. 36).

15. On the centrality of the documentary to twentieth-century culture, see Paula Rabinowitz, "People's Culture, Popular Culture, Public Culture: Hollywood, Newsreels, and FSA Films and Photographs," in *They Must Be Represented: The Politics of Documentary* (London: Verso, 1994).

16. Vachon's conception develops more fully Stryker's initial notion of the FSA project: "I was thinking," Stryker recalls in a conversation some years later, "there was this little thing in the back of my mind, I was going to assemble a lot of stuff and some day it might be useful for the encyclopedia." Dorothea Lange rejoins: "The encyclopedia was the big thing then" (Conversation between Roy E. Stryker, Dorothea Lange, Arthur Rothstein, and John Vachon [n.d.], 26, transcript in Vachon Collection); see also Terry Smith, *Making the Modern: Industry, Art, and Design in America* (Chicago: University of Chicago Press, 1993), on the "inventory" as the "key figuring device of the moment" (296).

17. John Vachon, "Minnesota: Beyond the Cities," *Earth Journal* (Minnesota Geographic Society) 3, no. 6 (1973): 24. The exact title of Morse's book is *A Map of the World of Knowledge* (Baltimore: Arnold, 1925). Morse's work is a brief, definitional survey of the various fields of knowledge with a list of recommended readings.

18. Conversation between Stryker, Lange, Rothstein, and Vachon, 35.

19. Some FSA photographers, including Gordon Parks and Jack Delano, have written autobiographies; others, such as Dorothea Lange and Walker Evans, have been the subject of biographies (by Milton Meltzer and Belinda Rathbone, respectively).

20. See Stange, *Symbols of Ideal Life,* 111. In addition to being supplied to magazines, newspapers, and books, FSA images were visible in government publications and exhibitions. Some of Evans's FSA work was shown at New York's Museum of Modern Art, and the FSA group as a whole was featured at a trade show at Grand Central Station in 1938, where it was enthusiastically reviewed by Edward Steichen in *U.S. Camera 1939* (New York: William Morrow, 1938), 7.

21. Doud, interview with Vachon, 7. Vachon added: "But during all these two weeks, of course, I photographed everything I saw that would go good in the file and that meant, you know, farmers, and deserted houses, and small towns, and building fronts."

22. "The Farm Security Photographer Covers the American Small Town" [publicity release], Stryker Papers, University of Louisville Photographic Archives.

23. For an excellent discussion of the small-town ideal in the photography of Russell Lee, see Curtis, *Mind's Eye, Mind's Truth,* chap. 5.

24. Smith, *Making the Modern,* 311.

25. John Vachon, "Minnesota," 25.

26. Vachon's letters to his wife, Millicent—known as Penny—constitute a major source of information for the photographer's life on the road during the FSA years. The letters are undated, but I am using the postmark date on the envelope—preserved with each letter—as a guide to the date of composition. Vachon usually sent off his letters on the day he wrote them, and mail pickup was commonly several times a day in those years.

27. In a letter to Stryker, Vachon writes: "Arthur really made quite a dent out here. All kinds of unexpected people ask about him—bell boys, etc. Little boys on the street say 'Arthur Rothstein carries 4 cameras. How many do you carry?' When I am introduced as 'from Rothstein's outfit' I command immediate respect" (April 1940, Stryker Papers, University of Louisville Photographic Archives).

28. John Vachon, "Tribute to a Man, an Era, an Art," *Harper's,* September 1973, 98.

29. See, for example, Bill Ganzel, *Dust Bowl Descent* (Lincoln: University of Nebraska Press, 1984).

30. Cf. Stryker's observation that the first generation of photographers did not face the problem that the later ones did: "Russell [Lee] was the first one of the people who had to match himself up against a going concern, a block of material that was already in, and from that time on every new photographer had to face that problem that they were up against a tough problem there with pictures in the file they had to match, equal or better" (Conversation between Stryker, Lange, Rothstein, and Vachon, 38).

31. Roy E. Stryker, "Suggestions for Photographs," n.d.; "Suggestions for Community Photographs," n.d.; "Pictures Needed for File," n.d.; and "Ideas for Pictures," n.d., all in Stryker Papers, University of Louisville Photographic Archives.

32. Roy E. Stryker, "For Vachon Trip to Iowa," April 1940; "Outline of Possible Photographic Work in Minnesota and Wisconsin," 1940; "Random Notes in Iowa for John Vachon," April 13, 1940 (two quotations); and "Field Notes for John Vachon," n.d., all in Stryker Papers, University of Louisville Photographic Archives.

33. See Abigail Solomon-Godeau: "the very working methods of some of the F.S.A. photographers attest to a preference for the poignant over the militant" ("Who Is Speaking Thus?" in *Photography at the Dock* [Minneapolis: University of Minnesota Press, 1991], 179).

34. For Vachon's description of the Dubuque experience, see his letter to Stryker, April 19, 1940, reprinted in "Correspondence with Roy Stryker" in "Additional Writings."

35. Roy Emerson Stryker, "The FSA Collection of Photographs," in Stryker and Wood, eds., *In This Proud Land,* 8.

36. Stryker to Russell Lee, June 26, 1941, Roy E. Stryker Papers, microfilm reel NDA 31; Stryker to Dorothea Lange, Roy E. Stryker Papers, microfilm reel NDA 30, Archives of American Art; quoted in Nicholas Natanson, *The Black Image in the New Deal: The Politics of FSA Photography* (Knoxville: University of Tennessee Press, 1992), 4.

37. Vachon, quoted in Edna Bennett, "John Vachon: A Realist in Magazine Photography," *U.S. Camera,* December 1960, n.p. Looking back on his FSA employment, Jack Delano also affirmed that he felt free, after a while, to set aside Stryker's very specific instructions and "take liberties if I felt it advisable" (Delano, *Photographic Memories* [Washington, D.C.: Smithsonian Institution Press, 1997], 34).

38. John Vachon, "Tribute to a Man, an Era, an Art," 98.

39. According to historian John Raeburn, Abbott had written a Guggenheim application in 1937 (with Elizabeth McCausland) that promised to photograph ten American cities, excluding New York, arguing the importance of urban documentary to future historians. "There is a reality superior to guidebook wisdom, an observation far more profound than the postcard view of the Empire State Building" ("Plans for Work: Plan to Document the Portrait of Contemporary Americans," Stryker Papers, University of Louisville Photographic Archives). Raeburn speculates that the Guggenheim application wound up in the Stryker Papers because Stryker had been asked to review it (E-mail to author, February 9, 2003). I am very grateful to Professor Raeburn for generously sharing his research on Abbott with me. I also thank Louise Rosskam, Beverly Brannan, and Maren Stange for their help in trying to ascertain the author of this anonymous piece.

40. John Vachon, "U.S. Camera Annual 1949" (review), *Photo Notes*, spring 1949, 22. Although Vachon favored images that were spontaneously conceived, his typical approach to a subject—whether farm or city—was first to walk through as much of it as he could without taking pictures, planning the shots he would then take on a second pass.

41. John Vachon, Teaching Notes, University Note Book, 1974.

42. See Tod Papageorge, *Walker Evans and Robert Frank, an Essay on Influence* (New Haven: Yale University Press, 1981).

43. Solomon-Godeau, "Who Is Speaking Thus?" 176–78. John Pultz qualifies that commonplace: "During the 1930s, as the United States turned its attention to the plight of the unemployed and the battle for economic recovery, doc-style photography came to dominate. But even as high modernism, like Pictorialism, became out of date, it left as its legacy the possibility that photographers could use their medium's mechanical realism, as Walker would do, to make documentary equivalents of reality that were expressive through formal rather than sentimental means" (Pultz, "Austerity and Clarity: New Photography in the United States, 1920–1940," in *A New History of Photography,* ed. Michel Frizot [Cologne: Konemann, 1998], 486).

44. Cf. Smith: "The stylistic point here (for the little it is worth) is that documentary photography is not opposed to modernism, nor is it only realist: it draws in both tendencies; their contrary connotations activate the imagery, not problematically but productively" (*Making the Modern,* 301).

45. Cf. Lange, on being on the road: "We were staying out too long, working too hard"—and she goes on with a list of complaints similar to those of Vachon's (Conversation between Stryker, Lange, Rothstein, and Vachon, 47).

46. In a letter to Penny from Poland in 1946 Vachon wrote about the "warmth and real even terms with people which I think a photographer has got to have" (Ann Vachon, ed., *Poland, 1946,* 25).

47. Although Smith's general observation—that the FSA acted as a surveillance instrument of the government and that local agents are invisible in their financial roles—may be true (*Making the Modern,* 310), Vachon's photographs frequently depict the marked difference in status between FSA agents and those being served by the agency.

48. Hurley, *Portrait of a Decade,* 170.

49. Vachon's difficulty explaining his purpose to his subjects had been with him even before America's entry into the war made the problem more acute: "Tell Philip Brown his idea of carrying FSA pictures with one is invaluable. They make clear at once what I used to spend days trying to get across to people" (Vachon to Penny, May 6, 1940).

50. Vachon wrote to Penny from Poland in 1946: "I been lying here thinking about how happy I was on all my various photographic assignments for Roy, really feeling longing for those good old days—that February and March '42 in Dakotas and Montana though, that is always my very happiest memory. . . . I've been thinking a lot about Roy lately. For one thing, I'm realizing how really damn much he means to me—the old father stuff. . . . I practically love the guy. Then also, I'm realizing that the way I'm trained I can work well only by working for him— that is real well" (Ann Vachon, ed., *Poland, 1946,* 21, 23).

51. Doud, interview with Vachon, 16.

PHOTOGRAPHIC PLATES

1. See introduction, nn. 2–4.

2. In the Library of Congress catalogue numbers, the last letter of the negative number denotes the negative size: A = 8 × 10 inches; D = $3^1/_4 × 4^1/_4$ inches; E = $2^1/_4 × 2^1/_4$ inches; M = 35 mm.

3. E.g., George Ross Leighton, *Five Cities: The Story of Their Youth and Old Age* (New York: Harper and Brothers, 1939).

4. *Retrospective: Photographs by John Vachon,* Imageworks, Cambridge, Mass., November 6–December 8, 1962; *An Exhibition of Photographs: John Vachon,* A Photographer's Place, Philadelphia, March 29–April 26, 1963; *An Exhibition of Photographs by John Vachon,* Kelmscott Gallery, Chicago, November 16–December 30, 1993; and *Dubuque, 1940: Photography of John Vachon and the Farm Security Administration,* Dubuque Museum of Art, November 15, 2000–February 15, 2001.

LETTERS TO PENNY

1. Cf. the reprinting of a similar article on Bourke-White by James Agee at the end of *Let Us Now Praise Famous Men* (1941), in which she is also implicitly held up to ridicule.

2. Vachon is writing on heavily decorated hotel stationery.

3. Vachon is planning to visit his parents' home in St. Paul.

4. Presumably he is reading Father Charles Edward Coughlin's *Social Justice,* an anti-Semitic periodical advocating the inflammatory political goals of the National Union for Social Justice. Coughlin began as a Roosevelt supporter, but by the late thirties he was attacking the New Deal and the supposed conspiracy of international bankers; by November 1940 he was excusing Hitler and blaming the Jews for the Russian Revolution and everything else. At the height of his popularity, before his time on the airwaves was limited in 1939, the "Radio Priest" held an audience of 30 million.

5. Vachon included in the envelope a portion of an Iowa highway map, with his journey outlined on the roads.

6. *PM,* a New York newspaper, was founded by Ralph Ingersoll and was anti-fascist, pro-Roosevelt, and pro-consumer (it accepted no advertising). *PM* used color consistently and printed photographs with unusual clarity; published from 1940 to 1948, it featured, among others, Ernest Hemingway, Ernest Caldwell, Margaret Bourke-White, and Weegee.

7. Hugh Herbert was an American comic actor known for his fidgety finger movements.

8. Albert Maltz's novel *The Underground Stream: An Historical Novel of a Moment in the American Winter* (1940) depicts a struggle between workers who are organizing at an auto factory and the fascistic managers.

9. The letter is addressed to Penny c/o Ralph C. Limber, Bayville Road, Locust Valley, New York.

10. During the late thirties and forties, Duncan Hines wrote annually updated restaurant guides, called *Adventures in Good Eating for the Discriminating Motorist,* as well as travel guides, called *Lodging for a Night.*

11. Federal Indian Liquor Laws, prohibiting the sale or gift of alcohol to Indians, were enacted in 1897 and were in effect in the 1930s. Though Prohibition was repealed in 1933, the Indian laws were not repealed until 1953 by President Dwight Eisenhower.

12. Typewriter. From here on, the letter is typed.

13. Indian Service.

14. Office of Civilian Defense.

15. The clipping is no longer in the envelope.

16. Jack Delano, FSA photographer, and his wife Irene.

17. A reference to Richard Wright's *Twelve Million Black Voices* (1941), originally published as a poem.

18. The postmark on the envelope is March 29, 3 P.M.; the previous letter is postmarked March 29, 10 A.M.

19. Hammond would later become a jazz critic and music producer.

20. Probably Arthur Rothstein, FSA photographer.

21. Theodore Jung, FSA photographer. "Paul's Case" (1905) is a story by Willa Cather.

22. "Ballad for Americans" (1939), a liberal vision of America.

23. Vachon's May 18, 1942, letter to Penny was "a letter of extreme frankness," containing a long catalogue of criticisms about her person and personality. He ends by asking her to destroy the letter and in subsequent letters returns to this request. Penny never did, and Vachon also kept the letter.

24. Vachon later corrected the name to Jim Tillman; however, all his photographs of the engineering student are captioned "Jim Tillma."

25. The Reconstruction Finance Corporation was a U.S. government agency, established in 1932, that during the war years helped finance the construction and operation of war plants.

26. Vachon suffered for weeks from an eye infection, which at times prevented his working.

27. Gordon Parks, the photographer and filmmaker, had started his career as an FSA photographer under Stryker.

28. The War Price and Rationing Board issued three types of cards for gasoline: A, B, and C. A, the most generous, was for people who worked in national defense industries.

29. Vachon had sent a letter to Penny that he'd torn into little pieces; the letter was pieced together with transparent tape, but the adhesive has since melted and it cannot be opened.

30. Vachon's meaning is uncertain: Whining Boy? Winning Boy?

31. The letter was addressed to Mrs. John Vachon, c/o C. W. Leeper, Box 96, Terrace (Allegheny Co.), Pennsylvania.

32. The dated envelope is missing. I have estimated the date from internal evidence (Vachon's birthday).

33. This letter and the next two are addressed to Penny at her brother's house (Mrs. John Vachon, care of Mr. Alan Leeper, 1808 W. Texas, Midland, Texas).

34. Vachon probably means James M. Cain.

35. Vachon had done a series on San Augustine, Texas, in April 1943.

36. Civilian Air Patrol.

37. Vachon had been asked to leave Catholic University—for excessive drinking—during his first year of graduate study in English. He had concealed this fact from his mother.

ADDITIONAL WRITINGS

John Vachon's journals are in the possession of his family (they are promised to the Library of Congress); "Standards of the Documentary File" is a typescript in Roy Stryker Papers, University of Louisville Photographic Archives, Louisville, Ky. (the original is typed in all capital letters); typescript copies of the shooting scripts are in the Stryker Papers; and the letters are also in the Stryker Papers (Vachon's letters to Stryker are handwritten, and Stryker's are typed). "Tribute to a Man, an Era, an Art" was first published as a "Commentary" in *Harper's,* September 1973, 96–99.

1. Though Vachon received encouragement from editors, his fiction remained unpublished; written well after the FSA years, it is not included in this collection.

2. The balance between hardship and pleasure might shift from day to day. In a 1964 interview, Vachon remembered the relative pleasures in terms somewhat like those of his letter, although not so extreme. "My deepest and strongest and fondest memories of working there for five years I guess, six, something like that, are all connected with traveling around this country, seeing places that I'd never been before. I had traveled very little until that time, I'd only been from my native Minnesota to non-native Washington, and it was just great to be alone in a car, and to be paid for driving around, and taking pictures of what you liked to take pictures of" (Richard Doud, interview with John Vachon, New York City, April 28, 1964, 16, transcript in Archives of American Art, Smithsonian Institution, Washington, D.C.).

3. Mildred Irwin, described in Vachon's letter to Penny of October 29, 1938; see figure 25.

4. Vachon was shooting photographs to illustrate George R. Leighton's, "Omaha, Nebraska: The Glory Has Departed," in *Five Cities: The Story of Their Youth and Old Age* (New York: Harper and Brothers, 1939), 140–236; Vachon's images appear on 151, 198, 199, 215, and 216.

5. See the Dubuque photographs in the introduction, figures 4 and 5.

6. Perhaps "letter of authority."

7. Office of Emergency Management, created by Roosevelt in May 1940.

8. Vachon re-creates fragments of overheard conversation.

9. Most likely Philip Brown, one of Vachon's close friends. "Mrs. B," at the end, is Polly Brown.

10. Vachon did in fact take several more, shorter trips for the FSA-OWI, into the summer of 1943.

11. In recounting this incident in "First Day Out," Vachon calls the lady's son "Charles."

ILLUSTRATIONS

All illustrations (except where noted) are reprinted courtesy of the Library of Congress.

FRONT

FIGURES

PLATES (FOLLOWING PAGE 40)

6. *Grain Elevator.* Superior, Wisconsin. August 1941. LC-USF34-063816-D.

7. *Stockyards.* Omaha, Nebraska. November 1938. LC-USF34-08864-D.

8. *Wires, Poles, and Fences along U.S. Highway #10.* Dickinson, North Dakota. February 1942. LC-USF34-064781-D.

9. *School House.* Ward County, North Dakota. November 1940. LC-USF34-061587-D.

10. *Rural School.* Wisconsin. September 1939. LC-USF33-001537-M4.

11. *Children Doing Calisthenics at the School Playground.* Irwinville, Georgia. May 1938. LC-USF33-001158-M5.

12. *Playing "Out to Pie" or "Fox and Geese" at Noon Recess at Rural School.* Morton County, North Dakota. February 1942. LC-USF34-064805-D.

13. *School Girl.* Morton County, North Dakota. February 1942. LC-USF34-064710-D.

14. *Negro Dock Worker and Son.* New Orleans, Louisiana. March 1943. LC-USW3-22841-E.

15. *School Children at the Post Office to Buy Defense Stamps.* New Boston, Ohio. January 1942. LC-USF34-064390-D.

16. *A One Room Schoolhouse.* St. Mary's County, Maryland. September 1940. LC-USF34-061342-D.

17. *The Tygart Valley Subsistence Homesteads, a Project of the U.S. Resettlement Administration. Daughters of a Homesteader with a House and a Factory in the Background.* Elkins, West Virginia. June 1939. LC-USF33-001409-M1.

18. *Girls Who Work at Aberdeen Proving Grounds, and Share a Room in the Farm Security Administration's Dormitory for Defense Workers.* Aberdeen, Maryland. December 1941. LC-USF34-064180-D.

19. *Ladies Who Live in the Rooming House.* St. Paul, Minnesota. September 1939. LC-USF33-001639-M1.

20. *The Tygart Valley Subsistence Homesteads, a Project of the U.S. Resettlement Administration. Meeting of the Women's Club.* Elkins, West Virginia. June 1939. LC-USF34-060023-D.

21. *The Tygart Valley Subsistence Homesteads, a Project of the U.S. Resettlement Administration.* Elkins, West Virginia. June 1939. LC-USF34-060051-D.

22. *Oil Wells.* Kilgore, Texas. April 1943. LC-USW3-25291-D.

23. *Soda Fountain in Rushing's Drug Store on Saturday Afternoon.* San Augustine, Texas. April 1943. LC-USF34-025104-D.

24. *People on the Main Street on Saturday Afternoon.* San Augustine, Texas. April 1943. LC-USF34-025222-D.

25. *The Main Street.* Scranton, Iowa. May 1940. LC-USF34-060741-D.

26. Untitled. February 1942 [?]. LC-USF34-064845-D.

27. *Christmas Shopping Crowds.* Gadsden, Alabama. December 1940. LC-USF34-062097-D.

28. Untitled. Cincinnati, Ohio. October 1938. LC-USF33-001214-M1.

29. *Coffee Shop.* Chicago, Illinois. July 1941. LC-USF33-016075-M5.

30. *The 4th of July Parade.* Watertown, Wisconsin. July 1941. LC-USF33-016137-M4.

31. *Watching Ballgame.* Vincennes, Indiana. July 1941. LC-USF33-016086-M4.

32. *Picnickers, Vincennes, Indiana.* Vincennes, Indiana. July 1941. LC-USF33-016130-M2.

33. *Commuters Waiting for South-bound Trains.* Chicago, Illinois. July 1941. LC-USF33-016119-M3.

34. *The Vestibule of the Baptist Church during Sunday Services with Hats Hanging on the Wall. They Belong*

WORKS CITED

Note: "Vachon Collection" indicates the largely unpublished materials, typescript and manuscript, owned by the Vachon family and promised to the Library of Congress.

Bennett, Edna. "John Vachon: A Realist in Magazine Photography." *U.S. Camera,* December 1960, n.p.

Brannan, Beverly W., and David Horvath, eds. *A Kentucky Album: Farm Security Administration Photographs, 1935–1943.* Lexington: University Press of Kentucky, 1986.

Carlebach, Michael, and Eugene F. Provenzo, Jr. *Farm Security Administration Photographs of Florida.* Gainesville: University Press of Florida, 1993.

Conversation between Roy E. Stryker, Dorothea Lange, Arthur Rothstein, and John Vachon. N.d. Transcript, Vachon Collection, 80 pages.

Curtis, James. *Mind's Eye, Mind's Truth: FSA Photography Reconsidered.* Philadelphia: Temple University Press, 1989.

Delano, Jack. *Photographic Memories.* Washington, D.C.: Smithsonian Institution Press, 1997.

Doud, Richard K. Interview with John Vachon, New York City, April 28, 1964. Transcript in Archives of American Art, Smithsonian Institution, Washington, D.C.

———. Interview with Roy E. Stryker at his home, Montrose, Colorado, October 17, 1963. Transcript in Archives of American Art, Smithsonian Institution, Washington, D.C.

Evans, Walker. *Walker Evans: Photographs for the Farm Security Administration, 1935–1938.* New York: Da Capo, 1973.

"The Farm Security Photographer Covers the American Small Town" [publicity release]. Roy Stryker Papers, University of Louisville Photographic Archives, Louisville, Ky. Available on microfilm (Chadwyck-Healy Ltd.).

Fleischhauer, Carl, and Beverly W. Brannan, eds. *Documenting America, 1935–1943.* Berkeley: University of California Press, in association with the Library of Congress, 1988.

Ganzel, Bill. *Dust Bowl Descent.* Lincoln: University of Nebraska Press, 1984.

Guimond, James. *American Photography and the American Dream.* Chapel Hill: University of North Carolina Press, 1991.

Hastings, Scott E., Jr., and Elsie R. Hastings. *Up in the Morning Early: Vermont Farm Families in the Thirties.* Hanover, N.H.: University Press of New England, 1992.

Heyman, Therese Thau. *Dorothea Lange: American Photographs.* San Francisco: San Francisco Museum of Modern Art and Chronicle Books, 1994.

Hurley, F. Jack. *Marion Post Walcott: A Photographic Journey.* Albuquerque: University of New Mexico Press, 1989.

———. *Portrait of a Decade: Roy Stryker and the Development of Documentary Photography in the Thirties.* Baton Rouge: Louisiana State University Press, 1972.

Just before the War: Urban America from 1935 to 1941 As Seen by Photographers of the Farm Security Administration. New York: October House, 1968.

Kernan, Sean. "John Vachon—Profile of a Magazine Photographer." *Camera 35,* December 1971, 31+.

Leighton, George Ross. *Five Cities: The Story of Their Youth and Old Age.* New York: Harper and Brothers, 1939.

Levine, Lawrence W. "The Historian and the Icon: Photography and the History of the American People in the 1930s and 1940s." In *Documenting America, 1935–1943,* edited by Carl Fleischhauer and Beverly W. Brannan. Berkeley: University of California Press, in association with the Library of Congress, 1988.

Levy, Paul. "Picturing Minnesota: John Vachon and the Photographers Who Searched for the Heart of America Fifty Years Ago." *Minneapolis Star Tribune Sunday Magazine,* November 26, 1989, 6–11.

Meltzer, Milton. *Dorothea Lange: A Photographer's Life.* New York: Farrar Straus Giroux, 1978.

Morgan, Thomas B. "John Vachon: A Certain Look." *American Heritage,* February 1989, 96–109.

Natanson, Nicholas. *The Black Image in the New Deal: The Politics of FSA Photography.* Knoxville: University of Tennessee Press, 1992.

Orvell, Miles. "John Vachon: On the Road in Iowa" [letters and photographs]. *DoubleTake* 3, no. 1 (winter 1997): 102–13.

———. "Portrait of the Photographer as a Young Man: John Vachon and the FSA Project." In *A Modern Mosaic: Art and Modernism in the United States,* edited by Townsend Ludington. Chapel Hill: University of North Carolina Press, 2000.

Papageorge, Tod. *Walker Evans and Robert Frank: An Essay on Influence.* New Haven: Yale University Press, 1981.

Parks, Gordon. *Voices in the Mirror: An Autobiography.* New York: Doubleday, 1990.

"Plans for Work: Plan to Document the Portrait of Contemporary Americans." Roy Stryker Papers, University of Louisville Photographic Archives, Louisville, Ky. Available on microfilm (Chadwyck-Healy Ltd.).

Pultz, John. "Austerity and Clarity: New Photography in the United States, 1920–1940." In *A New History of Photography,* edited by Michel Frizot. Cologne: Konemann, 1998.

Rabinowitz, Paula. *They Must Be Represented: The Politics of Documentary.* London: Verso, 1994.

Rathbone, Belinda. *Walker Evans: A Biography.* Boston: Houghton Mifflin, 1995.

Reid, Robert L., ed. *Back Home Again: Indiana in the Farm Security Administration Photographs, 1935–1943.* Bloomington: Indiana University Press, 1987.

———. *Picturing Minnesota, 1936–1943: Photographs from the Farm Security Administration.* St. Paul: Minnesota Historical Society Press, 1989.

Schulz, Constance B., ed. *Bust to Boom: Documentary Photographs of Kansas, 1936–1949.* Lawrence: University Press of Kansas, 1996.

Singal, Daniel Joseph. *Modernist Culture in America.* Belmont, Calif.: Wadsworth, 1991.

Smith, Terry. *Making the Modern: Industry, Art, and Design in America.* Chicago: University of Chicago Press, 1993.

Solomon-Godeau, Abigail. "Who Is Speaking Thus?" In *Photography at the Dock: Essays on Photographic History, Institutions, and Practices.* Minneapolis: University of Minnesota Press, 1991.

Stange, Maren. *Symbols of Ideal Life: Social Documentary Photography in America, 1890–1950.* New York: Cambridge University Press, 1989.

Steichen, Edward. *U.S. Camera 1939.* New York: William Morrow, 1938.

Stott, William. *Documentary Expression and Thirties America.* New York: Oxford University Press, 1973.

Stryker, Roy. "Field Notes for John Vachon" [shooting script]. N.d. Roy Stryker Papers. University of Louisville Photographic Archives, Louisville, Ky. Available on microfilm (Chadwyck-Healy Ltd.).

———. "For Vachon Trip to Iowa" [shooting script]. April 1940. Roy Stryker Papers. University of Louisville Photographic Archives, Louisville, Ky. Available on microfilm (Chadwyck-Healy Ltd.).

———. "The FSA Collection of Photographs." In *In This Proud Land: America 1935–1943, As Seen in the FSA Photographs,* edited by Roy Emerson Stryker and Nancy Wood. New York: Galahad, 1973.

———. "Ideas for Pictures" [shooting script]. N.d. Roy Stryker Papers, University of Louisville Photographic Archives, Louisville, Ky. Available on microfilm (Chadwyck-Healy Ltd.).

———. Letters. Roy Stryker Papers, University of Louisville Photographic Archives, Louisville, Ky. Available on microfilm (Chadwyck-Healy Ltd.).

———. "Outline of Possible Photographic Work in Minnesota and Wisconsin" [shooting script]. 1940. Roy Stryker Papers, University of Louisville Photographic Archives, Louisville, Ky. Available on microfilm (Chadwyck-Healy Ltd.).

———. "The Photographer and the Focus of Attention." N.d. Roy Stryker Papers, University of Louisville Photographic Archives, Louisville, Ky. Available on microfilm (Chadwyck-Healy Ltd.).

———. "Pictures Needed for File" [shooting script]. N.d. Roy Stryker Papers. University of Louisville Photographic Archives, Louisville, Ky. Available on microfilm (Chadwyck-Healy Ltd.).

———. "Random Notes in Iowa for John Vachon" [shooting script]. April 13, 1940. Roy Stryker Papers. University of Louisville Photographic Archives, Louisville, Ky. Available on microfilm (Chadwyck-Healy Ltd.).

———. "Suggestions for Community Photographs" [shooting script]. N.d. Roy Stryker Papers. University of Louisville Photographic Archives, Louisville, Ky. Available on microfilm (Chadwyck-Healy Ltd.).

———. "Suggestions for Photographs" [shooting script]. N.d. Roy Stryker Papers. University of Louisville Photographic Archives. University of Louisville, Louisville, Ky. Available on microfilm (Chadwyck-Healy Ltd.).

Stryker, Roy Emerson, and Nancy Wood, eds. *In This Proud Land: America, 1935–1943, As Seen in the FSA Photographs.* New York: Galahad, 1973.

Tagg, John. "The Currency of the Photograph." In *Thinking Photography,* edited by Victor Burgin. London: Macmillan, 1982.

Trachtenberg, Alan. "From Image to Story: Reading the File." In *Documenting America, 1935–1943,* edited by Carl Fleischhauer and Beverly W. Brannan. Berkeley: University of California Press, in association with the Library of Congress, 1988.

Vachon, Ann, ed. and afterword. *Poland, 1946: The Photographs and Letters of John Vachon.* Washington, D.C.: Smithsonian Institution Press, 1995.

Vachon, Brian. "Assignment: Chicago." *Chicago Tribune Magazine,* February 24, 1991, 10–15.

———. "John Vachon: A Remembrance." *American Photographer,* October 1979, 34+.

Vachon, John. Journals. Transcribed typescript, 448 pages. Vachon Collection.

———. Letters. Vachon Collection.

———. "Minnesota: Beyond the Cities." *Earth Journal* (Minnesota Geographic Society) 3, no. 6 (1973): 22–27.

———. "Omaha." In *Documenting America, 1935–1943*, edited by Carl Fleischhauer and Beverly W. Brannan. Berkeley: University of California Press, in association with the Library of Congress, 1988.

———. "Standards of the Documentary File." Roy Stryker Papers. University of Louisville Photographic Archives, Louisville, Ky. Available on microfilm (Chadwyck-Healy Ltd.).

———. Teaching Notes, University Note Book. 1974. Vachon Collection.

———. "Tribute to a Man, an Era, an Art" [commentary]. *Harper's,* September 1973, 96–99.

———. "U.S. Camera Annual 1949" [review]. *Photo Notes,* spring 1949, 21–22.

Weigle, Marta, ed. *Women of New Mexico: Depression Era Images.* Santa Fe, N.M.: Ancient City Press, 1993.

INDEX

Note: Page numbers appearing in italics refer to illustrations. "Vachon" by itself refers to John Vachon. With regard to Vachon's letters and diaries, more intimate or domestic content (e.g., love, finances) is indexed under "Vachon, John, letters to Penny" and "Vachon, John, journals of," while more "public" topics (e.g., labor strikes) appear as main headings.

DESIGNER: Victoria Kuskowski

INDEXER: Carol Roberts

COMPOSITOR: Integrated Composition Systems

TEXT: 10.25/15 Bulmer

DISPLAY: Rosewood Fill, Bodoni Book, Bulmer

PRINTER AND BINDER: Friesens